WHY ARE OUR PICTURES PUZZLES? IS THE FIRST BOOK OF ITS KIND: IT QUESTIONS THE NOTION, PREVALENT IN ART HISTORY TODAY, THAT PAINTINGS ARE COMPLEX PUZZLES IN NEED OF SOLVING, THAT THERE ARE HIDDEN MEANINGS IN IMAGES, AND THAT VOLUMES OF INTERPRETATION OF A SINGLE IMAGE ARE SOMEHOW WARRANTED. JAMES ELKINS EXAMINES THE MODERN ORIGINS OF PICTORIAL COMPLEXITY, EXPLAINS WHY WE HAVE ONLY RECENTLY BECOME AWARE THAT PICTURES ARE COMPLEX, AND EXPLORES A VARIETY OF EXPLANATIONS FOR THE INTRICATE MEANINGS WE NOW TAKE FOR GRANTED.

ADVANCE PRAISE FOR *WHY ARE OUR PICTURES PUZZLES?*

"IF OUR AGE IS RIGHTFULLY SAID TO SUFFER FROM A 'FRENZY OF THE VISIBLE,' IT OFTEN SEEMS AS IF OUR DISCOURSE ABOUT IMAGES IS NO LESS FEVERISHLY DELIRIOUS. EVERY POSSIBLE HERMENEUTIC APPROACH HAS BEEN MARSHALED TO CRACK THEIR CODES AND UNRAVEL THEIR MYSTERIES. IN HIS REMARKABLE NEW BOOK, JAMES ELKINS TAKES ONE STEP BACK AND REFLECTS INSTEAD ON THE SOURCE OF OUR NEED TO CONSIDER PICTURES AS RIDDLES TO BE SOLVED. DRAWING ON AN ASTOUNDING RANGE OF EXAMPLES FROM ART HISTORY AND AESTHETIC THEORY, HE EXPLORES NINE POSSIBLE EXPLANATIONS WITHOUT FORCING A SIMPLE ANSWER. WRITTEN WITH CRYSTALLINE ELEGANCE AND ANALYTICAL RIGOR, *WHY ARE OUR PICTURES PUZZLES?* WILL BE OF INTEREST NOT ONLY TO STUDENTS OF VISUAL CULTURE, BUT ALSO TO ANYONE CONCERNED WITH INTERPRETATION IN THE HUMANITIES AS A WHOLE."

—MARTIN JAY, UNIVERSITY OF CALIFORNIA AT BERKELEY

"...A DAZZLING INTELLECTUAL PERFORMANCE BY AN EXTRAORDINARILY GIFTED AUTHOR. THIS BOOK IS A MEDITATION ON THE NATURE OF ART HISTORICAL INTERPRETATION. IT OFFERS THE READER BOTH A THEORY OF AESTHETICS AND ITS DECONSTRUCTION. ARGUING THAT ART HISTORY BASES ITSELF ON THE ALLEGED 'COMPLEXITY' OF THE IMAGES IT CONSIDERS, ELKINS CONCLUDES THAT THIS 'COMPLEXITY' IS A PROJECTION OF THE DISCIPLINE THAT SEEKS TO MAKE SENSE OF THEM. SUCH A CONCLUSION IS, OF COURSE, CONTROVERSIAL AND A DARING CHALLENGE TO THOSE WHO WOULD CONTINUE TO DEFEND ART·HISTORY'S STATUS AS A POSITIVISTIC DISCIPLINE."

—KEITH MOXEY, BARNARD COLLEGE

JAMES ELKINS IS PROFESSOR OF ART HISTORY, THEORY, AND CRITICISM AT THE SCHOOL OF THE ART INSTITUTE OF CHICAGO. HE IS THE AUTHOR OF *WHAT PAINTING IS*, PUBLISHED BY ROUTLEDGE, AND SEVERAL OTHER BOOKS, INCLUDING *THE OBJECT STARES BACK*.

WHY ARE OUR

PICTURES

PUZZLES ?

by James Elkins

What Painting Is (Routledge, 1998)

On Pictures and the Words that Fail Them (1998)

Our Beautiful, Dry, and Distant Texts: Art History as Writing (1997)

The Object Stares Back: On the Nature of Seeing (1996)

The Poetics of Perspective (1994)

JAMES ELKINS

WHY ARE OUR
PICTURES
PUZZLES?

ON THE MODERN
ORIGINS OF
PICTORIAL
COMPLEXITY

ROUTLEDGE

NEW YORK AND LONDON

Cover Design: Dennis Kois/koisdesign

Cover Credit: Detail from *Saint Sebastian*, by Andrea Mantegna, c.1460.
Kunsthistoriches Museum, Vienna, Austria. Photo courtesy of Erich
Lessing/Art Resource, NY.

Published in 1999 by
Routledge
29 West 35th Street
New York, NY 10001

Published in Great Britain by
Routledge
11 New Fetter Lane
London EC4P 4EE

Library of Congress Cataloging-in-Publication Data

Elkins, James, 1955–
 Why are our pictures puzzles? : on the modern origins of pictorial complexity /
James Elkins.
 p. cm.
 Includes bibliographical references and index.
 ISBN 0–415–91941–X (cloth : acid-free paper). —
 ISBN 0–415–91942–8 (paper : acid-free paper)
 1. Painting—Psychology. 2. Picture interpretation. 3. Communication in art.
I. Title.
 ND1140.E49 1998
 750'.19—dc21 97–47282
 CIP

To my mother,
who loves puzzles—
here's the most difficult puzzle I know

Inin gos pozilt hozelu e dasevetwa ota od?
Getwa'aph inin stin.

CONTENTS

PREFACE

Once upon a time, pictures were simple. It used to be that relatively few words would suffice to describe an image: for ancient authors, a sentence or a paragraph was often enough. Giorgio Vasari wrote a page or two on some pictures, but never more than that. As far as cross-cultural comparisons make sense, the same is true of Chinese, Islamic, Indian, African, and Native American pictures.

Given that history, what does it mean that pictures have come to require so much more explanation than in any previous century? Why do writers involved with images find it necessary to write at such length? Why, in the span of a little more than a century, have pictures become so difficult to explain, so demanding, so puzzling?

These are the questions this book sets out to define, and then try to answer. They turn out to be treacherous questions, hard to frame and sometimes even hard to acknowledge. As Wittgenstein knew, the first step in seeing a problem is seeing that it is a problem, and the opening chapters are largely devoted to showing that some kind of disparity exists, and to characterizing it with a useful degree of precision. The mere fact that art historians write more is part of what interests me, but not enough of it: the significant change has more to do with the *way* we write, paying concerted attention to argumentative complexity and the play of competing meanings. The body of the book explores three modes of modern response: the notion that the meanings of a picture are like the meanings of a picture–puzzle; the management of ambiguous meanings; and the habit some historians have of interpreting pictures by discovering other images hidden within them.

Puzzle–solving is implicated in this from the beginning. The question of the title is itself a puzzle, though perhaps not in the typical sense of an exam question or a logical conundrum. An ordinary puzzle—say, in a book of "recreational" mathematics—might spark a reader's interest if it looks as though the route to the answer may be just out of sight. The title question is of a different order, since it is not immediately apparent what might count as a solution even if one could be found, or whether the assumption it makes (that "our" pictures are already puzzles) is true in any important sense. It looks as if the question

may be trivial or too obvious to warrant much thought, and without further qualifications it is not clear enough to suggest a line of attack. Whatever answers might emerge, they will inevitably be complex ones since puzzles will figure both as a subject of the inquiry and a method of analysis—a sure condition for analytic confusion. I take it that such enveloping uncertainties are the mark of a truly interesting question.

• • •

With a project as eccentric as this one, an author needs help from many quarters. I am grateful to many readers, including anonymous referees at several journals. Karl Werkmeister was especially helpful at a crucial juncture, when the project was threatening to drift away from art history. Thanks also to the helpful comments of audiences at Duke University, Northwestern University, the University of California at Berkeley, and the University of Chicago. But I owe special thanks, even outweighing those, to the successive chairs of my department, who have let me wander far from what often counts as art history in order to find these questions: to Thomas Sloan, Bob Loescher, and Catherine Bock. It has now been seven years since I have taught a course in my specialty (Italian Renaissance art theory), or a course organized by period, country, or artist: and that has given me a kind of freedom seldom encountered in major research universities.

An earlier version of Chapter 5, "On Monstrously Ambiguous Paintings," appeared in *History and Theory* 32 no. 3 (1993): 227–47; portions of Chapter 4 appeared as "On the Impossibility of Stories: The Anti-Narrative and Non-Narrative Impulse in Modern Painting," *Word & Image* 7 no. 4 (1991): 348–64, and "An Ambilogy of Painted Meanings," *Art Criticism* 8 no. 2 (1992): 26–35; and parts of Chapters 1 and 2 appeared as "Why Are Our Pictures Puzzles?," *New Literary History* 27 no. 2 (1996): 271–90.

LIST OF PLATES

11 Giorgione, *La Tempesta*. Venice, Gallerie dell'Accademia.

12 Margaret H. Richardson, *The Gleaners* (after Millet). After 1908. Picture puzzle, 406 hand-cut wood pieces. Courtesy Anne Williams.

13 Picture boards for educational testing. 1918. C.H. Stoelting, Chicago, IL. Plywood boards, with 60 square pieces. Courtesy Anne Williams.

14 Anonymous artists working for Consolidated Paper Box Co., Somerville, MA., *Winter's Ermine Robe / Snowed In*. 1930s. Box containing double-sided picture puzzle, 280 die-cut pieces. Courtesy Anne Williams.

15 *Vierundzwanzig Bildkarten* Landscape puzzle. 1977. Ria Holler, Munich. Envelope with 24 cardboard pieces. Photo: author.

16 Jackson Pollock, *Convergence, No. 10*. 1964. Picture puzzle, color lithograph divided into 340 die-cut cardboard pieces. Springbok Editions. Courtesy Anne Williams. Original: Pollock, *Convergence, Number 10*, 1952. Buffalo, Albright-Knox Art Gallery.

17 Relief puzzle showing a harbor scene. Courtesy Anne Williams.

18 Jess, *Cross Purposes*. 1974. Collage. Boston, Museum of Fine Arts. Purchased with funds provided by Mr. and Mrs. Graham Gund, and Barbara Fish Lee and Thomas H. Lee, and the support of Mr. and Mrs. Federico Quadrami. © 1997 Boston, Museum of Fine Arts. Photo Courtesy Odyssia Gallery, New York.

19 Anonymous artists working for Parker Brothers, *The Approaching Ship*, whole and detail. 1940s. Jigsaw puzzle, 785 hand-cut plywood pieces. Courtesy Anne Williams.

CHAPTER 4

20 Left: Francisco de Goya, *Dog*. Madrid, Prado. Photo: Ampliaciones y Reproducciones Mas (Arxiu Mas). Right: Goya, *Dog*, as it appeared in J. Roig, *Colección de cuatrocientos cuarenta y nueve reproducciones de cuadros, dibujos y aguafuertes de don Francisco de Goya* (Madrid: Editorial "Saturnino Calleja," 1924), fig. 339.

21 Max Beckmann, *The Beginning*. 1946–49. New York, Metropolitan Museum of Art.

22 Adolph Gottlieb, *Apaquogue*. 1961. Fort Worth, Texas, Modern Art Museum. © Adolph and Esther Gottlieb Foundation / Licensed by VAGA, New York, NY.

23 Balthus (Baltusz Klossowski de Rola), *The Street*. 1933. Oil on canvas, 6' 4¾" x 7' 10½." The Museum of Modern Art, New York. James Thrall Soby Bequest. Photograph © 1998 The Museum of Modern Art, New York.

24 Vassily Kandinsky, *Red Oval (Rotes Oval)*, 1920. Oil on canvas, 28⅛" x 28⅛." New York, The Solomon R. Guggenheim Museum. FN 51.1311. Photograph by David Heald.

25 Giovanni Pietro da Birago, copy of Leonardo, *Last Supper*. c. 1500. Bartsch XIII.28. From Steinberg, "Leonardo's *Last Supper*," *Art Quarterly* 36 no. 4 (1973): fig. 4.

26 Leonardo, *Last Supper*. Milan, Sta. Maria delle Grazie.

27 Marcantonio Raimondi, *Leonardo's Last Supper*, after Raphael. Bartsch XIV.26.

45 Andrea Mantegna, *Triumphs of Caesar*, canvas III, *Trophies and Bearers of Coin and Vases*, with detail of upper right. 1490s. Distemper (?) on canvas. London. The Royal Collection © Her Majesty Queen Elizabeth II.

46 Andrea Mantegna, *Pallas Expelling the Vices from the Garden of Virtue*, detail of upper left. c. 1499–1502. Tempera on canvas. Paris, Musée du Louvre. Photo courtesy of Réunion des Musées Nationaux.

47 Persian, Safavid school (attributed to Sultan Muhammad), *The Court of Gayumars*, from Abu'l-Qasim Mansur Firdawsi, *Shah-nama* (early 11th c.), folio 20v. After 1522. New York, Metropolitan Museum of Art, Formerly A. Houghton coll.

48 Miskina, *The Story of the Unfaithful Wife*, from Jami, *Baharistan* (15th c.). 1595. Mughal school, originally Lahore. The Bodleian Library, University of Oxford, MS Elliott 254, folio 42r.

49 Hans Leu the Younger, *St. Jerome*. c. 1515. Basel, Kunstmuseum, Öffentliche Kunstsammlung Inv. no. 411. Photo © Oeffentliche Kunstammlung Basel, Martin Bühler.

50 Michelangelo, *Pietà*, and detail of hidden skull. Rome, Vatican. The detail is from Enrico Castelli, "Umanesimo e simbolismo involuntario," *Umanesimo e simbolismo, etti del iv convegno internazionale di studi umanistici*, published in *Archivio di Filosofia* 2–3 (1958): 17–21, pl. IX, top.

51 Left: Bosch, *Owls' Nest on a Branch*. Rotterdam, Museum Boijmans Van Beuningen. Right: W. Kroy and J. Langerholc, Diagrams of *Owls' Nest on a Branch*, labeled (clockwise from top) "Outline of bird's head formed by branches and trunk," "Man with a turban," and "Male anatomy." From Kroy and Langerholc, "Ambiguous Figures by Bosch," *Perception and Psychophysics* 35 (1984): 402–404, p. 403 fig. 2 and p. 404 figs. 4, 5.

52 Albrecht Dürer, *Six Pillows*. 1493. New York, Metropolitan Museum of Art, Robert Lehman Collection.

53 Mi Youren, *Distant Peaks and Clouds (Yuanxiu qingyun tu)*. 1134 (?). © Osaka Municipal Museum of Art.

54 Left: Unknown artist, *Tiger by a Torrent in Rain and Wind*. Right: detail of bamboo-leaf inscription. Sung Dynasty. From William Willetts, *Chinese Calligraphy* (Hong Kong: Oxford University Press, 1981), 220–21.

55 *Funeral Dance*, second half of the 5th c. BC. Formerly Ruvo, now Naples, National Museum.

56 Jackson Pollock, *Out of the Web: Number 7, 1949*. 1949. Oil and duco on Masonite. Staatsgalerie Stuttgart. © 1998 Pollock-Krasner Foundation / Artists Rights Society (ARS). New York.

57 *Book of the Marvels of the World*. 1388. Originally Baghdad. Now Paris, Bibliothèque Nationale, Supplément Persan 332, folio 158v.

58 *Anthology of Iskander Sultan*, fol. 111v, *Iskander Peering at Sirens as they Sport by a Lake*. 1410. Originally Shiraz. Lisbon, Gulbenkian Foundation, L.A. 161. Courtesy Calouste Gulbenkian Museum, Lisbon.

59 Oskar Pfister, diagram of the vulture hidden in Leonardo's *Virgin and Child with St. Anne*, from Sigmund Freud, *Leonardo da Vinci and a Memory of his Childhood* (1910), in *The Standard Edition of the Complete Psychological Works of Sigmund Freud*, edited by James Strachey (London: Hogarth Press, 1957), vol. 11, p. 116.

60 Parmigianino, *Portrait of a Man*. 1523. London, The National Gallery.
Reproduced by courtesy of the Trustees.

61 Warner Sallman, *Head of Christ*. 1940. Anderson University. Photo courtesy
David Morgan.

62 Van Gogh, *Crows in the Wheatfields*, detail. 1890. Amsterdam, Van Gogh
Museun (Vincent van Gogh Foundation).

63 Frank Meshberger, *The Human Brain Superimposed on the Creation of Adam
from the Sistine Ceiling*. Left: left lateral aspect of the brain, tracing modified
to fit Michelangelo's *Creation of Adam*. Right: medial aspect of the right hemi-
sphere of the brain, tracing modified to fit Michelangelo's *Creation of Adam*.
Modified from Meshberger, "An Interpretation of Michelangelo's *Creation of
Adam* Based on Neuroanatomy," *Journal of the American Medical Association*
264 (1990): figs. 12 and 13. © 1990, American Medical Association. Lettering
added.

64 Turner, *Music Party*. c. 1835. As reproduced in Birger Carlström, *Hide-and-
Seek* (Urshult, Sweden: Konstförlaget, [privately printed], 1989), pl. 61.

65 Cézanne, *Small House at Auvers*. 1873–74. Cambridge, Mass., Fogg Art
Museum, Harvard University Art Museums, Bequest of Annie Swan Coburn.

66 Leonardo, *Virgin and Child with St. Anne*, rocks at St. Anne's feet. Paris,
Musée du Louvre. Photo courtesy of Réunion des Musées Nationaux.

67 Leonardo, *Virgin of the Rocks*, detail of the angel's drapery. 1485. Paris,
Musée du Louvre. Photo courtesy of Réunion des Musées Nationaux.

68 Kandinsky, *Composition VII*. 1913. 200 x 300 cm. Moscow, Tretiakov Gallery.

69 Courbet, *The Stonebreakers*. 1849. Formerly Gemäldegalerie, Dresden; pre-
sumed destroyed.

70 Left: Salvador Dalí, *The Endless Enigma*. 1938. right: Dalí's explanatory keys,
from a facsimile of the catalogue, Julien Levy Gallery, 1939.

71 Bernhard Koerner, *The Knot Rune: Ar-kun-sig*, as demonstrated on
Rembrandt's *Rape of Ganymede*. From Koerner, *Handbuch der Heroldskunst*
(Görlitz: C.A. Starke, 1923), vol. 2, pl. 17.

CHAPTER 8

72 American folkloric cartoon of the nineteenth century. From Dalí, *Le mythe
tragique de l'Angélus de Millet* (Paris: Jacques Pauvert, 1963), 4–5. Photo cour-
tesy Northwestern University.

73 Millet, *The Angelus*. 1859. Paris, Musée du Louvre. Photo courtesy of
Réunion des Musées Nationaux.

74 Salvador Dalí, *The beginning of an erection on Dalí while being photographed
disguised as The Angelus*. 1934. Paris. From Dali, *Le mythe tragique, op. cit.*,
106.

75 Salvador Dalí, Instantaneous image associated with the *Angelus*. From Dali,
Le mythe tragique, op. cit., 26.

76 Salvador Dalí, *Hitler Masturbating*. 1973. From Dalí, *The Tragic Myth of
Millet's Angelus, Paranoiac-Critical Interpretation* (St. Petersburg, FL:
Privately printed and published by the Salvador Dali Museum, 1986), 178.

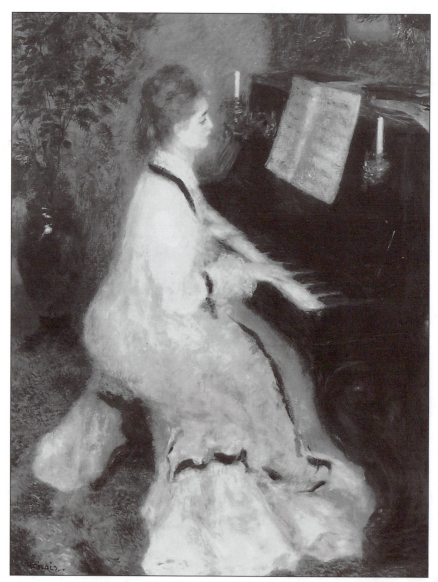

Plate 1

INTRODUCTION:

MUTILATED FIRE UNITE

At first nothing could be more charming than Renoir's *Woman at the Piano*, painted in 1875 (plate 1). The nameless woman plays quietly, almost dispassionately, her fingers placed lightly on the keys. It's a popular image, and for many people it is refreshing and innocent: I can imagine the liquid motions of the pianist's hands (or at least one of them—her left hand is just a blur), the fluent sounds of Saint-Saëns or Chopin, the flowery breeze, and the compassionate, fatherly eye of the painter.

If the painting is beautiful, it is because we can let ourselves drift into the swirl of a slightly meaningless reverie. If it is treacly or a little nauseating, it is because we cannot follow Renoir into the damper recesses of his feminine devotions. Either way, the painting is nothing but the purest, most sincere portrait of a certain sense of music, and a certain hope for what women might be. People who love Renoir also tend to be absorbed in the sheer luxury of it all. "The focus is so soft," observes one historian, "that one can just make out that the piano stool is apparently upholstered in a flowered wool challis (or perhaps silk), and the diaphanous fabric of the dress— *mousseline de soie*, possibly mull—is beautifully realized with its black ribbon banding and blue underdress."[1] If any painting is forthright, this one is: it wears its allegiances on its sleeve, it makes no secret of its happy, somewhat humorless pleasures.

Perhaps the painting is fundamentally a "dazzlingly painted" exercise in synesthesia. I would prefer to see it as a psychologically suspect, partly unintended expression of desire — more like the beginning of a confession than a dream. Other historians might rather explain it as a sign of its times: as a bourgeois utopia or an emblem of middle-class aspirations. Still others might say that it is just another sign of Renoir's odd inability to make contact with the more interesting artistic themes of the 1870s. No matter which narrative we choose to tell, the painting remains fairly simple. It never loses its straightforwardness, even if it comes to seem a bit unfortunate or misguided.

But art history has learned to find dense complexity in even the most simpleminded picture. Consider another interpretation of the same painting: this one from Birger Carlström's *Hide-and-Seek*, a monograph devoted to exposing the Impressionists as political pamphleteers. In Carlström's version of history, painters from Gainsborough onward made use of their newly liberated techniques to secrete hidden political slogans in their paintings. Each artist had different concerns, and they used their pictures as platforms, telegraphing their messages at unsuspecting audiences.

Renoir, it seems, was particularly obsessed with the politics of the Panama and Suez canals. In paintings such as the *Young Girl Reading* in Frankfurt, he allegedly used an engraving needle and a magnifying glass to inscribe tiny letters in and around his signature that spell "TRAVERSEZ SOT ANGLETERRE SUEZ CANAL," that is "STOP STUPID ENGLAND at SUEZ CANAL."[2] As Carlström explains in imperfect English, "Renoir thought the English were stupid and now he is not wishing them to have part of this canal." The *Portrait of Marie Goujon* in the National Gallery, Washington, seems at first to be a straightforward image of a young girl holding a hoop and stick (plate 2). Carlström says her left sock is a map of the Panama Canal, and written in the canal (or rather, on the sock) he reads words such as "CANAL, REVER" ("strive to attain"), "RELATION," "GEANT" ("enormous"), "PROSP" ("PROSPECTUS = object"), "PANAMA," and "COLON": all where an ordinary observer would see only a slightly scuffy bobby sock. In Renoir's *Umbrellas* in the National Gallery, London is a crowd scene — a few dozen people with jostling umbrellas — and at the lower right there is another little girl with a hoop and stick. This time Carlström zeroes in on the ruffled hem of the girl's skirt, which looks to him like another map of the Canal. As he puts it, "the little girl with her rolling hoop has the constructing in Panama." She holds her stick at an angle, and Carlström sees it as a pointer, "showing us the Suez-canal, which is the blue field on the dress of the bigger girl" next to her (35, 36). Seen this way, the picture is not a

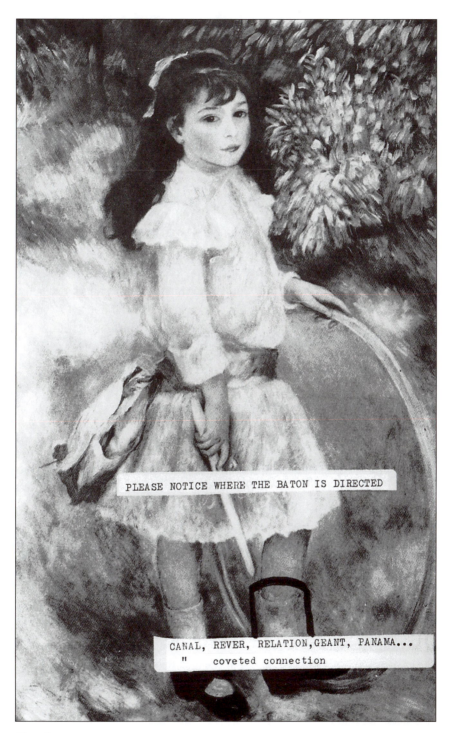

Plate 2

friendly crowd scene at all: it is actually Renoir's attempt to tell us that the good reputation earned by the French (and especially by Ferdinand, vicomte de Lesseps) for the construction of the Suez canal was about to be lost in the problems surrounding the Panama Canal. Renoir has not written his signature in a normal fashion, but he has misspelled it "RENIER = denial" to expose the fact that de Lesseps was covering up his difficulties in Panama.

Although it may seem that the politics of canal-building is just a mask for Carlström's prurient interest in young girls' skirts and socks (along with hoops, sticks, and waterways), most of *Hide-and-Seek* is determinedly asexual. In other paintings Calrström finds evidence that Renoir was angry at Russia and Austria for their treatment of Poland, that he was upset at France for its liberal policy about immigration, and that he was disappointed in Napoleon III (23, 26, 43). In *Woman at the Piano*, Carlström sees the Isthmus of Panama in the houseplant at the upper left (plate 3). One twig that lies at an angle is the "black line where the canal is to go," and he reads the letters PAN and COL for the cities of Panama and Colon at opposite ends of the canal. The canal is drawn a little inaccurately, Carlström says: "the Isthmus of Panama goes a little more west-east, than what Renoir has put it out here"; but it doesn't matter, because Renoir has written the essential message across the middle of his cryptic map: "TAC = BANG." The entire scandal, Carlström says in half-English,

> were to degager shortly. And so they were. From c. 1884 Renoir has now told about this project of Panama-canal and he and the French people are now demanding for an open account but in the next year 1889 so it crashed and many people lost their savings. TAC = BANG. (42)

The same painting also depicts Russia's relations with Poland, which Carlström calls "the Poland-Strangling":

> If we have a look at the light spot to the right just on the piano [at the far right margin of the painting] we can see the head of a bear and the text below it: R LOI A POL, what means: RUSSIAN LAW IN POLAND. And if we turn the picture up and down we can also find on this head [i.e., the bear's head, in the smudge] 19 ANS = 19 YEARS. Yes, in 1869 the Russian started the take-over of the university and then also all the other schools of Poland. That was to start an obliteration of that country and Renoir cannot help telling it over and over again in his works.

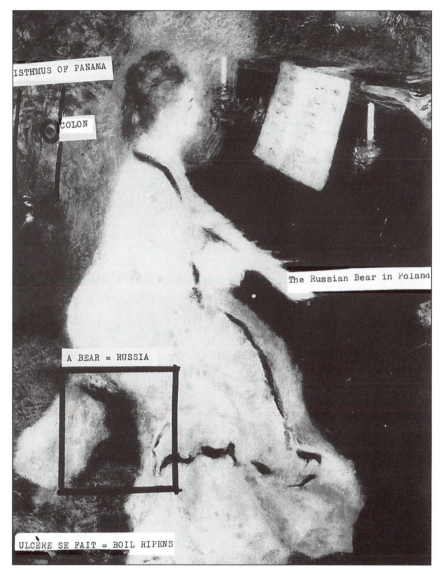

Plate 3

And there's more, because what we have thought to be the music-stool is only another big brown bear.

Turning the picture once again [so that it is rightside up] we can find that the paw of the bear is on the throat of a young woman here quite white. Above her we read POL for POLAND but also ETRANGES = STRANGLES.

Carlström also reads micrographic script hidden around the letters of Renoir's signature: Renoir, he claims, has used some of the letters of his own name and some tiny letters inscribed with the engraver's needle to spell "ULCERE SE FAIT = BOIL RIPENS." Reading the micrographic script is not easy, because Renoir did not simply spell out ULCERE SE FAIT. Instead he put bits of it in different places in and around his own name: "In the first R in Renoir we find UL. Between R and E we then find a C. E is E and then we can find RE before FAIT. T we find lying into the upper part of the last R."

Carlström is willing to read anything—trees, plowed fields, bonnets, socks, piano stools—but he especially loves signatures. Here "Renoir" is "BOIL RIPENS"; in another painting his name becomes "MUTIL(E) TISON UNI = MUTILATED FIRE UNITE." "C. Pissarro" becomes "SOC. PISCIAC-TUS = SOCIALISTIC FISHING," "Claude Monet" becomes "LE BAN DE BONAPARTE N. EST SOT BEVUE ET FAUTE = DEPORTATION OF BONA-PARTE N. IS A SILLY BLUNDER + much more text," "Manet" becomes "ASSEZ BISTOURNET PAILLER = RATHER DISTORTED WHISPER," "Berthe Morisot" becomes "BON(APARTE'S) MORT NOS SORT SOT = BONAPARTE'S DEATH OUR FATE-SILLY," and Sisley becomes "HISSING WAR."[3] Sometimes the names have an uncanny aptness: in one painting, "Degas" signs his name "SOT LEGAL USAGE = STUPID ALLOWED CUSTOM," and in a drawing called *Woman Drying Herself*, his name appears as "THOUGHT-PROVOKING DISCHARGE" (50). It seems all these great Impressionist and Postimpressionist painters—Stupid Allowed Custom, Rather Distorted Whisper, Socialistic Fishing, Mutilated Fire Unite—were actually determined pamphleteers, using their art to coerce the masses.

Sometimes Carlström reads hidden texts, and other times he sees images embedded in other images. Sometimes he finds complete sentences, and other times fragments. Some of the figures he locates are fairly realistic, and others are simple stick figures. (The Russian bear in the piano stool is a reasonable version of a bear, but the woman he strangles is the simplest stick figure, and the bear's head at the right of the piano is a misshapen dog-like caricature.) There doesn't seem to be any rhyme or reason to his accounts, or to his ideas about Renoir's politics. Were the images and texts subliminal? Or would they have been seen by anyone interested in deciphering the Impressionist's secret code? And what about the curious passages where Carl-ström sees "much more text" or "trees full of names of places"? Often the act of interpretation seems to be both interminable and entirely free of method. In one of Monet's views of Rouen Cathedral, Carlström sees a head of Martin Luther and an emblem of Christ, and then he spots four round

arches at the upper left, "watching," as he puts it, "the head of four different persons" (plate 4). "Very goodlooking persons indeed," he comments, "but a little too faint to be able to observe any details." The entire façade begins to glow with half-seen faces.

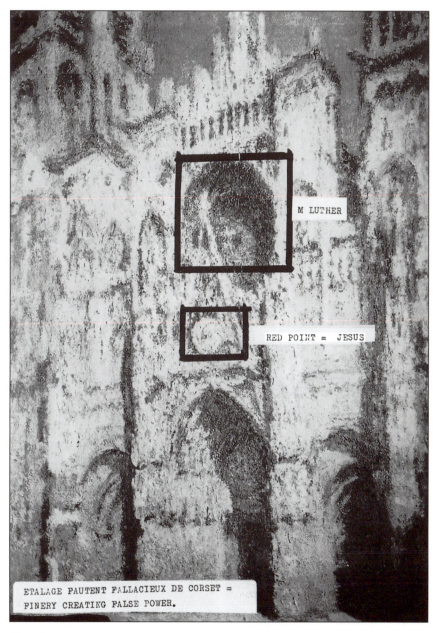

M LUTHER

RED POINT = JESUS

ETALAGE FAUTENT FALLACIEUX DE CORSET = FINERY CREATING FALSE POWER.

Plate 4

It's exhausting, reading these descriptions. And what has become of Renoir's painting? Once it was a sweetish scene of summertime music-making, and now it is a combination atlas and menagerie, with explosions, strangulations, and festering boils. What was originally the dappled stem of a plant has become a map of Panama. The "flowered wool challis" has become an allegorical bear throttling a doll-like woman. The harmless signature, "Renoir," has turned into a ripening ulcer. And what's worst, it seems the interpretation has hardly begun. I can imagine Carlström writing an entire monograph about *Woman at the Piano*, turning it into an illustrated history of mid-nineteenth century Europe.

Certainly it's tempting to say Carlström reads things into pictures. We have no independent evidence (from Renoir's letters, from contemporary critics, from any other Impressionist or Postimpressionist painter, historian, or critic) that Impressionist artists hid messages and images in their paintings. As Carlström himself has discovered, it is difficult to find historians who agree with *anything* he sees. So perhaps a consensus of art historians might want to exclude his interpretations from the growing literature of serious scholarship on the grounds that he is hallucinating.

It may also seem that his interpretations are just too far outside the consensus—too wild, too idiosyncratic to be taken seriously. They don't connect well—or I should say, at all—with other historian's concerns, and so in a way they are beside the point. In this perspective, Carlström's book should be assigned to the category of miscellaneous approaches to art that would also include books introducing children to famous painters, art therapy manuals, conservator's reports, museum files detailing provenance, and reproductions of *Woman at the Piano* in advertisements for United Airlines. In other words, Carlström's ideas would be irrelevant even before they could be true or false.

It's a complementary problem that Carlström's accounts are too different one from the next, too unpredictable. He finds stick figures in some pictures, and fully-fleshed "paintings" in others. Sometimes he sees letters that many viewers might also see; other times he merely reports on lettering so tiny it does not reproduce. Although most of his readings are political, a few are personal or anecdotal; he thinks Degas's *Glass of Absinthe* is really about the woman's queasiness at having to sit next to an ashtray full of dirty "fagends." Sometimes the politics is allegorical (the Russian bear) and in other cases it is coded in the colors of peoples' hats (Seurat's *Bathers* is interpreted as a guide to contemporary political parties, each hat standing for one party). Perhaps in the end *Hide-and-Seek* is just too detailed. *Woman at the*

Piano may be just that: a woman, a piano, some music, some lights. Carlström may just be seeing too much, spending too much time looking. It appears reasonable to say that Renoir wanted to create a relatively simple, focused drama—there are no French engineers parading across the painting, no Russian flags flying, no newspapers displaying banner headlines about the destruction of Poland. The painting has very little in it, and even apart from the sheer implausibility of Carlström's claims, it can seem that he simply says too much.

These amount to four possible objections: the imputation that he is seeing things, the objection to his marginal position, the feeling that he is inconsistent or unpredictable, and the reservations about his hypertrophied sense of narrative incident. They are each sensible points, but I find it is surprisingly easy to argue against them. In regard to the first point (that he is projecting his own fantasies onto the pictures), consider that historians commonly rely on concepts that are entirely absent from pictures. If it seems tempting to argue against Carlström by noting that Renoir never mentioned his concern about the Panama Canal, then it becomes necessary to explain any number of other texts that posit meanings that are less than manifest. Adjudicating such questions would involve an account of the pertinent uses of such concepts as community, intention, interpretation, relevance, and reliability. These are large issues, often difficult to manage, but there is also a more immediate one, as easy to state as it is hard to refute: art historians aside from Carlström often find hidden images in paintings, and it can be argued—as I will later in the book—that the identification of hidden images is one of the defining strategies of late twentieth century art history. Carlström, in other words, fits right in.

The second point, about Carlström's intellectual isolation, relies on the idea that there is a consensus of concerns among specialists in nineteenth-century art. But notoriously that is not so, and historians' interests become more disparate and less well connected each year. Already feminist interpretations jostle with psychoanalytic and social readings, and there is no clear sense of what art history might look like if its methodologies were somehow to be reconciled. Writers such as Donald Preziosi who have considered these issues often opt for pluralism, "bricolage" and "heteromorphic" discourses. Others such as Keith Moxey and Mieke Bal argue for the most diverse kinds of interpretation, taken from any number of disciplines and paradigms. By those criteria, Carlström's account is no more isolated than many others, and there is no sure way to go about arguing he is *too* isolated, or that he has overstepped some invisible disciplinary boundary.[4]

Nor is it cogent to say (as in the third objection) that Carlström has no fixed method, that he drifts from one interpretive principle to the next. He has an exhilarating freedom from self-consistency, but it could also be argued that art historical texts are typically mixtures of methods, and that the transition from one method to the next is normally made fairly quickly and without explanation. It is common to find art historical essays that depend on a succession of formal analysis, psychoanalysis, feminism, and social art history, and often enough the methods are mixed together. The word "brico-lage" that Preziosi uses to describe art history fits our use of methods, and in that respect we are no more attentive to the coherence of our texts than Carlström.

And finally, it could be said that Carlström just works too hard, and finds too many meanings. Yet art history is replete with vertiginously complex arguments, and by most standards Carlström's analyses are too short. In many cases he declines to report everything he finds in pictures, and his descriptions usually take up less than a page. In a discipline where twenty- and thirty-page essays have been written about some of the paintings Carl-ström reproduces, his account is relatively spare.

In short, I am not sure that art history possesses the arguments that might unseat Carlström. I would not deny he is marginal, and that he seems more than a little uncontrolled, if not lunatic. But how different are his concerns from those of more mainstream art historians? He looks very carefully at paintings, and he sees things in them that untrained observers might not. He is well informed about the political and social currents of the 1870s and 1880s and he finds their echoes in the paintings—something social histori-ans do as a matter of course. He spends time thinking about what Renoir intended, and trying to relate that intention to the ways the paintings were made—just as any professional historian would. He interprets the painterly style itself, from Gainsborough onward, as an opportunity for increased expressive power—exactly what an art historian might say. There are many senses, I think, in which Carlström is a typical art historian. It is true that he looks very closely (working, as he says the Impressionists did, with a magni-fying glass): but what art historian would want to argue against close read-ing?[5] When he finds hidden political meanings, he is following the lead of social art historians, and when he discovers arcane symbolic programs, he is taking his cue from iconographers. He seems to hallucinate meanings into paintings—but who is to say which mainstream historians are not guilty of projection? It certainly appears that he does not know when to stop—but does any historian?

My purpose in arguing this way is not to persuade specialists to take Carlström seriously, or to add my voice to those who advocate invigorating new interpretive strategies chiefly because they are invigorating. (In other contexts, I would defend both claims.) Carlström might well be wrong about Renoir's intentions, but he is not "wrong" about art history. He is what statisticians call an "outlier": a data point far to one end of the scale, but not off the scale altogether. He is less an eccentric, out of time and place, than a symptom of contemporary art history, and his extremity can be used to point up the shape of the discipline as a whole. The purpose of this book is to understand how pictures drive each of us to behave—more or less, with reserve or abandon, inadvertently or with full awareness—as Carlström does.

"MALAISES" AND "HALLUCINATIONS" OF ART HISTORY

By a logic whose perversity will occupy me throughout this book, pictures have come to seem intrinsically unsuited to monothematic or monomethodological explanations. Almost any interpretation that is clearly plausible, apparent, or self-evident, can begin to appear inadequate, naïve, obvious, too immediately convincing, too easy. Part of our suspicion is directed at the mere act of painting, as if we were to say Renoir couldn't possibly have been content rendering pretty colors, or depicting a nameless woman playing unidentified music in an anonymous setting. But we also doubt our own accounts, and we continuously work on them, constructing complexity and adding analytic bite. Unlike scientists, we are suspicious of simplicity, and our writing rarely tends toward the schematic when it can become more intricate. Chapter 1 opens by setting out the basic evidence for this propensity. It seems important, in first considering this question, to distinguish between the brute growth of the discipline and something more peculiar that happens within it. That stranger thing I will call "pictorial complexity," and describe it as a certain quality of argument: an attachment to density of thought, and to intricacy. We love something about the particular concentration of meaning that some pictures possess, and we are baffled or uncaring about images that seem simple, clear, or otherwise lightweight. Chapter 2 is an attempt to describe the *kind* of complexity that attracts the discipline, and the species of simplicity it avoids.

After that introduction (comprising Part One, "Considering Things"), the book follows the lines of our hysteria, building through three successively less well controlled kinds of response. First is the intuition that pictures are somehow like puzzles: that they are not complete objects, closed in themselves, but structures that can be assembled and disassembled. In this view,

a complete interpretation "solves" a picture, at least for the moment and for a particular purpose, by putting its meanings together in the correct configuration. Puzzle-solving is the most common and the calmest of the three models of pictorial interpretation, and its most persuasive practitioners assemble meanings that seem complete and entirely correct. A careful iconographic reading would be a good example, but any interpretation that acknowledges a number of signs in a picture and "places" every one is consonant with the picture-puzzle metaphor. It is an unexpectedly flexible metaphor, and it can be extended to embrace methods that would seem incompatible—for example "incomplete" interpretations and psychoanalytic readings that are founded on the impossibility of full utterance. Chapter 3 takes up the question of puzzles, and proposes we deal with our picture-puzzles in five epistemologically distinct fashions, ranging from positivist optimism to deconstructive skepticism.

A second kind of response sees pictures as objects where meaning is always multiple, so there are "aspects" or "levels" instead of single solutions. Pictures are understood as multivalent from the beginning, so that no single meaning will ever do, and those who propose primary meanings do so only at the risk of eclipsing or even repressing corrosive alternate accounts. In this model an interpretation can only be "complete" by fully attending to its obligations to map as many alternate meanings as possible. Chapter 4 introduces the theme, and Chapter 5 considers images whose ambiguities have been argued for so long, and with such intensity, that the literature can no longer be assessed in an ordinary academic format—say, in a year-long seminar. I call those images "monstrously ambiguous," and suggest that their ambiguity becomes indistinct, trailing off into fogs of unread papers and ill-understood theories.

Ambiguities are the order of the day in visual theory, but there are opposing voices, and some historians are on the lookout for explanations that are both economical and effectively simpler than previous accounts. Chapter 6 is a detailed case study, taking Watteau's *fêtes galantes* as the example, of the possibility of arguing against complexity, against the puzzle metaphor, and against the models of ambiguity. It explores another key term in the search for ambiguity, the *je ne sais quoi*. The concept flourished in Watteau's generation and it still lingers as a name for whatever eludes clear language, or is so tenuous that it escapes analysis. My supposition is that Watteau knew the term or the concept behind it, and arranged his paintings so that his meanings were elusive from the very outset. The chapter has a positive purpose but a negative result, since I think that the accelerating

complexity of interpretations cannot be undone, no matter how attractively the case is put.

That concludes Part Two, "Staying Calm." Part Three, "Losing Control," is about the third and wildest of the major responses to pictures: the purposive and sometimes uncontrolled use of what used to be known as *fantasia* and is now generally called hallucination. On occasion, historians are so overwhelmed by pictures, so disoriented by the rigors of interpretation, that they try to "solve" pictures in the quickest possible way, by claiming they contain hidden objects. I hope I have said enough about Carlström to suggest he is not the simple case of projection that a psychologist might want to claim. As Renaissance and Enlightenment philosophers knew, *fantasia* or *invenzione* is not a deviation, but an integral part of our responses to the world. It is as far from epistemologically suspect as it is possible to be: imagination is a condition of perception, not merely a disease that afflicts it. What I stress in Chapters 7 and 8 is the pathological *mixture* of imagination and deep anxiety over how to respond to pictures. When the anxiety becomes strong enough, the hallucinations pour out in unbelievable profusion; when it can be folded back into the act of interpretation, hallucinations become insights and the act of reading seems normative. The final chapter is an attempt to write something sober and appreciative about a deeply hallucinatory text, one that may seem to be sheer willful fantasy—Salvador Dalí's *Tragic Myth of Millet's Angelus*. The book is crazy, I think, in a clinical sense: but it is also one of the most sustained and brilliant pieces of historical writing about images that we possess, and I am serious when I propose it as the best work of twentieth-century art history.

It is difficult not to read the three responses to pictures—puzzle-solving, ambiguation, and hallucination—as symptoms of an underlying malaise. Throughout the book I have found it rhetorically helpful to call our condition an "illness," a "pathology," or a "deviation," and I also characterize historians' preferred meanings as "excessive," "monstrous," and "hallucinatory." I mean those words to point up the historical oddity of contemporary responses to pictures; but in the end, I have no diagnosis to pronounce, no unconscious malady to exorcise. We live in a period whose sense of pictures is significantly different from anything that has gone before—but we live *in* the period, and so it cannot make sense to look for some new model of pictorial meaning. I am strongly attracted to pictorial complexity myself: at one point, I thought this book should be subtitled *In Praise of Pictorial Complexity*. If there is a malaise here, it is that we do not see *how* we see—and even that may not be something that should, or could, be "solved." A principal burden of my book

Our Beautiful, Dry, and Distant Texts is a critique of the assumption, nearly universal in philosophy and visual theory, that writers (and in particular, art historians) should become conscious of how their writing works.

Still, using words like "malaise" and "hallucination" puts a certain distance between this text and the ones I am trying to characterize (even when they are texts that I have written, or that I admire). One of the themes of this book is the position I take in relation to the discipline of which I am ostensibly a part. In order to consider pictures as puzzles, it is necessary to step back far enough to see the shape of art historical writing in general, and to suspend judgment about the truth or falsity of claims in any individual instance. That position is in many respects just *outside* art history, and it gives rise to any number of figures of speech that make it sound as if I have stepped back in order to judge. But the authorial position is variable, and subject to continuous adjustment. What I have in mind is something more akin to Dominick LaCapra's model of "dialogic" understanding, in which speaking takes place both with and "within" an interlocutor.[6] I hope, in other words, that what I have to say will not often lose its relevance because it seems detached, or lose its balance because it appears too partisan. Dialogue, and not judgment, is my purpose—and often I intend something less like critique and more like celebration. Pictures have become exponentially, even bewilderingly intricate in the span of only a hundred years, and we should spend some time celebrating that fact.

THE DESIRE FOR COMPLEXITY

Jacques Derrida's *The Truth in Painting* has been a constant companion in the writing of this book because of its fundamental purpose to describe, as Derrida puts it, the "desire of *restitution* if it pertains to the truth in painting."[7] Derrida's interest in what he calls "restitution" is not my subject here, nor am I specially interested in the truth in (or "on" or "with") painting. What is key for this project, and of inestimable help, is the stress on *desire* and the phrase *if it pertains to.* As Derrida knows, much of the humanities is seized with an interpretive fervor—a desire that issues in our increasingly intricate texts. (Derrida himself is one of the best and most prolific examples of the effects of that fervor, and his book is also an intricate attempt at self-diagnosis.) As historians, we might be tempted to explain the desire to interpret in terms of other things: the history of the discipline, the shifts in culture, the changing values assigned to painting. But I believe with Derrida that the most interesting questions that can be asked of this material concern the desire itself.

The theme of desire is half of what I take from Derrida: the other is the

interest in a special kind of desire that pertains to pictures. Many of the interpretive "excesses" and complexities I will explore also mark literary studies, music, classics, theater, and even the histories of architecture and sculpture. But it is at least plausible—so I understand Derrida as arguing—that there is a form of the desire for interpretation that specifically pertains to pictures. I have tried to follow that lead here by tracing the kinds of complexity to which pictures drive us, as distinct from the complexities elicited by texts, buildings, dramas, music, or other forms. My second model (ambiguities) can certainly not be restricted to art history, since it exists in even more elaborate forms in literary studies. But the first and third models (jigsaw puzzles and hidden images) are at least partly specific to art history, art criticism, and visual theory. Versions of them certainly exist in other disciplines (jigsaw puzzles are a familiar metaphor especially in criminology and detective stories), but I have tried to describe them as they pertain to pictures. Their model instances are pictures, and so they fit texts only by analogy; and both of them operate by locating images rather than words. It strikes me that *The Truth in Painting* is often about "restitution" in any sphere, and Derrida spends considerable time on restitution among philosophers, or between philosophers and artworks. (In that respect *The Truth in Painting* leads more or less directly into Derrida's later work on gifts and indebtedness.) But the last chapter of *The Truth in Painting*, called "Restitutions in Pointing," has a great deal to say specifically to art historians.[8] The three models I offer in this book are at least partly about a desire—or an illness—that strikes people who spend time looking at pictures as opposed to texts.

Here and there, throughout the text, I have paused to consider possible explanations for the desire, and the current condition of art historical writing. I entertain four of the commonest hypotheses in the first chapter (ones I have heard in conversations, and in presenting this material); five others are scattered through the later chapters. They are arranged in order of increasing strength, and the Envoi considers the three best answers I have to the book's title question.

The simplest of the answers I propose in the Envoi is that pictures provoke art historians merely because they are less familiar than texts. All art historians write, but relatively few draw with any relevant degree of facility, and that commonplace condition instills a faint but persistent fear of failing to understand pictures. That low-level anxiety may be a prime cause of the intensity of our texts, which would be attempts *not* to come to terms with a fundamental lack of confidence about pictures. Alternately, art historical writing may be a response to the apparently unstable ontology of pictures, in that

pictures may be understood as objects that appear "lost" and make us think of returning them to words and to the world. By their nature they may depend on what Derrida calls a "structure of detachment," kindling a hope that we might restore them to the places, texts and contexts we think they must once have had. Or else—and this is my favorite hypothesis, the one that I think goes farthest toward making sense of our behavior—pictures are bewildering because they present us with the most powerful examples that we can know of the absolute lack of meaning. Like sunsets or fallen leaves (my example in the Envoi), pictures provoke emotions but resist explanations and ultimately refuse to let themselves be turned into words. Visual narratives can be recounted, but the brushstrokes or pencil lines that convey them are inenarrable. If that supposition is true, then we behave so strangely because we sense a very simple, unanswerable property that pictures have always had: in the end, after all the interpretations have failed, they reveal themselves to be utterly meaningless.

Much of modern and postmodern art history and criticism would then be a kind of collective hysteria about pictures, brought on by the fact that pictures do not speak and do not mean anything aside from their trappings of legible signs. The simplicity and irreducible nature of visual meaningless-ness would make pictures even more exasperating for minds bent on under-standing. Images, I think, elicit a kind of attention that returns again and again to an originary non-linguistic ground, where articulable meaning seems conclusively inaccessible. Hallucination may be the echochamber of that particular anxiety.

At first—in past centuries, and in other cultures—it was all right for pictures to be pictures, and have a few meanings known to everyone who cared to inquire. Now their underlying meaninglessness has become an oppressive force, a blow to reason, an insult to our sense of our own mean-ing. If we see pictures as puzzles it is because the illusion affords us a chance to create elaborate interpretations. It is even better to see them as reservoirs of ambiguous meanings, because then interpretation can go on indefinitely. But it is best of all to see them as pockets stuffed full of hidden images and secret messages, because then the interpreter can short-circuit the entire regimen of interpretation and find instant and conclusive meaning. On the surface, in the day-to-day workings of art history, we are satisfied to tell each other that pictures can be adequately explained by narrative or symbolic meanings. But our intricate and voluminous writing says otherwise. Pictures are effectively and forever without meaning, and art history is the bruise that has grown up around that injury.

CONSIDERING

THINGS

THE EVIDENCE

OF EXCESS

IT MAY BE UNFAIR TO COMPARE VASARI'S ACCOUNT WITH THESE MODERN
INTERPRETATIONS....BUT WHY DOES HE SAY SO MUCH LESS ABOUT PIERO
THAN PRESENT-DAY COMMENTATORS?

—DAVID CARRIER [1]

It is best to begin by setting out some pertinent facts about the growth of the
literature, simply to show that contemporary writing is historically anom-
alous in a potentially significant fashion. That condition, I think, may be
especially transparent to working art historians. Writing art history, and read-
ing it from the age, say, of fifteen, it may appear that what gets said about
pictures is about right, and that the detail of art historical writing is more or
less commensurate with the actual detail of the artworks, or perhaps even
insufficient. Certainly, working on a specialized subject—for example on a
dissertation—fosters the conviction that the existing literature is inadequate,
and that a great deal remains to be said: but it does not usually lead to the
conclusion that the *amount* or the *kind* of writing is fundamentally strange.

To see the writing itself as a problem, it is helpful to take a step back from
the concerns of any one subject or specialty, and consider the shape of the
discipline in a more abstract sense. In this chapter I offer some stories, facts,
and figures about the growth of art historical writing, and especially about
the length of our texts. At first I want to do this without drawing any conclu-
sions, taking the numbers as what scientists call raw data. Afterward I will
consider several of the explanations that might be, or have been, proffered to
explain why contemporary historians write so much more than past genera-
tions. I am not entirely satisfied with any of the initial explanations, and this

opening chapter is principally intended to unsettle the more common convictions about what is happening (or not happening) to the discipline.

THE SHEER VOLUME OF WRITING

According to George Steiner, there are on the order of 30,000 dissertations written each year on modern literature alone.[2] His estimate may be right, because American art history departments account for almost 400 dissertations each year, so it would not be unreasonable to guess that there are nearly 1,000 dissertations worldwide.[3] The two principal indices of artwriting, the *Art Index* and the *Bibliography of the History of Art* (BHA) each record a total of around 30,000 entries each year, written by an average of 22,500 different art historians and critics.[4] Certainly the discipline has grown precipitously. The earliest index of art historical literature is the *Répertoire de l'art et d'archéologie*; its first volume was published in 1910 and has a combined subject and author index which runs to about 4,000 entries. A combined subject and author index for the 1995 *Art Index* would have on the order of 30,000 entries.[5] As the discipline grows, the number of subjects also increases; the *Art Index* has 4,773 subject headings in its 1995 volume, up from 2,258 in 1989.

Another tangible sign of the discipline's growth is the list of journals that are classified as art history. The 1995 *Art Index* collates 268 journals explicitly on art history, and the BHA includes entries from about 1,125 journals in various fields; by contrast, the first volume of the *Art Index*, for the years 1929–1932, lists only 150 journals. Most large libraries subscribe to fifty or so journals in art history and criticism—less than a fifth of those listed in the *Art Index*. Even fifty is too many to read in a month, and an average art historian might subscribe to two or three, and flip through perhaps a dozen more: a first sign that our writing has outgrown us.

Given the volume of writing, it is inevitable that a great deal of attention has been paid to less well-known artists. The *Art Index* and the BHA list references to approximately 10,000 artists in their indices each year.[6] Non-canonical, minor, non-Western, or otherwise neglected artists are increasingly likely to be the subjects of single volumes, monographs, and *catalogues raisonnées*. As of 1995, on the order of 3,000 artists had been described in monographs—substantially more than the 1,000 or so artists described in Janson's *History of Art*.[7] Along with this interest in what were once called second- and third-rate artists, the expanding literature has also treated "first-rate" artists more thoroughly than ever before. These are two different forms of interest, which I want to mark with two different phrases: I'll call writing

on less well-known artists *extensive* research, and writing on better-known artists and artworks *intensive* research. The difference is interesting and crucial, since a discipline that writes extensively is expanding its purview and experimenting with new subjects, while a discipline that grows intensively is consolidating its interests and focusing on canonical figures. Art history does both, but it largely advertises itself as doing the first; intensive research goes on more quietly, but may account for just as much of the discipline's growth.

WRITING OUTSIDE ART HISTORY

Consider, by contrast, the state of artwriting before the later nineteenth century, and before the inception of art history as a discipline. In Greek and Roman texts, writing on individual pictures is uncommon or rare, and always succinct. Callistratus's *Descriptions* and Philostratus's *Imagines*, the two best-preserved sources for the ancient art of ekphrasis, each take about three hundred words to describe most images, and never more than seven hundred—that is, in most editions, from a single paragraph to about three pages per image.[8] The *Imagines* itself is a short work. Outside Callistratus and Philostratus, descriptions of pictures are even more laconic; Pliny is a perfect example of extensive writing, since he covers a lot of ground but describes most images in a phrase or two. The majority of ancient texts mention paintings rather than describe them, and few offer interpretations. The exceptions, such as Pausanius's famous description of Polygnotus's paintings of the *Nekyia* and the *Iliupersis*, prove the rule: and even they are not long in comparison to modern writing.[9] Pausanius's "lengthy" account of the *Iliupersis* is roughly 2,000 words long; by comparison a recent review of the problem of the *Iliupersis* by Mark Stansbury–O'Donnell runs to nearly five times that length.[10] The extra length is partly due to Stansbury–O'Donnell's analysis of Pausanius's prepositions (in order to reconstruct the painting, it is essential to understand what Pausanius meant by "next to," "above," "below," and associated terms); but a fair amount of Stansbury–O'Donnell's essay is devoted to analyzing the political meaning of Polygnotus's composition, and showing how it balances the transgressions of the Danaans and Trojans. As always it is far from simple to decide if Pausanius thought such meanings were implicit in his text, and therefore went without saying. The structure of his narrative echoes the painting's structure well enough so that he may have thought he had already done what Stansbury–O'Donnell did for him two millennia later. But whatever the explanation, the difference remains, and it only becomes more stark if we begin looking at other modern reconstructions of the *Iliupersis*.[11]

The ekphrasis of the *Iliupersis* may be the longest surviving ancient description of a single image; the best-known example, Homer's description of Achilles's shield, is only 120 lines long.[12] There are also marginal examples such as Solensis Aratus's poem about the constellations (which was illustrated in medieval and Renaissance editions), but the *Phenomena* is not a discourse on pictures in the sense I mean here. Aratus does not describe the forms of the constellations as much as the actions of the gods; and similarly, the "pictorial" descriptions in Bion, Moschus, Virgil, and other writers have only indirect and problematic relation to actual pictures.[13]

Much the same—and at the same level of generality—can be said of medieval practice. As Hans Belting and others have noted, there are numerous medieval texts on the subject of images, but they tend to consider pictures as vehicles of worship or idolatry, or as possessions of the Church or of individual churches. There are long texts associated with the Iconoclastic Controversy, some of which refer to individual images.[14] Most longer documents concern the cost and commissioning of paintings or the use and abuse of religious images, but even the most intricate texts are not *about* individual pictures in the sense we might take that phrase today. It is commonly noted that the Renaissance was also the renascence of writing on art. As Belting puts it, when "the image became an object of reflection," artists "found themselves driven by new kinds of arguments" that had to take account of aesthetic concepts, optical veracity, skill, *invenzione*, and a number of other generative concepts.[15] E.H. Gombrich has argued somewhat differently that writing on art is a "leaven" of the art criticism that began with public competitions in Florence in the beginning of the fifteenth century.[16] Gombrich's and Belting's accounts are commensurate with those that stress the rise of art academies, with their attendant literature.[17] There are other ways of explaining the renascence of artwriting; for Panofsky, the increase is linked to the dawning sense of historical change, and the concomitant necessity of locating each generation's place in the movement of culture—*"le età,"* as Vasari said, of art.[18]

These explanations partly serve different purposes, but they each give evidence of a shift in the volume of writing at the end of the middle ages, and especially of a new emphasis on intensive description. In many respects the Renaissance is the origin of our ways of writing about art: it is the period in which pictures first became the objects of intensive intellection, and were first able to bear the weight of philosophic and critical concepts. By the mid-fifteenth century, pictures had begun to be able to carry the burden of arguments about such seminal concepts as naturalism, relief, *grazia*, *disegno*,

colorito, perspective, *contrapposto*, *fantasia*, and *invenzione*.[19] Pictures and other artworks were widely discussed, and there were public debates, open letters, invited conferences, academies, public speeches, and philosophic defenses on the arts and on individual artists and artworks. In this context, the period from around 1435—when Alberti finished writing *De Pictura*—to about 1563—when the *Accademia del Disegno* was founded with Michelangelo as its tutelary head—is the beginning of the modern understanding of painting. After 1600, with the histories by Karel Van Mander, Joachim von Sandrart, and others, the literature on painting and drawing begins to grow exponentially, so that even Julius Schlosser's encyclopedic *Kunstliteratur* can barely mention the major titles.[20]

Still, most Renaissance writing about pictures is extensive rather than intensive, in that the treatises, letters, and dialogues become longer even though the passages on individual images remain short by modern standards. Again there are exceptions—one might name Martino Bassi's dialogue on a relief sculpture proposed for the Milan cathedral, and Gregorio Comanini's dialogue centered on the works of Arcimboldo—but for the most part attention is focused on the idea of painting or on the achievements of artists, rather than the meanings of individual pictures.[21] Vasari is fairly generous in his descriptions; but even pictures that he judges to be important, exceptionally skillful, or complicated only occupy him for a page or two. Although the *Vite* is longer than almost any monograph that a university press might publish, comparatively little space is allotted to individual pictures: it is primarily extensive, not intensive. It is important to bear in mind just how markedly unmodern Vasari is in this regard; today two or three hundred words is scarcely enough to state the basic facts about a picture—to say something about its leading meanings, or to rehearse its title, date, size, medium, and provenance. In an average *catalogue raisonné* that basic information occupies a short paragraph, perhaps on the order of a hundred words (including dates, page and volume numbers, and dimensions). Vasari's average descriptions are significantly shorter—on the order of a sentence or two.

So while Renaissance writers were the first to feel it necessary to speak at some length about pictures, their texts fall significantly short of modern standards of intensive interpretation. Over the next several centuries the extensive literature continued in full force (as Schlosser's bibliography shows), while intensive writing became increasingly prominent. By and large the late Renaissance and Enlightenment texts that matter to art history are those that pay intensive attention to at least a few works. Winckelmann, Le Brun, De Piles, and others continue to be indispensable to the discipline's sense of

itself, while any number of "lesser" authors have fallen into oblivion at least
in part because they do not engage the peculiarities of individual artworks.
Thomas Da Costa Kaufmann has recently demonstrated this in the case of
Winckelmann, whose immediate predecessors, writing in German and
Latin in the century preceding the *History of Greek Art,* sometimes make
strikingly "modern" points but fail to engage the reader's interest in individ-
ual artworks.[22] Reading in the large secondary and tertiary literature on art in
the seventeenth and eighteenth centuries is rewarding for the light it casts on
art history's sense of its own history, but it seldom uncovers intensive engage-
ments with artworks.

The growth of writing on art accelerated in the nineteenth century, and in
the last hundred years there has been a surge in both extensive and intensive
writing. The contrast with even the more extended examples of Renaissance
writing has become extreme. Consider that Vasari allots a little over two pages
to Leonardo da Vinci's *Last Supper,* while Leo Steinberg's essay on the *Last
Supper* fills 113 pages—it is over sixty times longer than Vasari's account.[23]
Giorgione's *Tempesta,* another painting we will be considering later in the
book, attracted only two sentences—or rather, a faulty sentence and a
sentence-fragment—during the sixteenth century: Marcantonio Michiel's
annotation "A little landscape on canvas with [a] storm [and a] gypsy and [a]
soldier was by Giorgione"; and "another picture of a gypsy and a shepherd in
a landscape with a bridge."[24] Today the painting has been the principal subject
of at least 3 full books, and on the order of 150 essays and other notices.

Contemporary writing is also textually intricate. Vasari does not use foot-
notes or illustrations aside from woodcut portraits of the artists, but Steinberg
requires 29 pages of footnotes and 51 illustrations, including plans, fictive
restorations of the space, cardboard models, and even a photograph of a bill-
board of the *Last Supper* (plate 5). Vasari gives about ten pages to another
central image, Masaccio's frescos in the Brancacci Chapel. By contrast, in
the last hundred years there have been at least three book-length studies on
the Chapel.[25] In a rough count, the Brancacci Chapel inspired approxi-
mately 50 pages of writing before 1800 and on the order of 1,500 pages since
then.[26] Steinberg's essay—which we will read in Chapter 3—is not at all typi-
cal, but the gross amount of writing on the Brancacci Chapel is. In general,
we write much more than past centuries: not just more pages, but also more
pages on individual works. In many ways (and not least in the raw statistics)
our practice is importantly different from anything in the past: different
enough, I mean to suggest, so that it is puzzling that we do not experience
the difference as a problem.

BRIEFLY, ON NON-WESTERN WRITING

The phenomena I am trying to explain in this book are Western in origin and meaning: art history developed from Western assumptions about pictures, and the voluminous responses I am going to consider have only shown themselves in writing done in Europe, America, and places influenced by their versions of art history. In another context it would be possible to expand on the hypothesis that the relevant properties of contemporary non-Western art histories are founded on Western models, and that the West continues to project its sense of Western art and history onto new material.[27] For such reasons the workings of pictorial complexity have resonance outside Western art, although I will not be pursuing non-Western art histories here. Even so, it is helpful to look quickly at some representative examples of non-Western artwriting that is not significantly influenced by the West, in order to bring home the uniqueness of what happened in the West. Our writing practices are odd not only in light of our own Western past: they are also odd in respect to all the known histories of artwriting in all cultures where records survive, from the various inceptions of writing to the present. My first sense of our position, and the germ of the idea for this book, came from reading histories

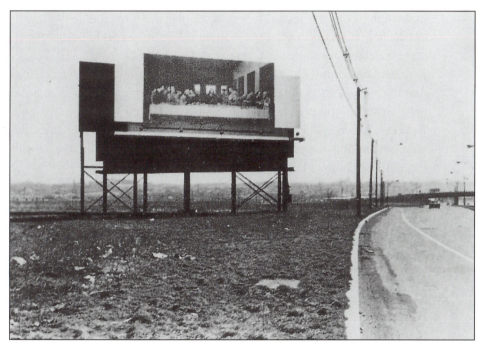

Plate 5

of art written in the West before the nineteenth century, those written about the Western tradition but from outside Western Europe and America, and those written in China, Persia, and India before or beyond the influence of Western art history.[28] Those experiences brought home, as no others could, the oddity and mannerisms of our own writing.

Several cultures developed their own traditions of written art history and criticism before they made significant contact with the West, and each of them involved far less writing per picture than we would consider adequate. Persian and Indian traditions each possess an extensive native literature on art that is relatively and in some cases entirely uninfluenced by Western artwriting, and none of the texts of which I am aware include extended discussions of individual works or debates about meaning on the scale, say, of the literature on Leonardo's *Last Supper* or the Brancacci Chapel. In China a well-developed tradition of art criticism goes back at least to the eighth century AD, but before the twentieth century there is no recorded instance of a single painting requiring more than the equivalent of a page of commentary.[29] Native Americans practiced a large number of pseudo-picto-graphic modes of writing, many involving extensive repertoires of pictorial signs: but there is no literature indicating an extensive exegetical tradition *about* those signs, as opposed to a practice invested in reading the signs.[30] Ojibwa priests in Minnesota, for example, read their mnemonic signs without the help of an interpretive tradition regarding the proper forms of images, their technique, arrangement, or extralinguistic meanings.[31] The images were passed on from one generation to the next by silent memorization and drawing.[32] Hopi altars are another example of a highly developed pictorial practice; there is no evidence that the practice involved an interpretive tradition centered on individual images.[33] Australian Aboriginal paintings are the occasion for long stories, songs, and mimes, but the pictures themselves call for minimal commentary and they have not given rise to any traditions of criticism.[34]

Needless to say, a list like this is potentially endless; what I mean to suggest is just that where writing on art has become intensive, it has done so under the diffused influence of Western art history. That is the case today in China, Japan, South America, Australia, and to a lesser extent India and Africa: wherever art history flourishes as a discipline, it does so according to a version of the traditions that are being worked out in Europe and America. Before Western contact, a few cultures had extensive writing traditions (China is the principal example), but none had intensive traditions.

FIRST EXPLANATION: WE SIMPLY KNOW MORE

It is tempting, I think, not to see a problem here at all. Especially in light of
the examples I have been reciting, it seems reasonable to say that historians
know more than previous generations. We write more because we have more
to say, and we have more to say because knowledge has been accumulating.
This is in a sense unarguable, since we are clearly able to articulate more
about pictures than in past centuries. But can we assign our loquaciousness
to a surfeit of facts?

In classical ekphrasis it was enough to "bring before the eyes the sight
which is to be shown," as Hermogenes of Tarsus put it.[35] Ekphrases normally
state what was later called the *sensus litteralis*, the ostensive content of a
picture. Pausanius begins his description of the *Iliupersis* by briefly setting
forth the subject of the entire painting: "Inside this building," he says, "the
whole of the painting on the right depicts Troy taken and the Greeks sailing
away."[36] That phrase, *Troy taken and the Greeks sailing away*, might have
become the picture's title in the modern sense, if it had survived. Titles are
frequently minimal statements of content, normally restricted to the *sensus
litteralis*. The opposed term in medieval writing is *sensus spiritualis*, and
Pausanius never ventures near it.[37] In modern terms, *sensus spiritualis* might
also be called the "allegorical" or "nonliteral" meaning, when such distinc-
tions are maintained at all.[38] For classical authors, descriptions had a much
narrower range: either what I will call the "title" (the shortest convenient
phrase or mnemonic for the picture's content), or something longer such as
the *fabula* (the full textual source of the picture), or the *sensus litteralis* in
the form of a re-telling of the *fabula* or an inventory of the picture's contents.
(Thus Pausanius does not follow the *Iliad* in describing the *Iliupersis*, but he
ranges around the picture describing groups of figures that catch his eye.)

For ancient writers everything beyond the *sensus litteralis* was simply not
available as the subject of description, neither hinted nor omitted in any
comprehensible fashion. The conviction that there is something beyond the
sensus litteralis, and that it might be partly put into words, arises fitfully from
the beginning of the seventeenth century. In 1672, Giovan Pietro Bellori
became the first art historian to note the fact that words are insufficient to
describe pictures; and a decade later the concept of the *je ne sais quoi* was in
wide circulation.[39] Our present situation is very different from these glim-
merings: whatever earlier centuries took for granted in pictures, we have
learned to experience as unwarranted assumptions. We have many more
words to find our way toward paintings: if Vasari had them, so David Carrier

implies, he might have written at greater length.[40] We have teased out many things that went unsaid, and found subtexts beneath ostensibly neutral descriptions. Ekphrasis has become a charged term, meaning anything but the unproblematic summary of a picture's contents.[41] Vasari, Winckelmann, and even Pliny have become "texts," harboring unarticulated feelings about gender, politics, and the purpose of art.[42] Nothing is as it once seemed, and pictures are no longer objects to be summarily understood.

Hence most of what we write is not "facts" or "information" in any normal senses of those words. Still, it's often true that contemporary writers *also* simply know more than past writers. Vasari is a well-known example: modern editions correct him, and our lists of artists' *oeuvres* are longer than his. This first explanation—we write more because we know more—is occasionally the most sensible way of accounting for the increased volume of recent literature. Certainly it is the most straightforward explanation, and at the least it explains some quotient of any modern text.

SECOND EXPLANATION: AS THE DISCIPLINE GROWS, SO DOES THE WRITING

Another way of looking at the problem is to consider the discipline itself. Like many other fields, art history is rapidly expanding. There are more MA and PhD programs than there were only twenty years ago, and many more art historians. The growth may be so intense, and so competitive, that a kind of Darwinian explanation might be in order. Because there are more applicants than jobs, and more assistant professors than tenured ones, perhaps texts have to be conspicuously ambitious in order to take their authors forward. Once it would have been unusual to see a monograph on Raphael's *School of Athens*, or even on the Parthenon sculptures. Now it is not surprising to find an entire book on the "secret geometry" that supposedly hangs in the architecture above the figures in the *School of Athens* (according to the author, a stellated polygon provides the proportions for the entire scene), or a long essay claiming that a topographic map of Athens is nascent in the minuscule rocks depicted on the Parthenon frieze.[43] That kind of outlandishly narrow concentration makes good sense from a Darwinian perspective: when they are successful, such projects create new niches where competition is minimal and expertise is concentrated on one person.

In this view, the growth in both extensive and intensive writing might be explained by looking back to the origins of disciplinary art history in eighteenth- and nineteenth-century antiquarianism and art criticism. Enlightenment and romantic art criticism have certainly played a part in what art

history has become, and contemporary art history has been influenced more than it sometimes allows by Diderot and Baudelaire. Philosophy has also contributed, though we still lack judicious assessments of the influence of such writers as Wilhelm Dilthey and Maurice Merleau–Ponty. The current pressure to write would ultimately be a consequence of the incorporation of such influences, together with the expansion of the American university system. We would write a great deal because there are large numbers of us, and we would write voluminously in order to be heard above the background.

Many parts of this explanation ring true. The sheer volume of writing can probably be correlated with the number of historians who must write in order to find jobs, or improve their jobs, rather than with the art historians who have no immediate pressure to write. It may be that if more accurate figures were available it would become apparent that the total amount of our writing has increased in proportion to the difficulty of the job market. But this second explanation also has its weak points. There's something peculiar about picturing art historians as the passive products of their own discipline, as if they are jostled by the pressures of jobs and teaching and unable to do anything other than comply with the discipline's commands. In order for this explanation to work *as an explanation,* it needs to acknowledge that historians make the discipline as much as it molds art historians. Despite appearances, we all write as we please: it is our discipline, and the majority of us are content to voice even the most strident critiques within the apparatus of colloquia, journals, and universities.

This is one of the places where the distinction between extensive and intensive writing is especially important. A given scholar might well feel beleaguered by the imperative to publish, but the writing that engages the largest number of historians is something more than a response to disicplinary demands. Most of the texts that are considered central to their specialties, or to the discipline as a whole, are complex: they are intensive more than extensive, and therefore not typical products of the pressure to publish. A Darwinian fight for survival might well generate the volume of essays recorded in *The Art Index* or the BHA, but it wouldn't explain the few, compelling, and disproportionately intense readings that provide the subjects of so much of our conversation.

THIRD EXPLANATION: WE ARE MORE REFLECTIVE

It's certainly true that Darwinian-style pressures rule part of our lives, and many of us play along by being a little compulsive. But intensive writing, in particular, isn't well explained by theories of competition and a growing

population. The first explanation (that we need to write at length to spell out everything we know) is also partly true, but perhaps it would work better if it weren't restricted to "facts" and "knowledge"—notoriously slippery categories in any case. Instead we might say that we know more, but that what really accounts for the growth in writing is that we are more aware of what we are doing, more eloquent, and more reflective than writers in past centuries. The very words "picture" and "interpretation" have become so complex very few of us would want to say what they mean. It is not so much that knowledge is accumulating, as that it is deepening. We don't just know more, we know differently. It is possible that Pausanius knew what the *Iliupersis* "meant" in Stansbury–O'Donnell's sense, but chose not to say: in that case Stansbury–O'Donnell would not know more than Pausanius, but he would be writing differently. Where Pausanius was content to say what he saw, Stansbury-O'Donnell is compelled to say many things about what was implied, and about how Pausanius wrote when he tried to say what he saw. Pictures and their interpretation have become entangled, and we write about each simultaneously.

This is a particularly difficult explanation to pin down. I have heard it in many guises, and I think it may be a way of saying several things at once. Part of what it means is that the "disparity" (as I'll call it for short) between premodern and modern accounts is a matter of our gradually increasing ability to find meaning in pictures. We have stopped treating pictures as silent narratives (as virtually all premodern writers did) and we have even come to doubt the old Horatian formula *ut pictura poesis*. The whole literature on "word and image"—which began in the sixteenth century, but only flowered in the twentieth—can be taken as a sign that contemporary art historians are aware, as never before, of the *problems* of putting text together with image. We are more reflective about interpretation, more aware of its pitfalls.

An initial impediment to assessing this explanation is its implicit aggrandizement of the discipline of art history. Assigning the disparity to an increased capacity for eloquence, an awareness of the problems of interpretation, or a tendency toward reflective thought comes close to saying we have an improved understanding of images. In the end I think it is a version of the first explanation, with "reflection" substituted for "knowledge." Contemporary art historians would know more deeply, more thoroughly, and therefore *better*: our ways of looking and writing would be closer to the truth, more faithful to the images. Though this sounds inappropriately self-congratulatory, it must be in some measure what we believe; otherwise we would prefer re-reading Vasari to reading the latest offerings in Renaissance art history.

What confuses me about this explanation is where it gets its force. Is it possible to think of this as an explanation for our condition, when it refers us back to the condition itself? Do I understand why I am attracted to complex writing, if I am told that I am more reflective than earlier writers? There's a sniff of tautology here: we write more intensive essays because we are intensively self-reflective. In asking whether this third explanation can serve as an explanation, I am drawing near to the most difficult historiographic question of this book: What kind of phenomenon (historical, historiographic, cultural, psychological, scientific, and so forth—the list is by definition open-ended) is to count as a sufficient explanation?

FOURTH EXPLANATION: THE CULTURE HAS CHANGED

A fourth explanation, roughly as common in my experience as the first three, is that contemporary art historians write more intensively because pictures function differently in our society than they did in the past. Pictures were used very differently by the Renaissance, and so they called for quite different kinds of description. The lack of intensive medieval texts on painting is to be understood as a consequence of the functions of medieval illuminations and stained glass: basically, discussions that went beyond the religious use of images simply did not have meaning. Gradually, as art history came into being, pictures became repositories for kinds of meaning that had not been developed in past centuries. Portraits probably always signified power and gender relations, but it took a discipline devoted to images to tease out their meanings. Abstraction, expressionism, minimalism, and conceptual art have meanings intimately tied to the discipline that first described them. The disparity, in other words, is only a surface effect of a richer vein of meanings that unfolds in society, in patronage, and in the discipline of art history.

There are certainly improvements here over the first three explanations, since the way is now open to a more inclusive understanding of our version of pictures. We would no longer be compelled to claim that contemporary historians have become aware of what pictures are "really like," because we would not need to say that we have a greater pool of knowledge. Nor would it be necessary—pace the third explanation—to rest content with saying we possess deeper or better insights than past generations. The surrounding cultures would be the sources of meaning that tell us *why* we see things differently. This fourth explanation can also help clarify the second explanation (that the growth of the discipline is driving us onward), because it could presumably tell us *why* our culture has produced a discipline that drives us.

Certainly the question of my title cannot be well described in isolation, as if it were confined to the space between the museum and the library. But I also wonder, even while I acknowledge the play between institutions and the changing function of art, how close this fourth explanation comes to the actual texts of art history. The point is not that our society prompts us to change, but that it prompts us in very precisely definable ways, to produce specific texts. When would it make sense to appeal to general conditions of late capitalism, or the dissemination of popular images, in order to explain a text as intricate as Steinberg's meditation on the *Last Supper?* The locus of interest, I think, has to reside in the exact forms of complexity we give to images, and the more general the explanatory principle the less able it is to make contact with what is actually written. So when people say that my question depends on the changing nature of culture, I agree, but I still wonder what makes us so fascinated by the politics of the *Iliupersis* or the position of St. Peter's left hand in the *Last Supper.* We have inherited, or invented, a certain kind of complexity that cannot be described simply as the effect of the meanings of pictures in academic or intellectual late capitalist Western culture. And which is more in need of explanation, the practice of interpretation or the culture in which it is embedded? What in culture, or cultural history, can be considered well enough understood so that it can serve as a starting point for explaining intensive interpretation?

THE PLACE OF SELF-INTERROGATION

These first four explanations are the ones I have heard most commonly, and they each have a measure of truth. They often overlap, blurring into a single explanation—something like Things change, and so our writing has to keep up. Reading Janson's *History of Art,* I can sense the echoes of all four explanations: Janson knows more than most of his sources; he is an exemplar of the rewards of consistent and voluminous publishing; he is reflective about his position in history, and takes time to set it out; and he is clearly the product of a certain evolution of the notions of art, art history, and Western culture. In each of those ways, the *History of Art* differs from its predecessors such as Pliny, Pausanius, Vasari, Bellori, Sandrart, Van Mander, or Winckelmann. Even when Janson has only a paragraph to spare for a picture, he is sure to imply complexities beyond his text's capacity, and he is virtually never satisfied with the equivalent of the *sensus litteralis,* or a dramatic ekphrasis. In *The History of Art,* bland as it has become in successive editions, pictures are intensely demanding objects, implicitly and explicitly overflowing their allotted spaces in the text. The four explanations I have

sketched do manage to describe some salient differences between Janson's book and those of his predecessors, but only at the cost of making him into a kind of historical puppet. The explanations picture art historians as fairly helpless heirs of their own accumulating knowledge (the first explanation) or their burgeoning profession (the second explanation), or as the vehicles of some mysteriously deepening skill (the third explanation), or of the culture that surrounds them (the fourth explanation).

Each explanation tends to erase the question I am interested in by making the disparity "natural," or seeing it as a side-effect of forces at work elsewhere. If contemporary writers are more eloquent, I would want to know *why* they are driven to eloquence. Surely we would not want to say that an average art historian is more eloquent than Pausanius or Pliny, and Vasari is a formidable model of easy eloquence. And would we want to claim greater awareness of the perils of interpretation than the Greeks? Questions like these lead into two blind alleys. If a given art historian is more eloquent or reflective than a given primary source, then the eloquence itself would stand in need of explanation. Where did it come from? Why does it seem appropriate? And if the historian is imagined as being equally or (as is more likely) less eloquent than the source text, then it would be interesting to know why eloquence and reflexivity are displayed so prominently in contemporary writing and so little in previous texts. What makes us want to write eloquently? What makes us think that reflections on the interpretive act are apposite, or even required? If we understand pictures better than past generations, then what accounts for this sudden efflorescence of understanding, after generations foundered in relatively naive and unreflective oblivion? And who is in control: do our texts passively grow to accommodate our insights, or do we push the discipline to make room for what we want to say? Have our institutions taken over, and burdened us with proper nomenclature, specialized terminology, and institutional protocol? What value should we assign to our prolixity, our easy articulateness, our rhetorical versatility, our conceptual acumen? Are they signs of ever-more-vigilant attention to paintings, or symptoms of an inability to write concisely? Have we gained in critical awareness what we have lost in concision?

For me, the entire project of explaining the influx of writing by appealing to an agglomeration of facts, or a profusion of art historians, or an efflorescence of understanding, or a sea change in culture, is suspect. I am uneasy, too, about the near-match between these explanations and art history's sense of itself. In part the disparity cannot be explained within art history, since historians' ways of answering it would necessarily have to do with what would

be taken to be the fact that pictures *are* complex. Michelangelo's Sistine Ceiling, so the argument might run, requires all the attention it has received because in many ways it *is* as complex as the interpretations suggest. Within the frames of art history, that kind of answer is irrefutable: the historical literature shapes the way we see, and so inevitably it seems about right even when individual arguments and methods are unconvincing. If apparent complexity were my subject, the book could end here, with the tautology that complex pictures demand complex interpretations. But when interpretation is the subject, always the question is why: Why should we write at such historically outlandish length? Why do pictures affect us the way they do? Why do the older accounts seem inadequate? And—in the shortest and best formula—Why have pictures become so puzzling?

One sign that something strange has happened is that it is difficult to link our texts to the past. Often enough the exotic fauna of postmodern historical thinking cannot be imagined as the organic outgrowth of the simple—even skeletal—rehearsals of fact that satisfied earlier writers. It is crucial in this respect to note that our prolix interpretations have done more than make earlier ones seem elliptic or uninteresting. Older accounts can appear not so much wrong as wrongheaded, and often enough contemporary historians do not trace their work to earlier efforts as much as they dissociate themselves from the past.

A review of the literature on the *Mona Lisa*, for example, shows that most ideas spring from a few essays, and ideas succeeding generations have found interesting do not grow in proportion to the number of people who find something to say in print. Instead a relatively small number of ideas has been repeatedly cited and discussed. There is no good correlation between the number of people writing on the *Mona Lisa*—a number that has been growing sharply over the last hundred years—and the number of claims that have been registered about the painting or about previous scholarship. Some ideas, such as Freud's guess that the face echoes Leonardo's wet nurse's face, have been stated and restated without clear consensus. Others, such as a recent computer study that found similarities between the *Mona Lisa* and the late self-portrait drawing, have yet to find any response at all.[44] Many subjects have fallen into oblivion: the notion that she smiles from only one side of her mouth, in compliance with Renaissance manners; the idea that the *Mona Lisa* is a sublimated version of Leonardo's contemporaneous anatomical studies; a pediatrician's diagnosis that the figure is pregnant since she has swollen glands; Carlo Pedretti's interest in the columnar chair, which is reminiscent of Bramante's *Tempietto*.[45] Arguments about the sitter's

identity are a common theme in the literature, but the guesses don't grow one from one another: rather they alternate in strident succession.[46]

Michael Baxandall has proposed that much of what we see in Renaissance paintings is nascent in Vasari, and I do not know how one might go about disputing that.[47] (Even though Vasari's texts are abbreviated by our standards, and though his anecdotes can seem irrelevant, he continues to be cited and those citations are the thin threads that connect the masses of recent writing to the *Vite, Ricordi,* and other documents. What, then, prevents us from seeing the spaces *between* our citations as elaborations of ideas Vasari launched?) Still, it is equally plausible that much of what happens in Vasari is invisible or uninteresting to us. Steinberg does not develop just anything in the earlier literature of the *Last Supper;* he looks at specific texts and images that bear on ambiguity, or that claim univocal meaning. We underestimate the strangeness of our position when we use the fact that even specialists have a difficult time mastering their fields to explain our writing as the product of a growth of any kind. Many of Steinberg's interests are different from anything in the Renaissance sources. Art historians write at length on particular kinds of problems, and they don't care much for most of the things Vasari saw. What is it about Vasari's admiration for well-executed details like chairs and tables, or his enthusiasm for "divine" faces and "noble" figures, that seems so unpromising?

All four explanations, in other words, assume that something old grew into something new. Often, though, what's new is entirely new, and any model that implies things have "naturally" grown into postmodern profusion begs the question. The explanations are also essentially historiographic: they make it look as if the answers I am looking for could be found in the history of the discipline, or the history of Western intellectual work in general. But the problem I am trying to raise belongs less in historiography than in self-interrogation and self-critique. The question is less: How have pictures been understood in the past?—and more: What is a picture, that it drives me to respond by writing art history?

It seems to me the subject has a certain urgency: as historians and viewers, we tend not to reflect on why we understand pictures the way we do. We are isolated from the practices of past centuries more than we often suppose, and our writing bears witness to a kind of reaction that did not leave many traces in past cultures. Our writing is more challenging, more imbricated and dense, more exquisitely reflective, more intensive and profuse, than in any past period. We are alone in the history of writing on art, and we may not think often enough about that strange isolation.

WHAT COUNTS

AS COMPLEXITY?

I AM THINKING OF THE DESIRE... TO DECIPHER THE SECRET, TO IDENTIFY THE
LETTERS (OR LETTER) THAT CONSTITUTE(S) THE FORMULA PROVIDING ACCESS
TO THE PAINTING; THE DESIRE FINALLY TO MAKE EXPLICIT THE DISCOURSE
WHOSE ORIGIN THE PAINTING CONCEALS...

—LOUIS MARIN [1]

Since statistics can be at once over- and underdetermined, I want to call a
halt, hoping I have said enough to indicate the general shape of the prob-
lem. The extensive properties of current writing—its bibliographic and
cultural sweep—may or may not be meaningfully different from writing that
was done in imperial Rome, Ming Dynasty China, medieval Europe, or
sixteenth-century Florence. But the intensive attention we pay to pictures is
entirely unprecedented. Given the dramatically increased bulk of what we
say, it is not surprising that we also say different kinds of things: we do not
merely flesh out observations made by past commentators, but we find new
subjects and new sources of meaning. It's a difficult subject to see clearly,
since the debates can be so fascinating that even a passing description gets
drawn toward questions of truth and falsity. It helps, I think, to keep to a root-
level approach, assuming as little as possible and drawing only minimal
conclusions.

 An interesting point of entry is provided by the everyday objects that have
always been present in pictures. If this were a seventeenth-century text, the
mention of paintings of tables, walls, and windows might conjure what are
now called genre paintings, or perhaps rudimentary exercises in perspective.
To an audience of contemporary art historians, those universal objects have
full bibliographies, and call to mind involved discussions of representation,

realism, and pictorial space. Windows are central to perspective, from Alberti's translucent *velo* to Hubert Damisch's opaque "Cadmium Yellow window."[2] Walls are also indispensable to our sense of paintings, from Sven Sandström's "levels of unreality" in the Sistine Ceiling to Clement Greenberg's wall-like picture planes, and even to Julian Schnabel's paintings that are also walls.[3] Nor would it be difficult to assemble an entire lecture (or even a lecture series) on tables, including the ambiguously aggressive tabletop in Caravaggio's *Supper at Emmaus* and the tables that barricade a viewer's imaginative ingress in works as different as Vermeer's *Girl Asleep* and Cézanne's *Black Clock*.[4]

In past centuries the issues were much simpler. In Greek ekphrasis as in Renaissance art theory and historiography, commonplace objects such as faces, figures, buildings, streets, and landscapes often caught the commentator's eye for their verisimilitude or the skill they revealed. Vasari is full of praise for well-painted streets, arcades, wells, towers, windows, chairs, and beds. In the twentieth century that practice is nearly extinct among art historians and critics, having been overtaken by more self-reflective and metaphorical observations. We are no longer concerned with skill or talent *per se*, and we are only interested in the machinery of naturalism as it pertains to ideologies of the image—the Dutch sense of naturalism, for

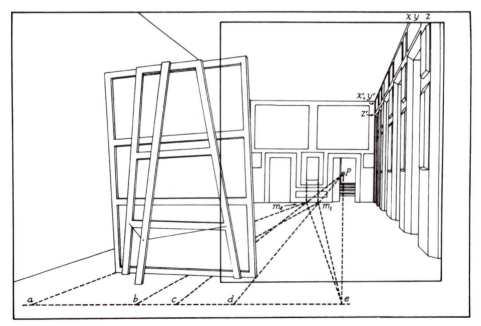

Plate 6

example, is bound up with Dutch society, and nineteenth-century French realism has become a vexed term, mingling political meanings with psychological and phenomenological constructions of the word "realism."[5] No contemporary art historian writing for a major journal can afford to *simply* praise a feat of naturalism without finding another register of meaning that somehow contains or explains the painter's feat or the historian's attraction. Gombrich's lifelong investigations into perception and representation are the closest to a premodern interest in the techniques of realism, but they are not addressed to artists and patrons (as Vasari's comments were).[6] Rather they are couched in terms of a larger history of Western illusion and a broad theory of resemblance and representation. From our perspective, Vasari's ekphrases seem charged with unexamined assumptions and ineffectually concealed motives; and conversely, our own interest in the naturalistic building-blocks of pictures is expressed in terms of many other phenomenological, allegorical, political, and psychoanalytic interests.

Our aversion to mere description, or to the apparently simpleminded praise of illusion, shows itself in the unexpectedly large bibliographies that have grown up around some everyday objects. I have mentioned windows, tables, and walls; and I want to spend a minute more on some meanings that have been attached to mirrors, doors, checkerboard floors, and shoes. I do so to hint at the nature of their complexity: they have become dense with metaphorical meaning, even though very little has been said about what would once have been taken as their most obvious attractions—their technique or their powers of illusion.

The mirror in Velázquez's *Las Meninas,* which apparently functioned for generations of viewers as a reflection of the King and Queen, was first brought to wider scholarly attention when Michel Foucault pressed it into service as a reflection of fragmented Western epistemology, "the representation, as it were of classical representation." Foucault's text is animated by an infectious enthusiasm for epistemological slippage: "the observer and the observed take part in a ceaseless exchange," he says near the beginning of his argument, "the subject and object, the spectator and the model, reverse their roles to infinity."[7] That famous result prompted art historians to a number of technical counter-arguments intended to fix or clarify the painting's structure by deducing the mirror's exact placement in the geometry of the room, and by locating even more intricately specifiable arrangements of architecture and figures. A diagram I drew for an essay by Joel Snyder can stand for the historically dubious precision that such arguments sometimes entail: the question being the relation between this kind of analytic precision

and Velázquez's own methods and interests (plate 6).[8] Snyder's work shows how nuanced the meanings of mirrors were in Velázquez's time, especially for those who knew how to read emblem books; and given the contents of Velázquez's library it is reasonable to conclude he could have stage-managed the elaborate construction. But the meanings implied by my diagram—its precise, analytic, unforgiving, argumentative exactitude—is foreign to Velázquez's contemporary reception.[9] I take it as a direct confirmation of my general hypothesis that even papers like the one to which I contributed the illustration have not settled or even effectively framed the central issues that *Las Meniñas* seems to raise. Instead they have focused yet more attention on the mirror, making the painting into a central instance of what W.J.T. Mitchell calls a "hypericon"—a picture that stands for picturing, or for our responses to pictures. (It would be possible to write a history of hypericons; it would include such forgotten episodes as the nineteenth-century debate about Hans Holbein's *Burgomeister Meyer*. *Las Meniñas* may be like the *Laocöon*, and keep center stage for several centuries; or it may be more like *Burgomeister Meyer*, very much a product of a certain time and place.[10])

In recent years the literature on *Las Meniñas* has continued to spiral, with readings building on counter-readings.[11] Mieke Bal has written a chapter on the painting's power to induce "narcissistic" reflections on self-reflection.[12] She argues that the painting is at one and the same time a spatial construction and a scene of self-reflection, and that the dissonance between the two propels writing on *Las Meniñas* into a fourfold schema of accelerating self-reference, ending—in some cases—in unproductive narcissism. Geoffrey Waite's essay "Lenin in *Las Meniñas*: An Essay in Historical–Materialist Vision" surveys nearly a hundred texts on the painting, and condemns them all as historical-materialist interpretations made possible by a complacency about the historical facts regarding the Spanish economy and Spanish class structure. He reproduces a painting by Peter Waite that shows Velázquez's painting stripped of its inhabitants, with a lone figure of Lenin (plate 7).[13] Essays on *Las Meniñas* continue to be produced at the rate of a little over two a year, and there is also a growing literature on copies, adaptations, and travesties of the painting.[14] For Leo Steinberg, the painting is a "great musical composition of which there are no definitive renderings"; Mitchell has called *Las Meniñas* "a meta-metapicture," because it is "an endlessly fascinating labyrinth of reflections on the relations of painting, painter, model, and beholder."[15] At the moment the densest reading is by the Belgian psychoanalyst Pierre–Gilles Guéguen who proposes the mirror as a representation of Lacan's register of the Symbolic.[16]

Whatever Foucault's essay accomplished for its generation, and whatever it continues to mean, it remains inadequate to read it as an argument about epistemology that turns on a seventeenth-century painting.[17] It is also about a certain sense of painting in general, and what interesting painting might be. I mean that both in an historiographic sense—since it is possible to argue that Velázquez intentionally made the most complex painting he could—and in a critical sense—in that a certain version of the painting's complexity (possibly not congruent with its complexities as Velázquez may have understood them) continues to be important for current scholarship.[18] Snyder is correct in saying Velázquez constructed an intricate perspective, but

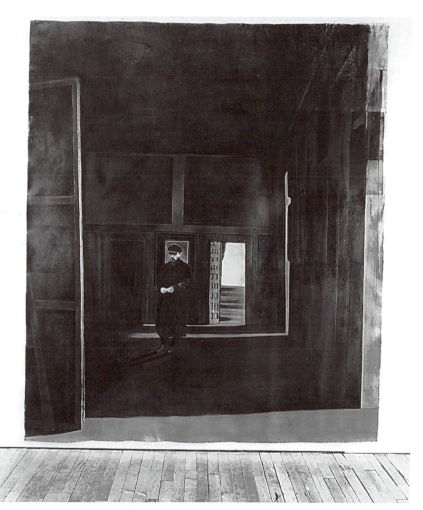

Plate 7

Velázquez would not have recognized way that fact has been displayed and analyzed. Perhaps, as Svetlana Alpers says, the complexity of the painting is "at odds with the interpretive procedures of the discipline"—meaning both its pre–Foucauldian narratives about the Spanish court, and its post–Foucauldian plays with epistemological uncertainty.[19] Among the criteria for our interest in this sense would be analytic complexity and specifically perspectival "paradox," and those criteria function nearly identically in virtually all the subsequent literature, no matter what position it may take in relation to Foucault's original paper.[20] Even Bal's argument, which purports to be an analysis of the appearance of paradox rather than of paradox itself, is driven by curiosity about mirrored meanings and the production and solution of puzzles. The picture became a special object of attention as soon as it was possible to see it as a scaffolding for analytic, spatial, epistemological, and perspectival paradoxes. Before, it had to do with the Spanish court, with decorum and etiquette, and with transcendental technique: now, it has to do with cat's cradles of inferred lines, relative positions, possible viewers, and the many logical forms that follow from them. *Las Meniñas* is an occasion for our texts, and also an excuse for them: despite our close analyses, we hardly notice how reflexively we are drawn to its mirror and its "paradoxes" of self-reflectivity.

Like mirrors, open doors seemed self-explanatory to generations of writers before the twentieth century. In the earlier literature the Golden Gate, the portals of heaven, and the inviting doors of Dutch interiors were among the few instances that occasioned comment.[21] As Austin's speech act theory diffuses through art history, it can now appear reasonable to talk about the performative function of depicted doors. Claude Gandelman has written a suggestive chapter on that subject called "Penetrating Doors" in a book on visual-verbal interpenetrations.[22] Gandelman draws on Arnold van Gennep and Victor Turner, and several other scholars have also written about doors using the anthropological vocabulary for rites of passage, in order to stress a doorway's "liminal" function. Christine Hasenmüller has written in that fashion about Van Eyck's *Madonna and Chancellor Rolin*. The painting presents its figures as if they were in a large loggia, open on one side to a balcony, which in turn leads downward to a garden, and then up a few steps to a parapet. In itself the arrangement is inviting and spatially clear. Hasenmüller's meditation on the act of passing through the various spaces leads her to describe the painting as a narrative about liminality, and finally a "highly intellectualized, sophisticated, and self-conscious discourse" of the "structure and function of ritual."[23] To make the argument, she draws on van

Gennep and also Edmund Leach's accounts of Claude Lévi–Strauss's work on symbol and ritual.[24]

Checkerboard floors, once among the proud accomplishments of the early perspectivalists, and later one of the signs of wordless domesticity in Dutch interiors, have become emblems of perspectival realism and of naturalism in general. In *The Poetics of Perspective* I noted the unexpectedly large number of meanings that have been assigned to the simple "perspective box" and its receding checkerboard pavement.[25] Writers have seen it as a metaphor for time, melancholy, subjectivity, intellection, representation, theatricality, art history, language, eternity or infinity, and even metaphor itself. Among the most elaborate interpretations is Hubert Damisch's contention that the checkerboard is less a geometric construction or even a cultural "code" than a "paradigm," the manifestation of a mode of thought native to painting. Perspective, and by association the checkerboard, become a kind of questioning and problem-solving that can only take place in paint, and not in thought.[26] As Vasari might have noted, a checkerboard pavement is an accomplishment every time it is done right; but it is no longer available to scholarship in those terms because it has been overwhelmed by our interests in the metaphorics of representation. Of these rudiments of painting, perspective has by far the largest bibliography, partly because the same kinds of argument are made repeatedly. Since the eighteenth century, writers have been interested in the exact circumstances of perspective's discovery, and even now historians continue to map out the Duomo and Baptistery in an attempt to recapture the precise effects of Brunelleschi's first experiment. Since the fifteenth century, writers have been impelled to prove perspective, or to reduce it to first principles of geometry or optics. The attempts continue, and in the last half-century they have grown steadily more complex, involving physiological optics, the neurobiology of perception, and sociology as well as geometry. It is a large subject, and *The Poetics of Perspective* is about the obsessive search for origins and proofs, and the delight in metaphorics, which continue to lead us away from the Renaissance interest in the techniques themselves.

Shoes are not the least on my list of quotidian objects, because they are the subjects of one of the most widely read texts of all—Jacques Derrida's "Restitutions of the Truth in Pointing" in *The Truth in Painting*. Derrida's essay is famously a commentary on Meyer Schapiro's critique of Heidegger's text on art, and specifically on the use to which Heidegger put one of Van Gogh's paintings of shoes.[27] Heidegger's point is bound up with his philosophy of the art object, and Schapiro's purpose is to bring philology and inves-

tigative history to bear against what he takes as Germanic assumptions on Heidegger's part. One of Derrida's purposes is to question the desire to interpret or "appropriate" paintings, in order to describe the shapes that desire takes in art history.[28] For Derrida, the main point about painted shoes is what they can say about what pictures have become: How, he asks, does it happen that paintings drive even reflective historians and philosophers into precipitous claims? That way of putting the question is very close to my purpose in this book, and I will return to his answers in the Envoi.

I am not parading these readings of windows, tables, walls, mirrors, doors, checkerboard pavements, and shoes as if they were inane or inherently wrongheaded. On the contrary, they are the shape of pictures as we understand them today. Any account of these objects that is unaware of the contours of the scholarship will be unable to find serious readers, and accounts that receive the most attention are likely to be those that carry the metaphorical and interdisciplinary meanings forward rather than tearing them down or returning to talk about illusion. No historian who wishes to write about *Las Meniñas* is compelled to master Guéguen's delicate argument, but what he says fits the contours of current writing in a way that scholarship before Foucault does not.

There's the shape of the discipline to consider in weighing any argument, and I do not intend any judgment about what constitutes trivia or overinterpretation.[29] It may bear repeating that the word "excess" in the title to Chapter 1 is strictly rhetorical: it is a label for the quantity of writing relative to Renaissance and classical norms, rather than a judgment about it. In the end the very notion of forming a judgment against contemporary art history is incoherent, because it would entail taking some earlier literature as the standard. The impossibility of any such willed anachronism has been forcefully argued many times.[30] On the other hand, any comparison of the kinds I have been assaying leads toward descriptions that are nascent judgments. Contemporary literature is "excessive" in the sense that it drastically exceeds earlier work, if not in the sense that it needs correction. When we begin to look beyond what the statistics can reveal, we come to this kind of complexity, and to the strange tendency of art historical accounts to become unmanageably intricate no matter what they are arguing. Our writing is extravagant, ruleless, and often fantastical where earlier work was restrained and decorous. We write intensively, with an aversion for plain meanings, technical mastery, and simple illusion; we are attracted to metaphors, and especially ones loaned by other disciplines; we love whatever can be made conceptually intricate.

FIFTH EXPLANATION: WE WRITE TO REMEMBER THE PAST

Adding his voice to the texts on *Las Meniñas*, Leo Steinberg remarks that people may continue writing about masterpieces because the writing has historical force: it assures the works will not "suffer gradual blackout."[31] On some occasions, a single text may be enough to propel a work from its place in the historical background into the light of the canon; Steinberg has said as much about a short essay on Picasso's *Three Dancers*. But eventually the blackout approaches, and engulfs the work—unless, that is, historians continue to write forcibly about works they consider important. Steinberg's proposal might add up to another explanation for the disparity, since it would picture art historians' incessant writing as a strategy for "shoring the ruins," preserving something of a sense of history from the approaching oblivion of ordinary forgetfulness. Complexity would be an especially powerful method for ensuring notice: the more meanings a work can be shown to harbor, the less likely it can be ignored in future scholarship. Even the exponential increase in writing might be accounted for by such a model, since the twentieth century is often spoken of as a time when historical continuity is especially threatened.

Like the four previous explanations, this one has a measure of truth. Impassioned accounts have certainly elisted works for art historical attention (Artemisia Gentileschi's ascendence over Orazio is a case in point) and other works, never lost, have been successively promoted (such as Picasso's *Three Dancers*, or the *Demoiselles d'Avignon*). Art historians' interests in particular versions of the past, and their commitment to a certain sense of culture, are elusive but essential aspects of the discipline, and even though it may not be easy to characterize the motives for advocacy in any given instance, it is probably true that art historians do not write *against* their sense of the important past. (There might be room here for an exception: Margaret Olin tells me that Alois Riegl deliberately sought out periods and styles that he couldn't appreciate.) I find the shortcomings of this fifth explanation derive mostly from the difference between the kind of eloquent writing that can propel a work into public view, and the inbred complexity that typifies the literature on objects such as doors and mirrors. Only a few texts are both complex and eloquent, both ambiguous and impassioned. The writing on doors and mirrors suggests that often enough historians are interested in the arguments themselves, sometimes even more than the works. How interesting are Van Gogh's paintings of shoes, outside Heidegger and Derrida? Do they really stand out above his paintings of beds and potatoes? And how much interest is added to Van Eyck's *Madonna and Chancellor Rolin* by the notion of liminality? Aren't the anthropological possibilities more intriguing than their enactment in the painting?

HOW WILD WE ARE

I have been looking at art history from a distant vantage, keeping away from the individual arguments and even from the content of contemporary writing, in order to suggest that some of our most important writing may be different in kind from what has gone before. The quality of that difference is not easy to pin down; but it is not impossible, either. A fair part of what I mean by words such as "complexity," "wildness," and "intricacy" can be captured in a half-dozen central traits: writing that attracts attention, I would say, presents pictures as logically involved, finely detailed, polymathic, and intensely intellectual. The first—logical convolution—is a property of argument itself: our reasons are never monotonic; rather they are heavily qualified, hedged and abetted, divided and subdivided. It would be a daunting task just to describe the many intersecting trains of thought that animate texts such as Joseph Koerner's *Moment of Self–Portraiture in German Renaissance Art* or T.J. Clark's *Painting of Modern Life*.[32] Fine detail accompanies logical convolution, hand in glove. For those who read it with care, Michael Fried's development of the thematic of absorption and theatricality is extremely nuanced, and it finds its purchase in the forms of individual paintings as much as in its broad historical sweep. Polymathic and polylingual arguments can also be attractive; I think for example of Barbara Stafford's new configurations of the histories of science, philosophy, and art.[33] Thinking of these themes, it may go without saying that such texts are intellectual, though I prefix the adjective "intensely" to point out the dedicated concentration with which the most interesting writers confront their objects. There is something more than untiring energy and enthusiasm in the historians I have just named: there is often enough a dedication that borders on fervor, and a palpable concentrated force of intellection.

These four traits are a good starting place for a description of current complexity, and it is possible to add several more. Contemporary art historians tend not to care for pictures with common themes, readily apparent or systematic symbolic programs, ordinary scenes and objects, or familiar stories—precisely the things that satisfied Baroque and Enlightenment viewers. We tend to be fascinated with the first instance of a given symbol or narrative, and we are attracted by oddities, mistakes, idiosyncrasies, anticipations, provincialisms, and unaccountable departures from the norm. We love the dissolution of ideas, the deliquescence of categories, the ruin of canons. Those qualities are almost a definition of current interests: even studies of Renaissance art stress its "decline and impending collapse," its lapses and backwaters, its internal incoherence, its "mysterious, introverted,

even tormented aspects."[34] Endings, borders, margins, frames, transitional states, blurred categories, "remnant" art, and unclassifiable hybrids fascinate us.[35] The most reflective literature on historical traditions focuses on the concepts of origin and tradition themselves, producing meditations on the fictions and "origin myths" of historical sequence. Whitney Davis's *Replications* is a text of that sort, engrossed in the structures of iteration in art history, psychoanalysis, and archaeology.[36] In this context *Replications* could be described as a logical endpoint of the normally unanalyzed concern with originality and origination, so that it functions as an example of that interest as well as an account of it.

Conversely, we are less intrigued by the rote application of a symbol or a narrative device, and we are especially jaded by artists who are indifferent to the symbolic and narrative complexities of their craft. Like a burning glass, art history's attention is focused on what philologists call the *hapax legomenon*, the single unique occurrence of a word—or in art history, a unique narrative, symbol, attribute, gesture, device, context, strategy, or configuration of patronage or public. A hapax (or hypax) is a fascinating obscurity, a sudden failure of meaning, a lacuna, a stubborn darkness that calls out to be explained. It can be as central as the *Mona Lisa* (whose smile continues to be perceived as a hapax, even though it descends through Verrocchio and has curious antecedents in the enigmatic smiles of Greek sphinxes), or as specialized as the meanings of the "blood scroll" in Mayan iconography (which is associated with a number of half-understood motifs and personifications).[37] The hapax attracts us in any setting because it requires the attentions of a specialist.

The same can be said of visual narratives, the stock-in-trade of premodern painting. For contemporary scholarship, the best narratives are tangled, incomplete, or arcane. If a familiar story is told in a labyrinthine fashion—as in Giulio Romano's maze-like ceiling in the Palazzo del Tè in Mantua, which shatters the story of Psyche into an irregular constellation of scenes—then it is immediately more interesting.[38] If a painting depicts some figure who can be identified from contemporary texts or other pictures, that fact is always mentioned, even when it does not add anything comprehensible to the meaning of the picture. Severe disruptions of iconographic conventions, as in surrealist paintings, attract some of the densest commentary; and conversely, docile repetitions of commonplace stories repel our attention, even if they take place in pictures that might be compelling for other reasons.

All this happens, or seems to happen, within the pictures themselves, as

if we are merely discovering strange properties that had been overlooked or underinterpreted. But it also happens—or seems to happen—within theory, since contemporary visual theory is also historically anomalous in its intricacy. We have a panoply of theories to choose from (psychoanalytic, semiotic, social or political, feminist, structuralist, iconologic, and so forth), and we tend to prefer our theories to have oblique, perspectival, anamorphic and "parallactic" connections with pictures, rather than utilitarian or pragmatic ones.[39]

If this list were to have a culminating point, where the different senses of complexity might converge, it would probably be self-awareness. In every instance I have named, from Hasenmüller's "highly intellectualized, sophisticated, and self-conscious discourse" to Mitchell's "endlessly fascinating labyrinth of reflections," our interest turns on the viewer's self-consciousness. If a painting engenders an awareness of the act of looking, it has an immediate interest for art history, whether the experience is taken as an instance of voyeurism and the "gaze" or (in a more inflected and negative manner) as an example of "theatrical" distancing between the viewer and the viewed. If, in addition, a painting clearly offers itself as a meditation on our awareness of the act of looking, it is prone to become an object of fascination, as *Las Meninas* first was for Foucault. Writing of Poussin's *Arcadian Shepherds*, Louis Marin says "it is as though Poussin, in his painting, enunciates the basic model of enunciation or represents the elementary structure of representation." The painting becomes an enactment of understanding itself: not only are the figures eloquent in the seventeenth-century sense (not only, for example, do they play out rhetorical and physiognomic types) but they impel reading by demonstrating reading's "theoretical" or "basic model of communication": and the viewer watches this, aware of his watching, watching himself begin to see how looking becomes reading.[40] Marin's book *To Destroy Painting* observes this process with exemplary diligence: it makes the *Arcadian Shepherds* into a hypericon. In a more rapid fashion any number of art historical texts find themselves drawn toward instances of reflexivity and self-reflexivity in painting. Fried explores how Courbet's *Studio* "represents representation," and Douglas Crimp argues one of Degas's photographs is a metaphor for the photographic process; and, in general, self-awareness if not self-reflexivity is frequently a criterion of interest.[41] Yet it wouldn't be entirely correct to nominate self-awareness as the guiding concept behind complexity, because it is only partly an interest in its own right. Complexity can happen with or without it; and often enough complex argument is the soil from which self-awareness grows, rather than the other way around.

As a working definition then, let me take "complexity" and its cognate terms to mean logical involution, fine detail, polymathism, and intense intellection, together with thematized self-awareness and an attraction to whatever is marginal, extracanonical, outside or before tradition, or otherwise a hapax. What important art historical text of the last several decades is not of this kind?

SPELLING THINGS OUT

In historiographic terms, the urge to complexity began in the last decades of the nineteenth century, especially in German scholarship. August Schmarsow required an entire book to set up the claim that Masaccio, as harbinger of the Renaissance awareness of art's history, could switch styles at will, while his collaborator Masolino could not.[42] Because Steinberg wants to show that the *Last Supper* is a matrix of intentional ambiguities, he has to negotiate an array of counterclaims that Leonardo intended only a non-contradictory set of meanings, or—in the usual iconographic fashion—that he intended only a single meaning. It is not easy to defend the hypothesis that an artist intentionally built irreducible alternates and undecidable propositions into a picture, and even at over a hundred pages, Steinberg's essay is compactly reasoned. Another example, Michael Fried's account of the "structure of beholding" in Courbet's *Burial at Ornans*, is an intricate argument requiring careful adjustments of fundamental concepts such as realism, painter, and beholder. It is persuasive in thirty pages, but a gloss could easily run to three or four times that length.[43] And the same is true among philosophers who are interested in visual art: the most attractive pictures continue to be ones that can be taken to pose analytic questions. As of this writing, philosophers in America and England are working on Mark Tansey (who is of interest for his apparent statements about philosophy and history, and perhaps for Derrida's lack of interest in his evasion of clear positions), Barnett Newman (for the "tragic" semantics he claimed for his paintings, and his supposed sixteenth-century kabbalism), and Hans Holbein's *French Ambassadors* (partly for the epistemological play afforded by its anamorphoses, and its prominent place in Lacan's theory of pictures). In each case the paintings are ready-made for intellectual and aesthetic interrogation: they are already almost advertisements for philosophic debate. In this ferment of analysis there is no sign of work on analytically unchallenging, but equally compelling, works by the uncountable number of artists who do not directly address intellectual themes or make significant contact—as I said of Renoir's *Woman at the Piano*—with the most challenging contemporaneous issues in art.

The works I have been naming are ambitious projects, very different from the simple things Vasari finds to say about Leonardo and Masaccio. Vasari's only abstract point about the *Last Supper* concerns the way Leonardo justified his habit of staring at the wall of the refectory in Santa Maria delle Grazie rather than painting on it. (Apparently Leonardo said invention was as important as execution, and that a painter should be able to "paint" in his *fantasia*.) Vasari's sentences are loose and conversational, while Steinberg is dissatisfied with anything short of a crushing machinery of argument. Vasari has time for any diversion; Fried has time for none. Yet it would be too quick to say that Vasari is simpleminded: this is not so much a claim about complexity as about a certain *kind* of complexity, and a *show* of complexity: the texts by Steinberg, Schmarsow, and Fried tend to possess overtly rational arguments and to prominently display their reasoning. The antecedents, evidence, criteria, and conclusions are all anatomized in the texts themselves, so that readers can participate in the construction of argument—and presumably be better armed to engage in productive critiques. In contrast to a writer like Vasari, such texts are written under high pressure, so that claims and concepts jostle one another for breathing room. Vasari is relaxed and expansive, and the complexity of the *Lives of the Artists* comes from sources other than connected argument. Why are our accounts of pictures intellectual games, instead of (for example) occasions for praise, wonder, and admiration? And can we say why Vasari did *not* experience pictures as intellectual challenges or philosophic dilemmas? I do not think we can, though it may be possible to describe why it is that we have no way to explain why Vasari did not see pictures as puzzles: it would be because our sense of pictures blinds us to other ways of experiencing them.

Perhaps this attachment to argument, this commitment to exploring every byway of meaning, is a good description of the differences between our volumes and Vasari's brief notes. To use Steinberg's formula, ambiguity for us has become "a species of power."[44] And so naturally it takes longer to construct sturdy arguments, longer to shore up a loose notion, to soften a claim that seems too sharp, to situate a text in the flux of theories. Certainly, if argument itself is at stake, the texts will be both longer and more dense. No problem that is visible to the writer will be allowed to pass by unexamined—no allusion, no nuance, no potential solecism will be permitted on the page without its cushioning introduction. We watch our arguments as they unfold, and we move more warily, as if citing sources were like stepping over land mines. Everything is written out, nothing is merely cited. (Ideally, our discursive rigor reaches even into footnotes and end matter. The long

argumentative footnotes, excurses, and appendices in texts by Steinberg and Fried show the effects of the imperative that everything should be written out.) In contrast—or so it appears—Vasari writes with a freedom that can only come from a mixture of naiveté and insouciance. Writing for him must have been as easy as ripping napkins, as John Berryman once said of Mozart.

Why do we think it is necessary to diligently construct as many qualifications and alternate meanings as occur to us? Why describe each "rhetorical frame" that gives our arguments their sense? Vigilance, after all, does not entail prolixity. Some of the most perspicacious texts are also the most perspicuous, and Vasari often knows exactly what he is not saying. We not only spin out our arguments at length, we also write about the spinning. Phrases such as "I cannot unpack that argument here," or "in this context I can only begin to open these questions," are signs of our meticulous self-awareness. In other disciplines such things may go without saying. Vasari's ill-framed expositions, and his slurred and inconsistent ideas, may be parts of an argument at least as intricate as anything we build. Perhaps there are two issues here, each linked to the other: if we could explain why we find it necessary to spell everything out, then we might also gain some insight into why Vasari did not think that he had to spell everything out.

WHY ARE SIMPLE PICTURES UNINTERESTING?

To a substantial degree the new intensive writing is concentrated on a relatively small number of artworks. Something about those works, it appears, is conducive to specifically intellectual argument: they seem to invite, imply, or support the kinds of questions that depend on philosophical, anthropological, geometrical, political, and historiographic ideas (to take examples from the literature on mirrors, doors, floors, and shoes)—and more, they seem to *demand* extended argument, leading to spirals of ascending conceptual difficulty.

The images on which art historians spend most energy are strictly different from the overwhelming majority of "simple" portraits, still lifes, landscapes, and academic histories that crowd the auction catalogues by the tens of thousands but scarcely appear in art historical texts. In the twentieth century, a picture of great interest tends to be difficult in ways that pictures rarely seemed to be, and conversely, pictures that are somewhat less engaging may appear so because they cannot engage the philosophic questions raised by the more central artworks. It is a salutary exercise to take an old Sotheby's or Christie's auction catalogue—say, from first decades of this century to the 1950s—and try to imagine its offerings as the subject of a university lecture. It can be quite difficult to construct plausible art historical

narratives around the religious narratives, landscapes, portraits, and genre scenes that constitute the vast majority of all marketable pictures. They are not mysterious, ambiguous or difficult, and even when they are works by accomplished artists—since I am not suggesting it is necessary to find something to say about every indifferent picture—they may not seem interesting. Often the only comments that come to mind are stray thoughts about influence, since most minor paintings appear at first as works influenced by painters taken to be more interesting. The few historical narratives that make contact with such pictures are generalized stories about *fin-de-siècle* landscape, late romanticism, the transformation and decay of the concept of the sublime, and—inevitably—the problems of sentimentality and kitsch.

Plate 8 is a typical instance, taken nearly at random from a collection of catalogues from the 1920s. The catalogue entry includes a well-observed description—almost a classical ekphrasis—of the painting:

> Nature is alive, light and gay, and the painter is of her humor, in this bucolic landscape of springtime, with ducks coming down to a pond in the foreground, hens pecking in the green grass in the sunshine to the left, and apple trees in riotous blossom, two on the right of the pond and others in front of a farmhouse in the background. Woods are back of the farmhouse, to right, and at left before it stretch wide green fields to further woods. Behind a fence at left a few small trees and a haystack. Signed at the lower right, BRUCE CRANE.[45]

Plate 8

The copy of the catalogue that I have seen has the selling price penciled in ($410), but no further annotations.

Pictures like this one fail on each of my four criteria of analytic complexity. It is not logically involved; in fact there is little point in talking about pictorial logic in an obviously informal farmyard scene. If it follows pictorial rules, they are the rules of the picturesque, as it was developed at the turn of the nineteenth century and developed through mid-century: the slightly off-center composition, the objects half-obscured behind one another, the disheveled trees, the swampy pond, the bright hazy springtime sun, the scattered birds, the old fence, and even the haystack are all *staffage* that can be found in any number of picturesque scenes. The problem for art history is that the uses of previous paintings and engravings is entirely obvious, and requires no professional attention.

If anything, this painting is *more* complex than most of Crane's work. He tended to paint simple views of the far corners and borders of empty fields, and the backs of lots where woods encroach on fallow land. Another painting, *Gray December*, is glossed in a catalogue as follows:

Brownish fields with boulders and stacked logs, brightened by a gleaming pool and the white trunk of a birch; golden saplings border a hazy blue distance, partly screening a light wintry sky. Signed and dated 1919.[46]

And this is a generously detailed description, since the painting is little more than a bleary view of woods. Painting like this is uninvolved with logic, and it offers little purchase for an historian intent on locating intellectual content.

Nor could this painting plausibly be the subject of a "finely detailed" exegesis (my second term) since there is so little happening in it. Because Crane was born in 1857, the particular devices he uses here could be found in academic and popular illustrations starting in the 1870s: the ducks and apple blossoms, for example show up in numerous popular magazines as well as in Salon paintings. But Crane's borrowings do not take those conventions further, or attempt to overthrow them, or treat them ironically. He merely *uses* them—a practice that makes him invisible to most art history. Nor would a polymathic critique have much to say here, since there is no need to invoke contemporaneous science, politics, or literature, beyond the relatively easy project of situating Crane among many other painters who retreated from each of those sources in order to spend their time immersed in a nature they took to be largely unreflective. Nothing "intensely intellec-

tual" (my fourth criterion) need be said about the painting at all: instead it calls for a nonverbal, unanalyzed kind of contemplation. It is not that contemporary art historians might not sometimes enjoy such a state of mind: but the discipline of art history is geared toward intellectual challenges, and this—or so it appears—is not one of them. Its simplicity, nonchalance, disconnection from avant-garde work, lack of narrative, lack of interesting symbolic program, and lack of engagement with gender or social issues, all conspire to make it anathema to the discipline. At the most, the painting might be of passing interest as an example of larger phenomena—say, the continuation of conservative academic painting into the twentieth century—but an art historian would be hard pressed to find an excuse to publish an essay on *Springtime*.

We have little to say about painters such as Bruce Crane. We prefer pictures that are analytically complex, conceptually challenging, full of symbols, hidden intentions, coded meanings. Our pictures play the game of painting with a full deck: they engage the issues of their day and push them forward, and they do so in concerted bursts of energy. By comparison Crane is lazy and semi-retired.

At the same time, I think we are largely unaware of this bias. (I except a few historians, such as Michael Fried, who are acutely aware of the fact that they speak only about artworks that "compel conviction" in Stanley Cavell's phrase.) The great majority of historians, I think, decline to engage the question in any extended fashion. It only becomes apparent as a bias when the tiny fraction of paintings art historians study are compared with uncounted "miles of painting 'in the manner of,'" as Picasso said. In general, art historians naturally assume that their theories are approximately right for pictures (it's a natural assumption, since otherwise the theories would appear questionable from the outset). If contemporary writing and visual theory are so fraught, then pictures must share the properties that the theories explain. But this may be an insecure inference. If writing is an answer, then there must be a prior question, and it must seem to be posed by the pictures themselves.

Hence the questions I want to put to the discipline: Why do pictures urge us to be so excessive? What is it about pictures that makes us respond at such length, with such energy, and wit, and hysterical exactitude? What impels our spiraling complexity? What are pictures, that they drive us to such distraction?

STAYING

CALM

HOW TO SOLVE

PICTURE PUZZLES

<div style="float:right">

3

</div>

A SUPERFICIAL ACQUAINTANCE WITH THE SCHOLARLY LITERATURE REVEALS THAT
ALTHOUGH BOSCH'S WORK HAS ALMOST UNIVERSALLY BEEN ACKNOWLEDGED TO
BE ENIGMATIC, ONE AUTHOR AFTER ANOTHER HAS APPROACHED IT AS IF IT WERE
A PUZZLE THAT NEEDED SOLVING OR A CODE THAT SHOULD BE BROKEN.

—KEITH MOXEY [1]

Saying our preferred texts are logically involved, finely detailed, polymathic, and intensely intellectual is one way of characterizing them, but it reaches its limit when it becomes interesting to know *how* the logic works, and what counts as "intensely intellectual." A reasonable way to sharpen the inquiry is to recall other examples of problems (not paintings) that have given rise to extremely involved and verbose explanations. First on the list would probably be paradoxes. Dilemmas, conundra, contradictions, false dualisms, irreducible polarities, and the "double bind" are classical sources of intricate writing in philosophy and mathematics. In this century, the irreducible, insoluble wave-particle duality in quantum mechanics has given rise to a mountain of literature, and so has Bertrand Russell's applications of the Barber paradox, the liar paradox, and other logical problems. Perhaps, then, something about pictures seems paradoxical, and art historical writing responds to that intuition in a hopeless attempt to salvage uncontradictory meaning. In that model, art history would be like the philosophies of complementarity and indeterminacy that have arisen in the wake of the generative paradoxes of modern physics and mathematics: that is, art history would be an extended attempt to reframe discourse in the face of apparently intractable paradoxes. It's an attractive thought, but it can hardly be pushed beyond a basic intuition: certainly we would not want to say that some para-

dox in modernist painting crippled historical writing—especially because there is no single moment of logical failure in painting as there is in physics or set theory.

Another kind of problem that has generated huge and intricate critical literature is the perception that thinking has reached a critical impasse or dead end. When it looks as though a subject is exhausted, and there is nothing further to say, a field may suddenly explode in a proliferation of ideas— a change in the conversation, as Richard Rorty says. In such cases the profusion of writing is brought about more by an intense claustrophobia or boredom than by a single logical knot. Critical impasses are more common and less easy to define than paradoxes, and they have occurred many times in science (and here it is only necessary to name Thomas Kuhn's concept of paradigmatic science, itself an embattled subject) and philosophy (where the most prominent example may be Heidegger's attempt to think through Western metaphysics). Wittgenstein did something of the sort when he began to see the flaws in his early *Tractatus*, and the same might be said of the change that has taken place in biology from empirical and morphological inquiries to genetic and systematic ones. Each historical moment produced surges of writing, replacing steady-state literature with flourishing growth. Here too there may be parallels in art history. Before the First World War, style analysis and connoisseurship were already experienced as limiting and unfruitful strategies, and between the wars they gave way to the social and iconographic readings that still proliferate today. The notion of a critical impasse giving way to a period of "revolutionary" writing is more seductive than the rather dry model of the paradox, but it is still too vague to take us far toward understanding our responses to pictures. Impasses are too generic, and their synonyms too flexible, to say much about the particulars of historical responses to pictures.

To my mind these scientific, logical, and philosophic parallels are suggestive but unfruitful. Happily there is another model that is much closer to pictures—so close, in fact, that it risks appearing as a reduction of pictures rather than a metaphor for them—and that is the puzzle. In naming puzzles (and in particular, picture or jigsaw puzzles) as an optimal analogy I am aiming principally to be literal as possible about how meaning is experienced, and in that respect jigsaw puzzles are an enticingly close match, almost a copy, of assumptions that drive twentieth-century writing about pictures. For one thing, jigsaw or picture puzzles are put together piece by piece, beginning with small passages and working up to the whole picture. In the same way, art historians tend to work on parts of pictures, assembling

meanings one by one, in such a fashion that it can seem the interpretation will be complete when each symbolic form—each piece of the puzzle—finds its place in the overall shape of the picture. The first pieces often seem to link up by luck, and only later on does it become possible to get the hang of the puzzle—or the painting—and to see some of the principles of its organization. It's a common experience in research: first comes the intuition that there is a puzzle, together with some hint of what the solution might be; and then the details build one by one until they reach a critical mass. It does not matter for this model how the pieces correspond to passages in the paintings. In iconographic research it may happen that a painting seems to come apart along the lines of its painted figures and symbols; but I intend this as a very general model, since it applies to any reading that understands a picture as a *structure*, something with internal differences that demand separate acts of attention. If a social interpretation of *Las Meniñas* concentrates on the figures, their gestures, and their clothing, then there is a remainder of uninterpreted paint that would call for some other kind of explanation: any such intuition of structure is enough to set the picture-puzzle model in motion. (And for the same reason, the model has no purchase when a picture is understood as an indissoluble whole. Such accounts are not common in art history, but they do happen; some of T.J. Clark's work on abstract expressionism is writing of this kind, where the subject—constructions of "vulgarity," social uses of art—makes it unnecessary, for the immediate purpose, to illustrate the *internal* structure of pictures.[2] Later in the book we will encounter other examples, and I will argue—as I would with Clark's texts—that apparently broad readings can contain an especially daunting kind of complexity.)

Picture puzzles are also appropriate models because they can be *completely assembled*: the pleasure in completing a puzzle is to see every piece in its proper place, and to see how they form a single continuous unity. That, I think, is the great unspoken desire in art historical interpretation: to be able to do justice to a picture, to say—at least for a certain audience, and in a certain context—what it means, to bring its essential significance onto the page intact and whole. No one ever claims as much, or even believes they have achieved it: but the idea is there, impelling the dogged gathering of scattered meanings. In this model, ultimately a picture would be structurally equal to the sum of its meanings, just as a picture puzzle is physical sum of its pieces.

The picture puzzle is a structural metaphor, but it expands into the psychology of process and the limits of self-awareness. The extension is

natural since the word "puzzle" is a verb as well as a noun, and it names a state of mind as well as a class of objects. A puzzle entices its would-be solver into a state of concentrated attention, exerts a particular pull on the imagination, and often demands a tiring intensity of thought. The difference between an ekphrasis by Vasari and an analysis by Steinberg exemplifies the kind of ratiocinative distance I have in mind: both texts may be mesmerizing and evocative in their different ways, but I need a pencil in hand to follow what Steinberg has to say. Steinberg's essay is closer to a logical or mathematical puzzle than to Vasari's gossipy prose. Hence the word "puzzle" can be both a structural metaphor for several specific forms of art historical argument (which I will outline in a moment) and also a token for the kind of experience contemporary writers prefer in reading and writing about pictures. We puzzle when we look, and we write in the same entranced, slightly anxious, and concentrated mood that we also fall into when we solve puzzles.

The puzzle model also breaks its structuralist mold in the classical manner of poststructuralism, by raising the question of self-awareness. With enough experience in puzzle-solving, it becomes impossible not to reflect on the limits of self-reflexivity. A mind that works on puzzles, and also works on its own working (as any strategist will), is going to encounter the question of motivation. What is the purpose of completing a picture puzzle, if it is apparent from the beginning that the full puzzle is contained in the box? The answer is in the pleasure of the construction—but how can that pleasure not be modified by the growing awareness that the process can only lead to its own repetition? There is always a small chance that a piece or two may be missing at the end, destroying the pleasure of the solution: but that doesn't mean the pieces didn't once exist (perhaps they have fallen on the floor, or been omitted at the factory). The picture was once complete before it was cut in the press; it is complete at the moment it is solved; and it will be complete many more times in the future. Serious puzzle aficionados also send defective puzzles to restorers, and have the missing pieces fabricated in imitation of lost originals. Where, then, is the puzzle-solver in the puzzle? What is the pleasure of pressing pieces together, and watching for perfect fits? What is the pleasure of watching as incomprehensible fragments of the image slowly accumulate into figures and faces? Why does the pleasure continue, and not grow weaker with the awareness of its obliviousness? And why, finally, will some people give up picture puzzles, while others keep at them year after year?

These are questions that strike at the center of the discipline, since they address the day-to-day attractions of puzzling out paintings. For the moment

I will let the structural and psychological or psychoanalytic meanings drift apart; at the close of the book I will set out a possible connection between them. It seems to me that the picture-puzzle metaphor can go a good way toward explaining some of the principal interpretive strategies in current art history, including not only the old-fashioned ones such as iconography (which might seem most appropriate), but also the newest and most experimental, such as those driven by deconstruction, new historicism, and reader-response theory. More often than we might expect, the meanings of pictures fit together as if they were the pieces of picture puzzles, and the reader's pleasure in following the solution re-enacts the writer's pleasure in finding it. In what follows, then, I will set out five kinds of puzzles, always noticing both the picture-puzzle versions and their ostensibly more intellectual cousins in art history.

PUZZLES THAT ARE FULLY COMPLETED

In the most reductive metaphor, the meanings of a picture might be imagined literally as the pieces of a picture puzzle, so that each local meaning dovetails with contiguous meanings, until an image is fully accounted for. A polyptych, for example, might be adequately described by identifying every saint and saint's attribute, and citing the appropriate precedents for each. The structure of the meanings would then be geometrically similar to the structure of the painting: each would consist of roughly equivalent, roughly uniform, strictly interlocking pieces. An interpretation would be a model of the original, related to it by simple laws of scale and detail: to each sign in the picture would correspond a meaning, and the meanings would join up like the signs themselves, leaving no gaps. Even in picture puzzles that only happens in the simplest of cases. Children's puzzles and "antique" puzzles are the principal examples, as in this one from 1807 where the allegory of the "hill of science" is closely matched by the shapes of the pieces (plate 9).[3] Today only children's puzzles are cut so that the pieces correspond to the outlines of the shapes in the picture, since that strategy only works if there are very few pieces — usually, less than twenty — and if the picture itself is blocky or sinuous enough so that its forms can make reasonable puzzle pieces.

We do not need to be told why this is impossible: philosophically it is nearly incoherent to say that meanings dovetail just like cutouts, that they are evenly distributed like puzzle pieces, or that they are more or less the same size and shape like puzzle pieces. At the very least, no historian would claim that such a reading exists for any painting. Still, art historians often behave as if they were at work on just such a puzzle. Keith Moxey notes as

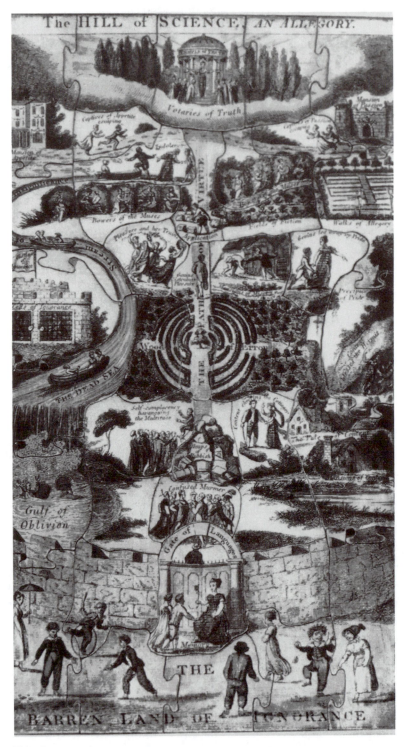

Plate 9

much in relation to Hieronymus Bosch (in the epigraph to this chapter), and other historians explicitly endorse the idea that perfecting an interpretation is like solving a picture puzzle. Salvatore Settis's book on Giorgione's *Tempesta* makes this utterly unambiguous: "the first rule for putting a jigsaw together," he writes, "is that all the pieces must join up with no gaps in between [and] the second is that the completed jigsaw must make sense."[4] Bertrand Jestaz, reviewing the French translation of Settis's book, bemoans the absence of theoretical accounts of iconography's "rules," and says that Settis's puzzle metaphor is "full of humor."[5] But it is far from a joke: it is the only methodological concept in the book, and—as we will see in Chapter 4—it guides every move in Settis's argument. Occasionally an historian will even picture the entire of art history as a puzzle, as W. McAllister Johnson does when he says that a hundred years ago it was still true that "large pieces of the art-historical puzzle remained to be discovered and fitted in."[6]

It is rare to find an interpretation that pushes the puzzle metaphor through to its literal end, and even rarer to encounter an historian who allows that is his purpose. Some come close: Marilyn Lavin has said that ideally "every element visible in the painting contributes to an overall message, [and] all the elements necessary for understanding the message are to be found in the painting itself"—a close match, or a near miss, to the puzzle metaphor.[7] At the close of Settis's book, the previous attempts to solve the puzzle have been discarded, and the puzzle of the *Tempesta* is completely solved. That is the moment, known to all fans of picture puzzles, when it seems as if the best thing to do is glue the puzzle down onto a board, varnish it, frame it, and put it on the wall as if it were a normal picture. But by the nature of picture puzzles, the snaking lines between the pieces only remind viewers of how different a puzzle is from the picture itself, and how difficult—and ultimately, how tedious—it must have been to construct the puzzle (plate 10).

Often enough, art historians build meanings according to informal rules of connectedness and coherence that are not at all incommensurate with this picture-puzzle model, but they terminate analyses without saying how they know they have found and assembled all the pieces. Settis enumerates thirty or so iconographically significant features of the *Tempest*, and together they constitute his complete "jigsaw puzzle" (plate 11). He names the man, the woman, the child, the stream, the man's staff, the city, some details of its construction, the broken column, the lightning and storm, the bridge, and—most contentiously—a small wormlike form in the foreground, which he says is the snake from the Garden of Eden, slinking back into the earth.

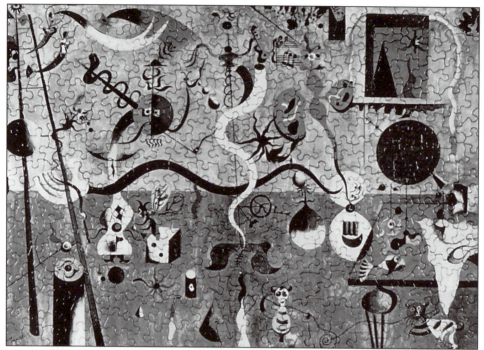

Plate 10

(It is just above the painting's bottom margin, below the woman's right foot.)
But there are many more potentially symbolic forms, down to the smallest
namable tree, shaped cloud, generic house, and pebble.

Many early jigsaw puzzles were not made of interlocking pieces, and in
the period between 1909 and 1915 puzzles were especially precarious—the
slightest shock, and all the pieces would slide out of place.[8] Some puzzle-
makers tried to follow the lines of the painting itself, as in this version of
Millet's *Gleaners* (plate 12). The same general arrangement is still used in
paint-by-number sets, where the pieces correspond with some accuracy to
the shapes of brushstrokes. This is another way of dividing a picture, one that
does not follow represented shapes as much as formal structure. On occa-
sion, such a division might make sense for an art historical account: but the
great majority of accounts could not find meanings for pieces like these. At
the same time, much art historical writing would be hard-pressed to say why
images do *not* divide into ever-smaller pieces.

A critical puzzle in Settis's book—one of its metapuzzles—is the absence
of a justification for his list of pieces. I might ask, for example, why the other
roots and twigs aren't also in need of explanation, or—more plausibly by

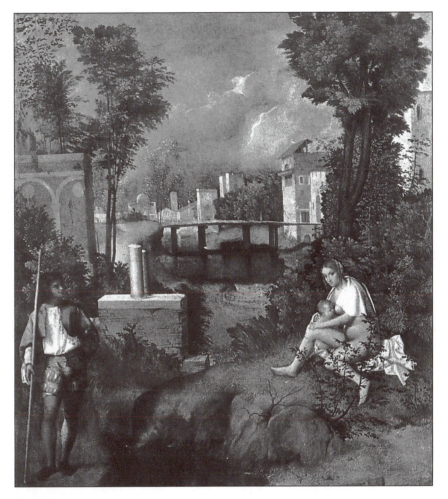

Plate 11

historical standards—why it is not necessary to account for the prominent residential building with its adjoining crenellated structure. Daniel Arasse has written a witty page on the alleged "snake," noting that it isn't even a twig or a root—in his opinion, it's a pure artifact of the technique. If so, Settis may not be naming a piece of the puzzle at all—but there is no discussion of such possibilities.[9] The picture-puzzle model itself explains the absence of critical reflection at these points: if a painting is understood strictly as a picture-puzzle, there is no need to "justify" the pieces, or even to count them. They are *given*, and they only need to be put together. It is even less likely that Settis would wonder whether the project of explaining "all the pieces" is sensible to begin with.

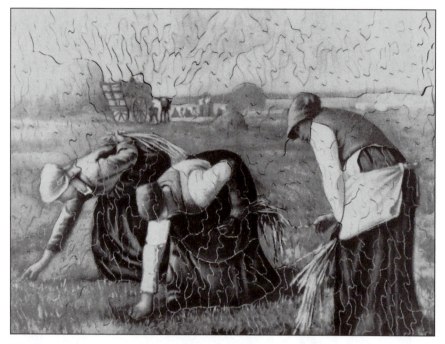

Plate 12

Occasionally historians chafe when they recognize a puzzle, even though they do not subscribe to alternate models of meaning. Linda Nochlin is bothered by the fact that Courbet's *Studio* appears inescapably to be an allegory of the painter's life; but even though she hopes for other meanings, she acknowledges the allegory as the primary sense of the painting.[10] For Settis, as for many iconographers, the model itself is never in question, and interpretation is a matter of assembling meanings that fit.

PUZZLES THAT ARE LEFT INCOMPLETE

Other historians solve puzzles part-way, naming some aspects of pictures and omitting others, and they stop without saying how many pieces might be missing, or why they do not think it is worthwhile continuing on to the end. This, I think, is one of the most common forms of art historical writing. The strategy is the heart of art historical practice: the overwhelming majority of texts offer to explain particular aspects of artworks, and when they are not accompanied by methodological reflection it is natural to assume that they might ideally be built into fuller accounts. When an essay does not mention an example of full interpretation, or make a gesture in that direction, it may imply that a full assembly of meanings is impossible (and therefore that the

picture-puzzle metaphor is misguided); but it may just as well imply that the author aspires to build an entire puzzle, but is constrained by time, space, ability, or the accidents of historical preservation. Art historians are tolerant of incomplete interpretations because complete ones are so hard to come by; but we may not always remember that incomplete interpretations take a large measure of their persuasiveness from the unspoken assumption that they are parts of a larger whole. If an historian presents a partial interpretation and then also muses on the possibility that it may not fit into any larger sense of the picture, the interpretation suddenly loses its purchase and begins to seem a little wrong.

But for the most part writers avoid implying that larger solutions may not exist. Optimism (or at least agnosticism) about full solutions ensures that the picture-puzzle model is fully intact. Even if a completed picture puzzle does not appear in the text at hand, there are examples in other texts, and it is still a good idea to work on picture puzzles. The two kinds of incomplete interpretations (they are my second and third kinds, after completed puzzles) have important epistemological differences. If a picture puzzle has been in use for a number of years, it will almost certainly have lost pieces, and so the project of assembling it cannot be aimed at creating a complete picture. It is also a slightly more difficult task, since it is impossible to know if you're searching for a piece that no longer exists. The purpose of assembling such a puzzle is really to exhaust the available pieces, and not to recreate an entire image. An historian who sets out incomplete readings in this sense is claiming, in effect, that no complete reading is possible. Historians who write incomplete interpretations while also implying that full solutions exist are in a different situation. Their project is like working on a new picture puzzle, where all the pieces are available, but giving up partway through. In one case there is no such thing as a complete puzzle; in the other, the complete puzzle is uninteresting or unattainable.

Among the many puzzle-like games that have appeared in the last century and a half, an apposite example for the first case are the aptitude tests in the form of puzzles, manufactured around the time of the First World War. In one such test, children were presented with pictures that had pieces missing, and they were asked to choose from sixty possibilities to complete the scenes (plate 13). In the episode at the lower right, a mother points out something on the floor to her son, and an appropriate choice from among the small blocks would be a scissors, a spilled jug of milk, or the cat. In the episode at lower left, four rather ominous shadows are cast by three figures and an empty square; a reasonable choice would be a small figure of a woman. The

Plate 13

object is not to exhaust the possibilities, since that would be impossible (I could choose the small figure of a woman, and put it in the lower-right scene, claiming that it was a doll, or even a hallucination). Instead, the idea is to let the child show some awareness of plausibility and likelihood. The game has a beginning, but no clear end, and it becomes—or so its makers would have thought—less interesting as it goes along. Once the best choices have been found, the others are somewhat pointless, but it is never pointless that the choices are potentially endless, because *that* source of disinterest stems from the fact that life itself is open-ended.

Related possibilities have been explored by Carlo Ginzburg, especially in the essay on Morelli, Freud, and Sherlock Holmes.[11] It is Ginzburg's thesis that what art history knows as iconology operates according to an investigative method that is also shared by Conan Doyle (whose strategies were admired by Panofsky[12]), by Morelli, the connoisseur of the overlooked form, and by Freud, who ascribed his method of "despised details" to Morelli in the essay on Michelangelo's *Moses*. Ginzburg identifies all of them as participants in a "lower," empirical method, which he sees as an alternate to Western scientific methodology. There are many problems with the essay, which has arguably been over-used and under-critiqued. Recently Georges Didi–Huberman has questioned the conflation of Freud's psychoanalysis, which sees multiple meanings in every symptom, and Holmes's method, where clues are only susceptible to single meanings. Several of the more rapid juxtapositions Ginzburg allows himself are historically suspect; at one point he adds Mesopotamian divination to his list of examples, but Akkadian texts reveal a practice far more systematic, and even map-like, than anything Ginzburg intends.[13] The essay depends on undependable conflations of disparate methods, and it is persistently slightly vague about the opposing scientific method: both tendencies or strategies help give the essay its appearance of consistent sense, but any interrogation of individual methods upsets it. One might also question the stifling of the autobiographical voice throughout the essay, so that the implied author himself becomes a "despised detail" and his other works become unreflective examples of the "lower" method rather than controlled applications of it. And there is the problem of Ginzburg's curious, unscientific attempt to exclude from the domain of science what he describes as the intention to observe without theorizing. But here I do not want to read Ginzburg as much as I want to collect this second way of construing puzzles.

If a picture is a puzzle in Ginzburg's sense, then its meanings need not be completed the way a picture puzzle's are, and in fact they would usually not

be, since a puzzle in Ginzburg's sense is solved by the kind of wandering eye that Doyle and Morelli exemplify—an eye that looks for a single crucial fact, instead of a mosaic of all possible facts. The salient point is that murder mysteries do not maintain a one-to-one correspondence between facts named in the narrative (and therefore "given" but not necessarily seen by the protagonists) and facts that are interpreted by the protagonist and perhaps also declared to be significant. Instead, characters in murder mysteries sleuth the "obvious" within the hidden (as Sherlock Holmes is fond of instructing Dr. Watson), or the hidden within the obvious (as in Poe's "Purloined Letter"). A reader who has just finished a murder mystery may think back on the many "unnecessary" pieces of information: some planted by the author to mislead would-be detectives; others that the protagonists mention, but do not bring into play; still others that are strewn throughout the narrative to create what Barthes calls the "reality effect." All such information is part of the "full picture," but it does not matter for the purposes of the detective story. At any given moment we may imagine that Holmes knows far more than he says about the suspect, his appearance, his clothing, his manner of walking, his choice of tobacco—but it is not important to paint the full picture. A "full picture" of the suspect is only the crucial detail that is needed to convict. Because their protagonists and authors are deliberately selective, murder mysteries can be read as partial deconstructive critiques of the picture-puzzle model of meaning—but I underline *partial*, since they retain the notion of final, unalterable solution.

(There is, incidentally, a delightful murder mystery in the art historical literature. It is the work of the historian Jörg Traeger, and it has to do with Jacques-Louis David's *Death of Marat*, not normally considered a mystery. In the usual account, Marat was in his bath, reading Charlotte Corday's note—his pen in his right hand and her note in his left—when she stormed in and stabbed him. His left hand slumped, but the note stayed in its grip, and his right arm dropped to the floor, as we see it in the painting. Traeger observes that Charlotte Corday's note is stained with bloody fingerprints, even though the fingers of Marat's left hand, the one that holds the note, have no blood. How did that happen? There are only two possibilities. Perhaps Marat tried to defend himself from her attack, and raised the note to his chest reflexively, without thinking to drop it. Then he shifted his grip on the note as his arm relaxed in death, leaving the fingerprints. That seems implausible: if David had intended such a scenario, why not just spatter the note with blood, instead of carefully placing fingerprints on it? Traeger suggests that the bloody fingerprints are Corday's. She would have killed

him, and then put the note in his hands so everyone could see. His suggestion is brilliant and economical, like the best of Sherlock Holmes's, and it seems to me that the only way to argue against it is to say David was not paying such close attention to the forensics of the crime. He just put some blood on the note for dramatic effect, without thinking how it could have gotten there. But what a risky conclusion, given David's exquisite attention to hands and gestures, and to the contact between figures, and given his very literal attention to Marat's bathtub and his vinegar-soaked cloth. It strikes me that Traeger's thesis has all the force of a good murder mystery: it compels us to rethink the drama, and the artist's involvement in it, even if we are normally uninterested in the machinery of murders. Like Holmes, Traeger is a little insistent and unwelcome, but he can afford to be because he is almost certainly right. Murder mysteries are hard to ignore, and even Traeger's larger thesis—having to do with David's dependence on Rousseau—gets lost in comparison to the fascination exerted by his little theory. When I have taught this material in seminars, students latch onto it as if it were the crux of the entire painting, overshadowing even its politics.[14])

If Settis's model of picture puzzles has affinities with the kind of iconography that seeks entire systems and programs of symbols, Ginzburg's more selective "lower" method is closer to art historical narratives that focus on isolated "keys" or central symbols. In that sense his model is present in virtually every art historical essay, at those moments when the reader's attention is drawn to something hidden, misinterpreted, marginal, suppressed, or overlooked, or to something so obvious it has not been seen. As such, Ginzburg's model (which I suppose should be called the Morelli/Doyle/Freud/Panofsky/Ginzburg model) is seldom absent from art history's interpretive strategies or epistemological ideals. Both the art historical species (the one in which the author implies that a full picture could be constructed, and the other that implies there is no "complete" picture) are compatible with what Ginzburg says, because what matters in the "lower method" is identifying a few crucial meanings. Writing on Piero della Francesca, Ginzburg remarks that "the best solution fits together as many puzzle pieces as will convincingly fit with as few hypotheses as possible"—a letter-perfect conflation of the picture-puzzle metaphor and the investigative method.[15] Perhaps that means some pieces are forever lost, and therefore unavailable to historical interpretation; or perhaps they are all potentially present, but irrelevant or uninteresting. Sherlock Holmes would probably opt for the second choice—that there is no "complete" set of information. Only a minimum number of clues are needed to solve a crime, even though the evidence might add to a complete

picture of the murderer. Despite his admiration for Doyle, Panofsky would probably have chosen the former option, because it is more in accord with the commonplace experience of history that the vicissitudes of preservation erode the "complete" picture, so that some meanings either do not exist as such, or are out of reach.

So far I have outlined two slightly but crucially different versions of the "incomplete puzzle" model. The first (implying the complete solution is ideally possible) is optimistic or agnostic, and the second (implying the "incomplete" solution *is* the full solution) is pessimistic; and the pessimistic option comes in at least three varieties. An historian might imply that the partial solution is *effectively* a full solution, because it captures the meaning of the whole picture. An analogy in the history of painting is the *non finito*, the category of intentionally unfinished paintings whose expressive power is taken to equal or exceed what would be possible in conventionally finished works.[16] Alternately, an historian might imply that the incomplete solution can never represent the whole of the picture. The analogy in that case is paintings that have been abandoned or damaged, and whose incompletion has no intrinsic expressive significance. They are forever fragments—though in the case of interpretation, the pictures themselves may be complete even though the historians imply otherwise. It is a slight but crucial step from *implying* meaning is incomplete to *demonstrating* that it is. Some of the most interesting results in modern physics and logic are proofs that things are unknowable, and in its less rigorous way, art history occasionally tries to sketch the limits of meaning in specific cases. But for the most part we leave such explorations to one side, preferring to find meanings rather than theorize on their relations to one another.

Socrates was the first to demonstrate that an argument can be coherent and still have as its object the demonstration of aporia, and some of what art historians write borrows this ambition in a weaker way. Contemporary art historical narratives are occasionally meant to raise questions as well as solve mysteries, to sharpen the reader's sense of the complexity of issues, to set out possibilities without adjudicating them, and less frequently also to rigorously demonstrate unresolvable dilemmas. As those possibilities become clearer, the most "pessimistic" incomplete solutions give way to more radical kinds of skepticism.

PUZZLES THAT GO TOGETHER DIFFERENT WAYS

The first three configurations I have named entail the belief that parts of the puzzle (and sometimes, the entire puzzle) fit together in reasonably reliable ways. The next thing to doubt is that *any* puzzle pieces fit with certainty into

other pieces. There are many possibilities, even in actual picture puzzles; I will describe just four kinds that occur in both puzzles and in art history.

Some picture puzzles are printed on both sides, so that as the pieces lie on the table, each one may be facing "up" or "down"—it may show the obverse or the reverse. In the easier versions of these puzzles, the pictures are obviously different: one might be an oil painting, and the other a photograph. That is a common enough situation in interpretation of all kinds, where a writer may work determinedly to assemble a single interpretation, realizing that each piece of the puzzle also pertains to a shadow meaning—a double that accompanies the intended meaning at every point.

More devious double puzzles have the same picture (or the same kind of picture) on both sides, so that each piece is nearly perfectly ambiguous between "up" and "down." There is a puzzle version of the Mona Lisa printed on both sides; the author of the accompanying booklet suggests assembling and disassembling it as a way of clearing one's mind while contemplating the Mona Lisa's history.[17] The "Perfect Double Puzzle" is an variation on that more difficult kind: it is made of two scenes printed side by side, each similar in style to the other, and in addition the person who works on the puzzle does not know what the second scene looks like (plate 14). When an obverse-reverse puzzle is completed, the two reciprocal pictures are clearly separate, and each one is entirely invisible when the other one shows. In the side-by-side puzzle the two pictures are juxtaposed. In the analogy, the first is a kind of interpretation that yields two mutually contradictory meanings, either one of which cancels the other; and the second yields two meanings that are clearly distinct and have no priority over one another. Either way, there are alternate meanings "on the other side." Those issues only become apparent when the interpretation is complete; during the construction of meaning, the only interpretive rule is that any given meaning might also mean its opposite. (In philosophy, this is Pyrrhonist skepticism— but nothing quite as rigid happens in art history.) The situation is familiar enough in historical research: an historian might work patiently to accumulate meanings for a given work, knowing all the while that the interpretation could swing one way or another, so that it might point in one of two diametrically opposed directions. Any given piece of evidence then becomes a potentially subversive element that might be part of either picture.

For most historians, the principal difficulty in assembling meanings is finding the right fit, but there are also times when it seems suspiciously easy to put meanings together, as if any meaning might fit with any other. The picture-puzzle analogy is given by puzzles whose pieces are shaped nearly

Plate 14

identically to one another, so that one piece may fit "perfectly" with a number of others. If the pieces are cut as rectangles or as similar polygons, there may be no clear criterion to help decide how the pieces should fit. A German puzzle made in 1977 reproduces a panoramic print in twenty-four pieces, and the cover boasts that they can be arranged in 1,686,553,

615,927,922,354,187,744 different ways—generating a practical infinity of meanings, and an equal number of ever-so-slightly unconvincing pictures (plate 15). Because the puzzle is cut from an original print, there is only one correct solution, but the text promises that "the quadrillionth" variation will again yield a landscape as pleasing as the original one. The one correct solution is no longer the only one, though it is still *almost* the only one, since the septillion-odd "solutions" only yield one or two equivalently pleasing ("gleichmässige") landscapes. (A French text on the other side of the puzzle-box puts it a little more strongly, claiming "la quatrillionième variante donne une paysage aussi bien composé que la première.") As it often happens, interpretation is a matter of sifting though an "infinity" of wrong answers for the best fit, or else settling for a "gleichmässig" alternative. (In the photograph, I have arranged some of the pieces correctly and others incorrectly, producing a fairly pleasing, but technically incorrect, solution.) In art history such compromises are the rule, since any slight change in wording will slightly alter the interpretation. Few would want to claim they had *the* correct solution, but when the pieces of meaning go together in so many

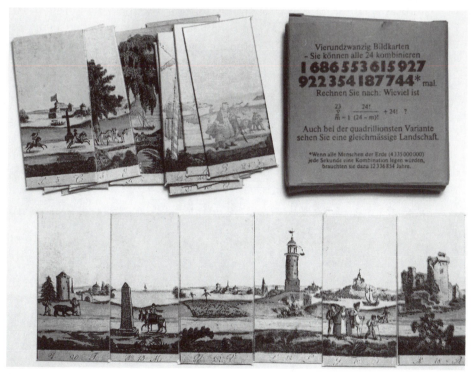

Plate 15

ways, a "gleichmässig" solution—one of a dozen out of an infinity of choices—is good enough, and can count as a correct answer.

The same kind of ambiguity can also occur when the pieces interlock in the normal fashion, provided they are similar and there is enough tolerance. One such puzzle is a reproduction of Jackson Pollock's *Convergence, Number 10* (1952) which was very popular on the puzzle market in 1965 (plate 16). (It sold 100,000 copies, and so it must have been many peoples' closest encounter with Pollock.) It was billed as "the world's most difficult jigsaw puzzle," partly trading off the popular perception of Pollock as an incomprehensible artist whose works have no regularity or method. It might be possible to argue that the puzzle's difficulty would decrease in proportion to the public's understanding of the kinds of gestures that comprise the all-over paintings, but the puzzle would still be difficult because of the deliberate near-match between the size of the pieces and the average size of Pollock's marks. (That way many pieces contain most of a single color, and it becomes difficult to search for the contiguous pieces.) In addition, the pieces are fairly uniformly cut, and they fit in such a fashion that it is possible to assemble large portions of the puzzle, and then disengage vertical or horizontal strips, transpose them, and fit them together into a completely different "correct" version. When I was young, our family owned a copy of this puzzle, and it was nearly complete one evening when an art historian, invited for a dinner party, looked at the nearly-completed puzzle and

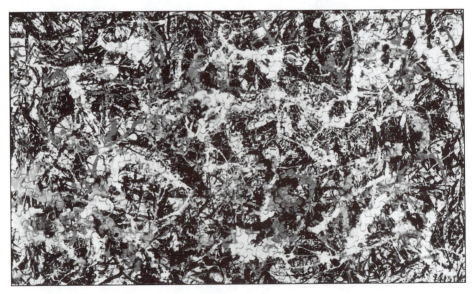

Plate 16

declared that Pollock would never paint in such a manner. He detached several vertical strips, transposed them, and revealed the correct solution.[18] Springbok's *Convergence, No. 10* differs from the German panoramic puzzle in that the pieces interlock, even though there may be some uncertainty in any given case. Metaphorically speaking, *Convergence, No. 10* has some structure to its indeterminacy, as if parts of an interpretation might cohere, but have indeterminate relations to other parts. In the other case almost any two meanings might go together.

Yet another kind of puzzle is constructed in bas-relief, so that some parts of the image have two layers, and others three or four (plate 17). Each layer fits together separately, and then they are stacked to complete the puzzle. In such puzzles there may be up to four different pieces that depict the same part of the image. Even harder cases occur when there is uncertainty about the contents of the puzzle box itself. Puzzles bought at flea markets might have mixtures of several different puzzles, or even pieces from two copies of the same puzzle. In terms of art history, layered puzzles correspond to the commonplace notion that meaning comes in layers, so that an interpretation might jump from an "obvious" meaning to a "deeper" one, or from a social

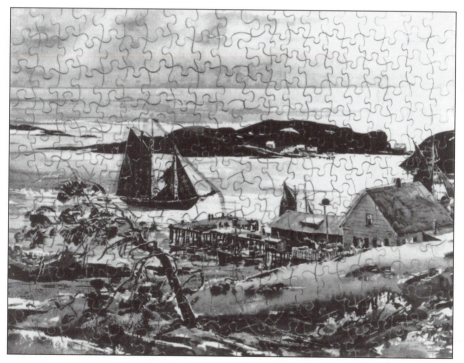

Plate 17

interpretation to "some other layer." Ideally all such layers have the same pieces, since they are all accounts of a single image: but as the picture puzzles suggest, the layers are in effect different pictures that are only held together by gravity. In art history, it can seem that "levels of meaning"—as represented by different accounts of a painting—aren't even held together by gravity, but that they merely float at variable distances from the single object they purport to describe.

Puzzles are the first of the three models of meaning I am going to explore in this book; the second is ambiguity. The models intersect with one another (in some cases, they are certainly "layers"), and in this instance each of these puzzles implies a different sense of pictorial ambiguity. The first—puzzles that have double meanings, clearly distinct from one another—corresponds to ambiguity in the logical sense, where a picture may seem to mean two contradictory things. Renoir's *Woman at the Piano* might be about music and light, or it may be about Panama and Poland. The two jar with one another: they are not opposites, exactly; but they are as close to logical antipodes as it is possible to get in painting.

The second kind of ambiguous puzzle—where the two meanings are similar, as in the "Perfect Double Puzzle"—is even more corrosive to common sense. The two meanings can undermine one another, but also mimic one another, and that double relation can persist until the last moments of interpretation—or until interpretation fails. When they are dissimilar (for example when the puzzle has a painting on one side and a photograph on the other) the interpretation is driven with increasing certainty toward the perception of paradox. If I think only of the gender issues in Carlström's reading, I might be impelled to think of the vulnerability of Poland (the "Poland-strangling"), or more simply of the vulnerability of the piano player. The two have a wavering, uncertain relation to one another: they are alike, in that they are both constructions of femininity; but they are also utterly unalike, since one leads to the standard literature on Renoir and the other to an strange sexual and political allegory.

When the pieces seem to fit several ways (as in the third model), then an interpretation might be put several ways and still be both coherent and complete. Interpretations that shuffle their claims and their suppositions, and move between several alternate reconstructions of a picture's meaning, are not common in art history. Jean–François Lyotard's readings of Duchamp shift in that way, and so do Thierry de Duve's thoughts on the relation between Duchamp, art history, and psychoanalysis.[19] In *Pictorial Nominalism*, de Duve slides between explaining psychoanalysis in terms of

painting, and explaining painting in terms of psychoanalysis: it is as if the principle of interlocking meanings has been intentionally suspended, so that the single "correct" picture can become a kaleidoscope of possibilities.[20] What is more common is the *idea* of shuffling portions of an argument while the argument is in progress, as if to say: Painting is complex in this way, and a picture's meanings might go together differently but just as well.[21] That kind of playing-at-shifting can end by strengthening an argument, since it gives the impression that many answers have been tried and discarded.

The fourth kind of puzzle (the bas-relief, where some portions of the scene are two or three layers deep) is a common occurrence in visual theory and art history: it corresponds to the sense that some elements of an image have single or primary meanings, and others lead into doubly, triply, or indeterminately many alternatives. The fundamental "level" may be the *fabula*, the painting's underlying story, or its naturalistic elements (what Panofsky calls the "pre-iconographic level"). "Higher" levels may include iconographic, iconologic, social, and other meanings: there is no end to the possibilities, though there is often a sense that only part of a picture is susceptible to multiple meanings. Multiple levels of meaning are familiar enough in the literature on figures such as Caravaggio who are at once strongly naturalistic and infused with many other themes, from religious devotion to allegory, from violence to abstract questions of space. Writers who see Caravaggio as a proto-abstract artist, or a bridge to the later Baroque, would be said to be working on a different "level" of his oeuvre than those who prefer social or historiographic meanings.[22] There may be no historians who deny the existence of "levels," and there may be very few who have not had recourse to the exact metaphor of "levels"; but at the same time, not many would want to allow for infinite levels. Instead, pictures are imagined very much as is they were bas-relief jigsaw puzzles: some parts have several meanings, and others have effectively only one.

Since ambiguity is the subject of the next two chapters, I will not develop the possibilities any further here: it is enough to say that the pleasure of such puzzles is precisely in discovering, or shaping, their species of ambiguity. Just as it is with commercial jigsaw puzzles, the historian often knows the nature of the ambiguity from the start, and the play consists of working out the possibilities.

POSTMODERN PICTURE PUZZLES

It is a large epistemological leap, but a shorter historical leap, from demonstrations of irresolution or ambiguity (the fourth kind of puzzle) to the claim

that meaning itself cannot be contained (the fifth kind). The idea that mean-
ing unfolds in a way that is unconstrained by a work's initial context or by
constructions of intentionality is a common misreading of texts by Foucault
and others, and it continues to exert force on historians who have begun to
doubt the fabric of historically reconstructed intentionality. Contemporary
writers and artists have a fondness for meanings that just don't add up (plate
18).[23] (In Jess's *Cross Purposes*, two pictures have been cut into pieces, and
juxtaposed: one is a painting of Christ and the Elders—three of their faces
are visible at the right—and the other is a woodland scene, rotated ninety
degrees.) In the history of jigsaw puzzles the postmodern affection for
disjunction corresponds best to the practice of cutting "figure pieces" in the
shape of heads, ornaments, and even little narrative scenes, and scattering
them among the more ordinary pieces (plate 19). In this puzzle, called *The
Approaching Ship*, one piece is shaped as a boy playing with a dog; another
is a servant, bowing to a woman; and there are a dozen fancy symmetrical
ornaments that resemble mountings for drawer-pulls or brass doorknockers.
The figure pieces are randomly aligned in respect to the picture itself, but

Plate 18

Plate 19

Plate 19 detail

there are also pieces that strictly follow the picture's contours. A woman's silhouette cuts across the fir tree, spanning half its width and also taking in some of the sky to its right. Just behind her is a form-fitting piece that follows the tree but also her head. The puzzle is an intermittently random imposition of pictures and figures on a single large picture. Some pieces repeat the shapes of the *The Approaching Ship,* and others are scattered about by the puzzle makers so that they are spread evenly throughout the picture, without attention to how they overlap depicted forms.

It is as if interpretation could be at one moment attentive to a the artist's intentions and at the next willfully capricious or disinterested. The analogous situation in literary criticism has sometimes given rise to an interpretive freedom altogether disdainful of the artist's intention. Derrida is very careful about this, insisting that the acknowledgment of "rupture," the indispensable property of writing that allows its uncontrolled decontextualization, serves to renew the importance of asking about the "place" of intention in "the entire scene and the entire system of utterances."[24] But the claim of unchained meaning is more widespread—it has effectively broken with *its* original contexts—than measured discussions of the place or position of intention.[25] In art historical practice it has given rise to another way in which pictures are conceived as puzzles, since interpretation so understood allows artworks to be engaged as "originally" fragmented objects whose conventional meanings can only be supported with the help of arbitrary and ultimately indefensible assumptions about the veracity of some historically specific construction of meaning. Artworks that are conceived as puzzles in this sense can be put together in an indeterminate number of configurations, and their pieces (their units of meaning) can be manufactured at will by the player, so that there is no longer any necessary sense to the claim that a certain pattern is a "solution" or that it is the correct solution. This particular form of loosely deconstructive criticism is unusual in art history, but the notion of the relatively free play of signifiers, and especially of the institutionally determined paths of conventional interpretation, is one of the founding assumptions of the new semiotic art history.

From the moment that some version of this claim comes into force, picture puzzles become objects that are constructed jointly by the original artist, the picture-puzzle company, and the person who assembles the puzzle. It would be as if the game of picture puzzles could be played only by playing with the rules. I might deliberately press pieces together "incorrectly," creating a patchy mosaic of "wrong" solutions, or I might glue pieces from different puzzles into a new picture unintended by the makers. It

would be a kind of art game, since the more interesting ways of playing would not be purely random or anarchic, but would have some intriguing connections to the ways we expect meanings to work.

I would, in effect, be tampering with the relation between the disciplinary expectations about meaning and the disruptive possibilities latent in those same expectations. This understanding of what it means to read or interpret gives rise to arguably the most contentious art historical writing that is being done at the moment. Philippe Duboy's book on the architect Lequeu, for example, is full of misdirections and deliberate anachronisms, most notoriously the claim that Marcel Duchamp altered some of Lequeu's documents when he worked in a library in Paris.[26] Since the subject is a wildly eccentric, sometimes perverse, and always hermetic artist, and because the book itself bends its narrative to the shape of Lequeu's neuroticism, the claim is made utterly undependable; but the book's ambitious idiosyncrasies have a strange charm. A not dissimilar exercise can be found in the catalogue of Duchamp's works written by Jennifer Gough–Cooper and Jacques Caumont, where we are told what the artist did on each January first, then on each January second, and so forth.[27] The rearrangement produces strange effects on a reader's sense of the meanings of the works. On December 25, 1949, Duchamp was talking about his drawing *Avoir l'apprentice dans le soleil,* showing a bicyclist straining up a steep slope; on the same day in 1960, he sent a postcard to Catherine Dreier with a reproduction of Gentile da Fabriano's *Adoration of the Magi.* Both images have steep slopes, and even though there is absolutely no reason to connect them, the catalogue forges a connection. It's impossible, now, for me to forget the visual pun between the two images, or even to forget that on the same day in 1953 Duchamp went to dinner at Alexina Matisse's house—that is, he spent Christmas day with his future wife.

By incorporating an implicit criticism of normal interpretation, texts like Gough–Cooper's and Duboy's gain an interpretive power that cannot be returned—even as they risk losing contact with historical meaning by concentrating on the rules of history rather than its ostensive subject matter. Disciplinary art history, therefore, remains largely outside such possibilities.

HOW TO WORK ON A PUZZLE, EVEN WHEN IT SEEMS YOU'RE DOING SOMETHING ELSE

These are ways that the picture-puzzle metaphor makes sense in relation to art history: interpretations might be like complete picture puzzles, or incomplete ones, or puzzles that cannot ever be completed, or puzzles that are

inherently ambiguous; and in the end, the most interesting thing to do might be to deliberately put the puzzles together wrong in order to understand how they are said to work. Certainly the children's aptitude test is most intriguing when it is abused: if I put a window in the floor, or have a cat cast a human shadow, I am questioning the game itself, and asking how the people administering the test have come to know what is appropriate (see plate 13). Occasionally "mischievous" postmodern behavior is a tonic to well-established interpretive regimes, but more often it amounts to a flight from the more challenging ideas that are at work in less radical adaptations of the picture-puzzle metaphor.[28]

The puzzle metaphor is far from a "humorous" figure of speech (though it is significant that it *sounds* humorous); and I mean to propose that the five puzzle-strategies adequately characterize the theories of meaning implicit in virtually all art history that is currently being produced. But different as they are, each shares a thought that I would like to present as fundamentally odd: and that is the idea that a given explanation (as opposed to an ideal explanation) can be complete. These are all ways of constructing texts that end by saying *everything worth saying,* so that nothing necessary remains to be said, nothing that need not be said is named, and nothing that cannot be said is acknowledged. One sign of the puzzle metaphor is the careful gathering and interlocking of pieces of evidence; but another is the sense that the interpretation—whatever its limits, and regardless of the ambiguities it must tolerate or embrace—can be concluded, that it is effectively complete at the moment the essay ends. At first it may seem this applies better to the first three models and not at all to theories of ambiguity or the contextual play of meaning; but what is a continuous emphasis on the universality of dissemination except an attempt to occupy a field of interpretation entirely? And what is an emphasis on ambiguity if not a frame within which meaning can be exhausted, or at least assigned its proper place? In each case the encounter with the picture poses the problem together with the conditions of its solution. The result, as in any puzzle, is—for the moment, and in its context—final and comprehensive.

In addition to the five modes there may also be a sixth, and that is my own. To a large degree, the puzzle is a language game, and so this chapter raises the same questions that can be asked about Wittgenstein's *Philosophical Investigations.* Roughly put, I might ask: What language game is being played when language games are being compared?—and the equivalent question here would be: What model of puzzles does the detective work when puzzles are the subject? For the most part it is a trivial and general

model of puzzling, because I want to stress the strangeness of the conviction which comes upon historians that something must be solved. Art historians (myself included, when I am not writing about puzzles) tend to behave as if they are presented with conundra, paradoxes, or—in the best model— picture puzzles instead of pictures.

By arguing this way, I am in a sense declining—at least for the duration of this book—to play the games of art history at all. I have tried to construct these descriptions so as to place myself mostly outside the apparatus of art history in so far as it is a congregation of interpretive strategies that aim to find the truth in pictures. My position has no special privilege, because from the point of view of the positions I am exploring, it is not a position at all. I'm not sure if what I have to say in this book could be used to advance or confront any specific art historical reading. But the position has one essential virtue: it opens a gulf between the day-to-day business of art history and its implicit models, and makes it possible to begin thinking about the phenomenon of puzzling as a whole.

AN AMBILOGY
OF PAINTED MEANINGS

<div style="float:right">**4**</div>

[THE *MONA LISA*] IS UNIQUE. THERE IS NO GOOD TRYING TO LAUGH IT OFF OR TO
THINK ONE CAN EXPLAIN IT BY THE USUAL PROCESSES OF FORMAL OR PHILOLOGICAL
ANALYSIS. TO TRY TO ANSWER THE RIDDLE OF THE SPHINX HAS BEEN A TRADITIONAL
FORM OF SELF-DESTRUCTION....THE IDENTITY OF THE *MONA LISA* WILL CONTINUE TO
OCCUPY THE MINDS OF THOSE WHO HAVE A TASTE FOR PUZZLES AND ACROSTICS.
—KENNETH CLARK[1]

For some people, puzzle-solving is not enough. After all, puzzles demand
the repeated application of a small set of methods, and they do nothing but
build images—they do not alter images, or tear them apart, or find wholes
where there are parts.[2] There are ambiguous puzzles, but their ambiguities
are controlled: they are literally listed on the box. The "postmodern" inter-
ventions are ways of deliberately throwing off the yoke of puzzle rules; but
like many radical strategies, they tend to lose interest as time goes by. Fanci-
ful and fantastical interpretations are entertaining as experiments, but they
are often unable to engage the sources of interest in an image. (I am think-
ing, for example, of Mieke Bal's inventive uses of the Qur'an and other texts
to disrupt our accustomed readings of Rembrandt.[3]) For the most part,
puzzles are fairly sober propositions, and puzzle-solving is a task best suited
to people who are not in a hurry. Iconography is my central example of
puzzle-solving, and it is often done in a tone of dispassionate neutrality.

The search for ambiguity, second of the three responses that form the
subject of this book, is a different matter. Here things are heated up: pictures
are no longer static objects comprised of well-shaped pieces; instead their
meaning is variable—sometimes superficial and obvious, then suddenly
deep, shifting unpredictably and without clear limits. A puzzle may be in
many pieces, but at least it is one thing in the end. An ambiguous object

might be one thing one moment, and another the next: a monosemic message might split into a dualism, which may splay into three or more meanings. People who experience pictures as ambiguous objects are looking with a quicker eye, and in a more skittish and unbalanced way, as if the pictures were in motion. For a writer interested in ambiguity, one overall meaning is no longer enough and even the parts of a picture (or the pieces of the puzzle) may fracture under the pressure of many competing meanings. Meanings, in Charles Peirce's sense, will continuously ebb and flow, overlapping and ramifying as the contexts shift, so that the very project of building a picture-puzzle will begin to look as hopeless as making a sculpture of a mirage. It may be that the tolerance of ambiguity is one of the best ways to distinguish mid-century art historians from more recent writers. Even E.H. Gombrich worked hard to control ambiguity, but today it would be difficult to name an extended piece of writing that does not center its interpretive methods on some assumption of *unlimited* ambiguity, or at the least a tolerance of innumerable levels, layers, or competing meanings.[4] It is the epistemology of the moment.

PRIMARY MEANINGS IN PREMODERN PAINTING

Much of this seems natural to contemporary art historians, and so it is important to remember that like the puzzle metaphor, pictorial ambiguity went almost unperceived before the twentieth century. Renaissance and Baroque works were constrained to declare relatively stable primary meanings: a painting could mean many things, but it would normally be expected to present a principal message or subject matter, together with an allegiance to one idea or theme. This is true of all academic work except preparatory studies (whose subjects did not need to be specified), and it is true of the great majority of pictures before the twentieth century. To some degree this is a simple subject, because the primary meaning is often adequately captured by a painting's title. It does not matter much, in this respect, if Andrea Castagno's fresco in SS. Annunziata, which depicts Saint Jerome, the crucified Christ, two angels, and two obscure female saints, is called *St. Jerome*, *The Vision of St. Jerome*, or *The Savior, St. Jerome, and Saints*, or even (most explicitly) *The Savior, St. Jerome, and Saints Paula and Eustochium*. Any of the titles is enough to show that the painting has an explicit primary meaning. In another sense this is a huge and difficult topic, because it would soon become necessary to ask if the identities of the two female saints are essential or optional, and whether the indispensable point is Jerome's vision of the Crucifixion or the Crucifixion itself. In framing such questions, it would be

important not to lose sight of the far larger difference between all such titles and their ordinary absence in modern art. The change can be dated to the early nineteenth century, and in some measure to romanticism. Goya's "black paintings" are a touchstone, since a few have primary meanings (*Witch's Sabbath, Saturn Devouring his Children*), but most equivocate about their subjects (*Two Fighting Men, Reading*). The *Parcae* (1819–23) is a bizarre work, deeply personal and secretive, but also obviously a depiction of the three Fates. (Even if, as Priscilla Muller argues, the man has an erection: but that may be an hallucination, which I want to save until later.[5]) At least one painting in the series is famously without a primary meaning: *Dog* is nothing but a picture of a dog, staring (angrily? in fear? in hope?) at some traces and smudges in a blank sky (plate 20, left). It is possible that the dog was once staring up at a beetling cliff and an overhanging face, but that may just be a photofinisher's fantasy (plate 20, right). Even if Goya did paint the face, *Dog* is still one of the most enigmatic paintings in the tradition.

Normally, premodern works state their subjects clearly, and it is rare to find a picture that keeps its *primary* meaning entirely to itself. In the strongest possible contrast, modern and postmodern works of all kinds are understood to be potentially ambiguous *ab ovo*, so that they commonly lack primary meanings. Their ambiguity begins when they are first seen, and is unrelieved by long looking. Max Beckmann's eighth triptych (out of nine), called *The Beginning*, refers doubly to the artist's and any young boy's "beginnings" (plate 21).[6] Since there is no originary text (no *fabula*) there is no narrated order: but that does not mean we are not invited to look for one, and I would argue that habits of reading compel us to try, just as they impel us to search for chronological narratives at the expense of other principles of organization. Nothing tells a viewer where to begin: Is the central scene the first, merely because it is largest? Or is the triptych to be read left to right? In general, each scene is a drama of unhappy constraint and fugitive freedom—or, as Charles Kessler puts it, "spiritual isolation and childish longing."[7] On the side of freedom in the right-hand episode is the opened door, the plaster bust comparing itself to the shriveled schoolmaster, the sunny landscape (a boy, frozen in place as punishment, appears to reach toward it), and the boy in back with his pornographic sketch. Against freedom is the cramped space, the punishment, the hateful teacher's face, and the anonymous rows of students. In the left-hand episode, the boy (the same one?) stands in a dark room, watching a heavenly vision, and even sharing an intimate glance with an angel. The earthly girl next to him is oblivious or content with her mirror—another emblem of enclosure. The central

Plate 20a (left)

Plate 20b (right)

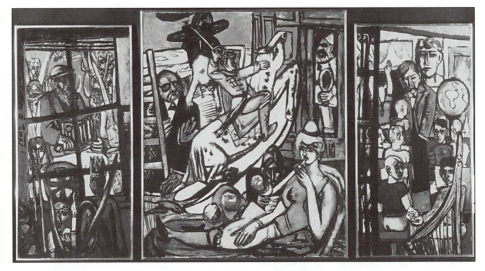

Plate 21

episode is apparently the boy's attic, in which he triumphantly gallops his rocking horse, accompanied by overgrown and overly live toys including two women, one sexual and the other ancient. His father tries to make him stop rocking.

In contemporary art criticism, it would be enough to say *The Beginning* is "about" transcendence and enslavement, or some such antithetical pair. But the phrase betrays the conceptual instability of the claim: *how* is it "about" such ideas? *What* does it say about them? In premodern painting, the answer could turn on the order in which the scenes were to be read; but in the absence of cueing signs, we can only guess. The central scene is the happiest, so it could cap a meliorist story of childish adventures. In that case the wings would be read as dramas of repression, culminating in the central scene of power and freedom. But without an original text, such a speculation collapses when a viewer looks back at the side panels. Just as the gaze inevitably cycles back to the flanking scenes, so the boy has to go back to his pornographic drawings or to the absent schoolgirl.[8] Does *The Beginning* tell a pessimistic story about thwarted hopes, or an optimistic story about the imaginative life? There is a disturbing richness here, since it would not be possible to cycle back through a Renaissance triptych with this kind of freedom from contradiction. In Kessler's view, the two flanking scenes of "childhood memory" (on the right) and "childish fantasy" (on the left) are "completely intermingled" in the center, so that there is no sequence and no conclusion.[9] At this point I find myself feeling that I have been *given leave*

not to think further about the order in which the events occurred or in which Beckmann has told them. I put the question of primary meaning in abeyance, without settling it or even being sure any one narrative was intended or implied.

Modes of reading are decisively affected by the absence of the *fabula*. Having gotten the elements of the story from the three episodes, an inter- ested viewer will return to see more: the painting gives away enough infor- mation at first so that it becomes a puzzle. But it is bound to be disappointing, except to admirers of Beckmann, that the puzzle hits a dead end so quickly. We might look to the organ grinder surrounded by angels in order to see if there might be a connection between that promised vision and the transcending energy of the center scene. But he is inscrutably double: part of him is Celestial since he is surrounded by angels, but part is impotent and fragile, even perverse. To one author, he is "the evil demiurge who has created the world and oppresses mankind"; to another, he is powerless but inaccessible Fate; and to a third, he is the Harper from Goethe's *Wilhelm Meister*.[10] If God is a blind beggar, then the center scene will indeed propel us back to the flanking ones; if he is anonymous Fate, then the child's wild rocking might augur well for the future.[11] The slow spread of ambiguation is a daunting challenge for an iconographical approach, despite the richness of Beckmann's mythologies. Clifford Amyx's book *The Iconography of the Trip- tychs* is an exercise in disillusion; at one point he concedes that ambiguity itself is the principle by which the paintings have to be understood.[12] There is broad critical consensus on the impossibility of finding what I have been calling the *fabula*, even in *The Beginning* where the subject is so clearly auto- biographical, and recent accounts have become reflections on the failure of meaning.[13]

The painting is like a sponge that squeezes itself dry. At first it seemed full of meaning, and then—rather suddenly—nothing more can be learned. If viewers do not want to turn away, what do they think of next? Where do they look? In practice talk usually turns to color, texture, composition, or Beck- mann's other paintings, but if we want to keep on this track, we are dissuaded from continuing to puzzle out the painting, and we are thrown into a meditative state of mind. (I take "meditative" here as an opposite of the deductive, puzzle-solving mode. Elsewhere I have proposed they are a widely useful pair, naming two principal modes of response to pictures. In this context, the "meditative" is whatever declines the invitation to find and solve puzzles.[14]) As the painting becomes the subject of undirected medi- tation, the figures may accrue meanings drawn from a viewer's personal

associations—they will remind us of moments from our own childhood, our toys, little girls and boys we loved at a distance, and so forth. Eventually a meditative viewer becomes a co-creators or co-conspirator in the story: bringing the narrative about, and even fixing it, by linking its shapeless clues to our own aimless thoughts. And this leads away from art history, and away from the painting, and toward private reverie.

Looking at such a painting is an experience of decaying possibilities. First it becomes apparent (or else we read) that there is no original text and therefore no conventional story; then we realize we cannot deduce the order in which some private story might have been told; and finally that we cannot continue a deductive search at all. None of these steps informs any other: that is, the initial slight unease a beholder may feel at giving up the idea that *The Beginning* tells *any* story is not softened by the successive defeats. Nothing solves anything else, doors are slammed and not reopened. Beckmann's narratives are like this, and that may be why they continue to hold painters' and critics' interest. They are anti-narrative, they tell stories about the impossibility of telling stories, and they confirm our interest in puzzles by showing us how ambiguity is at its peak when puzzles begin to deliquesce into less systematic meditation.

HOW AMBIGUOUS IS PICTORIAL AMBIGUITY?

I have recounted this example at some length because it stands for a contrast that is insufficiently marked in art history. Historians who specialize in modern art tend to assume that there is no unambiguous *fabula*, and that meaning is tracklessly ambiguous from the outset, and historians of Renaissance, classical, or medieval art tend to expect fairly stable starting meanings, even as they relish the branching ambiguities that may come afterward. Michael Camille's playful "postmodern" exegeses of medieval marginalia, for example, can always begin with more or less stable suppositions about the intended meanings of the figures.[15] These distinctions are largely taken for granted, and so when the interpretive apparatus of art history runs up against premodern paintings that intentionally work against unambiguous primary meanings, it can generate a potentially incoherent and self-contradictory literature—my subject in the next chapter.

One of the working assumptions about pictorial ambiguity is that it is necessarily and by definition infinite. That supposition is largely an article of faith, supported in part by Charles Peirce's mobile "semeiotics" with its infinitely subdividing and overlapping signs. Yet the assumption encounters difficulties when it comes to actual critical situations. What happens, for

example, if a group of artists, critics, or historians sit in a room with a painting and think concertedly about its meaning for—say—six hours straight? Will there always be more meanings to be found? Having tried this experiment in a number of classes, and compared it with historical and critical readings, I find that critical and historical thinking may not be as multivalent as we wish it to be: our ambiguous thoughts travel along certain well-worn paths. There are kinds of ambiguities historians expect in pictures, others that we accept, and still others that sometimes surprise us. At the outset, most viewers (and I mean to imply, most historians) would want to claim that an image is necessarily, logically infinite in its meanings, and that an interpretation—especially one freed of the obligation to follow the artist's intentions—could quickly find itself wandering in a forest of possibilities. But after a few hours of looking, even a determined group of viewers will exhaust every serious option and find themselves returning to meanings that seemed capricious or disconnected. The same kind of lesson can be extracted from an historiographic study of a given interpretive tradition: what seems at first to be a tangle of competing opinions combs itself into a number of strands, each remarkably uniform and even predictable in its claims and suppositions. Experiments like these suggest it is at least possible to sketch a map of the kinds of ambiguity that seem to inhere in any given picture or interpretive tradition.

Such a map would be an ambilogy—a logic of ambiguity—and every ambilogy is untrustworthy at least to the extent that it is ambiloquous (it uses ambiguous terms). Still, it's possible to look at the kinds of ambiguous meanings that contemporary historians and critics have assigned to paintings, and to ask about their numbers and kinds. I find this kind of impossible survey— or perhaps I should say, the fiction that such a survey is possible—to be a helpful aid, not least because listing ambiguities helps us begin to understand the dimensions and possibilities of our own sense of uncertain meaning—a thing seldom studied.

It helps, initially, to disambiguate the word "ambiguity" by distinguishing between two deceptively similar species. On the one hand, there is ambilogical *combinatorics*, a kind of logical tree of alternate meanings. Some ambiguities are dilemmas; others are antitheses or choices between three or more possibilities. In thinking about the apparently trackless profusion of meanings, it can help to have exact words for various types of ambiguity; and to find them, I will look at several literary-critical and philosophic models that inform the kinds of ambiguities art historians tend to find. On the other hand there is an ambilogical *pragmatics*: a set of domains that are likely to

appear ambiguous. Thus there are ambiguities of enframement, of owner-
ship, of conscious intention, of control, and dozens of others. By its nature,
pragmatics is more open-ended than combinatorics. Still, if one sets out to
collect kinds of things that seem ambiguous about pictures, the list proves
finite, and even manageable. And although it can be expanded at will
(perhaps an expanded roster could run to a hundred subjects), a few head-
ings serve to name those that are commonly in use. I will also call them
"arenas" of ambiguity to distinguish them from the "types" such as dilemma,
trilemma, and so forth.

THREE OF THE SEVEN TYPES OF AMBIGUITY

Modern philosophy and literary theory that concerns itself with ambiguity
largely avoids complex readings, either by concentrating on the linguistic
and logical conditions of ambiguity, or by satisfying itself with short lists of
ambiguous terms.[16] When Derrida, for example, sets out to speak about
multivalent meaning, he considers what it is in writing that gives rise to what
I have been calling ambiguity: the "force of breaking" with context, "the
possibility of extraction and of citational grafting," and a concept of intention
"never ... completely present in itself."[17] Considering specific ambiguities,
Derrida takes the sun, and Paul Ricoeur considers sex, as "universal"
metaphors.[18] In a related vein, Emmanuel Levinas's work has inspired a
"logic of ambiguity," a study of the ways that utterance might avoid knowl-
edge; it too is unconcerned with the disclosure of specific economies of
ambiguity.[19] The same kind of observation may be made of historical studies
that describe the place of ambiguity in movements such as sophism or skep-
ticism, or with the ambiguity of certain terms in the history of ideas.[20] From
this point of view, the insufficiency of recent texts on polysemy and poly-
semism—for instance, those by Stanley Fish—is that, in terms of the indi-
vidual work, they only provide overwhelming evidence of the "absolutely
nonsaturable" status of meaning.[21] On the other end of the scale, the
extremely detailed investigations of ambiguous or otherwise unreliable
meaning that have been written by Paul de Man, Derrida, and others on
texts by figures such as Locke, Rousseau, Plato, Nietszche, and Mallarmé,
tend to resist generalization as ferociously as the more "theoretical" texts
embrace it. Poststructuralist writing on ambiguity tends to be either tena-
ciously specific or broadly concerned with the ineluctable dissemination of
meaning and the inexorable deliquescence of interpretive communities.

　　Some crisper categories can be gleaned from that tattered classic of liter-

ary criticism, William Empson's *Seven Types of Ambiguity*, first published in 1930.[22] Empson's work has been partly revived in recent years, not as an encyclopedic reference—indeed, his seven types have been rejected in many more than seven ways—but as a pathbreaking attempt to show readers just how complicated meanings can be.[23] In that sense Empson's close readings remain exemplary, and we can learn a great deal from them. Complex readings and "complex words" (another of Empson's interests) arise whenever a reader is willing to take grammar seriously: whenever we are willing to follow the possible constructions of a phrase or stanza regardless of the growing conviction that we are doing something unnatural. Empson's readings are compulsively close, not unlike Sherlock Holmes's, Panofsky's, and Freud's in their utter slavery to detail and their apparent adherence to the letter of the law—grammar, in Empson's case. Like the archaeologist Alexander Marshack, whom I have studied elsewhere, Empson tries to read absolutely *everything* that is implied by the grammar: just as Marshack ponders the minute markings on prehistoric artifacts with a binocular microscope, Empson labors the shortest phrases, and even individual words, with an apparently inexhaustible encyclopedic energy.[24] At the same time, *Seven Types of Ambiguity* purports to be an account of any and all verbal ambiguity.

Empson reads English poetry and drama almost exclusively, and his visual parallels are usually unhelpful, but I find that nearly every page is pregnant with possibilities for understanding paintings. One connection with visual analysis, as unexpected as any other, appears in Empson's opening discussion of a line from a Shakespeare sonnet,

> Bare ruined choirs, where late the sweet birds sang.

Of Empson's seven types of ambiguity, the first is logically the softest, the one in which there is least self-contradiction. He finds first-type ambiguities wherever there is more than one meaning, and no *logical* (that is, grammatical) way to choose between them. An instance of this is a many-sided comparison of two things "which does not say which comparison is most important." In the Shakespeare, the comparison of forest and church holds for many reasons:

> because ruined monastery choirs are places in which to sing, because they involve sitting in a row [as birds do], because they are made of wood ..., because they used to be surrounded by a sheltering building crystallized out of the likeness of a forest ... (2–3)

This is not in itself ambiguous, but it produces a sort of ambiguity in not knowing which alternative to hold most clearly in mind.

A logician would despise Empson's attitude: since the line is not a sentence, it makes no claims and logic is strictly inapplicable. Empson is really thinking of two sentences:

There are the bare ruined choirs of stone, where late the sweet birds sang.

and:

There are the bare ruined choirs of wood, where late the sweet birds sang.

and he is thinking of them as if they were connected a logical operator for "or," like this:

{Bare ruined choirs of stone} ∩ {Bare ruined choirs of wood}

—but that's the way his mind works. He is expositing a *feeling of logic*, not an actual conundrum, and he is intentionally misreading the line in order to extract its "logical" consequences. Taking his word that the line entails a quandary, it is easy to agree that it is a low-level ambiguity, not nearly a full contradiction.

Empson insists "upon the profundity of feeling which such a device may enshrine," and he cites a couplet from one of Arthur Waley's translations:

Swiftly the years, beyond recall,
Solemn the stillness of this spring morning.

Between them, "swift" and "still" instill an ambiguity in the reader's mind: on the one hand, things move so quickly that even years can't be remembered; and on the other, there is the "eternal" perfection of the present moment. For Empson, the two time scales apply to both adjectives, so that "the *years* of a man's life seem *swift* even on the small scale," and at the same time "the *morning* seems *still* even on the large scale, so that this morning is apocalyptic and a type of heaven" (23–24). Waley's couplet juxtaposes two unrelated ideas, and leaves the reader to see how they might be related. Inevitably, with nothing more as a guide, a reader will mingle the two thoughts, switching adjectives, letting one mix into the other, playing with oppositions and harmonies until they find the "profundity of feeling" that (presumably) Waley, or the original Chinese poet, wanted.

The same feeling occurs often to viewers of pictures. Whenever a painting shows only two forms, it implies that they are somehow linked. Adolph Gottlieb's hard-edged and soft-edged "bursts" are signal examples, since they

tend to appear symbolic (plate 22).[25] But how are they connected? What tells us how to read them? Are they merely alternates, with no way to choose between them? Are they opposites, or are they examples of the same idea? The "burst" paintings are the endpoint of a long development that began with paintings that have many forms; gradually they congealed into a half-dozen, then three or four (as in this painting), then just two.[26] Especially to people who have seen the earlier pictures, the paired bursts look like signs, reduced to their most universal common denominators, as if the paintings denote life and death, or old / new, stasis / time, or perfection / corruption. For some viewers they harbor more specific meanings, such as eye / body, sun / land, or car light / street. One contemporary critic thought they represented the Yin–Yang opposition; H.H. Arnason thought they stood for "order and chaos"; and Dore Ashton proposed they denoted earth and sky.[27] Any interpretation, or no distinct interpretation, will do. Nothing internal to the painting tells us which shape is most important, or which interpretation closer to Gottlieb's intention. Gottlieb himself vacillated between a doctrine

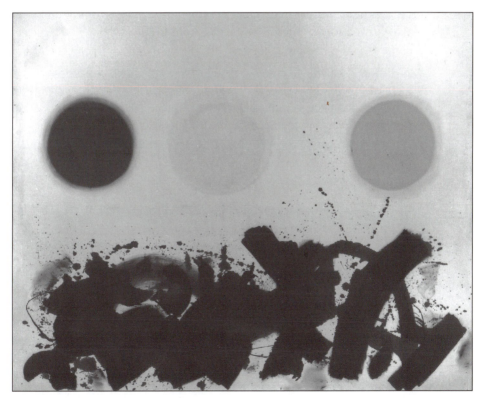

Plate 22

of "meaning in terms of feeling," where nothing more could be said than that the bursts were "intangible and elusive images," and a doctrine of dualities, where one side represents an "urge toward serenity and peace" and the other an inclination toward nervousness and energy.[28] The first would not be open to Empson's analysis, since it is a holistic approach (it would also be immune to the picture-puzzle model). But the second is already a type–1 ambiguity, since Gottlieb doesn't say whether "serenity" or "peace" is more important, or which one matches with nervousness. In other interviews he compounds the same difficulty, saying the bursts represent "opposites like black and white, night and day, good and evil."[29] Inevitably, it comes to seem as if duality or polarity is itself the subject, just as Empson makes Shakespeare's line into a meditation on ambiguity. There is neither contradiction, nor possibility of resolution, nor visible hierarchy of interpretations.[30]

Empson's "types" are suggestive for a wide range of painted phenomena, and they could easily be the basis for a book. I will give just two further examples. *Seven Types of Ambiguity* is organized according to a scale of ascending logical opposition; an ambiguity of the fourth type occurs "when two or more meanings of a statement do not agree among themselves, but combine to make clear a more complicated state of mind in the author."[31] The idea is that the reader perceives a "logical" disagreement and is "conscious of the most important aspect of a thing" (unlike in the first type, in which there is no disagreement and no "most important aspect"), but cannot keep all the conflicting alternates in mind. The possible meanings do not seem contradictory, since there are too many to recall all at once, and the reader "has no doubt that they can be reconciled." Empson's example, brilliantly analyzed over the space of three pages, is from Wordsworth's *Tintern Abbey:*

> And I have felt
> A presence that disturbs me with the joy
> Of elevated thoughts; a sense sublime
> Of something far more deeply interfused,
> Whose dwelling is the light of setting suns,
> And the round ocean, and the living air,
> And the blue sky, and in the mind of man,
> A motion and a spirit, that impels
> All thinking things, all objects of all thought,
> And rolls through all things.

Say we approach this as if it were written by a somewhat cloudy-minded high school student, and we see our task as a vicious disillusionment, to be

brought about by relentless grammatical analysis. That is essentially what Empson does. If we ask, he says, about the dogma here proposed, then we find ourselves in severe difficulty. Consider the nouns: is "presence" a synonym of "sense"? (After all, they are in parallel construction, divided by a semicolon.) Are they both a "something"? Empson spends an exasperated paragraph on the word "in." If it signifies a break, then everything before is "interfused" in nature, and "a motion and a spirit" are properties of the "mind of man," as if the punctuation were:

> And the round ocean, and the living air,
> And the blue sky. And in the mind of man:
> A motion and a spirit . . .

If not, then the passage describes a living nature, of which the "mind of man" is a part. The difference is essential if we are to understand the proposed dogma. The former possibility implies "man has a spirit in nature in the same way as is the spirit of God," and "decently independent from him"; the latter melts our minds into nature's and "subjects us at once to determinism and predestination."[32] Empson's subtle conclusion is that Wordsworth "talks as if he owned a creed by which his half-statements might be reconciled, whereas . . . he found these half-statements necessary to keep [the creed] at bay." Though it is indisputably annoying of Empson to say so, grammar gives him the right to accuse Wordsworth of "muddled opinions" and—most important for his analysis—of making a work that not conscious of its "complicated" state of mind, only its overall intention.[33]

This also occurs often and widely in modern art, for example when a painting shows a confusion of palimpsestic indecisions, leaving the viewer with an unfocused sense that the painting entailed changes of mind, and a long passage of time. Examples abound wherever intense labor has not been concealed as it once was: Picasso's canvases are especially rich in indecipherable indecisions; Matisse's pictures, though they commonly appear effortless, sometimes congealed unexpectedly into illegible superimposed marks and smears. In Matisse especially, the clotted passages express memory or time in an unmeasurable and unanalyzable way.[34] The same effect can occur in narrative painting, especially where an artist means to depict a narrative of private events. An example is Balthus's *La Rue* (plate 23). Even at the very beginning of an exegesis of this incomparably complex work, it becomes apparent that we are not dealing with a completed story. Figures that signify the painter multiply before our eyes, until the entire scene seems to be filled with stand-ins for the artist. A woman

at the right—her back turned to us in the pose that we have learned to associate with Balthus's self-portraits—lugs an oversized tot whose age, in an astonishing equivocation, is somewhere between five and forty-five. He resists her hieratically, eyes closed in sleep or in symbolic regression. A hand caresses this woman's hem, and it belongs—again we are surprised—to a younger woman some ten or fifteen feet behind. And when we see *her,* we also understand that the mannish infant might also be turning, eyes closed, to this younger woman. A toy-soldierish boy in brown (a swollen centerpiece of an earlier 1929 version, here shrunk back into the narrative) marches down the street and is about to brush by the younger woman. He is an echo of the boy-man, and seems a projection of the boy-man's desires. Some parts of the picture appear wholly incestuous and nightmarish, and others are like a frozen summer scene by Seurat.[35] Infancy telescopes into adulthood, and vice versa: a triangle at the left leads from violent sexual play forward to innocent childhood, but once we see that the little girl is a carbon copy of

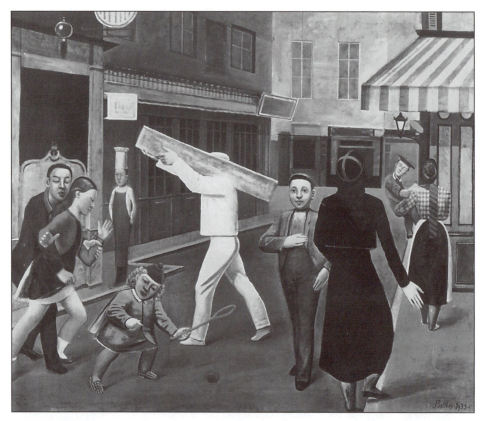

Plate 23

the molested adolescent, her play is no longer as innocent. The painting has a central religious axis formed by a figure taken from Piero della Francesca and a banner on the façade beyond. At the base of that axis is the red ball, potent with sexual and religious connotation. The painting is a confusion of tense detail: the young woman's head clamped in a stock formed by a distant doorway; the rigid chef balancing an invisible tower of goods reaching to the top of the frame; the sexual encounter at the lower left bracketed by swinging doors as if to say "these two belong together."

Balthus lived with this painting, in various unknowable states of incompletion, for two years, and it is a sure guess that many of the figures changed attitude, age, and perhaps even sex during that time. The mannish boy (and the boyish man to his right) are both figures for the painter; like many similar and dissimilar figures in other paintings, he recalls the painter's self and his memories of himself. The freedom Balthus gave himself to explore these "metempsychoses" fascinated Balthus's critics and continues to exercise his historians. From the beginning it was apparent that Balthus was allowing himself a range of ambiguity not ordinarily permissible. Jean Clair called him a "painter of metamorphoses," of "metempsychoses," and Jean Starobinski raised the observation to a principle—perhaps slightly overdetermined— by claiming Balthus set out to express certain ambiguous states.[36] At the same time the painting does not reveal the solution: it records the fact that there was change, but it reveals very little about what the changes were. After a while, the painting's half-stories diffuse through memory and we lose the ability to keep them all in mind. There emerges the impression that the work is an intricate memory, an autobiographical fantasy, and that "the subsidiary complexities ... are within reach" if we want them. They form a haze, a cloud of unknowing, implicating not only a miscellany of logical alternatives but deception, self-deception, and "muddled" thinking.

A crisper dialectic comes from Empson's sixth type, which "occurs when a statement says nothing," "so that the reader is forced to invent statements of his own and they are liable to conflict with one another." A poem can do this, he says, by creating a tautology that fulfills "rather exacting conditions": it must be "a pun which is used twice, once in each sense, [so that] the massive fog of complete ambiguity will then arise from a doubt as to which meaning goes with which word."[37] The example is a poem by Herbert, *Affliction*, which closes:

> Ah, my dear God, though I be clean forgot,
> Let me not love thee, if I love thee not.

Empson's point here is that the tautology entails two possible orientations of the narrative voice: the speaker could be enduring bravely, or revolting. The last line could mean, for example, "If I have stopped loving you, let me go; do not make me love you again in the future, so that I shall regret it if I return to the world," or else "Do not let me spend my life trying to love you," or again "And yet, though you have already clean forgotten me, let me not love you in achievement if I do not love you in desire." And Empson, iconoclast that he was, could not resist adding that a certain Archbishop Sharp died "with this couplet on his lips," perhaps indicating he had resolved the tautological dilemmas, but "be that as it may, the Archbishop was murdered and probably had little time."[38] In fact the poem does not declare one way or the other, and the meanings we supply are likely to be at once extravagant and conflicting.

Some surrealist and abstract paintings perform a similar act of non-disclosure when they incorporate reminiscences of various incompatible classes of objects, and then refuse to declare allegiance to one or the other. Kandinsky's *Red Oval* has some familiar-looking shapes: a tabletop, some egg-shapes, a rainbow (at the lower right), some mountains or pine trees (left of the rainbow), and a boat or a fish (plate 24). After a time they resolve into two possibilities: either the painting refers to the world of still-life or to that of landscape. The large yellow rectangle might be a tabletop or a plain; the red oval (just left of center) could be a sun or a cherry; the zig-zag forms could be mountains or drapery; the "fish" could be on the table, or part of the landscape. "Rainbows" and "boats" are more difficult to reconcile with still life, and there are freer gestures that wouldn't make sense in a conventional still life or a landscape. The painting draws its energy from the tautological opposition of two genres, two sets of symbols. It provides the incentive to interpret without providing the mechanism of resolution. Much of surrealism also operates according to Empson's sixth type: one almost perfectly comprehensible scene—say, a nocturnal landscape—is cut into by another ordinary scene—say, a bright sunlit sky—producing a meaningless juxtaposition that is irresistibly reminiscent of a logical dilemma. It is as if the mere proximity of night and day implied the logical falsity

$$\{\text{night}\} \cup \{\text{day}\}.$$

Magritte's variations on the day / night theme—such as *l'Empire des Lumières*, where a nocturnal landscape is crowned by a sunny sky—show his intention was (among other things) to provoke viewers into statements that "are liable to conflict with one another." In the "complete fog" that results,

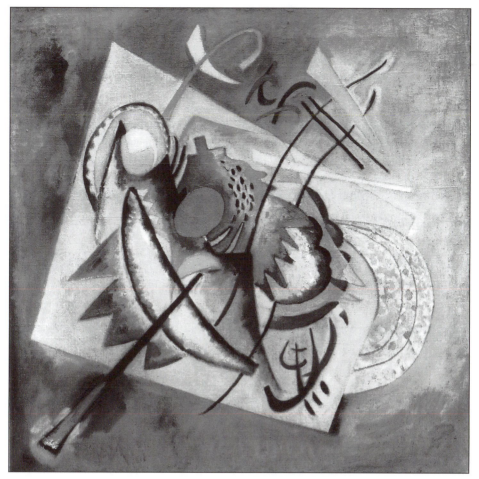

Plate 24

the viewer is given license to construct meanings at will. "Logic" is disarmed, and the field is open to wild and potentially self-contradictory experiments.

OUR FAVORITE AMBIGUITIES

Much more could be said about Empson's types. Provided we avoid becoming snared in his overdetermined lists, they could well prompt historians to be more exacting about how paintings are ambiguous. For me this evokes an entirely new field, so far unstudied, whose subject would be the "types" of ambiguity found in pictures, as opposed to texts. It would have to be accompanied by another inquiry, into the misinterpretations that locate logics where there is, after all, nothing but lines and colors (or agrammatical poetic syntax). In some measure it could also be directed at art historical accounts

that foreground logical problems. T.J. Clark's account of Manet's *Bar at the Folies–Bergère* (1881–82) is quite close to an Empson type one or four ambiguity. Klaus Herding brings this out in one of the few balanced reviews of Clark's *Painting of Modern Life*. As Herding quotes Clark:

> Behind the girl is a mirror . . . A mirror it palpably is: one has only to notice the edge of the marble counter reflected in it, or the back view of the bottle of pink liqueur, for the illusion to be inescapable . . . Looking out at us, the woman is symmetrical, upright, immaculate, composed; looking in at him, the man in the mirror, she seems to lean forward a little too much, too close, while the unbroken oval of her head sprouts stray wisps of hair . . . It is perfectly possible, in fact, to imagine the barmaid's face as belonging to a definite state of mind or set of feelings: that of patience perhaps, or boredom and tiredness, or self-containment. We might even have it be "inexpressive." . . . But the problem is that all these descriptions fit so easily and so lightly, and none cancels out or dominates the rest; so that I think that the viewer ends by accepting—or at least by recognizing—that no one relation with this face and pose and way of looking will ever quite seem the right one . . . the equation fails to add up.[39]

I can imagine the relish with which Empson would go at this passage: its strings of undecided alternates ("patience perhaps, or boredom and tiredness, or self-containment"), its mirroring prose describing a mirror ("Looking out at us, the woman . . . looking in at him, the man in the mirror, she seems . . ."), the indecision about "accepting" and "recognizing"—but my purpose here is to show that when ambiguity becomes important as a theme, Empson's types have some utility as tools for thinking through the implications of "complicated states of mind."

The types of ambiguity, it seems to me, are perfectly suited to a critique that is at once skeptical of closure and attentive to the microscopic movements of opinion and meaning; but the pragmatics of ambiguity (by which I mean the subjects that seem ambiguous) is another question, one that is much less readily susceptible to analysis. Empson himself thought that his logical list was only the first of three possibilities: ambiguities of logic, of "psychological complexity," and of the degree of conscious intention.[40] Ambiguity has occasionally been presented as a subject that somehow differs from the study of logic or illogic. I do not think it is possible to argue cogently that there are kinds of ambiguity other than logical ones; but it is entirely possible to explore subjects other than logic that can be the scene of logical ambiguities. Empson's other two categories also have (illogical) places in the interpretation of pictures.

1. *Psychological complexity* is the subject of a number of pictorial ambiguities; one characteristic instance is the figure in pictures who stands for the artist or the beholder. Some are *repoussoir* figures (their back-to orientation makes them work like viewers who have taken the first impossible steps into the painting); and they have also been called *Rückenfiguren*, "lookers," "beholders," "surrogates," and more simply "observers." Pictures have incorporated such figures in many ways. Balthus was oddly fond of depicting himself in his paintings as if he were walking away, into the picture. In Dutch interiors by Pieter Saenredam, "lookers" (the term is Svetlana Alpers's) stand in profile, observing things we cannot see because they are off to one side of the scene. Ever since Alberti's suggestion that paintings include "figures who point" to the narrative action, artists have included versions of themselves and of plausible spectators in order to urge the imagination into the scene. Michael Fried coined the term "painter-beholder" to suggest that such figures can be conceived as responses to the experiences of both viewing and making. In a particularly complex analysis of Courbet's *Burial at Ornans* (1849), Fried proposes distinctions between the acts of beholding by the painter, the beholder, and the "painter-beholder"; and when a painted "painter-beholder" seems to be mostly beholding, Fried calls it a "beholder-'in'-the-painter-beholder." And he goes on to describe an even more complicated persona, "what might be described as the *painting's gaze out at the beholder–'in'–the-painter-beholder* and the *painter–'in'–the painter-beholder's gaze into the painting.*"[41] The hyphenated terms are wild, but the argument is solid, and it is entirely possible to go further: as I have suggested elsewhere, the *"painting's gaze"* might also be called a "part of the painter-beholder's figure's gaze," and so the phrase *"painting's gaze out at the beholder–'in'–the-painter-beholder"* might have been *"part of the painter-beholder's figure's gaze out at the beholder–'in'–the-painter-beholder."* [42] In narrative terms, each figure is a figure for an aspect of the artist, and is therefore a character in a potentially endless narrative of "psychological complexity." Beholders, painter-beholders, and other more exotic species could potentially be related by any of Empson's types of ambiguity, and others he does not name; even in Fried's account some are strong alternates, and others work in concert.

2. *The degree of conscious intention* is subject to similar elaboration. In Empson the stress is usually on process: what the author was aware of while writing, or vaguely aware of afterward. Empson's explanations are therefore basically stories about the author's consciousness; these days we might rather leave Empson's dubious, optimistic sense of intentionality to one side, and

inquire into the location of what presents itself as the author's intention: whether it speaks from some projected thought, or is elicited by some conventional configuration of interpreted meanings. An intention, as Freud and others have taught, might be anything but what the writer or artist intends: it may originate in a *lapsus linguæ*, primary masochism, the Death Instinct, or psychosis.[43] Certainly the "degree" of conscious intention is open to question in ways it seldom has been in the past. Fried's reading of Courbet is an example, since he says early in the book that the meanings he uncovers would have surprised Courbet: they were mostly inadvertent, and only traces of them would have found their way—distorted and disguised—into his sense of what he was doing. The various intentionalities, inadvertencies, slips, habits, lapses of concentration, and other "paraintentionalities" (the word is Whitney Davis's) are inevitably ambiguously related, and as Empson says, they could certainly form a third "arena" of ambiguities.[44]

These two alternate approaches to ambiguity, the study of psychological complexity and the degree of consciousness, are each dependent on the original logical ambiguities, and so are various other possibilities that come up in discussions of pictures. Two that are common in the literature are ambiguities of reference and of ownership.

3. There is often a need to discuss ambiguities of the *mode of reference* of paintings. If a painter "lifts" a figure from another painting, as Balthus takes Piero della Francesca's figure from the *Carrying of the Wood of the Cross* in Arezzo, then the relation is described as "copying." But copying can be ambiguous: Piero's figure might be a "literal" or a "free" copy, though its openness precludes plagiarism. Picasso's celebrated paintings of *Las Meniñas* are often called "variations." Robert Lowell named his free copies "imitations." The histories of Western and Chinese painting are replete with types of copying.[45] All such possibilities are, in the first instance, *citations*. But they can also be *uses* or *mentions* of previous work, and they can *implicate* or *entail* earlier work—and citation, use, mention, implication, and entailment are manners, not types, of reference.[46] The type and the manner of citation can be augmented with the means of citation. This last refers to the artist's method, and it could be—among other possibilities—a tracing, projection, graft, collage, or condensation. This is not a disordered universe, since it is reined in by the interlocking concepts of the type of reference, the manner of reference, and the means of reference. Since paintings typically make indeterminate or underdetermined connections with the past, these possibilities often overlap, forming ambiguous constellations.

4. Then there are *ambiguities of ownership*, which devolve upon quasi-legal questions concerning intellectual and social property. A painting in a museum may seem as if it were the property of the museum board; but it is actually ambiguously owned. There are claims made on it by, at the least: (a) art historians, who propose themselves as the ultimate interpreters, (b) connoisseurs, who claim the right of authentication, (c) curators, who possess the right to move the paintings, (d) the public, which "owns" some paintings (at least, those that are thought to be "everyone's heritage"), (e) politicians, who sometimes claim ownership rights as part of their campaigns in the name of public morality, (f) individuals, who sometimes possess legal rights to retrieve paintings in museums, (g) guards and policemen, who occasionally reserve the right to sequester paintings from the public or *vice versa*, (h) bankers, who may see paintings as vouchers of solvency or capital, and (i) restorers, who possess a unique right to be alone in a room with paintings and physically alter them.[47] Since few pictures are owned in only one of these senses, ownership would be another arena of ambiguity.

I mention these four arenas in order to suggest that ambiguity can be discussed, since we tend to assume it operates on fairly homogeneous "arenas." Certainly there are many such arenas, though again I doubt the list is infinite. Among the commoner ones are:

of coherence and fragmentation,	of Lacanian registers,
of condition and conservation,	of light sources,
of degree of abstraction,	of modern, post- and premodern,
of depicted time,	of object and setting,
of discursive field,	of ornament and foundation,
of enabling theories,	of periods, phases, eras, and epochs,
of figurative and nonfigurative,	of perspective,
of form and outline,	of pertinent question,
of frame and work (*parergon* and *ergon*),	of physiognomy,
of haptic and optic,	of political affiliation,
of iconic and aniconic,	of pose and symbolic gesture,
of ideography and naturalism,	of provenance,
of influences and affinities, past and future,	of public,
	of purpose,
of intention,	of rhythm and proportion,
of interpretive communities,	of scale,
of interpretive strategies,	of semiotic structure,

of sequences and series, of sufficient explanation,

of size, of symbolism,

of *skēnographia* and *skiagraphia*, of technique,

of sources and precedents, of the structure of narrative,

of space, of viewing positions,

of style, manner, and school, of visual language,

of subject, of Zeitgeist.

In short: as many arenas as there are terms in the critical and historical lexicon. Still, in practice even the most extended essays and conversations turn on a list perhaps only half this size. In the end the moral I would draw from this excursion is that if contemporary writers feel ambiguity is endless, it is not because the types of ambiguity are too subtle to be discussed, or even because so many things appear ambiguous, but because we are interested in the *idea* of ambiguity more than in its operations. The field is infected by polysemy, but not circumscribed by it; ambiguity need not be treated as if it were irredeemably out of control.

Of the three responses to pictures that form the subject of this book, ambiguity is the one that seems least specific to pictures. Most relevant theorizing takes place in philosophy and literary criticism, and many of the humanities have had their champions of polysemy and dissemination. But I would say it is possible at least to begin to understand how pictures impel us toward certain types of ambiguity and toward certain subjects or "arenas" that appear especially susceptible to ambiguity. This is a young field, untested because it is assumed to be hopelessly complex; but by constructing specific complexities in art historical arguments, we end up providing evidence of the shape of our reluctance to stop at primary meanings. Ultimately art historical texts are portraits of the kinds of ambiguities that pertain to painting.

LEONARDO'S LAST AMBILOQUY

If this were a scientific text, each chapter could end with a set of exercises. That excellent tradition has somehow not caught on in the humanities, and in its place I will put a single example, Leo Steinberg's essay on Leonardo's *Last Supper*, an essay entirely devoted to the hypothesis that Leonardo was intentionally ambiguous. It is unjustly neglected, I think, and far more difficult to understand than it has been taken to be.[48] Just in terms of logic, it may be the most intricately argued work in the discipline: if art historical texts were heavy in proportion to the density of their argument, Steinberg's would be lead, and most others would float away. Steinberg's method owes

more than a little to modern scientific and technical writing, and a great deal in a deeper way to St. Augustine and later medieval scholasticism. Those influences make it exceptional, and also marginal: but as in the case of Birger Carlström, they do not make it something other than art history. As I read it, Steinberg's insistence on capturing ambiguity instead of evoking it is only the logical consequence—and what beside logic could we be following here, when the issue *is* logic?—of an attention to multiple meanings. Whatever tensions result, the text is only playing out consequences of ambiguity that the majority of art historians keep at arm's length. Here I will summarize his claims in fair detail (even though I will only be giving the bare bones of the argument) in order to show what kinds of excesses, and what logical traps, await historians who take ambiguity as seriously as Steinberg.

After a short introduction on ambiguity itself—which I am deferring until the next chapter—Steinberg begins by studying ambiguities about the moment depicted in the painting. His double position is that the single moment is *too easy* to depict, and that modern "positivistic" thinking and Goethean dramaturgy have led us to expect a single moment, so that we may even be incapable of registering a painting that shows us several moments at once. The earliest copy of the painting is captioned "One among you will betray me" (plate 25). Even if the copyist was right, "unus vestrum" ("one of you") implies not one moment but two: the one in which Jesus spoke, and the one immediately following when the Apostles reacted. Clearly, the painting may be either the second, or both, even if it cannot be only the first (plate 26). A closer look shows an interesting symmetry between Judas's left

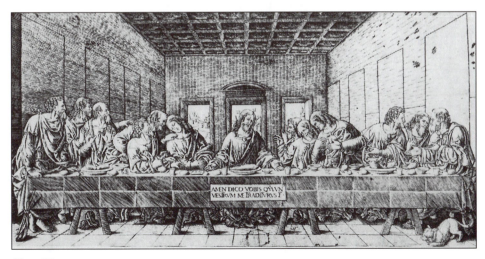

Plate 25

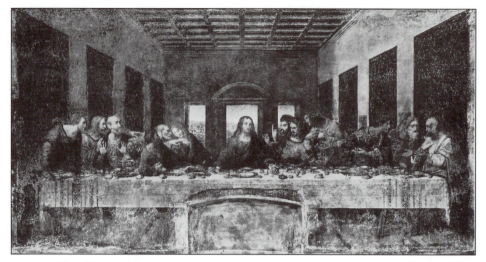

Plate 26

hand and Jesus's right hand: they flank a bowl from opposite sides, without touching it. That configuration implies a further moment: when the apostles ask who will betray him, and Jesus replies "he that dips his hand with me in the dish" (or else, as in Luke 22:21, when he says "the hand of him that betrays me is with me on the table").[49] That is three possible moments, the first two of which may overlap.

Steinberg collates the opinions of several writers, and decides that the first two moments are clearly present in the painting, despite an "avalanche of positivist rationality" that tried to reduce the theme to the moment of betrayal (301). But there is no clear trajectory from Renaissance multivalence to modern certainty, since even the earliest copy omits the dish. Raphael's version, engraved by Marcantonio Raimondi, "silences" Jesus, in order to ensure that the scene depicts the second option, when the apostles react to Jesus's initial statement (plate 27).

What is Leonardo doing to confound so many commentators and copyists? Steinberg suggests he is applying *sfumato* "even to the gradations of time," intentionally creating what Empson would call a first-type ambiguity, in which there is no logical way of deciding between compatible possibilities (303). So far at least, this is not a fourth-type ambiguity, where the disagreeing meanings "make clear a more complicated state of mind in the author"; it is simply a noncontradictory choice with no hope of adjudication. Other ambiguities take us farther afield. There are deliberate vacillations, for example, in the scale of the room and the objects within it. The table is too

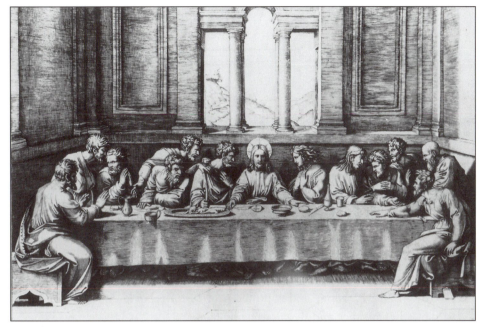

Plate 27

large for its setting—it seems to be squeezed up against the side walls, as several copyists and historians have discovered when they thought about the skeleton of the room (plate 28). But even the oversize table cannot seat the twelve apostles; as Heinrich Wölfflin said, Leonardo's table is too small. The room is too small or the table is too large, but either way the apostles are too large for the table; or, in logical terms:

$$[\{\text{the room is too small}\} \cup \{\text{the table is too large}\}]$$
$$\cap \{\text{the apostles are too large for the table}\}$$

—quite a logical difficulty for such simple elements. Then there's the problem with Christ's size: though he is seated, he is as high as St. Bartholomew (standing at the far left) and St. Matthew (standing third from right). A closer inspection reveals that Leonardo has built toward the center of the composition "through subtly graduated enlargements," increasing from relatively short figures standing in the wings to Christ, the tallest of all, seated in the middle (303). The principal ambiguity of scale, therefore, is the *historical* ambiguation between Renaissance isocephaly, where all heads are on a single horizontal, and medieval hieratic scaling, where more holy or important figures are represented larger. This is, at the least, a meta-ambiguity, since it is indeterminate between a problem of scaling having to do with the

Plate 28

room and its table, and a problem of historical reference pertaining to pre–Renaissance and Renaissance practices.

These problems occupy the first two chapters of the book-length article. Each ambiguity builds on the last, increasing the difficulty of the whole. Next is the question, If Leonardo did not confine himself to one scale, or to one instant, did he at least show a single subject? The two principal alternates are a "psychological drama" of the Last Supper and a "mystic theology" of the Eucharist. If it is a Eucharist, the painting would represent the moment when Christ said, "Take, eat, this is my body," and was about to say, "Drink ye all of it, for this is my blood"—or, in parallel with the choice of moments in the *Last Supper*, Leonardo may also have intended the moment just afterward, when the apostles reacted. There is something mystical about the composition of the scene, both in the way that "Christ's outspread arms initiate a forward directional flow that continues, under the drop of the tablecloth, in two orthogonal floorlines in front of the table," and also in the concatenation of Christ's left hand, Thomas's doubting finger, and James's hand outspread in wonder, which together suggest the mystery of the Eucharist "as if in a rebus" (229, 330). Most people who have analyzed the painting in pictures or in words tend away from the more mystical, holistic answer, preferring to read the painting as a "psycho-drama" comprised of separate moments.

To these ambiguities of subject Steinberg adds another, since the painting might also allude to the Crucifixion. It is possible that Leonardo originally painted a floor striped with orthogonals, in imitation of the ceiling. Plate 29

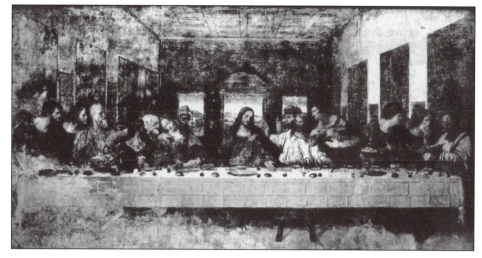

Plate 29

is a photograph of a destroyed copy, where a stripe to the right of the center line is still clearly visible. If Leonardo did paint bands on the floor, then Christ's feet would have rested squarely on the central line, and it would have formed a ghostly echo of the vertical beam of the cross in a Crucifixion (329). It would have been astonishing to suddenly recognize the crucified Christ, rising "through" the table itself, standing upright at the front of the picture.

The apparition would certainly have been unexpected, and it would have been representationally complex: as Steinberg says, the central stripe would have been "an actual vertical, representing a horizontal, which in turn stood for a vertical" (346). Most copies omit the floor stripes, and Steinberg proposes that viewers unconsciously resisted the apparition of the crucified Christ because it would make the painting inassimilably complex. Not so for Leonardo: "faced with the choice between psychological drama and mystic theology," Steinberg writes, Leonardo "embraced both" (337).

It might seem that all this is enough to propel us into Empson's fourth-type ambiguity, where we throw up our hands at the argument and opt instead for the sense of the whole. As far as I can judge from the art historical reception to Steinberg's essay, that may well be a common reaction. Certainly the argument to this point would make a formidable exercise in an introductory logic class: "formalizing" the argument would be a task on a par with Lewis Carroll's brain teasers. But Steinberg's text takes a middle ground: he neither spells out the formalism nor permits his readers to relax. Next come a further series of spatial ambiguities, this time leading to the

most difficult of all, the position of the painting on the wall of the actual refectory in Milan. To begin, Steinberg sets out to establish that the interior cannot possibly be a simple perspective box: at the least, it ambiguates between a left-right symmetry, a left-right asymmetry, and a triptych. Left-right symmetry is the obvious state of affairs. Left-right asymmetry is proposed by a dozen different inequalities between the two sides: there is a "drift to the right" best seen by reversing the picture (338); the table is slightly displaced to one side; the left wall seems to sink, the right wall rise; five disciples "cluster before the receding dark wall on the left" but "only three screen the right wall"; the five on the left "glance or strain centerward," and two of the right three "move away from the center" (339); the darkened left side recalls the Crucifixion (with Judas, Peter, and John) and the lighter right side the Resurrection (with St. Thomas); and the two "pier-like" sections of wall behind Christ "vail and lift" (he remarks the "cleft" on the left and the hands on the right) (340). At the same time the painting is a triptych, since it is "precisely trisected" by the walls (338).

Indeed, the space itself is an uncertain mix of the "horseshoe shape" that is common in *Last Suppers* and a "plane frieze" (341). It is no simple hybrid, as some are—a long central section, for example, flanked by foreshortened wings, or a tunneling view down a long straight table, with Christ alone at the end. Its asymmetries and tripartite division suggest something else is at work. At this point, the argument is close to Empson's fourth type, since a reader will be increasingly (if dully and insecurely) aware of a "complicated state of mind" in the artist. And still Steinberg continues: there are uncertainties over whether the rear aperture is a door or a window, since its sill—if one was intended—is just barely obscured (341); over the possibility that the painted frame around the painting may have been illusionistic, instead of flat and flush with the wall (343); and over the feeling that Christ is a distant figure hovering at the "door" or even at the "vanishing point," even though he may be close by (345). These are open-ended ambiguities of space, which lead to no immediate conclusion. It is not so much that they are terms in an infinite series, as that they set up the central dilemma of the position of the painting in relation to the refectory: building, as it were, a solid foundation of unresolved ambiguities on which the largest ambiguity can rest.

In situ, the *Last Supper* implies a center of projection 4.5 meters above the refectory floor, an impossible height for any viewer without a ladder. Steinberg establishes that Leonardo meant the painting to be as it is where it is, and proposes that the deep empty room behind the apostles was

Leonardo's "recourse against the high format of the wall to be painted" (349). The coffered ceiling, which disappears beneath the upper painted frame, can be completed by geometric construction, and when that is done—in paper, or intuitively by a viewer—then it "insinuates a whole ceiling rising, unseen, to the height of the painting wall" (350). The painting has simple geometric ratios to the wall: it takes up the central third of the wall, and the painting's horizon line bisects it.

Having established that the painting is exactly as Leonardo intended, and that what he intended cannot accommodate a normal human observer, Steinberg comes to the crux of his argument. The room, he says, is at once "fully present," "wholly removed," and "semi-detached." It is present in that the depiction is meant to be a "spatial appendage": Luke 22:12 mentions that the "guestchamber" was located in "a large upper room," much as Leonardo's painting appears to be on a level above the refectory (354). Yet it is "wholly removed" since the perspective assures that we will never be in the correct place (356). It is "semi-detached" in the way that Goethe intended when he described the painting as "an immanence," neither detached nor undetached (354, 356). The painting does nothing to disguise disjunctions between its fictive space and the room, or to adjudicate the three options: Leonardo did not shorten the spatial recessions, or cover them with objects, or provide a strong enframement to cushion the foreshortening from the refectory's walls (358). Hence the room must always seem "rectangular and not rectangular."

What meaning could unite the three functions of presence, absence, and "semi-detachment"? The answer must have something to do with the sacred function of the painting, and if Leonardo's thoughts were as well woven as they appear, the unusual spatial construction and its perspective armature must be assigned a "sanctifying" function. That leads, by a narrative bridge that is remarkable precisely because it is not logical, to a final excursus, in which Steinberg sets out seven reasons why the positions of Christ's hands denote the act of sanctifying: by lowering his hands, Christ shows resignation and indicates "the ministry [is] over"; by the shape of his arms, he forms an equilateral triangle, sign of the Trinity; by gesturing downward, his right hand "nails down what it condemns"; by spanning the wine glass and the bread, he signs the Eucharist; by flipping one hand, he alludes to the Last Judgment; by pointing with his left hand, Christ welcomes Leonardo's patrons (who were buried just outside a door that once opened in the direction of Christ's gesture); and finally, by stretching his arms he adopts the ground plan of the chamber and vice-versa, so that "the perspective

becomes ... a consequence of the event" (360, 367, 370–71). In these seven ways space "becomes sanctified" and "the laws governing visibility ... are received as a divine emanation"; in short, the perspective projection becomes "a revelation" (372, 381).

At this point, I think, it becomes extremely difficult to see how the chapters add, except by sowing ambiguations that have something to do with the fictive space of the painting. It is a perfect instance of a type-six ambiguity, and Steinberg would be liable to the charges Empson puts to Herbert, if it were not that Steinberg's ambiloquy is presented as an impeccably logical framework. On repeated reading, the sequence of chapters reveals itself as a logical progression shot through with parentheses whose positions could readily be transposed. The material on Christ's pose, for example, goes to show how a miscellany of features all create a sense of sanctity; but that argument might as well have come before the discussion of the "mystic" meanings of the Eucharist and Crucifixion. Close reading does not disclose the exact nature of the logical links between the chapters, except that they tend toward the question of space. The final chapter brings that tendency to its conclusion without justifying the sequences of the preceding argument.

The depicted space, Steinberg says, is experienced as trapezoidal instead of rectangular. That is so for a half-dozen reasons: because the room expands in "arithmetic progression" from three (apertures) to four (tapestries) to five (parts of the "frieze"); because the apertures are too large for a wall the size of the front wall; because the front of the floor is visible, but only the back of the ceiling, supporting our intuition of a disparity between foreground and background; because Leonardo has let the painting "collide" with the real room at the sides, assuring that we see it skewed; because a "widened forestage" is intensified by the way the table "wedges the walls apart"; because "the apparent spatial form of the chamber is exemplified in the painted shape of the ceiling"; and because the trapezoidal shape is "epitomized ... in the colors of Christ," which are a "red diamond" leaning on a "blue equilateral triangle"—forming the "primary trapezoid" (379).

The trapezoid would not have been unacceptable as such. It was a paradigmatic form of represented space in the Quattrocento, "co-present" with the rectangle, and constituting *another perfection* (376). It was "as much a form of meaning as a facial expression, gesture, or attribute," and in this case it may signify a polygonal apse, making the entire scene into an altar (in the shape of the table) and an apse, given by the "triune light" in the background (380). This would reconcile the three meanings he had proposed in the fourth chapter, that the room is "fully present," "wholly removed," and

"semi-detached," since altars and apses have all three of those relations to the public portions of the church. The painting's space, he concludes, is "surely an annex," "adjoined to the refectory as the chancel is to the nave" (when it is "semi-detached"), or as a "fourth table" to the refectory's three actual tables (when the painting is "fully present"), or as "an ideal autonomous realm" (when it is "wholly removed"). And with that conclusion, the essay ends—or rather, proceeds into the voluminous notes.

There is nothing easy about this argument. At times it appears that the unrelenting attention to ambiguities lets the argument stray as Steinberg becomes engrossed in subsidiary ambiguities rather than pressing his central argument. The structure of the chapters is unhelpful, even in retrospect:

Chapters 1, 2, 3: evidence that Leonardo intentionally embraced
 ambiguities
Chapter 4: the central dilemma: ways of understanding the painting's
 relation to the refectory room
Chapter 5: the connection between Christ's pose and the space
Chapter 6: the sacredness of the spatial construction
Chapter 7: the meaning of the spatial construction, and resolution of
 the dilemma.

Perhaps the central argument, that Leonardo intentionally controlled ambiguities, is itself not susceptible to strictly linear argument. There are, in Steinberg's account, several linked but semi-detached arenas of ambiguity, and several linked but semi-detached kinds of ambiguity. They cannot fully mesh, and I take it he does not want them to. The ambiguities of subject are one arena, and there are also ambiguities of history, of fictive space, and of meaning. Each of them has its own *kind* of ambiguity, and most have more than one kind: that is, logically they cannot add to a single chain of propositions. This is an exposition of ambiguity which is also partly a discourse on ambiguity (it is an ambiloquy, in both ambiguous senses of that word), but it does not take the form of a unified sentence, pulled and extended until it has reached the length of a book. If there is a guiding logic here, it is an *ambi-logic*: a series of logical disquisitions on ambiguities, linked collage-fashion with apposite but logically disjunct disquisitions.

I put things rather technically because it is important to be careful making claims about the structure of the essay. Steinberg's theme is ambiguity, and his method is also partly ambiguity. The essay includes several meditations on the nature of ambiguity itself, on the limits of ambiguities that might be expected from the best artists, and on the kinds of ambiguities that modern

writers might find in artworks. It is a principle, he says, that conflicting commentaries reflect complex truths, so it is not necessarily a bad thing to try to retain and harmonize many divergent opinions. The essay's claims exemplify that principle, but the essay's forms question the possibility of "harmonizing" divergent types and arenas of ambiguity.

THE ACCUMULATION OF AMBIGUITY

As Steinberg knows, ambiguity was once something artists and writers tried to avoid. Writers from Pliny to Winckelmann were content simply to tell the most apparent, "primary" meaning of an artwork. Now we seldom do that, and even historians who decipher what is taken as the primary meaning of a picture do not go on to claim that there are not multiple meanings. Most working art historians, I think, take it on faith that the most blatantly self-serving or orthodox narrative message has its unexpected subsidiary meanings, and that in general all pictures are ambiguous beyond measure.

That assumption does come up for discussion in rare moments before modernism, but for the most part it is our idea. It takes two forms in the current literature: the gesture in the direction of ambiguity, and the determined excavation. Things don't usually get as far as I have let them get in this chapter, and the first option is the most common. Typically, speaking about ambiguity is really *invoking* ambiguity, praising it from afar. The majority of art historical texts concentrate on single meanings—usually, the artist's intended meanings, or the patron's or public's perceptions—and conjure an infinity of lesser or secondary "levels of meaning" that pertain more to personal experience or art criticism. That cloud of hypothetical meanings is very far from the *absence* of such a cloud in the earlier literature, and the fact that it is ill-defined only makes it more complex, more intriguing. For that reason historians who work at finding primary meanings often end up participating in the modern interest in ambiguity.

The second response to ambiguous meanings—the determined excavation—is less common. In the next chapter I will return to Steinberg's essay, in order to ask what effect it has on our idea of Leonardo: certainly, after reading the essay (or even this summary of it) the *Last Supper* becomes tremendously, I think nearly hopelessly, ambiguous. Most ambiguities are not set out all at once as Steinberg's are. Instead they accumulate as the literature accumulates, by the mere fact that one monothematic interpretation follows another monothematic interpretation opposed to earlier readings, so that works of art slowly become ambiguous and in the end excruciatingly self-contradictory. As Empson would point out, a concordance of ambigui-

ties is not necessarily clearer than the unnoticed accumulation of contradictions and irrelevancies. After nearly five centuries of Western art history, none of the Old Masters speak with monosemic certainty. Many are half-buried, and some are nearly lost, in the Babel of documents they have inspired.

In considering these situations it helps to recall that Empson's book is illogical at root. It could not be more important that "Bare ruined choirs, where late the sweet birds sang" does not *propose* anything, and therefore it is utterly unambiguous. (Or more precisely, nonambiguous.) In strict terms, the ambiguities that historians dream of are almost all projections onto nonlogical material. Even an academic narrative painting has no "proposition": its primary meaning, *fabula*, or title is not a proposition, and therefore instantly infinitely ambiguous. But that fact rarely finds its way into art historical ambiloquies, where the primary meaning, though it may be in dispute, is universally held to be describable. And that is a final source of illogic, since the lack of actual propositions is the most corrosive ambiguity of all.

ON MONSTROUSLY AMBIGUOUS PAINTINGS

A dozen or so artworks have become monstrous: they have attracted so much attention that they have effectively outgrown the discipline of art history. Their literature can no longer be mastered by a single scholar, or judiciously discussed in a single volume, or taught in a year-long seminar. Among the works I have mentioned are the Brancacci Chapel, the *Mona Lisa*, and Velázquez's *Las Meniñas*, and I might add Raphael's *School of Athens* and David's *Oath of the Horatii*. Other paintings are on the borderline: their literature is very large, but specialists still master it more or less. In that group could be put Giotto's Arena Chapel, El Greco's *Burial of Count Orgaz*, Grünewald's *Isenheim Altarpiece*, Picasso's *Demoiselles d'Avignon*, Vermeer's *Art of Painting*, and several dozen others.[2] It wouldn't be a pleasure to read everything that has been written on Bosch's *Garden of Earthly Delights*, but it could probably be done. Most specialties in Western art have their candidates for monstrous and pseudomonstrous paintings. In general, things are better for non-Western art, and it is still feasible to read all the literature on major works such as Chao Meng-fu's *Autumn Colors in the Ch'iao and Hua Mountains* or Huang Kung-wang's *Dwelling in the Fu–Ch'un Mountains*.[3]

When it comes to artists rather than artworks, the number of monstrous subjects increases dramatically: I think it is not possible to read all the literature on artists such as Giotto, Michelangelo, Leonardo, Raphael,

Velázquez, Rembrandt, Goya, or David.[4] The two volumes of Michelangelo bibliographies for the period 1510 to 1970 list over 4,000 entries, and a scholar intent on mastering the history of reception would also want to study the 1,000–odd engravings after Michelangelo—not to mention the innumerable modern quotations, travesties, and take-offs.[5] Thinking only of the books and essays, the Michelangelo literature comes to roughly five texts every day for three years—in practical terms, an impossible project. In general, things get better when it comes to more recent artists. Some modern artists have also amassed huge bibliographies, though they may ultimately be readable: the literature on Manet is vast, but perhaps not unencompassable, as Michael Fried's work indicates; and the same may be true of Picasso, Matisse, and Pollock.[6] Of course, these are all utopian speculations: as any working art historian knows, it can be challenging even keeping up with the more important literature.

For my purposes here, the monstrous bibliographies on individual artworks are more telling than the spread of artists' bibliographies in general. In this chapter I am concerned to assess the essential symptoms—the pathognomonics, in medical terms—of monstrosity in three further examples: Giorgione's *Tempesta*, Botticelli's *Primavera*, and Michelangelo's Sistine Ceiling.[7] So much has been said about each of them that the history of their reception can no longer be fully told. Dissenting readings can be mentioned in monographs, but not evaluated or seriously considered. The discipline's response to this situation has often been to concentrate on new readings, shifting remarks on previous scholarship from the body of a text to appendices, critical biographies, or introductions. The Sistine Ceiling was recently treated to such an exposition: an edited volume of essays that proposes several new theories and scarcely mentions some of the major preceding scholarship.[8] An historian writing on one of the monstrous topics will probably want to answer a few previous authors, but the great majority of earlier work will have to be compressed or omitted. In some cases, when the history of reception is at issue, an author might try to list earlier opinions about a work; but even those lists have to be so abbreviated that they become litanies of claims, largely stripped of their original arguments and contextual support.

There is no single reason why historians do not try to keep the full range of previous literature alive in their publications. In part, earlier opinions seem outdated, merely wrong, or (as I suggested in Chapter 1) wrong in uninteresting and unpromising ways; and in part the discipline encourages readings that seem entirely novel. As university presses move away from

monographs and toward interdisciplinary works, books that try to respond to more than a tiny fraction of the preceding literature become rarer. Nor is there any easy way to address histories of reception in graduate schools. A typical graduate seminar can barely get started with the literature on one of the monstrous subjects, and in my experience even when twenty students do papers on aspects of the reception of a single work, they can only gesture in the direction of the many arguments that must be left behind. Even Steinberg, the most fastidious of all historians when it comes to thinking about past responses to works, cannot afford to engage each opinion or answer every argument. If Steinberg were to respond even briefly to all the previous scholars who did something more than just quote existing opinions on the *Last Supper*, his essay would be several times as long as it is. If he were to try to do full justice to older historians, by engastrating the relevant texts into his own, then his essay would swell to something over two thousand pages.

Naturally, monstrosity tends to concentrate most densely around pictures that are thought to have been made intentionally ambiguous. When pictures are perceived more as puzzles, then the successive writers can argue with one another in a more logical fashion. In this vein Rosalind Krauss rejects Jean Cocteau's "external" explanation of Picasso's neoclassicism (Cocteau said he led Picasso toward the theater, turning him toward thoughts of classical and neoclassical figures), and she also rejects Pierre Daix's "internal" explanation (Daix has argued that Picasso's neoclassical pictures are actually cubism, in another form). Her own explanation is that Picasso was partly driven by anxiety about reproduction, photography, and abstraction.[9] The binarism internal-external effectively sums the preceding scholarship and clears the ground for her own reading. No such method would be possible if the subject were truly monstrous, because it would be hard to know if the literature could be characterized under two, or even twenty, headings. (That does not prevent historians from summing the past in various ways; I'm agreeing that Krauss's binarism captures the two major explanations.) It is markedly different when the works in question are thought to be ambiguous: the first volume of the *Art Index*, which catalogues the years 1929–1932, lists about fifteen essays that might bear on the *Tempesta*. Some are trivial (1932 was the year the Italian government bought the *Tempesta*, and there are some more-or-less hysterical reactions to the purchase) and others are more substantive, such as Louis Hourticq's *Le problème de Giorgione*, which occasioned seven reviews and three replies by Hourticq.[10] (Hourticq's is a sweet text, praising the "heureux propriétaire" who watches over "son trésor," the "belle et honneste dame." He demonstrates that the town is Castelfranco by

illustrating the text with two of his own watercolors, which unfortunately have very little correspondence with the painting.) By contrast, sixty years later, in the equivalent four-year span between 1989 and 1992, the *Tempesta* is mentioned in at least 50 essays, reviews, catalogues, and books—adding to an amount too great, I think, even for a researcher writing specifically on the *Tempesta*.

I'll be arguing that the relative monstrosity of the *Tempesta, Primavera,* and Sistine Ceiling is the effect of a particular kind of trackless ambiguity. Where there are primary meanings, clear intentions, or unarguable documents, art history flourishes; without them it festers. The entire machinery of traditional art history is bent on that sturdy beginning-point of interpretation: overwhelmingly historians trace, fix, and confirm unitary intentional meanings, placing them before the nebulae of meanings that are unconfirmed, conjectural, ancillary, anecdotal, or personal. When primary meanings are elided, absent, or called into question, art historical interpretations lose their foothold: hence the troublesome nature of some pictures, and their overflowing bibliographies. Like infected wounds, such works injure the normal metabolism of art history, irritating the surrounding scholarship, spreading their inflammations to neighboring works and texts. They may originally have attracted attention precisely because they seemed like blemishes, imperfections that art history had failed to control. And despite our postmodern affection for infection, the literature on works like the *Tempesta* shows no signs of healing. Most recently, with ever-more extensive attempts to demonstrate primary meanings, its condition has been made worse by a growing, even endemic disagreement about how the injury should be treated.

SUBJECT, NOT-SUBJECT, ANTI-SUBJECT

In art history, the possibility that pictures might not have unambiguous primary meanings goes back to the Renaissance. In particular, some time around the mid–1470s in Venice it began to be possible to make pictures from which all narrative had been cleared, leaving only the frame for action. Fra Bartolommeo, Jacopo Bellini, and others made drawings that are either purely or primarily landscape scenes—with diminutive allegorical and religious figures, vaguely evocative buildings, or just meadows and groves of trees. The origins of the notion of landscape are obscure, but in this context it is not essential to decide whether the Venetians were first to make "pure" landscapes, or whether as Christopher Wood argues, Albrecht Altdorfer painted the earliest landscapes unfettered by subject matter.[11]

The best analytic frame for the problem was set almost a half-century ago, by Creighton Gilbert's essay "On Subject and Not-Subject in Italian Renaissance Pictures."[12] Gilbert was responding to Panofsky's theory of iconology, and trying to show that some works are not susceptible to the iconographer's zeal for "hidden" meanings. As it turned out, Gilbert's objections were not difficult to answer in Panofsky's terms (one historian calls them "rather incoherent"), but the essay's importance is not exhausted by its original purpose: it remains an exceptionally lucid way of putting a recurring issue in the visual arts.[13] The problems with Gilbert's original formulation can be assigned in part to his unfortunate choice of examples. He misreads Paolo Giovio as saying that Dosso Dossi's paintings are *parerga*, a word that can be variously translated as embellishments, details, "oddments," or *particolari* in Italian.[14] But Giovio meant to say that Dossi's paintings *contain* "oddments." Paintings such as *The Stoning of St. Stephen* in Lugano are certainly principally landscapes, and the diminutive figures of the Saint and his tormenters are *parerga*. But *The Stoning of St. Stephen* has a subject, and it is certainly not a *parergon* in the classical sense.[15] Gilbert also enlisted Piero della Francesca's *Flagellation* as a Not–Subject, though it seems that the inscription "convenerunt in unum," which is no longer visible, is sufficient indication that the painting once had an unusual, but probably well-defined, subject.[16] Historians have also disagreed with Gilbert's notion that landscape, as a genre, should be the original Not–Subject. Gombrich and others have pointed out that landscape paintings were originally linked to particular properties and patrons.[17] Some of Gilbert's principal examples, such as a pair of landscapes attributed to Ambrogio Lorenzetti, turned out to be fragments of larger paintings; and in general, drawings such as Fra Bartolommeo's are most reasonably explained as studies for the backgrounds of narrative paintings.[18]

Recently Salvatore Settis has reviewed Gilbert's categories in order to claim that no painting is effectively without a subject. In Settis's view, even works such as the *studiolo* in Urbino have a subject (the *studiolo* conjures "un clima 'antico'").[19] Gilbert had opposed paintings with subjects to those that merely produce "an emotive response in the viewer," or a "religious attitude."[20] Settis remarks that "the emotive response is the meeting point between the patron's request and the artist's offer, and the scholar must seek it out: for it is also a record of a particular religious attitude, or of a particular way of looking at the past—in other words, a fragment of history."[21] Settis's objection is reasonable—any historian would want to recapture "emotive responses" for history—but it does not erase the difference between an ordinary painting and the *Tempest*. Even if we would not want to "solve"

the *Tempest* by identifying it as the Not–Subject *par excellence*, it would seem there is enough truth in the distinction between Subject and Not–Subject to make it worth investigating. Settis's agenda, after all, is to identify the painting's true Subject, and Not–Subject would ruin his interpretive project.

1. Provisionally, then, let us say a painting with a subject is one that declares, or is taken to declare, a single narrative, theme, or genre. Necessarily, such paintings are taken to possess primary meanings and repress ancillary meanings: that is, they are not ambiguous *ab ovo*, but they have a structure of meaning that is built on their ostensive subject. To recognize a picture as Subject is to understand it in such a way that its genre or theme is situated at the beginning of interpretation, and rival or opposed meanings are devalued or left undescribed. Rubens's *Rape of the Sabines* may be ultimately of interest because of its muted use of landscape, its gender constructions, or its implications about nationalism, but a reading of the painting as Subject must begin by acknowledging the theme itself and its *fabula*—its source in Livy. Even the most wide-ranging contemporary scholarship still begins with catalogue entries or museum labels, and a description is still held to be minimally complete if it names the artist and the title or subject, as I have for the *Rape of the Sabines*. Many other things might then be said, but the painting is understood as having a Subject if naming the subject is necessary and also occasionally sufficient.

2. Not–Subject would then mean that the painter has left signs indicating that the work is to be understood as *not* having a primary narrative, meaning, message, title, theme, or genre. The question here is not the existence of pictures that are somehow free of subject matter (as Settis imagines), or pictures that have only emotional or religious meaning, and no symbols (as Gilbert proposes), but pictures that raise those possibilities by questioning the normal boundaries of explicit meaning. Lorenzetti's landscapes in Siena were not originally designed as "mere" landscapes, but they were collected, interpreted, and marketed as such, and so were Fra Bartolommeo's drawings. Some paintings by Giovanni Bellini, Dosso Dossi, and Giorgione are *almost* "pure" landscapes, and that is enough to raise the question of the Not–Subject. Or to take a twentieth-century analogy: an abstract expressionist painting can be said to have a subject (it might be the references to landscape, the expressiveness of the gestures, the flatness of the picture plane, or its manner of responding to surrealism) but it is also clearly aimed away from any single subject. By dismantling the Subject / Not–Subject distinction Settis blurs a fundamental possibility that Western art has had since the

1470s: to declare, however ineffectually, that a painting might fall outside of any genre, symbolization, or primary meaning.[22]

3. If Subject and Not–Subject are taken in this sense, then there is another option: a painter might begin with a Subject and try to obliterate it in whole or in part. It is helpful to distinguish between the Not-Subject, in which the painting is a blank from the very beginning, and the *Anti-Subject*, in which the painting begins with a determinate subject then becomes a cipher. Anti-Subject paintings show traces of the painter's effort to efface their subjects—they are palimpsestic, both literally and figuratively. (Balthus's paintings often work that way.) At times what is at stake is the evidence of X–rays or archival documents, and in other cases the painting itself shows its multiplicity; but even without physical evidence, an historian might effectively claim that a picture is an Anti–Subject in order to explain an apparent lack of subject. Analytically speaking, Anti–Subject pictures were possible before there was such a thing as a Not–Subject, since they only involve a motion away from a principal theme, rather than a full escape into subjectlessness. An Anti-Subject painting might effectively conceal its subject, hiding it from everyone except the painter; or it might tease viewers with clues; or it might be so arcane that few people can see its subject: what counts is the retreat from the obvious, unambiguous primary meaning.

These three concepts are surprisingly versatile. They describe not only the occasional intention of premodern artists to make pictures with ambiguous messages, but also the nearly universal intention of modern and postmodern artists to work against messages, "one-liners," and other kinds of restrictive primary meanings. A great deal of what happens in contemporary art can be understood as Anti–Subject: pictures begin by following some convention or adopting some narrative, theme, reference, or symbol, and they move against and away from primary meanings and into states of ambiguation where no one meaning predominates. The change from Subject to Anti–Subject, and then to Not–Subject, is a sea change in the Western understanding of pictures. Before, pictures had to be first and foremost *about* something, before they could be appreciated for their many nonnarrative qualities. Now, it is much more likely that pictures try not to be about any one thing, in order to ensure that those same nonnarrative qualities are given pride of place. A larger shift in sensibility, I think, can hardly be imagined, and it goes to the heart of the subject of this book: certainly pictures would not require as much interpretive attention, and would not be so vexing to understand, if they were overtly and obviously about single subjects. At the beginning of this development is the possibility that meaning

might fail, and so it is no accident that Giorgione's *Tempesta* is one of the most monstrous of the monstrous pictures.

GIORGIONE'S "MEANINGLESS" TEMPESTA

At first it appears that Giorgione is best described as an Anti-Subject painter. The so-called *Three Philosophers* in Vienna, depicting three exotic-looking men in front of a cave, demonstrably began as the *Three Magi*. (An X–ray revealed that one "philosopher" was black, in accord with the conventions of the Magi.) There is a possibility that the cave, which was more prominent before the painting was cut down, referred to a myth about the Magi, according to which they waited near a cave on the *Mons Victorialis* for the advent of Jesus. Their instruments and notations would have signified their astronomical interests: they were watching for the Star of Bethlehem, whose reflection may once have been visible gleaming on the cave wall. As we have it, with the Magi altered and the cave nearly cut out of the picture, the painting is an effective Anti–Subject: effective enough to occupy generations of scholars who have attempted to restore the Subject by naming the three philosophers.[23]

One reason Settis's book *Giorgione's* Tempest, *Interpreting the Hidden Subject* has been so widely read is that it entertains the idea that the *Tempesta* might also be an Anti–Subject, and specifically an attenuated or hidden Subject (see plate 11). Certainly it would be hard to argue that the painting isn't an Anti-subject of some sort: it has a long history of puzzled interpreters, going back nearly a hundred years. Antonio Morassi was the first to suggest the painting might not only be puzzling, but also a deliberate enigma (in his words, a "genre" painting rather than a proper *istoria*), and Settis puts Morassi's question in Gilbert's terms.[24] Even though Settis eventually proposes his own reading of the painting, what he does seems a relief after the tidal wave of opinions that began in 1895 when Franz Wickhoff saw the *Tempesta* as a scene in Statius's *Thebaid* in which Adrastus meets Hypsipyle, an exiled queen, nursing Opheltes. (Immediately afterward Adrastus takes Hypsipyle for a walk, and while they are off Opheltes is bitten by a serpent and dies.)[25] For Rudolf Schrey, the subject is from Ovid's *Metamorphoses*, and the painting represents the "Noetic" couple of Greek mythology, Deucalion and Pyrrha, resting as the floodwaters recede.[26] Morassi, Federico Hermanin de Reichenfeld, Robert Eisler, George Martin Richter, and Gustav Hartlaub agree that Giorgione painted the finding of Paris: the man is the shepherd who finds Paris, the woman is the nurse who suckled him; the town is Troy; and the lightning alludes to Troy's imminent

destruction.[27] For Piero De Minerbi, the painting depicts the mythical Phoenician origin of the Venetian Vendramin family: the soldier is Baal, the gypsy Astarte. "Both are symbols," De Minerbi says, "Baal of the source and governing force of life, Astarte as the common mother and goddess of the earth."[28] Angelo Conti sees a family drama, in which the tempest evokes "the inheritance of pain"—presumably the pain of childbirth, and mortal pain in general.[29] For him, the painting is not so much a Subject as *the* Subject, and Giorgione is not so much an artist as a mystery: "l'alto enigma umano che porta il nome di Giorgione," "the deep human mystery that carries the name 'Giorgione.'"[30] To Arnaldo Ferriguto the painting is a simple mystic duality, in which the man is the "active, operative factor," and the woman "inert, passive factor."[31] Günther Tschmelitsch proposes the painting represents the theme *Harmonia est discordia concors* (harmony is discord resolved), and he points to the harmonized contrast between the clothed "soldier" and the naked woman, between the town and the country, and between the storm and the scene's general serenity.[32] To Maurizio Calvesi, the painting depicts Moses discovered by Bithia, Pharaoh's daughter. On that reading, the "soldier" is both Hermes Trismegistus and the Archangel Gabriel, and Giorgione is said be intimating Moses's connection to Pharoah, since he grew up to become an initiate into the mysteries of Osiris, and ultimately Thormosis, "the hermetic sorcerer and biblical prophet."[33]

There are others, and I want to name some more in order to evoke the tenor of the literature (without, I should say, even coming close to reproducing its outlandish detail). Nancy DeGrummond sees the man as St. Theodore, a protector of Venice; Christ appeared to him in a vision and told him to fight a dragon that was demanding human victims. In another story St. Theodore burned a pagan temple, and DeGrummond finds the elements of both stories in the painting: the ruins refer to the burned temple, the "viper" in the dirt and the griffin on the distant building allude to the dragon, and the rescued woman sits on the bank opposite St. Theodore.[34] Luigi Stefanini is reminded of a passage from Francesco Colonna's *Hypnero-tomachia Poliphili*, and he proposes the dome is the Temple of Venus, the columns the author's name (*colonne*, close to Colonna), the mother is Colonna's character the *Venus genetrix*, and the "soldier" Colonna's protagonist, Poliphilo himself.[35] Edgar Wind sees an iconographically simpler pastoral scene with Fortitude, played by the "soldier," and Charity, represented by the woman, in a landscape dominated by Fortune. In his opinion the painting is an emblem, diffused a little by Giorgione's "lyrical mood," so that "uncertainty is their natural element, the congenial setting for their

virtues."[36] The whole has an "air of unreality," as Kenneth Clark observed, but in the end it is "a pastoral allegory in which *Fortezza* and *Carità* are dramatically placed in a setting of *Fortuna*."[37]

Walter Pater is the gentlest iconographer, suggesting that Giorgione ulti-mately has no subject, and that his attraction partly depends "on a certain suppression or vagueness of mere subject, so that the meaning reaches us through ways not distinctly traceable by the understanding."[38] Pater's sense of gentle "poetry" or "music" is the cloudy ancestor of much of the twentieth century's fascination with multiple meanings, and it can even be argued that Pater understood his own character as a Not–Subject. In the essay "Diaphaneitè" he advocates an aesthetic life that avoids harshly delineated types such as "philosopher," "artist," or "saint" in favor of a perfect "equipoise" among various "gifts" where none predominates.[39] In light of that self-portrait, Pater's essay on Giorgione is more a non-iconographic application of the idea of "diaphaneitè" to Giorgione's elusiveness, rather than an iconographic theory about "musicality" as Settis and others have understood it. As Adam Phillips points out, Pater's "indefinite words, 'sweet,' 'peculiar,' 'strange,' 'delicate,' are resonant as blanks that can evoke powerful personal associations in the reader"—and we might well add "music," "poetry," and "painting" to that list.[40]

Later authors put essentially the same thought in more analytic terms. To Lionello Venturi the painting is a landscape with figures, rather than the other way around. "The subject is nature," he writes, and "man, woman, and child are only elements—and not even the main elements—of nature."[41] What most attracts him is the storm, which mimics a certain effect found only around Venice in the springtime—when the sun is just setting and the sky is limpid, and clouds come up in the east, coloring the houses "in silvery lights, with reflections of the faintest azure and rose; everything has a delicate and almost timid fineness in the face of the oppressive purple storm that looms behind."[42] It's the late-romantic vision of twilight that entrances him, and the figures must be understood in its terms rather than vice versa. And finally, for Roy McMullen the painting has four levels of meaning: it is allegorical (as in Wind's hypothesis), narrative ("probably something to do with Zeus and Hermes"), philosophical-lyrical (following Venturi's definition), and musical (citing Pater).[43]

What is a reader to make of this outpouring of answers, this interpretive "hedonism" (as one reviewer calls it)?[44] Rules are what count when it comes to adjudicating the claims, and "the first rule for putting together a jigsaw together is that all the pieces must join up with no gaps in between."[45] For

Settis, Venturi's interpretation (that the "subject is nature") is not permissible since it avoids the central challenge of finding the "hidden subject." Wind's thesis about *Fortuna* is also wrong because Fortitude is normally a female figure, and her attribute is whole columns, not broken ones—making Wind's hypothesis an incomplete jigsaw puzzle.[46] Settis takes note of McMullen's use of the word "puzzle" in the title to his paper, but he concludes that McMullen has woven together too many kinds of meaning. In the jigsaw-puzzle metaphor, McMullen's would be a quadruple puzzle, one with four layers of pieces instead of the normal single layer.[47] Calvesi's reading (that the painting shows Moses discovered by Bithia) also seems wrong, because the sources say nothing about a guardian angel or a mythical Egyptian sage being present at the finding of Moses. If the painting is to show such a scene, therefore, Giorgione must have abandoned the Subject and opted for something else, which Settis calls a "concept": explaining the presence of Hermes Trismegistus, he says, "inevitably necessitates a swerve of direction from 'subject' to 'concept'" (54). I am not sure how stable Settis's position is at this point: is "concept" something essentially different from Subject? Or is it just an obscure kind of Subject? Settis's concept of "concept" is apparently something like "incomplete subject"—that is, any subject that does not account for the entire painting. Calvesi's hypothesis therefore violates the picture-puzzle metaphor because it is incomplete, not because it is less likely or less textually grounded than the other interpretations.

Settis then proposes an interpretation of his own, the "hidden subject" of the book's title. In his view the subject is *Adam and Eve Outside the Garden of Eden*, with Adam leaning on a suspiciously slender garden tool, Paradise in the background (paradoxically rendered inaccessible by an "uncrossable bridge"[48]), God as a thunderbolt, and the diminished snake creeping into a hole in the ground. As he acknowledges, this is not an ordinary scene of the Garden or the Expulsion. His interpretation depends on the idea that Giorgione "hid" or "effaced" his Subjects, working (in my terms) as an Anti–Subject painter. He says "Giorgione made a fundamental change to the relationship between the characters and to the background . . . to display his judgment and finesse as a painter" (97). In the completed painting Eve hides her nakedness behind a bush while she nurses Cain, and Adam rests from his agricultural labors (113, 115). His garden tool is downplayed (Settis says it has a small blade), and he is dressed as a contemporary figure (118). The serpent, too, is reduced, and God's presence is only evoked by the thunderbolt (119). Eden becomes an ordinary town—or as Settis puts it, with some iconographical fervor, "this distant, deserted city can be none other

than Eden, the *civitas, Hierusalem libera* of old tradition," the "*paradisus voluptatis.*" The inexorable Expulsion is figured by the "uncrossable bridge" (113, 118). In this way the picture is fully accounted for, and the jigsaw metaphor is fulfilled—but at the cost of admitting attenuated, "hidden," and transformed symbols rather than straightforward ones.

Settis's description of Giorgione's gradual effacement of the usual iconography has to acknowledge one important exception: X–rays show that the man was originally a second bathing woman. (In plate 30, the man's hand is visible at the upper left, above the shoulder of a seated woman.) Settis proposes two explanations for her anomalous appearance: either Giorgione began with a completely different idea, or else the overpainted figure was also Eve, shown bathing away her impurities for thirty-seven days after leaving Eden in accord with an old Hebrew tradition (117).[49] Unfortunately, we do not know whether the "bathing Eve" is in the same layer of paint as the nursing woman. Giorgione could have painted her alone, or with the other woman, or even after the other woman. But the ambiguity speaks for a

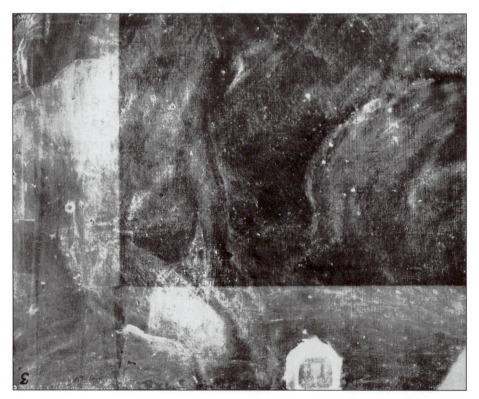

Plate 30

sequence other than the slow eclipse of obvious symbols that Settis wants, and it allows him to bypass the possibility that Giorgione was painting a Not–Subject—an initially subjectless scene. In the end, the *Tempesta* is a Subject, but of a special kind, since its meaning is "hidden." In my terms, Settis claims the painting is an Anti-Subject.

This Babel of interpretations is what I meant when I called art history a bruise that has grown up around our sense of pictures. Paintings like the *Tempesta* are injuries to these historians' sense of how pictures should have meaning, and their theories are the inflammation that results from irritating the wound instead of letting it alone so it can heal. Each of the interpretations, except Marcantonio Michiel's (see p. 24) and possibly Pater's, chafes against both models of meaning I have been exploring in this book. The *Tempesta* is neither a proper jigsaw puzzle nor a well-behaved ambiguity, and its failure to conform is a sign of the apparent absence of a primary meaning.

In any version of the jigsaw-puzzle metaphor, a fundamental problem is deciding the number of pieces in the puzzle. Settis makes a point of claiming his solution is complete, since it provides an explanation for every element of the painting. But it's open to question how many elements there are, and what counts as a piece. (Arasse's remarks on the "snake" are a case in point.[50]) Since Settis's book appeared in 1978 there have been at least twenty more interpretations, and several of them name different puzzle pieces.[51] (Among them are reviewers who are unable to resist adding to the list of interpretations, even though they chide others for falling into the trap Settis has supposedly disarmed.[52]) Elhanan Motzkin argues the subject is the life of Romulus: first being suckled by the prostitute Acca Larentia, then as an adult, and last his mysterious death during a thunderstorm.[53] Motzkin notices a detail few writers have seen: the stream flows *into* the picture, rather than out toward the viewer in the normal manner. Giorgione has made a point of it by painting a small cascade in the middle distance. To Motzkin, the stream is a narrative cueing mark, meant to show the viewer that the storm comes last in Romulus's life. But even without that interpretation, the detail seems to warrant a place in any explanation that aspires to picture-puzzle thoroughness. The most precise of the more recent offerings is Paul Kaplan's identification of the half-effaced coat of arms above the right side of the bridge as the *carro*, the arms of the Carrara family of Padua.[54] Since the *carro* was specific to Padua, Kaplan suggests the painting is a "martial allegory," commemorating the Venetian capture and defense of Padua against the Hapsburgs in 1509. Even aside from the veracity of his conclusion (which depends on the *carro* being found nowhere but Padua),

the *carro* is sufficiently clear and specific to be counted as a piece in the puzzle, and by Settis's own rules, no account can be complete without it.

Ambiguity, the second model of meaning, is even more strongly at odds with these interpretations. Despite Settis's attempts to contain it, ambiguity suffuses Settis's book, especially because he lists some of the earlier interpretations without arguing against them. By insisting on a single solution, and never returning to his long list of previous theories, Settis throws the earlier scholarship into a kind of limbo where opinions float unanchored in a reader's imagination. The reader is asked to ignore them when Settis presents his own interpretation toward the end. But inevitably, they continue to resonate for a reader as they undoubtedly do for Settis (who, I would assume, continues to mention them in his lectures). Even though we may not choose to take more than a few of them seriously, they veil our experience of the painting. After reading through an interpretive historiography like Settis's, the *Tempesta* becomes a remarkably complex object: it may be a Subject (perhaps even the one Settis proposes, though I do not find his argument convincing on that point), and even in his interpretation it is partly an Anti–Subject; but no matter which interpretation we favor, the others all remain more or less in memory. Eve, Bithia, Astarte, Hypsipyle, and *Fortuna* cohabit in our minds. Even supposing the painting is unarguably *Adam and Eve Outside the Garden of Eden*, it is precisely for that reason also not *Adam and Eve Outside the Garden of Eden*. I think it is important that Settis's book is untrue to our experience of the picture: the book unwittingly records how such a disorderly experience might be arranged by a mind intent on Subject and solution, but it fails to convince me that the rejected interpretations aren't still interesting, and even *essential*, to our sense of the painting. (Only a very few texts in art history acknowledge the irrational admixture of conflicting interpretations. Pater's famous description of the *Mona Lisa* is an instance, because it blends all sorts of plausible and implausible meanings—from "the mysticism of the middle ages" to Helen of Troy—into a single rhapsody. For that very reason, I think, it was inadmissible as art history from the moment it was written.[55]) An ideal interpretation would find a way to explain the ongoing fascination of even the most patently false theories, and a way of acknowledging that they contribute to the painting's value merely by adding complexity. I don't mean that we need to herd all improbable theories together, and let them keep company with the one we take to be true: but it is no less irresponsible to the texture of history to let theories accumulate into a critical mass, and then present a single correct theory *as if* it could stand entirely on its own. Without the fascinating cacophany of

"wrong" theories, Settis's thesis would be bare and unappealing: possibly not less true for some readers, but unarguably less interesting, and I think also dishonest to the painting's magnetic pull.

In this cloud of unknowing still other possibilities present themselves. Anti-Subject paintings might well begin *without* subjects, and veer aside whenever a Subject threatens. What if Giorgione had begun with a pure *poesia*, a picture without a subject, and then found himself at one point perilously close to *Adam and Eve Outside the Garden of Eden*, or *Baal and Astarte*, or *St. Theodore and the Christian Widow*? He may then have altered details until his painting was again almost Not–Subject. This is an inversion of the way I have been describing Anti–Subject: instead of beginning in a familiar place, and discarding symbolic clues, Giorgione could have started nowhere, and added signs while at the same time trying not to arrive back at a Subject. That, at least, is my own sense of what happened in the making of the *Tempesta*, and my own solution to the question of meaning: but in saying as much I do not want to erase or even contradict the entire monstrous bibliography that the painting has generated, since that tradition, and not my own hypothesis, is what draws me to the painting. The theories are attempts at the truth, and they are also pathognomonic reactions, pointing like the gnomons on a sundial to the place the picture has in each writer's mind. For me, the *experience* of Giorgione's *Tempesta* is this tempest of claims and counterclaims: it is the sum total of what I know about its critical history.[56] The harsh hermeneutics that sets aside whatever is partial, veiled, superseded, and even incorrect in favor of the single right answer is at least partly a response to some injury perpetrated by the picture itself. The generations of stark and uncompromising solutions, and the tenacity of effort that is still expended on the picture, are less signs of what the painting is, or was, than they are symptoms of what we want it to be. The *Tempesta* may have started out as an attempt to avoid the Subject, but it has become a troubled reservoir for our desire for meaning.

In considering what we have done to the painting, it is essential not to lose sight of the fact that the earliest accounts get along by saying very little. The earliest on record is nothing more than a hasty mnemonic: in 1525 Michiel, an acquaintance of Giorgione's, described the subject as "a little landscape on canvas with [a] storm [and a] gypsy and [a] soldier."[57] Giorgione and his circle of friends were engaged with the idea of *poesie*—roughly speaking, poetic utterances with a surplus of nuance and a paucity of overt symbolism. It is possible that Michiel's mnemonic was just enough to describe the picture: in his eyes, it might have been a full explanation. Even vigilant

historians tend to forget this possibility. Paul Holberton has recently admonished art historians to take Michiel seriously, and recognize the figure as a gypsy rather than assuming Michiel said "gypsy" because he couldn't find the right word. Holberton is also careful about other elements in the painting: the broken column, he says, "is no more symbolic than the trees," and helps "establish the perspectival recession."[58] In a passage that Empson would have loved (it is a perfect instance of his first type of ambiguity), Holberton juggles the storm and the theme of the gypsies:

> In an abstract sense the storm is the attribute of the gypsies, or, if one wishes to believe that the storm was the picture's *raison d'être*, homeless gypsies are appropriate figures to place in a landscape with a storm. But the picture is made by the two together, for the gypsies illustrate the threat in the storm, and the storm compounds the poignancy of the gypsies' condition.[59]

That would be a simple solution, a type-one ambiguity and a decided renunciation of the intricacy of the majority of other interpretations. Still, Holberton's analysis is dense with scholarly references: lines from a Sienese play produced in 1520; citations of histories of gypsies written in the sixteenth century, Renaissance opinions about Scythians; parallels with classical theories of primitive people and current theories of "woodhouses" (wild men), satyrs, and New World Indians. His writing style and his allusions make for slow going, and no matter whether we end up accepting Michiel's description, the new details take their places in our understanding of the painting, adding to the mountain of interesting, partly misleading, and even possibly true information that *is* the painting.

By the laws of our interpretive mania even a strong argument in favor of simplicity begins to seem dubious. Like many iconographers before him—though with a more plausible argument than most—Holberton's text ends a little at odds with itself: on the one hand there is the painting, obviously simple and direct in its appeal; and on the other there is his essay, crammed with ideas and only persuasive by dint of dogged accumulation of trivia. In the back of a viewer's mind is the sense that the painting must mean more. The symptoms of mania feed on one another: the essay claims simplicity but is itself complex, so that it feeds a restless urge for meaning, which can only be slaked by more research and more interpretation. Why, Holberton asks at the end of a very critical review of Settis's book, would Gabriele Vendramin have wanted a picture of a gypsy family, especially one that is "considerably idealized"? "Well, surely," Holberton adds, "that is an extremely interesting question. It is time someone set about answering it, instead of overriding the evidence."[60]

BOTTICELLI'S "POETIC" MEANINGS

A complement to "meaningless" *poesie* are "poetic" meanings—Subject paintings by nature so diaphanous that they appear as Not–Subject. Calling the *Tempesta* a painting of music or poetry is an example of this, and several of Botticelli's pictures are built around especially silky primary meanings. The principal theories regarding Botticelli's sources are fewer but no less embattled than the alleged sources for Giorgione's *poesie*.[61] Since Neoplatonism—an undoubted source, among others that are less widely accepted—is syncretic and synthetic, its meanings tend not to contradict one another; but neither do they reliably add to produce a single central meaning. (Neoplatonic meanings have also been proposed for the *Tempesta*, with similar effects.[62]) To the extent that they embrace Neoplatonism, the proposed sources for the *Primavera* do not conflict or build, but blend and alternate. They tell a story of commingling meaning (plate 31).

The painting is an unambiguous Subject since it is about the spring, *Primavera*, but its blending of ancient and Renaissance texts prevents it from being perfectly unequivocal. The sources themselves (among others there are Neoplatonist educational philosophy, Apuleius's *Golden Ass*, and a poem by Botticelli's contemporary Angelo Poliziano) soften the Subject, and they are not at odds with one another. Yet the negotiations between these

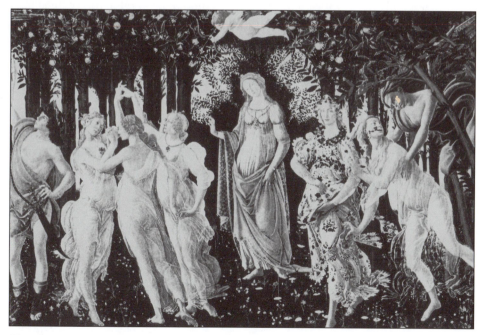

Plate 31

subsidiary meanings do not issue in a simple hierarchy of leading Subject and trailing references. Instead the choices among meanings that blend and alternate produces a higher-order conflict, and that conflict continuously speaks of the possibility of resolution — it reminds an unhurried observer that there is a resolved Subject after all, even though it becomes increasingly difficult to specify.

In recent scholarship these blendings have themselves blended with a half-dozen other interpretive strategies. Charles Dempsey distinguishes two principal modes beyond Neoplatonism: those that look first at the "humanist study . . . of ancient and vernacular poetry," and those stressing civic festivals, jousts, and other social contexts; in addition there are biographical, alchemical, astrological, and hermetic–Christian interpretations.[63] Dempsey's own approach is partly textual and partly anti-textual, since he aims to show "how to read the *new poem* encoded in the *Primavera*."[64] Some such approach is essential, since as E.H Gombrich notes, Botticelli's mythological paintings "are not straight illustrations of existing literary passages," but adaptations, based on "'programmes' drawn up ad hoc by a humanist."[65] Even aside from the Neoplatonic penchant for layered, compatible meanings, the painting is the product of a philosophic and courtly milieu that delighted in "twists of exegetic ingenuity" and the application of wit, and so it is to be expected that no single level of meaning will do.[66] Gombrich gives three lists of meanings for the Graces, each in letters Marsilio Ficino wrote to Lorenzo de'Medici: once they are "Verdure, Light, and Gladness," then "Splendor, Youth, and Abundant Happiness," and again "Jupiter, Sol, and Venus." Given such prolixity the problem is "not that we do not know any meaning, but that we know too many."[67]

The *Primavera* has also been read as Anti–Subject, in particular by art historians who prefer to look at the painting itself rather than spend time collating sources such as Ovid, Politian, or Apuleius. Ronald Lightbown says we should "look at the painting afresh, and carefully describe what we see" in order to free ourselves of the biases of previous scholarship.[68] Some Neoplatonic readings lend themselves to the Not–Subject, especially when they dissolve Neoplatonic tropes of transcendence into modern anti-metaphorical vagueness: Giulio Argan, for example, calls the painting's heavenly light an "interpretation" of space and objects "above and beyond considerations of knowledge," outside of logic, detached from matter, and deprived of corporeal substance.[69] At its limit, Neoplatonism can foster a kind of weak reading in which any iconographic source looks too precise, and no identification needs to be pressed.[70]

The same elusive dynamic can be found directly in the painting's arrangement. The *Primavera* is almost symmetrical: the central Venus and flying Cupid are flanked by three Graces on the left, and three figures on the right—but there is an "extra" figure, Mercury, on the left margin. At first, Mercury seems to balance the blue Zephyr flying in from the right.[71] The slight departure from heraldic balance announces that the play of meaning will be subtle. It says, in effect: Meanings are not fully determinate here, but there will be elisions and subtleties to contend with. Botticelli's typical figural distortions and his gentle reminders of "Gothic tip-toe" have an analogous relation to clear meaning, since they are neither firmly within the Renaissance orthodoxy of *contrapposto* nor indulgently nostalgic and anachronistic. His carefully chosen figural proportions give the picture a symbolic look, setting the stage for allegorical readings, and signifying a freer play of meaning than a viewer might otherwise anticipate.

This is where the distinction between Subject and Anti–Subject begins to break down: a single meaning can be so gently articulated and so bewilderingly rich that it can be difficult to name, as in the *Primavera*; and conversely, a flight from meaning can produce a nebula of partly cognized possibilities, as in the *Tempesta*. But even in the shimmering interpretations of works like these there is the lingering presence of the strict Subject, the invisible Not–Subject, and the ghostly Anti–Subject.

THE AMBILOQUY OF THE SISTINE CEILING

The Sistine is another monstrous topic, and it is likely that the cleaning has only temporarily distracted historians from the ongoing debates about its meaning.[72] (Cleanings have the effect of making it look as if substantive issues have been settled; the same has happened with the restorations of the *Last Supper* and the Brancacci Chapel.) The depths and radical divisions of the proposed readings of the Ceiling are not widely known outside of Renaissance art history, both because the general outlines of Michelangelo's intentions are clear, and because the alternate readings have tended to appear in unusually lengthy articles.[73] The Ceiling has been interpreted as a soteriological, anagogical, and ecclesiastical narrative, as a covert celebration of the Papal family, as an exposition of humanist Neoplatonism, and in various ways as a formalist aesthetic exercise or an essay on illusionism. Today a monograph that answered the major earlier readings would be almost inconceivable—it would have to look more like a short encyclopedia than a book. Few Renaissance specialists have a working knowledge of the intricacies of even the major interpretations by Esther Dotson, Frederick Hartt, or Staale

Sinding–Larsen. Instead, their theses are known in a general way, and their individual arguments—many of which have force, and most of which are not cited—are bypassed in favor of their overall import.[74] (Art historians tend to justify not reading each of the hundreds of sources on a subject by saying that minor sources are trivial or unoriginal. The Sistine literature is a clear counterexample, since its "minor" sources include major texts that have not been effectively addressed in the scholarship.)

The Sistine Ceiling may be an ambiloquy, a discourse on ambiguity, in addition to its necessary Subject. One sign that Michelangelo may have intended ambiguities is that those who have attempted to see the Ceiling as a single painting have fallen into self-contradiction when it comes to details (plate 32). Charles de Tolnay's reading has it that the Ceiling represents the Neoplatonic progress of the soul: along the spine, the soul ascends from a degenerate state (the *Drunkenness of Noah*, on the left) to perfection (the *Division of Light from Darkness*) as the worshipper walks toward the alter. Viewers who stop midway, and look upward from the walls to the spine, see first a realm of "darkness and death" in the lunettes and severies of the ancestors of Christ (the darkness has been lifted by the cleaning, but not the figurative death): "a world without meaning, without history, without hope and aim," where "generation after generation of men pass by in [the] shadowy sphere, perceiving nothing of the "true reality" of the superior world."[75] The bronze-colored nudes in the spandrels are, in the words of another writer, "unillumined captives of ancient ignorance."[76] Higher up, the prophets and sibyls "share" in the Divine, and the nudes (*ignudi*) serve as "prototypes" of man in their direct relation with God. Hartt has pointed out rudimentary logical contradictions in this reading. It is not clear, for instance, that there is a higher and lower realm at all. How do we know that the "trancelike" lower figures "are not absorbed ... in the meaning of the scenes that take place above them?"[77] And the horizontal and vertical schemata contradict one another. If the first scene, of the *Drunkenness of Noah*, is "the lowest stage of the soul," then how can it be *above* the prophets? And is the entire Holy Family to be plunged into the "zone of shadow and death"? But despite its Neoplatonic aura, Tolnay's interpretation is not entirely off-base, and its moments of self-contradiction may be taken as an indication of the trouble that awaits any overall account.[78]

On another level, the Ceiling may be an ambiloquy because of the peculiar attitude its interpreters take to contradictions between their accounts and rival interpretations. Recent writers have not so much tolerated such contradictions as they have ignored them, on the double assumption that the Ceil-

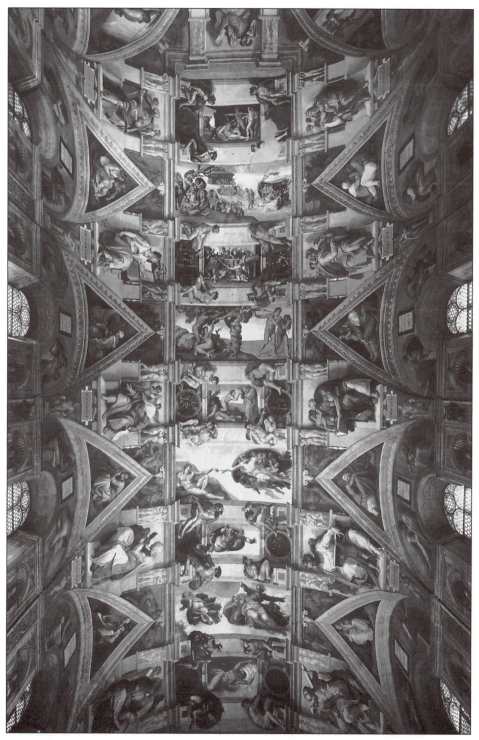

Plate 32

ing must have a single Subject and that its details, rich as they may be, must all bend to its principal purpose. A single example can conjure the current state of affairs. The prophet Jonah is set at the head of the Ceiling, between the first scene of creation, the *Separation of Light and Darkness,* and the altar wall containing the *Last Judgment* (plate 33). He looks backward, his glance grazing the creation scenes, his arms stretched behind his back in an awkward gesture. Edgar Wind says he is meant to be "arguing with God about justice and grace, demanding the destruction of the wicked" in the *Last Judgment* (Jonah 4:1–3).[79] In Hartt's opinion, Jonah is foretelling the

Plate 33

episode of St. Peter and the Miraculous Draught of Fishes (John 21:6). He defends the supposition by noting that Jonah's gesture indicates he's pulling on a fishing net, and that his fish is too small to be the "whale" that swallows him in the Book of Jonah.[80] Sinding-Larsen objects, saying that symbolic animals and attributes are often small, and that the gesture doesn't represent the pulling of a net. She argues instead that he is to be associated with Christ because his enigmatic gesture "repeats" God's gesture in the second scene on the spine. In addition, the pendentives on either side of Jonah—the *Hanging of Haman* and *The Brazen Serpent*—are references to the Crucifixion and therefore reinforce the identification of Jonah and Jesus. To Dotson, Jonah is a "'sign' of the Resurrection" (Matthew 12:39–40) and the "salvation of nations."[81]

These conflicts are irresolvable because each historian is bent on finding a single theme for the Ceiling as a whole. Dotson's reading, which is an examination of Augustinian meanings, and Hartt's proposal that the Ceiling is a Tree of Life, are cases in point. Hartt says he can "hardly imagine an iconographic system in which some of the scenes are anagogical, others literal."[82] Yet why should the *City of God* or the Tree of Life provide the reason for *all* the figures, for each scene, and every sequence? And why should the ordering principle (whether it is soteriological, anagogic, or some other) be the same throughout? The sometimes programmatic mentality of these exercises, entirely apart from their persuasiveness or historical grounding, might give pause for thought. One of the things that could give rise to a corpus of relatively self-sufficient and determinedly self-consistent monographs is an ambiloquy: a work that declares a single Subject, and then dissolves into a partly illegible orchestration of multiple meanings, provoking and then confounding any determined interpretation.

The self-contradiction of monothematic readings and the point-by-point contradictions between alternate readings, are two kinds of evidence that the Sistine Ceiling is an ambiloquy. To pursue the hypothesis it would be necessary to describe how and where Subject yields to Anti–Subject, or unambiguous ordering yields to indeterminate or indifferent ordering. But before such a reading can even get underway, it is hobbled by the realization that the Ceiling fails to present any clear (that is, reasonably unambiguous) division into parts, units, scenes, episodes, figures, motives or motifs, types, or sequences. Charles Seymour concludes his survey of the literature by remarking that "despite recent profound research it is not yet wholly certain how, in a more specific dogmatic or theological sense, all the various single elements of the theme relate precisely to each other"—but what, exactly, are

the "single elements"?[83] Malcolm Bull begins an essay on the Ceiling by stating there are "about one hundred and seventy-five picture units" in the Ceiling; but depending on how a viewer counts, there may be a dozen or a thousand.[84] Ascanio Condivi's account, generally thought to have been given him by Michelangelo, pauses longer than a modern viewer might on the *Flood*, simply (so it seems) because it has more figures, and so requires a longer description. The *Flood* scene contains on the order of fifty figures, and he doesn't spend fifty times the space he expends on *The Separation of Light and Darkness* (with its single figure): but it is clear that figures are "picture units" to him in a way they aren't for modern viewers.[85] To Sydney Freedberg, the Ceiling is composed of "single figure units," so that "[t]here is no wish to pursue . . . the idea of a unity of many figures in a single, naturally coherent space."[86] Several historians have tried to find middle ground. Sinding–Larsen complains that "Hartt's treatment of the whole is too complicated and his argumentation does not consider the visual economy of the frescoes, their compositional distinction between what is important and what is less important. . . . [but] simplicity in itself [as in Tolnay's reading] is hardly enough to make a case acceptable."[87] As usual, Heinrich Wölfflin has the most acute eye for such things. At one point he notes the spandrels are at right angles to the "histories," "so that both cannot be considered together, and yet it is impossible to separate one entirely from the other, so that the imagination is continually on the alert."[88] An observer knows there are "picture units," but it's never quite possible to settle into looking at just one because their interlocking parts are always poking at the corner of the eye, "torturing"" (as Wölfflin also says) the mere act of looking. (The same might be said of Sven Sandström's essay on the Ceiling's "levels of unreality," which assumes "a zero point in the construction," a depth of illusionistic surface that seems deepest, even though Sandström knows Michelangelo has intentionally designed the Ceiling so that no such level can be determined.[89]) Where can an analysis begin when a work presents itself, in Seymour's nearly self-contradictory formulations, as "a unity on a hitherto unprecedented grandeur of scale, rather than a dialectical interchange between equal pairs of like compositions," but also a collection of "elements" expressing a theme that is "enunciated in one place, rephrased in another, reinforced and enriched further in still others"?[90]

Any agreement on "units" will do to begin an analysis, and most historians posit a division into nine Genesis scenes, seven prophets, five sibyls, and so on: but, oddly enough, even such relatively unproblematic starting places only underscore a more difficult issue, since they bring out the possibility

that Michelangelo managed the transition from obvious primary meanings to possible ambiguations *differently in each case.* There is no general principle, in other words, that might govern or predict how secure meanings shift into ambiguous ones: no grammar in the ambiloquy. That could mean Michelangelo had shifting criteria for the decision to introduce ambiguations, or that he simply stopped making rigorous demands on ordering and meaning differently at different times.

There is, for example, indisputably a break between the trumpeted unambiguousness of the Ceiling's central aim (to cover the period from Genesis to the Flood, and to compare it to the ancestors of Christ) and the unstable meanings of the *ignudi* (they have been seen as simply "nudes," as the human soul, as the cherubim of the Temple of Solomon, as angels, and as prototypes of man). The suddenness of this diffusion of meaning has prompted historians to try to be systematic; but in order to build a fuller reading of the Ceiling, we would have to try to say why that dispersion seems too rapid. Are the *ignudi* obtrusive enough so that they erode our confidence in the meaning of the central scenes?

A fuller count yields other difficulties. There are ten classes of figures: (1) ancestors of Christ in the lunettes below; (2) another set of ancestors in the severies above them; (3) small *putti* holding up plaques with the names of the prophets and sibyls; (4) alternating prophets and sibyls; (5) small *genii*, figures that accompany the prophets and sibyls; (6) caryatid *putti* on either side of each throne; (7) bronze-colored figures in triangular spaces between the prophets and sibyls; (8) the *ignudi*, seated on the entablature; (9) figures on bronze medallions held by the *ignudi*; and (10) figures in the scenes along the spine of the chapel. To say these are "classes" obscures the unsteady relation between figures meaningful as narratives, as signs, and as decoration. Surely the "class" of *faux-peintures* (as in the Genesis scenes) are narratives—but is every *faux-bronze* or *faux-marbre* a sign? Where exactly does "decoration" effectively begin?

A second instance, just as often discussed, is the "mistaken" ordering of the nine Genesis scenes. They are primarily chronological, but there are troubling exceptions. Most prominently, the episode usually identified as the *Sacrifice of Noah* is before the *Flood*, rather than after it as in the Bible.[91] In the scene nearest the altar, God is apparently dividing the light from the darkness, which was done on the first day. In the second scene, He is making the sun and moon, something done on the fourth day, and he is also shown flying toward green vegetation, indicating either the production of the earth or of plants—both done on the third day. The second day of creation,

the "separation of the vaults" of Heaven from "the water beneath," is there-
fore not shown, unless it is the first scene. On the third and last panel of the
first triptych, God is shown hovering over the waters, suggesting one of four
texts: Genesis 1:2 ("a mighty wind swept over the surface of the waters,"
before the first day), Genesis 1:6–8 (the "separation of the vaults" of the
firmament from the waters, on the second day), Genesis 1:9–10 ("the gath-
ering of the waters" to produce seas, and separate land and water, done on
the third day), or Genesis 1:20 (God "commanding the waters to bring forth
life" on the fifth day).[92] Various arguments have been made defending these
readings; but no matter how they are interpreted, the triptych is not chrono-
logical: the best that can be managed is *First Day, Second Day, Second Day*
or *First Day, Third Day, Second Day.* Together with the "misplaced" *Sacri-
fice of Noah*, this misarrangement is evidence that ordering principles may
also be at work.

A third instance concerns the bronze medallions suspended and propped
between the pairs of *ignudi*. A specialized literature is devoted to discovering
their meanings, even though they did not seem to be of concern to either
Vasari or Condivi.[93] In an elegant short essay, Charles Hope establishes their
subjects and draws some conclusions about how strictly they could have
been read.[94] First, there is evidence the ten are not a single sequence,
because the two nearest the altar, representing the Sacrifice of Isaac and
Elijah carried up to Heaven, are types of the Crucifixion and Resurrection,
and so they were probably meant to be seen together with the prophet Jonah
(above the altar wall) and the pendentives of Haman and the Brazen Serpent
(on either side, above the altar wall; both are also types of the Crucifixion).
Second, the ten medallions are not in chronological order, perhaps "specif-
ically to indicate that they are not to be read as a continual narrative, but as
a group of exemplary studies." It follows that "no very great thought went into
their arrangement."[95]

The problem I am aiming to characterize is that examples like these (the
number of "classes" of figures, the relation between the narratives and the
"decoration," the disordering of the Genesis scenes, the disordering of the
medallions) are incommensurate. If every set of like episodes were disorderly
in the same fashion, or if every transition from meaningful to decorative
figure were managed equivalently, there would be less difficulty in arguing
the Ceiling is intentionally ambiguous *in certain ways*, or to certain
purposes, and therefore that it is partly an ambiloquy. Without such concor-
dances it is not easy to settle on what *kind* of analysis is most appropriate.
How do we achieve what Dotson calls "agreement on possible bases for

choice"?[96] And how do we know where to stop, or even what to take as given? What is "unity" or "complexity" here?

The three examples show up inconsistencies among the inconsistencies, and it is not surprising they provoke very different kinds of responses. Most scholars react by proposing very exacting programs that would enlist every ambiguity in a single theme—and typically the themes become outlandishly complex, theologically obscure, or unusually demanding on potential viewers.[97] Many other specialists have only contributed studies of portions of the Ceiling, where meanings can be argued in a more traditional manner.[98] Rudolf Kuhn, in a typical case, has to claim that eight of the ten medallions portray the Ten Commandments, with two doubled up on single medallions: surely, as Hope remarks, a "bizarre way of devising an iconographic programme."[99] Others react by softening the criteria, and allowing meanings to shift and settle. For some, the disorder of the nine Genesis scenes indicates Michelangelo's artistic freedom from "ecclesiastical rigor."[100] Tolnay excused the odd position of the *Flood* by suggesting Michelangelo "required the only large field available for the story of Noah": but what consequences follow from such an assertion? What arrangements *would* be significant, if any could be moved for aesthetic reasons?[101] Psychoanalytic and feminist readings produce the same softening, by changing the terms of the conversation enough to shelve old disagreements.[102] And as in Botticelli's *Primavera*, there is the problem of Neoplatonism's inherently multivalent meanings. Tolnay's vertical progression, for example, is divided into five steps: (1) the large *ignudi* above the prophets and sibyls are good spirits, *demoni buoni*; (2) the *putti* below, holding the seers' names, are evil spirits, *demoni cattivi*; (3) the *spiritelli* beside the seers represent divine love, *amore divino*; (4) the marble-colored *putti* or caryatids stand for human love, *amore humano*; and (5) the bronze-colored *ignudi* on the level of the seers stand for bestial or animal love, *amore ferino*.[103] Hartt takes this to task, both for its larger flaws (which I have named) and for its lax use of sources. Tolnay's categories, Hartt says, are "sort of" derived from the humanist Giovanni Pico della Mirandola, and "sort of" from Benedetto Varchi, and there is little rationality in multiplying categories like a "flourishing kindergarten."[104] But Tolnay might have replied that inventive syncretism is very much in the spirit of Neoplatonic writing, and so Tolnay's methodology might fit the Ceiling better that Hartt's, even if his five-fold configuration does not seem to fit the facts.[105]

One of the most creative approaches to managing ambiguity is Bull's idea that art historians should stop looking for textual sources that might explain

the Ceiling's meanings, and instead search for general formal and structural parallels (what he calls, in an idiosyncratic usage, "syntagmatic models"). He suggests the works of Gioachino da Fiore and the later *Libro delle figure* as sources for Ceiling-like genealogical diagrams, and there are certainly intriguing general correspondences between Gioachino's geometric schemata and the overall look and *dramatis personae* of the Ceiling.[106] They aren't exact enough to be called iconographic precedents, but Bull's argument is that they are the type of explanation that is best suited to the way meanings are altered, ambiguated, and arranged on the Ceiling.

The Sistine Ceiling has an utterly unambiguous *sensus litteralis*, to "show the development of the Church from its divine conception to its manifestation in Pope-ruled human society."[107] It complements the fifteenth-century frescoes on the walls beneath, which represent the lives of Jesus and Moses: as Freedberg has pointed out, the Ceiling represents man *ante legem*, in "prelude" to the fifteenth-century depictions of man *sub lege* and *sub gratia*.[108] Problems arise not because the *sensus litteralis* is complemented by more ambiguous meanings, or even because there are places where those meanings melt into decoration. The Ceiling is difficult because it is likely that Michelangelo intended it to be *unevenly* ambiguous, so that manifest meanings may slide at any moment into unresolvably rich references. One figure (such as Jonah) might be the focus of a beautifully orchestrated group of references to salvation, and then another next to it (the first two *ignudi*, the second set of medallions) might be products of "no great thought." There is no reason to assume that such "tortures" are not entirely intentional.

LEONARDO'S POSTMODERN *LAST SUPPER*

The literature on the Sistine Ceiling, the *Primavera*, and the *Tempesta* is the symptom of an irritation. Like Leonardo's *Last Supper*, the works embrace vacillation and take nuance as a governing principle, and that irritates scholarship bent either on unified solutions or on manageable ambiguities. The Sistine Ceiling raises the possibility that a very complicated work might appear to be about complexity itself—as if Michelangelo were embodying *all* of the antetypes and analogies between the Old and New Testaments. It is plausible that the Ceiling is partly an ambiloquy, in the sense that Michelangelo managed ambiguity as an organizational principle. That may also be the case with Leonardo's *Last Supper*.

Certainly the literature (and by implication, the works) are complex. The questions are also vexed: for many writers, it is annoying not to be able to close a case once and for all. "What is this nonsense about 'subject and 'not-

subject'?" Paul Holberton asks, "Why is it so hard to accept that Giorgione might have painted a gypsy family?"[109] The literature is overgrown, and even monstrous: has it reached a point where it makes sense to call it pathological? The rarely-read essays that comprise most of the bibliography of art history are a luxuriant undergrowth, wild and apparently endless. I have been suggesting that they can be understood as symptoms, as if they were an allergic rash that has grown up around a poisonous sting. The source of the inflammation, I think, is the conviction that pictures are complex, coupled with the inability of many writers to put the complexity in words, and exacerbated by the odd feeling that art history might be doing something wrong—that it might, in the end, be projecting historians' desires onto the pictures.

Steinberg is one of the few scholars who addresses this. He is aware of the fact that modernism is in love with ambiguity and has a penchant for seeing it where it may not exist. "Ambiguity," he notes, comes from the Greek *amphibolia*, meaning a predicament, but modern taste enjoys indecision and now we seek out ambiguity rather than avoiding it.[110] Twenty-five years after Steinberg's essay, our infatuation with ambiguity has hypertrophied. Most visual theorists no longer like the word "ambiguity": it sounds restrictive, and it is frequently replaced by "polysemy," the "supplement," the "full word," "dissemination," and other such terms. These are signs of a dangerous love. If multiple meanings are to be found everywhere, and if they are the condition of consciousness and language itself, then how can we know when we hallucinate the objects of our desire?

To Steinberg, "the question is not either/or—not who is right," "but rather, what is it in Leonardo's presentment that allows this plurality of interpretations?" Which competing meanings shall we take seriously? All, if they are "intelligent," proceed from "correct observations" and do not contradict one another: "it is assumed," he concludes, "that intelligent reactions to the *Last Supper* constitute a source of insight into the work itself. Scholarly disagreements are not treated as true-or-false situations, occasions for taking sides, but as hints that Leonardo is doing more than one thing at a time."[111] One might object that an artist may want to be self-contradictory, or to partly lose control over a work's meanings. Nor is it clear when an interpretation fails to be sufficiently "intelligent," so that it might contradict other interpretations. Is a *Tempesta* set in ancient Phoenecia, populated by the God Baal and his consort Astarte, "unintelligent"? How is it not based on "correct observations"? The historian De Minerbi, who proposed that reading, did not go out of his way to "contradict" other meanings. Do we then

accept his theory as one of Giorgione's intentions, or as part of the work's "presentment"?

To Steinberg, the only way an opinion can be incorrect is if it proceeds from "[in]correct observations" or presumes "to invalidate" another opinion. But aside from the engraved and painted copies, what opinions he cites *do not* set out to overturn previous opinions? And since ambiguities are admissible *ex hypothesi*, then what exactly is an "incompatible" reading? (After all, ambiguity is by its nature the simultaneous existence of alternate meanings.) Steinberg is extremely lenient about alternate points of view. "For this writer," he concludes, "there is one determining consideration: that it is methodologically unsound to imagine Leonardo insensitive to the implications of his inventions" (369). It's salutary to remember that great artists knew what they were doing, and weren't constrained by the simple rules that twentieth-century iconographers have tended to prefer. And it is often the case that great artists are more in control of their meanings, and more apt to want to control meanings, than average or unknown artists. But this reasoning can only land us in an odd place, where we impute potentially infinite ambiguity to an artist who is thought to be sufficiently skilled or "intelligent." I was arguing that the scholarship on Giorgione remains present in our minds, and therefore becomes part of what Giorgione *is* to contemporary thought; but that is different from claiming, as Steinberg does, that the alternate meanings were potentially *all true at once* in the painting.

This question was Freud's before it was Steinberg's. In "The Moses of Michelangelo" Freud wonders: "What if we have taken too serious and profound a view" of the details of the *Moses?* "What if we have ... thought to see quite clearly things the artist did not intend either consciously or unconsciously? I cannot tell. I cannot say whether it is reasonable to credit Michelangelo ... with such an elementary want of precision...."[112] Like Steinberg, Freud goes nowhere with this question, which really is not even a question. Freud's essay ends ten lines later.

No one, I think, has a reasonable answer to the question when it is put this way. To answer it, the terms have to be changed: instead of asking about what is the case with Michelangelo or Leonardo—rather than wondering about their intentions, or even their reception—we need to ask first about our own intentions. Steinberg's attraction to ambiguity leads him to find it where others would want it constrained. The more common fascinations with single solutions, with the picture-puzzle metaphor, and with iconography, are ways of repressing the utterly uncontrollable play of unmanageable meanings. Iconographers flee from enigma so forcibly that they commit sins

of commission, pressing their own sense of a picture's richer meanings into an ill-fitting theory. Listen, for example, to the reductive logic by which Elhanan Motzkin justifies identifying the "soldier" in the *Tempesta* with Romulus. "There are several possibilities," she writes:

1. The young man is both a shepherd and a soldier. He could then be Romulus, because Romulus was brought up with shepherds and fought to protect them from brigands in his youth, and so was in a way both a shepherd and a soldier.

2. The young man is a soldier only, and the staff is not a staff but a lance with no armed point. This interpretation is possible if we accept that the painting is basically an anti–Roman pamphlet. Then the man could still be Romulus because Romulus was closely associated with lances: after his death he became a god under the name of Quirinus, and Plutarch says that "Quirinus" comes from the Latin word "quiris," which according to him is equivalent to a lance.

3. The staff is a symbol of authority, and refers to Romulus's future kingship.

So in all three cases the young man could be Romulus.[113]

We know what we do in some measure, but much of our discipline is effectively out of our hands. Motzkin is wary of "surrealism" (in my terms, the Not–Subject) and the lure of enigmas, but she is drawn with such force to the opposite pole that she loses control of the logic of her own argument.

Curiously, the growth of monstrous literatures also spawns a kind of writing that could be used to interrogate art history's habits. I am thinking of the history of reception, which chronicles the reasons past historians and critics have been drawn to artworks. Much of the history of the reception of the *Tempesta*, for instance, is already in place. We have some idea about what Giorgione's paintings meant in the early sixteenth century, because we have contemporaneous poems and a few relevant letters on the subject of *poesie*. It is possible, but not proven, that both George Sand and Byron admired the *Tempesta*, and if so it would be possible to construct an explanation of their enthusiasm in terms of the romantic enthusiasm for nature.[114] Later in the nineteenth century, as interest in the painting grew, the writing gathered around aestheticizing ideas that were crystallized by Walter Pater. In the early twentieth century, the reaction against what was perceived as the nebulous transcendentalism of the previous generation was expressed in a series of narrow iconographic readings, beginning with Wickhoff's. Still later, surrealism may well have played a part in fostering interest in enigma, ambiguity, subjectless "genre" painting, and the Not–Subject.[115] That would be the

historical moment to which Motzkin's essay reacts: the moment between the wars when the Not–Subject became a serious possibility in surrealism and art history. The history of reception dispassionately records how generation after generation projected their fantasies into the picture; but in accord with the customs of the discipline (and not, I mean, by any law of historical understanding), the history does not extend to the present. Reception history is never applied to current scholarship; it never explains the most recent strategy, never accounts for the latest interpretation.

Why do we refuse to press ourselves, to learn more about how our own age might impel us in one direction or another? The usual answer would be that it is impossible to understand the current moment. That, at least, is the common observation that accompanies the fleeting awareness of parallels between what an historian "happens" to be studying and some quality of late twentieth-century culture, postmodernism, or a specific nationalism. A slightly more honest answer would be that it is a little unnerving to think of art history as the inadvertent projection of ideas onto the past. But the answer I would prefer is that we don't want to know what we are doing because we are following a desire: we need to understand what is taken to be the tremendous inherent complexity of pictures. The history of reception and its attendant self-awareness could only interfere. Steinberg's and Freud's encounters with the question have all the signs of a patient who can articulate, but not control, his own neurosis. To the extent that I am skeptical of exempting the present moment from historiographic inquiry, I want to continue the discussion of the Subject up to the most recent and plausible interpretations; but to the extent that I also think pictures are just as bizarre as we say they are, I am content to rummage among the opinions and choose the one that is the least improbable. But the search, as Heckscher says, would only be half serious.

CALMING THE DELIRIUM
OF INTERPRETATION

JE NE SÇAY SI VOUS M'ENTENDEZ: JE NE M'ENTENDS PRESQUE PAS MOY-MESME, &
JE CRAINS À TOUS MOMENS DE ME PERDRE DANS MES REFLEXIONS.

[I DON'T KNOW IF YOU UNDERSTAND ME: I HARDLY UNDERSTAND MYSELF, AND I'M
AFRAID AT EVERY MOMENT THAT I MIGHT BECOME LOST IN MY REFLECTIONS.]

—DOMINIQUE BOUHOURS [1]

Ambiguity has its opposite in rigid certainty, and perhaps the opposite of monstrously ambiguous traditions would be limited traditions, with only a few easy meanings in play. The problem with seeing these conditions as problems is that we would not want to live by their opposites. Unfettered ambiguity is more attractive than dogma, and a good puzzle is more intriguing than a tired old paradox. But there are times when it is sensible to try to call a halt to logically involved, finely detailed, polymathic, and intensely intellectual argument, if only to assess what has been accomplished, and what seems plausible. So I want to pause before we plunge into hallucinations—the last and wildest of the art historical responses to pictures—and see what kinds of arguments might be urged in order to dampen interpretative traditions that seem to be running rulelessly ahead of the truth.

Keith Moxey's discussion of Hieronymus Bosch in *The Practice of Theory* is such an argument: it is essentially an attempt to calm interpretation by proposing that Bosch's public savored a loose sense of the artist's ambiguities without hoping to understand fully what was intended. The paintings would have been reminders of humanist learning, and opportunities for open-ended gaming about meanings. Moxey himself suggests a couple of key meanings, even though they go to show the insoluble ambiguities of the work as a whole. He says a nude figure standing on his head in *The Garden*

of Earthly Delights might serve to remind viewers of similar figures in medieval marginalia, which stand in general terms for "the world turned upside-down." The inverted figure would then suggest the "humanist artist's new claim to artistic freedom." A viewer in Bosch's time might not notice the reference, and would probably not propose it as a meaning for the entire of the *Garden of Earthly Delights;* rather it is an emblem of the painter's unconstraint and a figure for the open-endedness a viewer might expect when searching for meanings. For Moxey, Bosch's pictures were received as enigmas, and possibly also intended as such: they were "to a large extent incapable of being read," so that viewers would have relished the way they resisted interpretation.[2] In part, Moxey's thesis echoes Michel du Certeau, who had argued that Bosch's painting embodies an "aesthetics of incomprehensibility," so that it is ultimately "unreadable."[3] But du Certeau's position gives away too much: it is a close relative of the Not–Subject, and it lays down whatever interpretive power comes to hand. As I read it, Moxey's reading is a middle ground, between narrow certainty and aporia. In the past half-century, a number of texts have cleaved to some kind of ambiguity in order to soften the harshness of iconographic theories. Albert Cook, for instance, speaks of "an overlay of conventional iconographic elements one upon the other ... to the point that we cannot ... detach them and assign significations."[4] Gombrich tries out a schema in which a given painted form in one of Bosch's works might "*represent* a broken vessel, *symbolize* the sin of gluttony and *express* an unconscious sexual fantasy"—and, of course, any symbol might itself be multivalent.[5] Of this group Moxey is the most recent, and among the most reticent.

The great majority of the Bosch literature works differently, and belongs to the "excessive" traditions I have been describing. Most famously, Panofsky compared Bosch to a locked room: "we have bored a few holes through the door," he writes, "but somehow we do not seem to have discovered the key."[6] Especially since Wilhelm Fränger's claim that Bosch was a member of the Confraternity of Our Lady of the Swan, interpretations have tended to be both intricate and arcane.[7] Most begin with a detail or a repeated motif, and then try to expand their readings until the motif provides the "key" to the entire opus. Laurinda Dixon's reading of alchemical motifs, for example, is an inventory of alchemical symbols—essentially a linked series of specific observations.[8] In *The Temptation of Saint Anthony* she points to a frog and an egg, both symbols of the alchemical work, and to "Luna" beside them, another common figure in alchemical texts and images (plate 34). The problem with the reading is that it cannot account even for the other figures

around the table, much less the entire painting. In another context, I took Dixon's theories as evidence that Bosch's paintings are *not* consistently or fundamentally alchemical: they borrow several dozen motifs, but alchemy is not their ruling metaphor.[9] Though there have been other attempts to make more systematic sense of Bosch's alleged alchemy (some, like Madeleine Bergman's, almost following Settis's first rule), so far none has achieved the degree of coherence that might provoke general assent.[10]

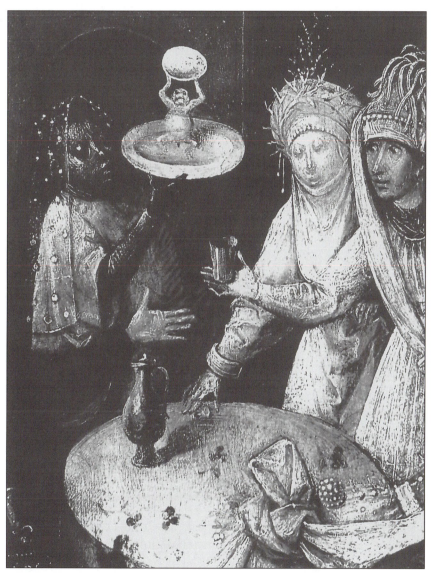

Plate 34

Moxey's figure of the man upside-down works entirely differently: it is a possible clue among many others that point to a general *inconsistency* in Bosch's motifs. The figure stands for the lack of iconographic program, for the lack of a key, a system, or a code to be broken. The indecipherability *is* the code. Moxey's chapter is a salutary effort to try to calm interpretation gone wild with desire for systematic meaning. As Moxey notes, "the literature is strewn with attempts to explain [Bosch's] imagery in terms of astrology, alchemy, rare forms of heresy, illustrated puns, and so forth," and there have been few attempts to quell such tendencies.[11]

Rhetorically, the challenge is almost insurmountable. Even though Moxey's case does not turn on the single upside-down figure, who is only introduced as an indicator—a gauge or a test of the possible meanings of the pictures—it can seem as if the figure is just the beginning of a systematic reading, like Dixon's egg, frog, and lunar woman. The upside-down figure necessarily appears, I think, as if it were the first piece of an iconographic interpretation. By its nature it looks like it should go with other clues to Bosch's humanist orientation, and so Moxey's reading appears curiously incomplete. After all, if Bosch were declaring a humanist's freedom, might he not want to leave deliberately uninterpretable signs, or signs that would be read as planned ambiguities? And wouldn't Moxey's reading be strengthened by finding such signs, and showing—even with an extreme degree of precision—exactly *how* they might have been taken to be uninterpretable? At the least, wouldn't there be other signs that also denote humanist inversions? At times, it seems Moxey is almost swept up by the temptation to make systematic use of signs that denote unsystematic inversion, as when he cites a few examples of womens' "inverted" dominance over men.[12] I take it that he is not trying to build a systematic reading, but his account shows the temptation of systematic solutions. In order to prevail, an anti-systematic reading must somehow contrive to succeed in doing exactly what it critiques: in this case, Moxey's interpretation must appear as a successful application of iconography, even as it uses the newly uncovered meanings to throw doubt on more overdetermined interpretations.

To argue against systematic, arcane, or overly rigid interpretations, it may not be not enough to propose something simpler. A few "upside-down" men and "inverted," dominant women cannot withstand the deluge of alchemical, astrological, mystical, eschatological, heretical, confraternal figures that have already been identified in Bosch's paintings. In art history the few voices that have been raised in favor of moderation, elegance, economy, plausibility, common sense, and ordinary language have been largely

drowned out by the rush to complexity. Michael Baxandall in particular has long been saying sensible things about what painters and writers might have known, and although he is widely read, his moderation has not taken root in the discipline. The necessary project of calming overwrought interpretations by practicing what they preach may be one of the most interesting challenges facing art history. It will become more frequent, I think, as the literature continues to expand.

In this chapter I propose another such argument, unlike Moxey's in method but like it in purpose. I want to suggest how a reading of contemporary texts can sometimes provide very exact reasons *not* to attend to exactness in paintings. I choose Watteau because the contemporary texts offer an exceptionally clear theory about the unclarity of meaning, but I would also like to make a more general point: that any contemporaneous source that declines to speak about precise, particular meanings—that is, the ones we expect—should be taken seriously. We can best slow our headlong rush toward analytic complexity by learning to read the familiar art historical sources as indicators of a certain level of attention, and a certain degree of exactness about pictorial meanings. The Abbé Dominique Bouhours, my principal textual source in this chapter, is explicit on the subject of inexplicitness, but in the end any text will do. Aretino shows us what some people might have seen in Titian's colors; Vasari shows us how much attention even a professional might have paid to symbolic meanings; Pausanius shows us how precisely some Romans might have attended to pictorial composition; Ruskin shows us how some Victorians might have experienced painted landscapes. The possibilities are endless, if we want to see them. To the extent that we do not listen to the sources, but continue to build accounts that would have surprised and bewildered the artists and their contemporaries, we need to think about how we are following the dictates of our own desires. This chapter is therefore my contribution to the question of truth: afterward I will continue to follow the wayward paths of our desires.

ANTOINE WATTEAU'S ESCAPE FROM MEANING

Recent exhibitions and books devoted to Watteau have underscored a perennial difficulty in understanding his painting: as Donald Posner says, "we sense, but cannot explain, a special meaning."[13] Shades of gesture and expression often resist attempts at precise analysis even as they beckon to resourceful interpreters. The paucity of settled meanings, especially in the *fêtes galantes,* led Hal Opperman to remark that "the crucial problem of interpretation [is] the relative presence or absence of precision."[14] M.R. Michel

puts it in more affective terms, as if theories about Watteau's meanings are partly revenge against the painter's obscurities: "The very notion of the *fête galante* clearly troubles us," Michel says, "perhaps because we have neither literary nor social points of reference. We get our own back by crudely interpreting everything in Watteau's work which we find disquieting or evasive."[15] There have been a few interpretive successes, but De Fourcauld's identification of *l'Embarquement pour Cythère* with Dancourt's *Les Trois cousines* and Michael Levey's argument that the painting is really a representation of the moment of departure are unusual accomplishments in a sea of conjecture.[16]

I will suggest here that the search for exact meanings might be inappropriate—that Watteau often did not want to tell one story, but to suggest several mixed together.[17] Like Bosch's contemporaries, Watteau's viewers would have experienced his works as intentional ambiguities; but in Watteau there is little celebration of humanist learning, and no penchant for the kinds of enigmas that garner knowing smiles. It seems much closer to the mark to say that Watteau's viewers would have been entranced by the *idea* of not knowing, rather than the tantalizing prospect of partly knowing. There is little resistance in Watteau's work to an inquiring eye, since a number of actors, plays, and characters can be easily identified. In Bosch's work some figures are aggressively enigmatic, and others are inexplicably misplaced. For Watteau, what seems to count is softening the focus of meaning; for Bosch, painting seems to thrive on brilliant points of partial understanding, and on familiar signs rendered meaningless by bizarre settings.

Watteau's passive elusiveness has only made matters worse, and he continues to be a flame to the moths of scholarship: historians fly around his work, as if they are fascinated by their own incomprehension. A medium-size mountain of art historical writing has been formed of attempts to identify the places, plays, people, and actors Watteau depicted; much of it pays empty tribute to the magnetic attraction of the painter's polyvalent images before it rushes in with an interpretation. One nineteenth-century historian, awakening for a moment from his dream of an art history replete with solutions, regretted "the time . . . lost in the past while seeking with an ill-starred zeal the names of the actors."[18]

A first task in constructing a more reasonable account is to say as clearly as possible how Watteau's paintings are different from the iconographer's dreams. Perhaps the *fêtes galantes* are Anti-Subject: Watteau would then have felt that ambiguity was the primary characteristic of his painting, an ideal—as Empson says—deliberately chosen and knowingly nurtured. In that case, he would have begun with an identifiable subject and then

attempted to remove its crucial identifiers or multiply its references until it could no longer be named. Art of this kind would also coy: it would mean Watteau invited discussion and explanation, but shied away, leaving "shadowy areas" in his pictures." Several interpretations come close to this formulation; Margaret Grasselli and Pierre Rosenberg in particular say some things that are quite close to the Anti–Subject.[19]

If Anti–Subject seems too strenuously aligned against determinate meaning or too vague, then we might rather call the paintings strange Subjects: for example, "sensual allegories of an indeterminate sort, or simple pastoral entertainments, strewn with musical or erotic symbols," or imaginary reconstitutions of the theater.[20] Nor is it entirely impossible that the paintings are Not–Subjects (pictures that were originally conceived as having no subject, rather than pictures that effaced their original Subjects), since there is at least some evidence that the Not–Subject was discussed at the time. Watteau's contemporary the Count Caylus said his paintings had "no object," and he left it at that: implying that they are neither strange Subjects nor Anti–Subjects but merely Not–Subjects.[21]

The kind of passive meaninglessness or unfocused ambiguity I was trying to conjure could be embodied in any one of these options, though it would seem to fit ill-defined Subjects or Not–Subjects best. In the eighteenth century, these kinds of questions were perceived as matters of genre: Was the *fête galante* to be considered a new genre (in which case it would be a new Subject), the absence of genre (Not–Subject), or an escape from genres (Anti–Subject)? In practical terms, *fête galante* is the name of the genre Watteau invented for himself, in order to give his paintings some category so that he could be elected to the Academy. But in analytic terms, the *fête galante* may signal the absence of genre, the avoidance of genre, or an ill-defined genre. Without implying that Watteau might not have been at different times on all sides of this question, we can consider the potential and problems of each model.

A difficulty with imagining Watteau as an Anti-Subject painter lies in describing exactly *how* he moves away from an originary subject. His three paintings of Cythera are especially illuminating in this context. An early version of *Le pélerinage à l'isle de Cythère*, his set-piece for the Academy, has all the trappings of the stage: a copy of part of a garden at Saint-Cloud, costumes, parasol pines, a gondola, tents, and other *chinoiserie* all conspire to signify a ludic theme (plate 35). But the picture is seamless, and there is no shadow between backdrop and stage, no rents between actors and audience. Watteau has literally painted over the boundaries between different

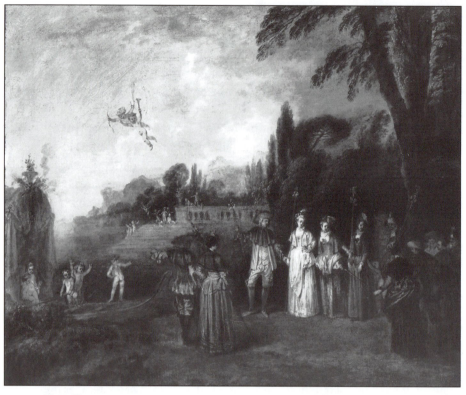

Plate 35

portions. In later versions and in other pictures he continued erasing the stage, moving from specific plays to theater in general, and from performances to an unspecifiably ludic atmosphere.

Yet Watteau's case would be a simple one if that was all he did to avoid declaring his subject. Other departures from Subject are evident in his work, and they can be listed one after another, tempting us to imagine a narrative of successive concealment. A second step, after the mingling of actors and audience, would involve a gentle but persistent neutralization of dramatic actions. The Louvre *Gilles* may not be a silent moment that was observed in a particular kind of play, as Dora Panofsky maintained; but it certainly replaces action, movement, and gesture by a static *tableau vivant* (plate 36). From a snapshot of a particular play it becomes an emblem of the theater. Alternately, action may be retained but rendered ambiguous; this is excellently demonstrated by the version of *Le pélerinage à l'isle de Cythère* in the Louvre (plate 37). There the action has become so hard to read that one historian has said that the figures are actually leaving Cythera, instead of

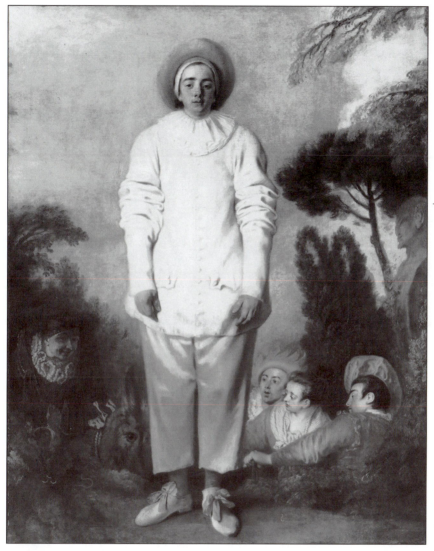

Plate 36

arriving there or leaving *for* Cythera.[22] That claim in turn has been softened by recent scholars, who prefer the idea that the figures are both coming and leaving, so that the "place" is an allegory of site itself, a non-place. At his highest level of abstraction, Watteau would have melted allusions to the theater into instances of theatrical behavior, especially including courtship and conversation. There are paintings, such as the *Assemblée dans un parc* in the Louvre, whose figures may be actors, spectators, or "merely" aristocrats strolling in their gardens. It can seem that at the end of this path of

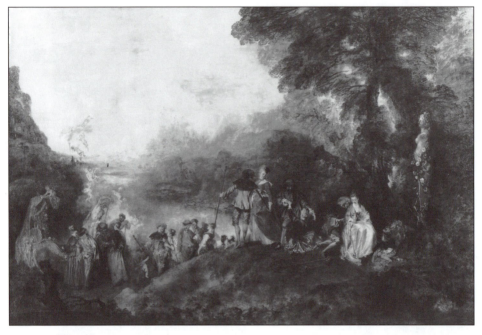

Plate 37

erasures there will be the simple, nameless and anonymous standing or conversing figure, and Watteau painted several such pictures, though he seems to have rebounded each time toward the specifics of Subject.

One problem with reading Watteau as an Anti–Subject painter is that these strategies do not form a sequence that runs through his work, so that he could be observed as he discovered each new way of avoiding the Subject. Much more often it appears that he was working with some subject that he simply did not care to specify. But what kind of subject could that have been? The *fête galante*, the subject "invented for Watteau," was not unambiguously recognized by Watteau's contemporaries as a genre. In the Royal Academy records, Watteau's *Le pélerinage à l'isle de Cythère* is listed by name, but the name is crossed out, and "une feste galante" has been put in its place.[23] This document shows that from the very beginning Watteau could induce a vacillation on the subject of Subject. His position induced aporia then as now, and it is not too extravagant to say that he occasionally painted the idea of Subject, rather than Subject itself.

And what would it mean to think of Watteau's paintings as Not-Subject? It would entail not only finding a way to read his paintings outside of genres—outside history, allegory, religion, landscape, portraiture, and most especially outside the genre of "genre painting"—but even outside of genre

itself—in a place somewhere apart from genre. To put it in terms indigenous to Baroque discussions, this amounts to a refusal to read the paintings at all. The "feste galante" itself is proof that nothing existed outside of the classification of genre: a painting that escaped from known genres had to have its own special genre in order to be comprehensible at all. I think that this alternate should be taken seriously, despite its extravagance and its historical failings, since something in the paintings impels us to return to it. Watteau is someone who is read, and then not read: like books, his paintings are continuously closing and showing us blank covers.

It is often said that Watteau's work cannot be "enclosed within a single system."[24] Subject, Not–Subject, and Anti–Subject each capture something at work in his painting, but taken together they do not form a satisfactory explanation of his practice. They are a harsh lexicon, with a Procrustean feel; what is needed is a single term that might fit the work more intimately. In what follows I propose such a term, the *je ne sais quoi*, and a contemporary source, the Abbé Dominique Bouhours, from whom Watteau might have learned it.

THE MISSING PROOF

Since there is so little documentation on Watteau's life, the connection with Bouhours must remain hypothetical; it is not even possible to adduce that "one scrap of evidence" with which Panofsky made his case in *Gothic Architecture and Scholasticism*.[25] Luckily there is a compelling amount of circumstantial evidence which suggests that it is unlikely Watteau did *not* hear of Bouhours after he came to Paris around 1702, the year Bouhours died. To begin, Bouhours's fame was, as V.M. Hamm has put it, "dazzling."[26] He knew La Fontaine, Boileau, and La Bruyere, and Racine submitted his plays to Bouhours "for approval" of their language. Boileau—"no sympathetic judge"—awarded him the palm in his protracted debates with the Jansenists.[27] Bouhours was at the height of his fame in the first decade of the eighteenth century; several of his works were translated into English (Dryden rendered the *Life of Francis Xavier, Apostle of the Indies*). He was praised by Addison and Pope and discussed vigorously by Orsi and Barrufaldi for his tendentious remarks on Italian poetry. His rhetorical question "Is German wit possible?" had already sparked debates in Germany, and Leibniz was among those who responded to his challenge to purify the French language.[28] Bouhours can also be connected with the *commedia dell'arte*: his thoughts on the *je ne sais quoi* were known widely enough to be made the subject of a play.[29]

There were several times in Watteau's life when he could have read or discussed Bouhours. It seems quite likely that Bouhours was a subject of conversation at the meetings frequented by Count Caylus, Pierre Mariette, and Roger De Piles which took place beginning in 1715. At that time Bouhours had not yet been eclipsed by Du Bos and De Piles, and was still the outstanding figure in French aesthetic and linguistic theory.[30]

The rest of the case must speak for itself. There is above all a remarkable chronological coincidence between characteristics peculiar to Watteau's art and various ideas of Bouhours's which just as quickly fell into disuse. For the present purpose the most important is the *je ne sais quoi*, first enunciated in the fifth of Bouhours's six *Entretiens d'Ariste et d'Eugène* (1671).[31] *Je ne sais quoi* and *nescio quid*, its Latin predecessor, are two of the most important premodern terms for intentional ambiguity—though it is important in reading the modern scholarship to bear in mind that neither was intended to describe a state of logical puzzlement, where meanings might finally emerge in all their obviousness.[32] Instead, they name a state of unfocus, of unresolvable meaning, of faint hints and fogs of poorly seen notions: or to put it most exactly, they name the pleasure of such a state.

In the dialogue, the two friends agree that the *je ne sais quoi* is an essential ingredient of all *pensée*; but at the same time they discover it is ungraspable, "incomprehensible," even "inexplicable." There are delightful passages in which they try various strategies to get at the idea. It is like the "flux & le reflux de la mer; que le vertu de l'aiman[t]," and it is even present in an ordinary fever: "Ces accés si reglez," Bouhours has his protagonist ask, "ces frissons & ces chaleurs, les intervalles dans un mal qui dure des années entières, ne sont-ce pas autant de je ne sçay quoy?"[33] But physical and even spiritual examples seem ineffective, and Ariste and Eugène explore literary metaphors. *Goût*, they say, is "un harmonie, un accord de l'esprit et de la raison," so *je ne sais quoi* may be similar: perhaps "*un parentesco de los coraçons*," "pour user des termes d'un bel esprit Espagnol." But in the end all their metaphors fail:

> Mais en disant tout cela & mille autres choses encore, on ne dit rien. Ces impressions, ces penchans, ces instincts, ces sentimens, ces sympathies, ces parentez sont de beaux mots que les sçavans ont inventez pour flatter leur ignorance, & pour tromper les autres, aprés s'estre trompez eux-mesmes.[34]

Sixteen years later, Bouhours wrote *La Maniere de bien penser dans les ouvrages d'esprit* (1687),[35] another dialogue in which two friends, Eudoxe and Philanthe, criticize the mannered *préciosité* that flourished in the

middle of the seventeenth century. *Préciosité* and its related movements— Euphuism in England, Gongorism in Spain, and Marinism in Italy—had drained writers of the ability to speak in a simple and direct fashion without clouds of allegorical embellishment. But Bouhours's real interest was not in establishing the foundations of truth but in describing the façade which properly ornaments it.[36] That which is added to thought is not "mere" ornament like a cartouche or frill, but an essential part of thought. "Le figuré n'est pas faux, & la métaphore a sa vérité aussi bien que la fiction" is the first formulation of this anti-scientific opinion; later he asserts that "le vray ne suffisoit pas."[37] The second book of *La Maniere* introduces the *sublime, agréable*, and *délicat*, three kinds of thought which convey this sense of truth. *Délicatesse* is the crucial kind and most original of these three, and when Eudoxe (who represents the Ancients) mentions it, Philanthe replies breathlessly:

> Ah dites moy, je vous prie, . . . ce que c'est précisément que délicatesse! on ne parle d'autre chose, & j'en parle à toute heure moy-mesme sans bien sçavoir ce que je dis, ni sans en avoir une notion nette.[38]

But, like Ariste and Eugene explicating the *je ne sais quoi*, Eudoxe has some difficulty answering:

> Mais quand vous me demandez ce que c'est qu'une pensée délicate, je ne sçay où prendre des termes pour m'expliquer. Ce sont de ces choses qu'il est difficile de voir d'un coup d'œil, & qui à force d'estre subtiles nous échapent lors que nous pensons les tenir. Tout ce qu'on peut faire, c'est de les regarder de prés, & à diverses reprises, pour parvenir peu à peu à les connoistre.[39]

Finally Eudoxe confesses that *délicatesse* is so difficult to explain that he can hardly understand himself and is afraid his confusion over the concept will infect his own speech (see the epigraph at the head of the chapter).

Délicatesse and its earlier version, the *je ne sais quoi*, are unusual ideas: they are both vitally important and impossible to understand. As Ariste says, the *je ne sais quoi* remains "inexplicable," "quoi que je fasse." Bouhours loves to try to match the subtleties of his prose to an idea which he admits he can never articulate; and I find this remarkable turn of mind again in Watteau. The parallels between them are best developed, as Eudoxe says, "de prés, & à diverses reprises" according to the unsystematic nature of the *je ne sais quoi*.

First, since every thought which contains *je ne sais quoi* is not susceptible to full explanation, it contains an *équivoqué*; and hence for Bouhours, *équivoqué* is an essential part of any thought proper to art.[40] Watteau achieves *équivoqué* most easily iconographical clues, as when he changes the traditional

costumes of the *commedia dell'arte* players—without disguising them completely—and conflates actions so that single meanings dissolve into unnumbered alternatives.[41] In a painting like the *Fêtes vénitiennes* in Edinburgh, for instance, the figures resembling comic actors are scattered throughout the scene: a young man behind the turbaned dancer, a musician, a figure behind him in a jester's costume, and a "rather histrionic" figure in the back are all actors (plate 38). But others are not quite plausible as spectators (a man in a ruffled collar at the extreme right), and the "spectators" are

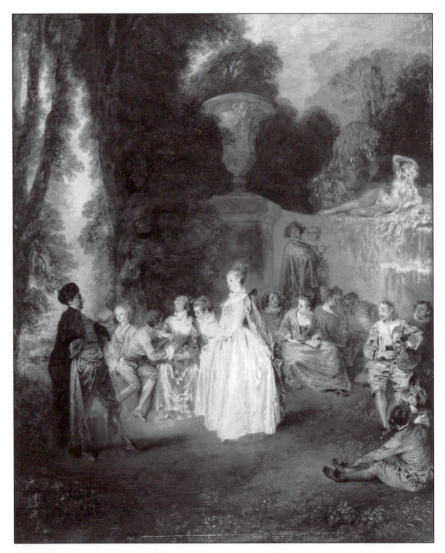

Plate 38

mixed in with the troupe. Even the turbaned man may not be Pantaloon: his costume seems "somewhat oriental," in Ettore Camesasca's words.[42] The figures have suggested a comedy of mistaken identities or a *tableau* of personal relationships including that between Watteau and his friend Jan Wleughels, but their gestures are not quite clear enough to decipher it.[43] By contrast, Claude Gillot is pedantic and even Nicolas Lancret and Jean-Baptiste Pater explain their figures and separate spectator from spectacle.[44]

This kind of erasure is Anti-Subject, but calling it *équivoqué* allows it to embrace a wider range of strategies. Watteau also erases genre clues: the *Fêtes vénitiennes* evokes landscape, theater, genre scenes, portraiture, and even allegory—especially in the disconcerting statue[45]—and each genre undermines the others' meanings. If this is Anti-Subject, then it is against all subjects at once: an odd way to proceed if the purpose were to avoid a Subject. A comparison brings out the way *équivoqué* is attained by blurring iconography and genre. Philippe Mercier's *l'Éducation du chien* in Detroit is an unequivocal moral lesson in a way that Watteau's *Gilles*—or, more properly, *Pierrot*, since the painting is another instance of equivocal iconography—is not (plate 39, and compare plate 36).[46] Both tell of a hopeless education; in both the ineducable subject is by itself, on display; and in both the subjects are either animals or compared to animals.[47] But the *Gilles* conflates moral lesson with theater, portrait, and "self-revelation" (to borrow Dora Panofsky's phrase) and escapes a single moral meaning.

For Bouhours, *délicatesse* and the *équivoqué* it generates are subject to limits. Unadorned truth has a certain graceful *naïveté*,[48] but overly adorned *délicatesse* is affectation:

> Le trop est vitieux par tout, répondit Eudoxe, & la délicatesse a ses bornes aussi-bien que la grandeur & l'agrément. On rafine quelquefois à force de penser finement, & alors la pensée dégénéré en une subtilité qui va au-delà de ce que nous appellons délicatesse: c'est, si cela se peut définir, une afféctation exquise; ce n'est pas finesse, c'est refinement.[49]

Watteau also ranges between these limits: at his simplest and least adorned, there is the direct erotic allusion of *La Marmotte* in Leningrad and the lost *La Fileuse*;[50] and at the other extreme, the exquisite, overwrought affectation of *La Perspective* in Boston or the Louvre *Assemblée dans un parc*.

Bouhours also thinks of *délicatesse* as an opposite of *grossièreté*, a characteristic eighteenth-century term which we might translate as "coarseness," although it also implies prolixity, or something overly obvious or bald. Among painters who are not at all delicate, Bouhours singles out Rubens:

"ses figures estoient plus grossiéres que délicates: au lieu que les tableaux de Raphaël ont avec beaucoup de grandeur, des graces inimitables, & toute la délicatesse possible."[51] In this light *délicatesse* is something which is not spelled out at length; it is more like something unfinished, or something that has to be guessed at:

> Disons par analogie qu'une pensée où il y a de la délicatesse a cela de propre, qu'elle est renfermée en peu de paroles, & que le sens qu'elle contient n'est

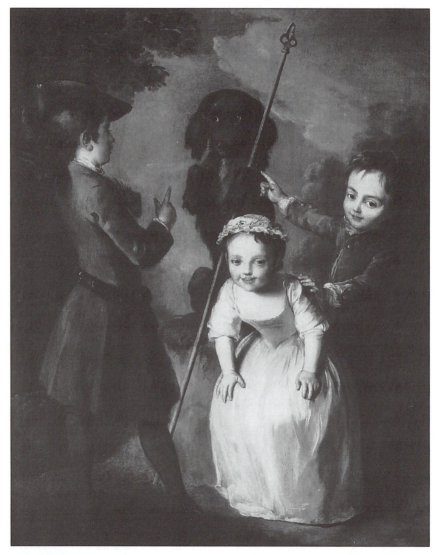

Plate 39

pas si visible ni si marqué: il semble d'abord qu'elle le cache en partie, afin qu'on le cherche, & qu'on le divine . . .[52]

Fragmentary, non-narrative action and the *non finito* have frequently been noted in Watteau's art. Dora Panofsky suggested that the *Gilles* represents the moment in the parade in which a donkey is led across the stage in imitation of Gilles's stupidity. Certainly the painting is a non-narrative moment, since nothing is said and no one needs to move except Pantalone or Balanzone, who leads the donkey.[53] For similar reasons, Watteau's version of the *Judgment of Paris* makes an interesting contrast with Rubens's fully-worked-out version, and its limpid, *non finito* brushstrokes mimic Rosalba Carriera's new pastel technique.[54]

If delicate thoughts are epigrammatic, it stands to reason they might often describe small objects; and Bouhours declares that "Les plus délicats sont ceux où la nature prend plaisir à travailler en petit, & dont la matiére presque imperceptible fait qu'on doute si elle a dessein de montrer ou de cacher son addresse."[55] And this leads to one of Bouhours's most interesting ideas for the fine arts, the "small allegory." "Quelquefois, poursuivit Eudoxe, une petite allégorie fait entendre finement ce que l'on pense, & un seul éxemple vous le sera concevoir."[56] The amorous pairs in Watteau's paintings are "small allegories" in this sense, as Posner has shown for *The Shepherds* in Charlottenberg Castle and as Gérard Le Coat has suggested in the case of *Le pélegrinage à l'isle de Cythère*.[57] And the pictures as wholes are also "small allegories" since their overall meanings must be guessed, and even then may "échappe à l'intelligence la plus penetrante, & la plus subtile."[58]

The interest in small subjects is related to Watteau's aversion to detailed portraiture. "La physionomie ingenieuse est un autre je ne sçay quoy," Bouhours says in the *Entretiens*, because if one searches for what makes a face unique, it is not detail, size, or "la forme & la couleur du visage; que c'est quelque chose qui resulte de tout cela, ou plûtost que ce n'est rien de tout cela."[59] Watteau made few detailed portraits; in most cases he was content to paint his faces small, and sometimes so small that a few painterly strokes suggest an entire personality.[60] In Bouhours's terms, if amassing detail will not ensure the *je ne sais quoi*, and if portraits are nothing without it (as he says elsewhere), then there is no reason to record minute detail. In this, Watteau's practice follows Bouhours and not De Piles or Joshua Reynolds, who held more traditional views.

The most frequent synonyms Bouhours uses to describe *je ne sais quoi* are *charme* and *agrément*, the latter itself one of his three kinds of thought.[61]

Both are unserious, and so it is not surprising that the more sober *sublime* and its accompanying term *noble* recede into the background as the discourse progresses. Bouhours praises authors who can inject an agreeableness into genres which are usually serious,[62] and he makes a general equation between the unserious and the pleasant, giving the impression that passion—as in Du Bos—as well as gravity are not necessary, provided the artist bases his works on truth. This is a very French conception of truth, which ties it to an agreeable manner rather than a heavy seriousness, and in Bouhours it is particularly strong.[63] Agreeableness is also consonant with Posner's critique of the view that Watteau was a melancholic, tortured soul. *Agrément* and the unserious exclude what would have been seen as a heavy Germanic seriousness (a character representing German seriousness is an adversary of the *Je ne sais quoi* in the contemporaneous play of that name[64]). Unseriousness is also a fundamental strategy for undermining the hierarchy of the genres, since if no genre need be more serious than another, the hierarachy collapses.

There is a constellation of ideas around the *je ne sais quoi*, and it would be possible to find parallels for other aspects of Watteau's practice. But these, I think, are the most important concepts. By conflating genres and avoiding single meanings Watteau produces that *équivoqué* so central to the *je ne sais quoi*. A history painting or full-blown allegory would be a *grossièreté*: their opposites are the *non finito*, the harmonious but fragmentary *fête galante*, and the "small allegory." *Je ne sais quoi* is also an example of moderation: it is neither simple *naïveté* nor affectation, as some of Watteau's followers thought. And perhaps most wide ranging is the unseriousness of *agrément*, since it applies to all of these qualities. Thinking of the *je ne sais quoi* makes it unnecessary to torture the Subject, Not-Subject, or Anti-Subject until they adequately fit Watteau's practice, and it also repairs the easy gestures that contemporary writers make toward Watteau's "mystery" or "elusiveness." *Agrément, équivoqué, charme, la petite allégorie,* and the *je ne sais quoi* are a congenial set of ideas: they fit the paintings well, and comprise a clear and unambiguous argument in favor of unclarity and ambiguity. They can resist the attractions of iconographic theories, I think, because they are themselves as exact as the usual run of stage and theater interpretations; and they are more rooted in contemporaneous sources than the polysemy and aporia invoked by recent writers. In short: they surpass the iconographer's game in precision and historical purchase, even as they undermine the very enterprise of iconographic detection.

In the decade after Watteau's death, Bouhours's ideas virtually disap-

peared from French culture. As a phrase, largely emptied of Bouhours's philosophy, the *je ne sais quoi* owes its familiarity to nineteenth century writers, since it had few echoes in the eighteenth century.[65] "Delicate thought" was even shorter lived. It shows up in Voltaire's *Dictionnaire philosophique* under *finesse*, but seems to have had no other influence until the next century.[66] Part of the reason for the disappearance of these ideas is that, like deliberately ambiguous paintings, they are difficult to exposit clearly. They flourished for a brief time when a painter and a *philosophe* took pleasure in inexact and fugitive thought.

ON IGNORING SIMPLICITY

I offer this argument—or rather, this "small allegory"—as a way of thinking about a more general problem. When interpretation seems to eschew simplicity in favor of implausible difficulty, the answer may already be close at hand in the contemporary texts. Vasari, Aretino, Pausanius, and Ruskin, the writers I named at the beginning of the chapter, are no longer available to us as models for our own writing: but they are always available as indicators of reasonable eloquence. When Marcantonio Michiel described the two figures in the *Tempesta* as "[a] gypsy and [a] soldier," he may have said just enough. More, and he would have ruined the delicate *poesia* that Giorgione had achieved; less, and he would have made Giorgione into a programmatic mystic bent on avoiding any understanding. Part of my *Poetics of Perspective* is devoted to trying to understand what it means that Piero della Francesca had no *theory* about his perspective, that he wrote nothing about its symbolic power, its expressive potential, or even its beauty. Perspective was a mute technique, a thing that was drawn rather than described. That difference, it seems to me, is profound, and even if we can never recross the gulf that separates his silence from our loquaciousness, we can try to think about what it might have meant.

By looking to contemporaneous sources we can get a sense of the sharpness of concepts, the size of the critical lexicon, and the span of attention that seemed right at the time. Even though we are compelled to betray it, that kind of information is invaluable. It shows, more powerfully than any argument, how far we have strayed from the works and their time, and how much of our own interests we are bringing to bear. Pondering Michiel's laconic description, or reading Piero della Francesca's affectless descriptions of his perspective, we may begin to doubt the truth of what we write: a doubt that should give us all pause to think why we persist in writing differently.

LOSING

CONTROL

HIDDEN IMAGES:

CRYPTOMORPHS, ANAMORPHS,

AND ALEAMORPHS

HARDLY ANY OBSERVER WHOM I HAVE CONFRONTED WITH MY LITTLE FIND HAS BEEN
ABLE TO RESIST THE EVIDENCE OF THIS PICTURE-PUZZLE.

—OSKAR PFISTER, ON THE VULTURE IN LEONARDO'S
VIRGIN AND CHILD WITH ST. ANNE[1]

Up to this point things have been fairly calm. Picture puzzles demand a
method, some patience, and a kind of tireless half-attention, somewhere
between concentration and boredom. Ambiguities also call for protracted
work, though the thinking is more varied: strategies for containing (or
unfolding) an ambiguity might vary from one moment to the next. Both
puzzles and ambiguities are typically time-consuming, as the art historical
literature testifies.

Hidden images are different. They are the products of a second of look-
ing, or even a fraction of a second. One moment the picture is more or less
incomprehensible—it refuses to declare itself, its meanings seem veiled or
illegible—and the next instant it all makes sense. The picture snaps into
focus, and reveals itself for what it really is: a cryptomorph, an image that
harbors another image as its secret or solution. The hidden image, once it is
revealed, *is* the answer that interpretation has been seeking. It is the paint-
ing's secret, or the painter's secret, and when it discloses itself the painting
becomes transparent to anyone who can see.

Art historians have a penchant for hidden images. They find them most
anywhere, from Michelangelo, Dürer, and Bosch to Goya and Courbet,
from Islamic miniatures to Chinese landscape paintings. Paintings are said
to harbor hidden lines, geometric forms, numbers, letters, ciphers and

signatures, and figures of all sorts—concealed animals, people, angels and deities, heads and skulls, hands, eyes, phalluses, labia, embryos, and "Apemen." Some are taken to be intentional; geometric schemata such as triangles, circles, modules, polygons, grids and lines are usually said to have been concealed on purpose, but organic forms are often thought to be inadvertent inclusions, put there by the unconscious mind.[2] (It is not easy to explain why that should be so: is an inadvertently drawn trapezoid less likely than an inadvertently drawn horse's head?) Some are unique, like the human brain that has been sighted in the Sistine Ceiling, and others are multiple, such as the many infolded deformities half-hidden in the drapery and clothing of Goya's *Capriccios*.[3] Not all are naturalistic: the cases of "anthropomorphism" discussed by Michael Fried in reference to Courbet range from "corporal" self-portraits in, or as, ordinary-looking trees and rocks (that is, foliage, cliffs, and stones that do not especially look like human forms, but stand in for them) to evocations of the painter's body in fish, and his own viscera in flowers.[4] Hidden figures have also been seen in scientific images, such as the fighting dinosaurs and disappearing birds that E.N. Lorenz, the father of chaos theory, found in his computer printouts of new "attractors" (plate 40).[5] (Lorenz had the habit of adjusting the mathematics of his attractors so they played out dramas like birds disappearing in bushes.)

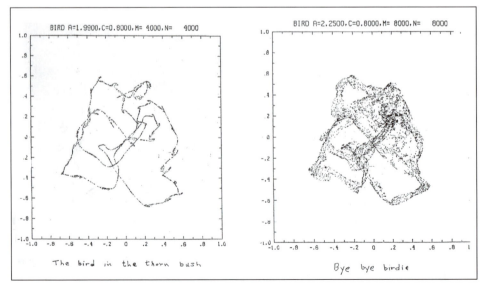

Plate 40

I find cryptomorphs historically puzzling, since they are found throughout the history of Western and Islamic art (but not in China, Mesoamerica, or India); and I find them epistemologically puzzling, since they are neither entirely false nor widely accepted. Since the field is so ill-explored, this chapter has several partly incompatible purposes: I will take up some questions concerning the history of cryptomorphs, and also a few of the problems attending the curious fact that no one finds it necessary to argue *against* them (almost as if they should disappear the same way they came — by fiat). I will also be pursuing a hypothesis about the place of cryptomorphs in the longer history of "chance" and "natural" images. But my principal interest is the behavior of the art historians who claim to find the images, and as I go through the material I hope the reasons for that bias will become clearer. Cryptomorphs, I think, are best understood as signs of a dire anxiety in the face of pictures. Finding something that seems to demonstrate itself may be a way of short-circuiting what is truly disturbing about pictures, and making them into merely surprising tricks: a possibility that I want to take as seriously as I can, both here and in the final chapter.

FROM ALEAMORPHS THROUGH ANAMORPHS TO CRYPTOMORPHS

To Pliny, Aristotle, and Lucretius, hidden images were made by nature, and they could be found by gazing at clouds, cracking open geodes, or sawing petrified wood.[6] Mineral inclusions, theriomorphic (animal-shaped) knots, driftwood, fossilized shark's teeth, arrowheads, and bread- and vegetable-shaped stones, were all taken as evidence of what nature could sculpt.[7] Such forms are variously called hidden, natural, or chance images, or more technically, aleamorphs. A full history would include the *argoi lithoi, baetylia,* and other natural shapes worshipped in early Greek religion: meteorites that were anointed with oil, stone slabs put in temples, unworked planks of wood set up as statues.[8] An example of the mixed nature of natural images is the Renaissance and Enlightenment practice of "improving" and "completing" aleamorphic designs that were found on the cut and polished surfaces of "picture agates." Images found in that way were thought to be originally "drawn" and "hidden" by nature, so that artists who then painted on the stones were helping nature to improve on her own miraculous fecundity, showing off both their skill and nature's at the same time, and producing aleamorphs that were compounds of chance and intention, nature and artifice.[9] The seventeenth-century belief that nature sculpted fossils (rather than merely recording the forms of dead animals and plants), and the early eigh-

teenth-century scandal of Johann Beringer's fake fossils (in which stones were carved in emulation of the kind of schematic fossils that might have been expected at the time), are also examples of the blurred lines between natural and artificial forms.[10] In the anthropomorphization of Nature, both the human mind and the natural world possessed the faculty of *invenzione* or *fantasia,* so that such artworks were not as nonsensical or whimsical as they can appear today.

If we choose not to believe that a personified or spiritualized Nature actually fabricates images, then there are still the images that *seem* to occur in natural and artificial objects. Vasari speaks of both kinds. A stained wall serves as a natural breeding ground for imagined images, but an artist can also set the process in motion by splattering paint or dabbing a panel with a sponge. Vasari tells a story about Botticelli throwing a sponge at a wall to see landscapes in it, and that story echoes Pliny's anecdote about Protogenes throwing a sponge at his painting of a slavering dog to catch the correct appearance of frothy saliva.[11] Vasari's story has been retold as a suggestion for landscape painters, but it was intended as an admonition: Vasari meant to point out that this kind of image cannot teach the fine points of landscape painting, and he goes on to say that Botticelli was not very good at landscapes. There is an important difference between finding a stained wall and making one, because the artist who throws paint at the wall is not reproducing nature's randomness, but making something with purpose and a certain emerging order. In modern terms, we might say that a naturally stained wall harbors no half-formed images until the artist projects them, while an artificially stained wall could plausibly be said to have half-formed images in it: at the least, the pattern of stains will record echoes of the artist's intentional movements.

Typically, aleamorphs are collaborative projects between "nature" and the artist, or (in modern terms) between the artist's tendency to see things that aren't there, and the related tendency to bring images "out" of their inchoate matrices in the material. Occasionally a "random" mark will be enough to serve as an image without being improved or completed. Picasso's *Crucifixion* (1930), an important painting that inventories a number of his previous styles, has a prominent asteroid-like sponge in one corner: one of Picasso's few gestures in the direction of chance images (plate 41). It is an unusual image, since it represents the natural object that could have helped make it. It is at once an aleamorph, an unlikely sun, and a painting of the Biblical vinegared sponge; and like Ugo da Carpi's painting "made without a brush," it cites the acheiropoietic images made in the middle ages.[12]

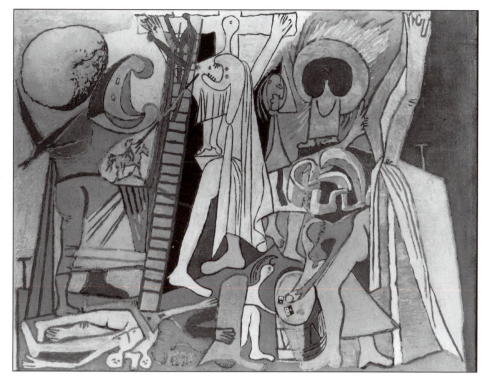

Plate 41

Aleamorphs mingle two possibilities that can be entirely disjunct: either hidden images are seen in objects, or they are placed there. The discourse is further confused by the permutations of natural and human agency: Nature or people might do the placing, and likewise the objects in which things are seen may be natural or artificial. Without disturbing that conceptual disorder, I would like to bring out the difference between "seeing in," as Richard Wollheim says, and hiding. Aleamorphs are sighted, "seen in," and afterward they may also be "brought out" (in the language of the studio). We might prefer to say classical aleamorphs are created by being seen, and that clarifies what I take to be an essential distinction between aleamorphs and other kinds of hidden images: aleamorphs are neither painted nor sculpted. A pure aleamorph is acheiropoietic, an image not made by human hands. By contrast, a pure cryptomorph is *made,* and then seen.

Making this slightly artificial distinction helps suggest a conceptual sequence leading from aleamorphs (which are merely seen) to cryptomorphs (which are imitations of aleamorphs). The conceptual sequence entails an historical sequence, and to introduce it I want to bring in a third term that is

"between" aleamorphs and cryptomorphs: anamorphs. In the sixteenth and seventeenth centuries anamorphs were the most common kind of hidden images. Anamorphs (meaning "without form") were images made with the help of perspective (or with knowledge of perspective, but without its rules), so that they could only be seen from certain skewed viewing positions. The stretched skull in Hans Holbein's *French Ambassadors* has become the classic, overinterpreted example. An image from a few years later, Erhard Schön's *Was siehst du?* (*What do you see?*) shows—apparently—a few marginal scenes, including a small *Jonah and the Whale*, around a central smear (plate 42, top). It turns out that the smear is a man defecating. To see the picture a viewer needs to adopt an uncustomary position, putting an eye close to the left-hand border of the picture. Anamorphs are full of wit about the displacement of the viewer, and humor at the viewer's expense; in this case a viewer who bends and squints to see that's in the picture may also sense a parallel between his pose and the pose of the figure in the print. Nor is it irrelevant that the form of the scene mimics its subject, since the smear is itself scatological. Schön's companion piece, titled *Aus, du alter Tor!* (*Out, you Old Fool!*) is pornographic, and we bend and squint to see it, as if we were looking through a keyhole. Often anamorphs contain a third and final moment, after the initial confusion and the subsequent enlightenment, when something new reveals itself. In this case a viewer who returns to a more normal viewing angle will be likely to search for the distorted figure, and notice the goat just behind him, rearing in surprise or disgust. In *The French Ambassadors*, the final moment may be the one when a viewer discovers the

Plate 42

tiny scene of the crucifixion, visible through the curtains at the upper left—another window on the same theme of transitory life and eternal redemption. Hiding and revealing, seeing and seeing-in, are all at play in the more interesting anamorphs. As the scatological scene becomes visible, *Jonah and the Whale* (a scurrilous metaphor for the body's evacuation) disappears, and when the skull is visible, the French Ambassadors and their worldly paraphernalia become slurred and "hidden." It is easy to see why anamorphs have become popular in the fifty years since the surrealists rediscovered them, and how they lend themselves to interpretive excesses as metaphors of failed subjectivity and the destruction of the Cartesian subject.[13]

Traditionally, chance images, anamorphs, and images hidden in paintings have been treated separately. But the three may be historically linked, since they form an almost unbroken chain of artistic practices from Rome to the present. The history of aleamorphs begins in the third century B.C., continues in the medieval interest in natural wonders, and wanes at the beginning of the Enlightenment when people no longer thought of nature as an image-making force. Anamorphs begin in the sixteenth century with the elaboration of perspective, and wane in the nineteenth century when more engaging and sophisticated optical toys began to supplant them; and images hidden in paintings are reported from the late nineteenth century to the present. There is some overlap: the interest in natural images continued into the early eighteenth century in curiosity cabinets and images of the miraculous signs of nature, and the first anamorph is recorded in a treatise by Piero della Francesca.[14] (Although chance is an important part of twentieth-century art, chance images are not, since works by Hans Arp and others are not meant to generate naturalistic images.) Cryptomorphs in the modern sense are reported first, I think, in Karel Van Mander's *Schilder-boeck* (1603–1604), which takes note of Joachim Patenier's "custom of painting a little man doing his business in all his landscapes," which earned him the nickname "The Shitter." The biography immediately following Patenier's is devoted to Herri de Bles, "the Master of the Owl, who put into all his works a little owl, which is sometimes so hidden away that people allow each other a lot of time to look for it, wagering that they will not find it anyway, and thus pass their time, looking for the owl."[15]

But, by and large, the three form a sequence, and aleamorphs are as absent from late twentieth-century concerns as cryptomorphs were from Renaissance writing about pictures. That sequence implies what no analysis could easily prove: that aleamorphs, anamorphs, and cryptomorphs may be part of a single, larger history of a certain response to images.

THE HIDDEN, THE HALF-HIDDEN, AND THE OBVIOUS

To say it fully, a cryptomorph is an image that is hidden at its making, remains invisible for some period, and then is revealed so that it becomes an image that once was hidden (and then can no longer be hidden again). Like caterpillars that hide themselves in cocoons, and then emerge in a different shape, a cryptomorph once uncovered can never be put back. The historical practices are varied, but the basic sequence remains. As a group crypto-morphs have an indeterminate relation to conscious thought, since both the hiding and the finding can be purposive or inadvertent. A cryptomorph might be placed with the intention that it would never be found, and remain forever outside viewers' experiences of the painting. Or it could be placed in order to be "felt," subliminally or subconsciously.[16] Alternately, it could be intended to be found, but only by a few viewers. Some cryptomorphs are all three possibilities at once: the cartoonist Al Hirschfeld has hidden his daugh-ter's name, Nina, in every one of his drawings, usually in people's cuffs and collars (plate 43). (There are three "Ninas" in this caricature of Arthur Miller.) It is reasonable to assume that he means the "Ninas" generally to remain hidden, but at least for him they must be felt in each picture; and since he has revealed the practice, he also means the "Ninas" to be seen by a few viewers.[17]

A few cryptomorphs, such as the horseman that Andrea Mantegna put into a cloud in his *Martyrdom of St. Sebastian* in Vienna—the type speci-men of all cryptomorphs—are not really hidden at all (plate 44). Many view-ers must have passed in front of the painting without noticing the small cloud at the upper left. Though the horseman was certainly not meant to be seen by everyone, it is not easy to say how thoroughly hidden Mantegna intended it to be. In a recent study, Ronald Lightbown agrees with Horst Janson that it is likely Mantegna was following Lucretius or Aristotle and recreating the look of a natural or chance image.[18] The painted figure would then be a demonstration of the harmony of natural and artificial *invenzione*, and it would have resonance with other artistic doctrines of the time. But that explanation does not solve the problem of reception. We may imagine that to Alberti, Leonardo, or like-minded artists interested in the concept of chance images, the cloud visitor would be an appropriate classical reference, exemplifying the balance between human and divine invention. But could Mantegna have intended worshippers to be distracted by that kind of refer-ence? Would they have taken it in the same spirit? The normative answer would be No, but other pictures by Mantegna suggest he was ambivalent about the question of disclosure. The episodes of the *Triumphs of Caesar* are

Plate 43

badly damaged, but even in their original state it is likely that the cloudy face on the third canvas would have been one of the most obvious elements of the composition (plate 45). The double profile faces high in the clouds at the upper left of *Pallas Expelling the Vices from the Garden of Virtue*, on the other hand, can easily be overlooked (plate 46). Since the forms around

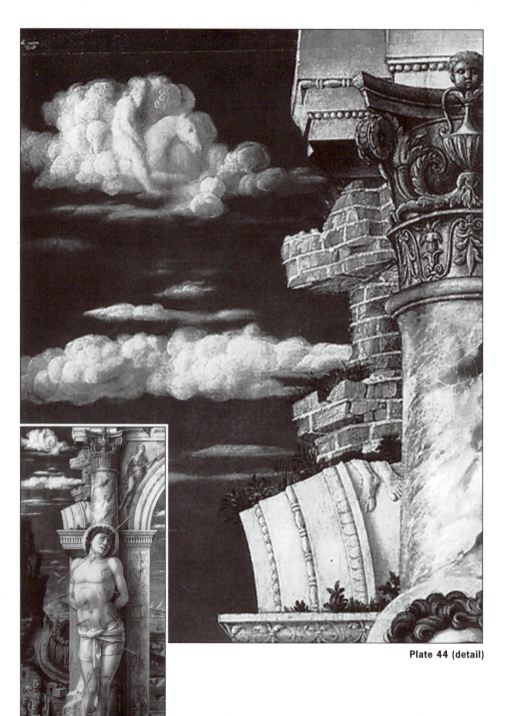

Plate 44 (detail)

Plate 44

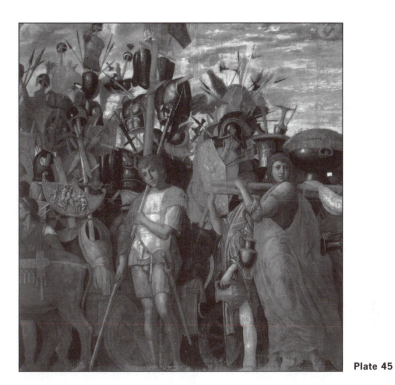

Plate 45

Plate 45 (detail)

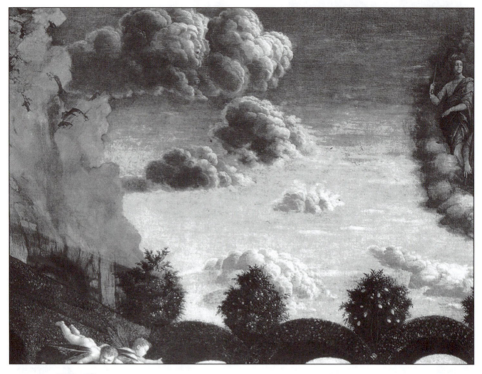

Plate 46

them—the other clouds to their right, the rock face to their left—are morphologically similar, the profiles are effective reminders of nature's ostensible power to create images. The same cannot be said of the *St. Sebastian*, where the remainder of the clouds and the rocky landscape follow the more mechanical laws of grouping and cleavage that unaccountably govern many of Mantegna's depictions of natural forms. Perhaps the faces in *Pallas Expelling the Vices* are supposed to produce an effect more akin to classical natural images (so that viewers might think they discovered them), and the forms in the other two paintings are more like modern images hidden in paintings (since viewers would realize the artist's skill had been used to strengthen their forms). *Pallas Expelling the Vices* would then be a different *kind* of painting than the *St. Sebastian*: it would be more akin to a natural scene than an artifact, and conversely the *St. Sebastian* would be more overtly a product of the artist's skill.

The same kinds of observations could be made of the people, gods, camels, dogs, and miscellaneous faces that sometimes grow from the rocks and mountains of Persian paintings. In one painting attributed to the

sixteenth-century artist named Sultan Muhammad, tiny faces—usually about a quarter the size of the people nearby—grow spontaneously from rocky excrescences (plate 47). A few are large and malevolent, but most of them are too tiny to have a clear psychology. (In this detail, they are mostly ranged up and down the right margin, with an especially dense group about half-way up.) Since there is no textual evidence to help interpret such faces, they can only appear as "mystically inspired earth spirits" (as one Islamicist says), or as fantasies with no clear thematic function.[19] At the bottom right of a painting by the late sixteenth-century Mughal painter Miskina, a cascade of rocks comes over the back of a cow, forming itself into increasingly theriomorphic faces and finally issuing in a simian profile just behind an actual goat (plate 48). To decide the meanings it would be necessary to also know something of the etiology: do the rock-faces mimic the goat, or does the goat spring from the rocks? (The same happens on the right margin, where an anthropomorph and a theriomorph are crowded into a small space between a camel and a man.[20])

In Persian painting and in Western art such unarguable examples are the exception. Panofsky saw representations of natural images in Piero di Cosimo's *Misfortunes of Silenus*; he said it has a tree with "an excrescence resembling the head of a deer."[21] Piero's theriomorphic trees are probably to be understood alongside Botticelli's and Leonardo's practices of looking into random forms and seeing recognizable shapes, and it is also reasonable to say that Piero "went out of his way to look for such phenomena." Piero's painting is a marginal example; the problems begin in earnest when cryptomorphs are so difficult to spot that we become suspicious that they were hidden at all.

In 1958, Enrico Castelli saw a Christ crowned with thorns hiding in a Northern pine thicket, in a corner of Hans Leu's painting of *St. Jerome* in Basel, painted in 1516 (plate 49).[22] He admitted that seeing the Christ takes a little more than simply looking in its direction and thinking of the Savior. In Castelli's view, the saint would have been worshipping a simple crucifix when the head of Christ suddenly appeared in the brambles above it. "To see it (or better: to recognize it)," he claims, "it is necessary to 'search' for it," with the "search" in quotation marks to indicate that it should not be necessary to look too hard, because after all, it *is* there.[23] The same author saw a death's head mask in the folds of the Virgin's drapery in Michelangelo's Vatican *Pietà*, just under her right breast, and he says that has to be "glimpsed" in the right light in order to be discovered (plate 50).[24] Here what is hidden is doubly hidden: Jesus is off to one side, so that our attention is elsewhere; but even when we look at it, the death's head continues to disappear, like a stick-insect in a

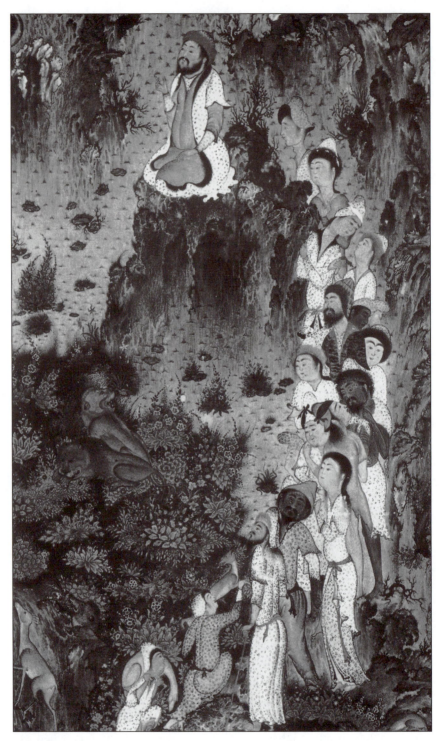

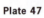
Plate 47

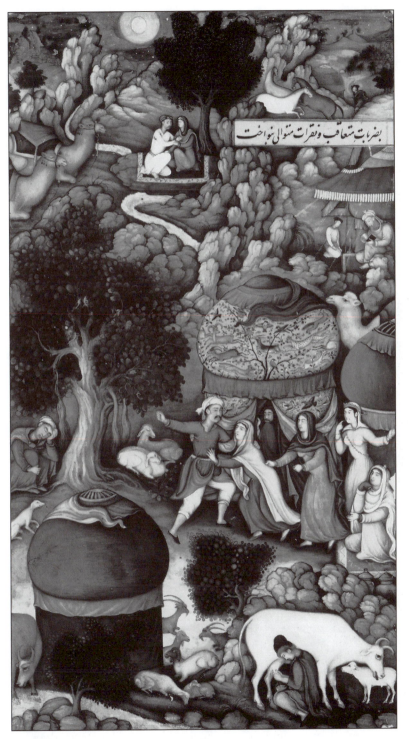

Plate 48

Plate 49

shrub. As Panofsky observed, the claim is dubious since the death's head only appears in Castelli's own photograph, which was taken in raking light, and it requires some force of imagination to see it in other lighting conditions.[25]

There is a difference between the kind of immediate recognition and assent that comes from finding an image that has been deliberately hidden — as in Mantegna's surprising horseman, Erhard Schön's rude jokes, or the

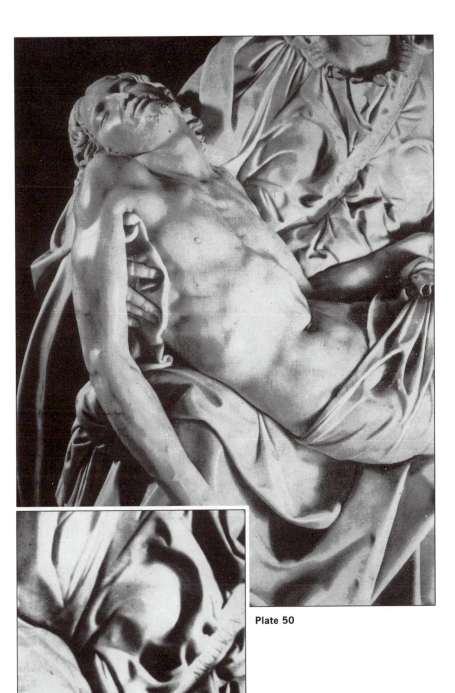

Plate 50

Plate 51a

"Hidden Pictures" made popular in *Highlights for Children* magazine—and the half-assent that results if we agree to suspend a nagging disbelief that a hidden image exists—as in the Michelangelo or the Leu.[26] Castelli defends his half-visible discoveries by appealing to depth psychology (*Tiefenpsychologie*): an artist, in his view, can be accomplished and in full control of his work and still produce a monster, an "unconsummated symbol," which is the true expression of the unconscious.[27] Since those symbols need not obey the conscious criteria of legibility, form, and technique, they might well be difficult to see. But the *tiefenpsychologische* approach also opens the door to any half-hidden form.

Hieronymus Bosch's drawing *Owls' Nest on a Branch* is nominally a depiction of owls perched in a tree: one stands over a nest hole and spreads its wings, looking at another that is already inside, and a third is perched at the top (plate 51a).[28] There are also four other birds, of some slimmer species: one flying, another looking at a spider; and two more at the left (one upside-down). According to an essay by J. Langerholc and W. Kroy there are many more. For them, the hole itself becomes a bird (plate 51b, top diagram), and three more birds are formed by the negative spaces between branches (one has a spider for its eye). They also see three more very tiny

Plate 51b

birds along the left margin—a continuum of birds, from the large obvious ones to little ones that seem to be just emerging into the tangle of twigs and spiders' nests. If finding hidden images is part of the game of the picture—a possibility I can't quite believe—then birds are certainly the best candidates: but naturally the authors don't stop there. They also see "a pair of hands clasped about the black hole in the trunk" (plate 51b, bottom left diagram), and an upside-down man "with spread legs, a beard, a fairly prominent nose, and a turban." Yet another diagram shows the whole trunk as a lizard with an

"opposing thumb," which they also describe as "a snake swallowing the alighting owl." And—of course—the trunk also reminds them of the "male anatomy": "it appears," they say, "to be a sketch of a thigh taken directly from an anatomy class, the blackened part strongly suggestive of the male sex" (plate 51b, bottom right diagram).[29]

Langerholc and Kroy's hypothesis is a particular species of cryptomorph that just keeps appearing, in potentially infinite numbers, until an image is crowded with multiple apparitions. There is a youthful self-portrait drawing by Dürer with a set of six pillows sketched on the back (plate 52). In 1960, Hans Ladendorf saw faces in these pillows—not merely one face in each pillow, but an indeterminate number of faces of different sizes and shapes: "many intangible, intertwined masks and faces." Some are just profiles, he says, and others have horns, turbans, "chimerical" features, sunken eye sockets, and prominent noses with big wings. The pillow at the upper right has a "peculiarly deformed head shape," and the one at the lower right has a man's face, looking left, with a voluminous hood pulled down to its eyes. The pillow at the upper left has a tiny face at its upper-left corner.[30] These findings have been endorsed several times—by Karl Schefold, Horst Janson, and Joseph Koerner[31]—and cryptomorphs have also been found in Dürer's landscapes and in the *Melencolia I*.[32] But what kind of hiding is it when even the most careful description still only reveals something that is half-hidden? In reviewing this case, Janson suggests that Dürer "probably discovered [the pillows'] physiognomic potential by accident, perhaps while sketching a pillow," and then proceeded to make it into a "game."[33] Ladendorf takes this kind of idea to its illogical conclusion, saying that we are justified not only in seeing faces in the pillows, but also in reading faces into the pillows.[34] In other words, Dürer's "game" involves an exchange between his *fantasia* and ours. The faces are not so much hidden once and for all as they are "planted," so that they grow in our imaginations with the aid of the drawing.[35]

There is a great coercive power to these theories. Once a cryptomorph has been firmly sighted it is difficult to erase it from memory, or find a way to believe it is not present in a work. In 1989, Peter Sturman found a face in Mi Youren's *Distant Peaks and Clouds* in Osaka, a Sung Dynasty painting from the dawn of the *literati* tradition (plate 53).[36] It is apparently a woman's head in left profile, coiffed in the style of the period, flying along through a fog bank.[37] (It is a small form, just to the right of the dark copse of trees.) "Once one's eyes adjust to this apparition," Sturman writes, it is irresistible; and I would add that like many cryptomorphs it has a viral effect on vision. Once I have seen the face, it is no longer possible to understand this painting as a

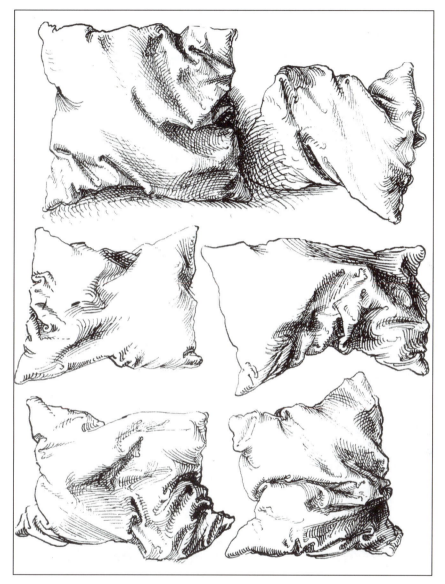

Plate 52

composition of trees and fog, and I am compelled to fight to see the landscape without the head. And this is so even though there are virtually no parallel instances in Chinese painting to help shore my conviction. The closest I know, and it is not very close, occurs in the lower-left corner of a painting of a tiger in the style of Mu Ch'i, where a thicket of bamboo resolves itself into a line of Chinese calligraphy (plate 54). It has been read either "Painted by

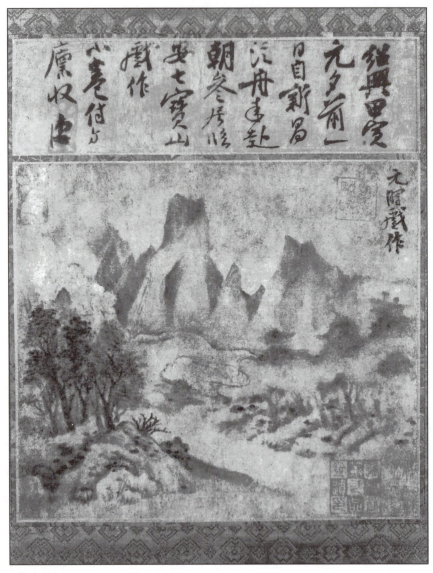

Plate 53

An Sung" or—more appropriately, *an hsü tso,* "What is the use of painting it?"[38] The bamboo picture-sentence is probably a legitimate cryptomorph— but it is too different from Peter Sturman's example to make me believe him.

The problem with these hallucinations—assuming, for the sake of argu-ment, that the Leu, the Michelangelo, and the Mi Youren are all false sight-ings—is that they ruin the pictures. As Leo Steinberg says of the erection he sees under Christ's loincloth in Maerten van Heemskeerck's *Man of*

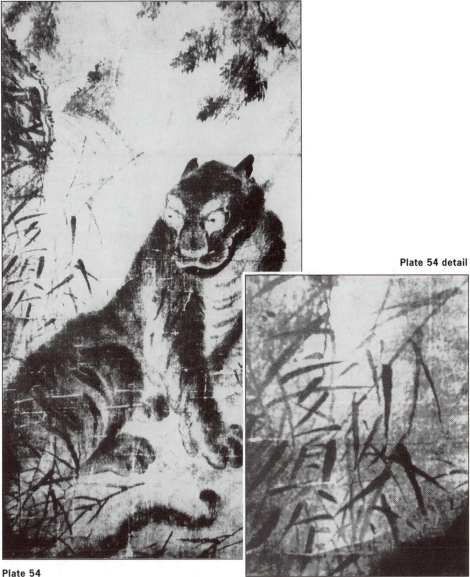

Plate 54 detail

Plate 54

Sorrows—an entirely different case in terms of its plausibility—"one either misses it, or sees nothing else; so that the failure is ultimately a failure of art."[39] The same might be said of a very different example, Frank Stella's insistence that Pollock did not achieve a pure abstraction, because his all-over paintings are haunted by "archetypal draped figures," and—as Rosalind Krauss also argues—especially by Picasso's figures. Stella cites the *Villa of the Mysteries* fresco to evoke what he sees in Pollock's pictures, but since he

is not literal any "draped figures" will do (plates 55, 56).[40] The kind of unspecific truth Stella's assertion carries is a peculiar species of cryptomorph, one that does not quite have to be specific: indeed, if it were to be made explicit the paintings would be reduced to a kind of graffiti, literally covering over images. Much the same happens in Robert Rosenblum's argument that the remnants of romantic landscape shine in Rothko's color fields.[41] Much as the painter disliked such notions, and much as the paintings elude any precise formulation, the feeling of landscapes half-erased by abstraction remains persuasive, as do the veiled narratives and figures that Anna Chave prefers to see.[42] At the least, the ill-defined cryptomorphs in Pollock, Rothko, and other abstract expressionists are insidious companions to any future read-

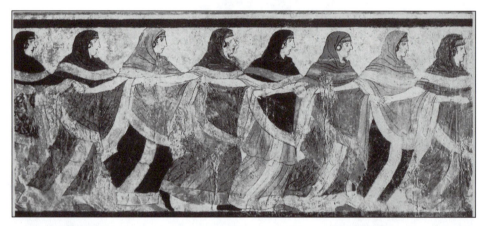

Plate 55

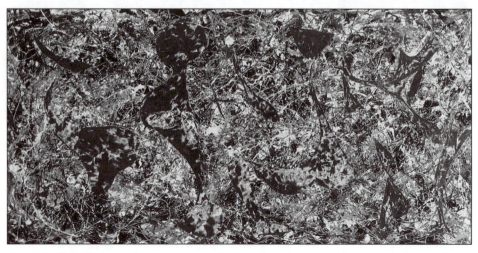

Plate 56

ing: and at the worst, they overwhelm the pictures with inappropriate visions of Roman togas and romantic scenes of the Campagna. Such cryptomorphs are not meant to be fully seen: they take their power from their vagueness, like the spectral figures in Beckett's *Ill Seen Ill Said* that never quite come into focus—and are all the more memorable for it.[43]

Cryptomorphs whose forms are close to what a picture already seems to depict are less insidious. By the nature of the moving body, Pollock's gestures are a little like figures, and by the nature of sunsets Rothko's glowing fields are something like clouds. That similarity—which is almost a strange camouflage, with the object hidden behind a version of itself—lets the manifest and the hidden coexist with minimal dissonance. If the stones in this image from the fourteenth-century *Book of the Marvels of the World* are little faces, then that is consonant with the fecund nature that actually does sprout faces in other paintings (plate 57). Some of the rockforms in this fifteenth-century illustration (plate 58) may well be faces, especially the ones near the

Plate 57

top of the ridge. If they are, they would fit the theme of Iskander (that is, Alexander the Great) peering at bathing sirens. Alexander's eyes would then be augmented by nature's, so that the sirens would be the objects of both living and inert gazes. In both pictures the possibilities are intriguing, but not quite disarming: in a way they would not be not a surprise, because the hidden and the revealed are so close together.

Plate 58

But when a cryptomorph is securely hidden and then suddenly revealed, the effect can be disorienting and even malicious. In that sense hidden images are coercive: just as a picture can grip the imagination in less time than a novel, so a cryptomorph can capture our sense of a picture instantly, and hold it captive indefinitely. More run-of-the-mill interpretations take time to read, and sometimes also time to see, and in that time we can bring our own thoughts to bear and resist the impending conclusion. If a careful, slow interpretation is like a garden in its variety and its different sources of pleasure, cryptomorphs are like deforestation: they burn the variegated flora of the picture into a charred stubble. In that regard the best-hidden images are the most dangerous, because when they are sprung on us they release a force often greater than the sum total of previous interpretations. The act of revealing fully hidden cryptomorphs is an act of terrorism against pictorial sense.

ARGUING AGAINST CRYPTOMORPHS

All the same few historians have tried to dispute claims about hidden images, and even Janson's essay "The 'Image Made by Chance' in Renaissance Thought," a principal source for this subject, is largely uncritical—the essay is mostly a list of examples. In a footnote, Janson wonders about images that are not "explicit." Such claims, he observes, invite even more extravagant ones, since there would then seem to be no possibility of opposing them. What is needed is some criterion:

> If . . . the actual presence of such "involuntary symbols" needs no proof other than our ability to perceive them, what is to stop us from regarding chance images among clouds or rocks, too, as "involuntary symbols"? Clearly, there must be a line of demarcation somewhere between "unconscious symbols" that may reveal the *stato dell'animo* of their creator and those betraying only the *stato dell'animo* of the beholder.[44]

But after stating the problem in this way, Janson does not return to it. Perhaps he felt a quicksand, or he may have thought that the problem lay in the province of the philosophy of history rather than the recording of historical fact. But I would like to entertain a complementary thought: what if the number of sightings has something to tell us about our own habits of seeing, as well as the pictorial practices of the Renaissance and other periods? What if, in accord with common scientific practice, a certain number of our hypotheses are mistaken, and we are "reading in" rather than "seeing in"?

One way to begin thinking along these lines is to try to improve Janson's curiously offhanded theory, and try mounting serious arguments against

some cases of cryptomorphs. That work has occasionally been done by the writers themselves, when they retract their own findings, or express reservations about what they have said, or say things that betray some lack of confidence. When Castelli writes "it is necessary to 'search' for it" instead of "it is necessary to search for it," he already gives away half the game. It is one thing to say, as Ladendorf does, that since Dürer started the game of faces in pillows, it is permissible to go on projecting our own faces where Dürer did not intend them, because it might mean that Dürer wanted to plant the *idea* of faces everywhere in the drawing. But it is another thing to find an individual face—one it seems Dürer did not specifically intend—and then realize there is no difference between that face and one Dürer supposedly *did* intend.

Arguing against cryptomorphs can sometimes be remarkably easy. Perhaps the most famous case occurs in Freud's interpretation of Leonardo. Since Freud mistranslated Leonardo's mention of the word *nibbio* (a kind of kite) as "vulture" when he was writing *Leonardo da Vinci and a Memory of His Childhood*, it follows that Leonardo probably did not paint a vulture into the *Virgin and Child with St. Anne*. The well-known diagram then becomes necessarily wrong, not just doubtful as Freud himself thought (plate 59).[45] Maurizio Fagiolo dell'Arco, in the course of a study of Parmigianino's hermeticism, saw a dead rat on the table in front of Parmigianino's *Portrait of a Man* in London (plate 60).[46] The rat fits perfectly into the program of alchemical symbols that Fagiolo dell'Arco proposes for the painting as a whole—but unfortunately the form in question isn't a rat, but an antique statue. As Daniel Arasse points out in reviewing this case, the "revelatory detail" so privileged by iconography sometimes leads the eye astray.[47] The serpent in Giorgione's *Tempest* is another case: to Arasse, it's a small gestural mark that could be a worm, or a root, a "fissure in the earth," or even "an undefined element of the representation."[48] The only way it can be seen as a serpent is to claim it is an erased serpent, its image slurred in order to make the painting an obscure Anti-Subject. (In that respect, Settis's reading is also cryptomorphic.)

Other hidden images are suspect because they appear to serve the viewers' interests more than the artist's. The art historian David Morgan has documented a tradition of hidden images in Warner Sallman's widely reproduced *Head of Christ* (plate 61).[49] Even though Sallman had not intended to hide figures in the painting, when he began to hear from people who reported seeing hidden figures, he altered his public lectures to incorporate chalkboard demonstrations diagramming their locations. In a survey of responses

Plate 59

to the painting, Morgan found that people tended to pick and choose hidden figures that corresponded to their own beliefs. Most people saw a wafer on Christ's forehead, a chalice on his temple, and a cross or a dove under his right eye. But some saw a figure on his left arm as a nun, and others as a monk or a Jewish prophet. So it seems likely that these images are partly projections; but are they merely incorrect, if the artist himself claimed he painted them without being aware of it? In later paintings Sallman began to hide images on purpose. A painting by Harry Anderson, perhaps made following Sallman's lead, shows a woman sitting on a bench in a garden. She has just put her book down, and she looks away from us, out toward some trees. At first, that's all we see—until the trees suddenly resolve into a huge face of Jesus. The painting is called *God's Two Books*, and it shows the cryptomorphic mindset at its most literal and revelatory.[50]

(More than other cryptomorphs, Anderson's leafy Jesus reminds me of the recent "magic eye" puzzles. If you look at a magic eye puzzle just right—

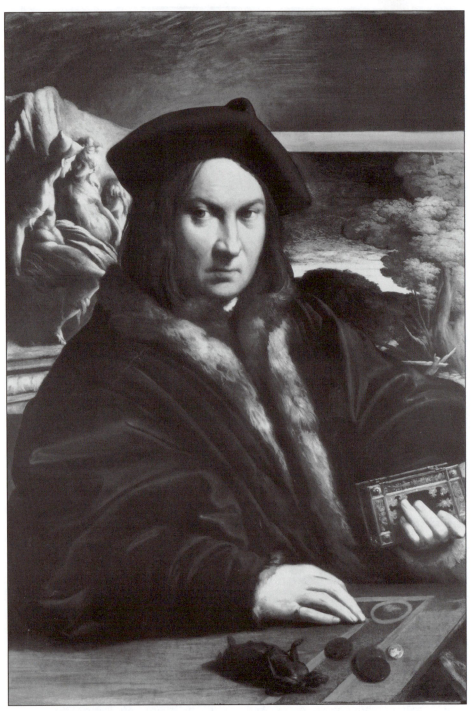

Plate 60

ing, and artists frequently have to erase unintended shapes that other people see in their pictures. Korshak's angel trumpeter is probably an aleamorph, seen in "random" marks.

Unfortunately these kinds of argument don't help with the majority of cryptomorphs. (And they do not offer a way of refuting Korshak's identification of the dove of the Holy Spirit.) Because simple claims, such as the sighting of a single hidden figure, can engender complex counterarguments, it can be very difficult to argue against even the simplest sighting of a cryptomorph. In 1990, Frank Meshberger, a doctor with an interest in art, reported finding a brain in Michelangelo's *Creation of Adam* on the Sistine Ceiling, outlined by the folds of drapery surrounding God the Father (plate 3).[53] Actually it is two views in one: Meshberger finds both a left lateral view (left-hand pictures) and the medial aspect of the right hemisphere (right-hand pictures). The left lateral view shows the fissure of Silvius (the prominent fold labeled S), and the medial aspect shows the sulcus singuli (A), the parietal-occipital fissure (B), the Calcarine fissure (C), the pituitary gland and the pons at the top of the spinal cord (E). As the diagrams indicate, left lateral view coincides with the drapery around God the Father, and issure of Silvius doubles as the base of God's ribcage. The sulcus singuli crosses God's beard and His shoulders, and continues across Eve's forehead and down God's arm. The pons and spinal cord (E) are formed by an angel just beneath God, and another angel's dangling leg forms the pituitary stalk and gland (D). The pituitary gland is bilobed, and Meshberger says Michelangelo has observed as much: "Note," he adds, "that the feet of both God and Adam have five toes; however, the angel's leg that represents the pituitary stalk and gland has a bifid foot."[54]

In fields such as the history of medicine, claims like this are not greeted with the skepticism that is more likely to meet them in the history of art, and Dr. Meshberger's hypothesis was reproduced on the cover of the *Journal of the American Medical Association*. Just the look of the superimposed brain might well be enough to make an art historian skeptical, but the naiveté of the claim does not make it any easier to refute. A number of art historical arguments might be urged against it, though they vary in generality and persuasiveness:

1. Initially we could observe that Michelangelo is not usually thought to have hidden images in his work. For that reason, as in the case of Mi Youren, the first claim should be an especially careful one. If Michelangelo had been interested in cryptography, as Alberti was, then the brain might be more plausible *prima facie*; but with no parallels stronger than some allegories

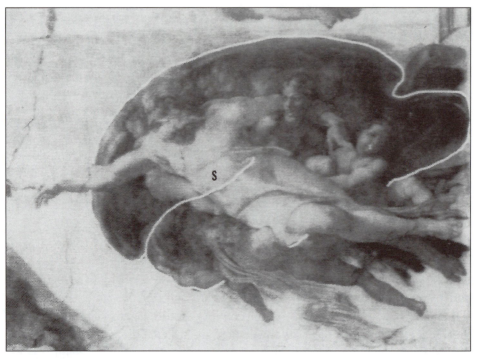

Plate 63 (left-hand view)

"hidden" in his sonnets, the claim must stand on it own as an unexpected anomaly. On the other hand, Michelangelo's work provides many examples of unique objects and ideas: the vexed problem of the nudes in the background of the *Doni tondo*, the enigmatic drawing of the archers, the lopped leg of the Florentine *Pietà*. The brain would then join the ranks of those one-time experiments, and in that logic it could even be said to stand in perfect harmony with Michelangelo's working methods.

2. Michelangelo was in all probability not interested in anatomic forms that are not visible on the surface of the body. He left several anatomic sketches, each of superficial muscles.[55] His interest in motion and *contrapposto* is well documented, and he left virtually no sketches of rigid "elevations" and "plans," not to mention "sections," which were largely developed in later centuries.[56] *Combining* the medial aspect of the right hemisphere (a "section," in the terms that nineteenth-century anatomists borrowed from architecture) with a left lateral aspect (an "elevation," employing the same terminology), as Dr. Meshberger suggests, is even more strongly anachronistic. So it could be said that this particular view of the brain is something that a nineteenth- or twentieth-century observer might tend to see, as opposed to a way of visualizing the brain native to the early sixteenth century.

ing, and artists frequently have to erase unintended shapes that other people see in their pictures. Korshak's angel trumpeter is probably an aleamorph, seen in "random" marks.

Unfortunately these kinds of argument don't help with the majority of cryptomorphs. (And they do not offer a way of refuting Korshak's identification of the dove of the Holy Spirit.) Because simple claims, such as the sighting of a single hidden figure, can engender complex counterarguments, it can be very difficult to argue against even the simplest sighting of a cryptomorph. In 1990, Frank Meshberger, a doctor with an interest in art, reported finding a brain in Michelangelo's *Creation of Adam* on the Sistine Ceiling, outlined by the folds of drapery surrounding God the Father (plate 63).[53] Actually it is two views in one: Meshberger finds both a left lateral view (left-hand pictures) and the medial aspect of the right hemisphere (right-hand pictures). The left lateral view shows the fissure of Silvius (the prominent fold labeled S), and the medial aspect shows the sulcus singuli (A), the parietal-occipital fissure (B), the Calcarine fissure (C), the pituitary gland (D), and the pons at the top of the spinal cord (E). As the diagrams indicate, the left lateral view coincides with the drapery around God the Father, and the fissure of Silvius doubles as the base of God's ribcage. The sulcus singuli (A) crosses God's beard and His shoulders, and continues across Eve's forehead and down God's arm. The pons and spinal cord (E) are formed by an angel just beneath God, and another angel's dangling leg forms the pituitary stalk and gland (D). The pituitary gland is bilobed, and Meshberger says Michelangelo has observed as much: "Note," he adds, "that the feet of both God and Adam have five toes; however, the angel's leg that represents the pituitary stalk and gland has a bifid foot."[54]

In fields such as the history of medicine, claims like this are not greeted with the skepticism that is more likely to meet them in the history of art, and Dr. Meshberger's hypothesis was reproduced on the cover of the *Journal of the American Medical Association*. Just the look of the superimposed brain might well be enough to make an art historian skeptical, but the naiveté of the claim does not make it any easier to refute. A number of art historical arguments might be urged against it, though they vary in generality and persuasiveness:

1. Initially we could observe that Michelangelo is not usually thought to have hidden images in his work. For that reason, as in the case of Mi Youren, the first claim should be an especially careful one. If Michelangelo had been interested in cryptography, as Alberti was, then the brain might be more plausible *prima facie*; but with no parallels stronger than some allegories

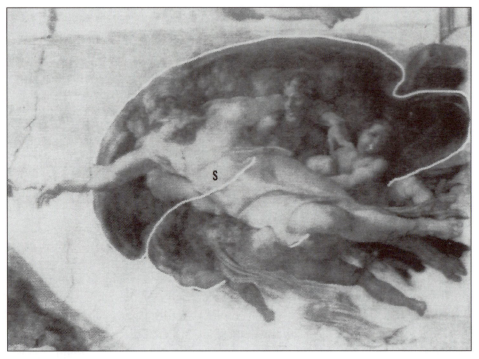

Plate 63 (left-hand view)

"hidden" in his sonnets, the claim must stand on it own as an unexpected anomaly. On the other hand, Michelangelo's work provides many examples of unique objects and ideas: the vexed problem of the nudes in the background of the *Doni tondo*, the enigmatic drawing of the archers, the lopped leg of the Florentine *Pietà*. The brain would then join the ranks of those one-time experiments, and in that logic it could even be said to stand in perfect harmony with Michelangelo's working methods.

2. Michelangelo was in all probability not interested in anatomic forms that are not visible on the surface of the body. He left several anatomic sketches, each of superficial muscles.[55] His interest in motion and *contrapposto* is well documented, and he left virtually no sketches of rigid "elevations" and "plans," not to mention "sections," which were largely developed in later centuries.[56] *Combining* the medial aspect of the right hemisphere (a "section," in the terms that nineteenth-century anatomists borrowed from architecture) with a left lateral aspect (an "elevation," employing the same terminology), as Dr. Meshberger suggests, is even more strongly anachronistic. So it could be said that this particular view of the brain is something that a nineteenth- or twentieth-century observer might tend to see, as opposed to a way of visualizing the brain native to the early sixteenth century.

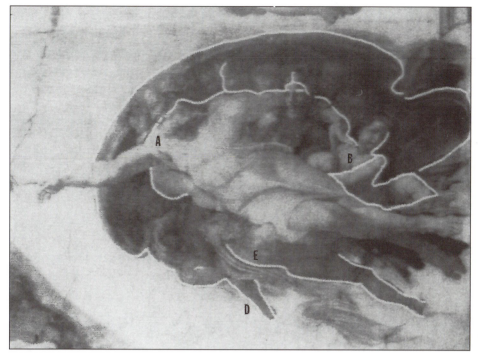

Plate 63 (right-hand view)

But against this it could be rightly said that Michelangelo's œuvre is replete with inventions that were not taken up until after his death.

3. The outline in question is composed of billowing drapery swags, forming an ornamental frame, a cartouche, for God the Father, Eve, and the angels. Such frames were a common device, and so a neuroanatomic explanation could be superfluous. At the least, it would be necessary to survey similar forms in contemporaneous paintings in order to be sure Meshberger was not observing a purely ornamental shape. On the other hand, this particular cartouche is centrally important in the Sistine Ceiling, and if any "decorative" form were to double as a symbol, this one might.

4. And finally, it could be argued that the fit between the anatomical outline and the painting is not particularly good. Dr. Meshberger omits a flourish at the upper right, four more at the lower right, and two trailing limbs. The fissure of Silvius does not follow a single form on the painted original but skips from drapery to angel, over an angel's knee, across God's abdomen, and onward from there. Yet there is no immediate reason why an unusual form might not be presented loosely, or "veiled" to keep it from being seen by uninitiated visitors to the Chapel. A perfect fit between cryptomorph and painting can be difficult to argue against, but so can an imperfect one.

None of these objections has much force by itself, and together they have a rhetorical weakness that Quintilian and Cicero both warned against: they harm their own case by ranging a profusion of arguments to answer a single claim. As they knew, a few well-chosen arguments are better, and a single decisive response is best. The most persuasive arguments are not based on historical criteria at all, but on the effect cryptomorphs have on meaning: they impoverish our understanding of pictures, canceling richer associations in favor of single obtrusive "secrets." When those fuller meanings are well attested—as they are abundantly in the Sistine Ceiling—we may be skeptical of a reading that emphasizes or interprets one form in a picture and bypasses the others, even if it makes a strong case for that one form. This kind of argument could be applied to the brain in the Sistine Ceiling, but it would be weaker with the stick-insect Christ in Leu's painting and the flying maid in Mi Youren's mountains, since there is comparatively less written on those pictures—less to array against the deviant reading. Less is ruined, and something might even be gained: both paintings owe a substantial fraction of their twentieth-century citations to cryptomorphic claims.

Cryptomorphs seem not to be able to contribute rich or nuanced significance, and they shrivel pictorial meanings even when there are swarms of them in a single painting. Some of Carlström's descriptions are especially dense, and full of unexpected (and potentially engaging) meanings: looking into Turner's *Music Party*, he spies the words "AVE POPE," and says "we can watch Pope sitting listening to the female pianist" (plate 64).[57] The concert is going well: "from his pleased face we understand, that he is enjoying this consert." But there is more, since there is also "a small miniature-painting" in the area above the "Pope's" white dress, and it shows "Pope in his outfit . . . together with bowing people . . . A very clever and sharp picture with the Pope wearing his high tiara." Carlström doesn't say anything about the other "miniature-painting," labeled "POPE IN PRIVATE," but he does mention more text: the words "SUITE" in big letters in the upper-left corner, and inside the "S" "other smaller letters which are going below in total with LUCKY ETHER(eal), [so that] in total we read LUCKY ETHEREAL SUITE." Often Carlström's readings have this Chinese-box quality, where it seems entirely possible that each glance will find something new, without end. The "miniature-paintings" within the painting are unusually nuanced cryptomorphs, and together with the lettering and the faces they give the painting more identifiable forms than it actually has: but even that generosity is not enough, and the painting still seems more than the sum of its (invisible) parts.

Plate 64

Hidden images are a principal subject of Sidney Geist's book on Cézanne, and several of his readings involve more than one hidden form per picture.[58] Geist sees a large right hand in Cézanne's *Small Houses at Auvers* (1873), formed by the bushes nearest the house and some vertical marks representing plowed fields (plate 65). The three main masses of the landscape

comprise a female torso, lying stomach up; the pubis is the slender triangular hill that enters from the right, and the hills above and below are thighs. Just at the bottom of the pubis there are two small pillowlike forms, stacked one on another (above and to the right of the peak of the largest house); Geist says they are labia, and the hand is groping for them. Since the two forms don't look like labia, Geist justifies himself by noting they *also* don't resemble trees, bushes, or other landscape forms in the painting: as he puts it, their "presence in the landscape is difficult to justify from a geological, botanical, or horticultural point of view." The reading is completed by a phallus on the horizon. The landscape in the *Small Houses at Auvers* is therefore hermaphroditic and anatomically disjointed: it has three legs, labia that lie on top of one another like pancakes, an erection sprouting from a thigh, and an unattached hand. Geist's reading is harsh and almost surrealist in its collection of misfitted anatomical parts, but even so it is difficult to argue against in light of the idiosyncratic sexual dramas and throngs of suggestive forms in Cézanne's early painting.[59] Since Giorgione, landscapes have been traditional carriers of half-hidden puns on the curves and rhythms

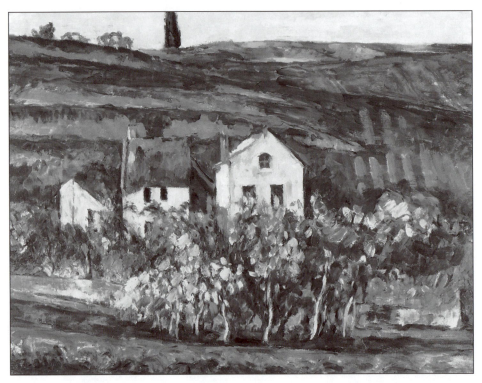

Plate 65

of the body. Given Cézanne's earlier work and the history of eroticized land-scape, it may begin to seem as if the only way to argue against Geist is to urge that his psychoanalytic preoccupations are modern, or that they miss the meanings of Cézanne's enterprise: but those are weak objections, resting as they do on a sense of propriety and a "proper" or conventional interpretation of Cézanne.[60]

The argument that cryptomorphs impoverish meaning may do better here, since the landscape is complicated well beyond the few limbs and sexual organs that Geist finds in it. There are flowers, vines, shrubs, planted fields, trees, rocks, houses, and textured plant growth in addition to the schematic forms that Geist singles out, so that his reading is forced to ignore the great majority of forms in the painting or construe them as decoys for the painting's true subject. But he might well answer that in order to hide, cryp-tomorphs need to be surrounded by complex distracting forms. It is not reasonable to propose that a hidden form be as extensive as the camouflage that lodges it, and so the argument that meaning is impoverished could be said to be based on a mistaken understanding of hidden images.

I don't know any logically or historically sturdy claims that can be made against cryptomorphs. Paintings can be simple wholes, and they can be disjointed and irregular in the ways that Geist imagines them to be. Painters may indulge in reductive strategies, so that reductive readings are not neces-sarily wrong. Paintings can harbor bizarre and offensive images, and even the most pleasant pastoral scene might be interrupted by a rough sexual reference. Most cryptomorphs, in short, are effectively impervious to falsifi-cation: a cryptomorph is like an acid that can burn right through an image, and no measured reservations can hope to compete with it.

SEEING AS PROJECTING

It might seem that the psychoanalytic literature would be an appropriate crit-ical tool, but cryptomorphs have always been vexed questions in psycho-analysis because analysts have made a number of claims to find cryptomorphs without subjecting them to the kind of self-analysis that psychoanalysis itself had defined. It could even be said cryptophilic viewers are attracted to psychoanalytically inflected subjects. In one reproduction, the *Mona Lisa's* lips are dissected into a clock, crystalline boulders, cause-ways, drawers, and diminutive paintings.[61] The psychoanalyst Kurt Eissler tentatively agreed with his colleague P. Stites, who saw "several fetuses in various stages of development" under St. Anne's foot in Leonardo's *Virgin and Child with St. Anne* in the Louvre (plate 66).[62] The racial theorist F.G.

Crookshank, working independently of both Eissler and Stites, saw an ape "concealed in the folds of the Angel's robe," in the Louvre version of the *Virgin of the Rocks*, and next to it "the mask of a foetus, that might be human, or merely that of an ape," together with an "Earth-Child" and "a gloomy and gigantic head and torso, emerging from the soil" (plate 67).[63] (Since Eissler, Stites, and Crookshank do not describe their finds in detail, I leave them to the reader's imagination.)

Oskar Pfister, the analyst who first saw the vulture in Leonardo's painting, described his discovery in a 1913 paper on "Cryptography, Cryptolalia, and the Unconscious Picture-Puzzle in Normal Subjects." One might expect to find there a theory of projection and cryptography, or at least the beginnings of one. But the paper is disappointing; Pfister attributes inadvertency to artists, but does not develop the possibility that the images might also be inadvertently projected by the analyst.[64] It is at least open to question whether theories of hidden images, developed within a theory of the psyche whose cornerstone is the unconscious, with its mechanisms of substitution and repression, should entail analyses of the interests of those making the analyses. The fact that the point seems obvious could be used to urge that cryptomorphs follow canonical rules of projection and repression.

Plate 66

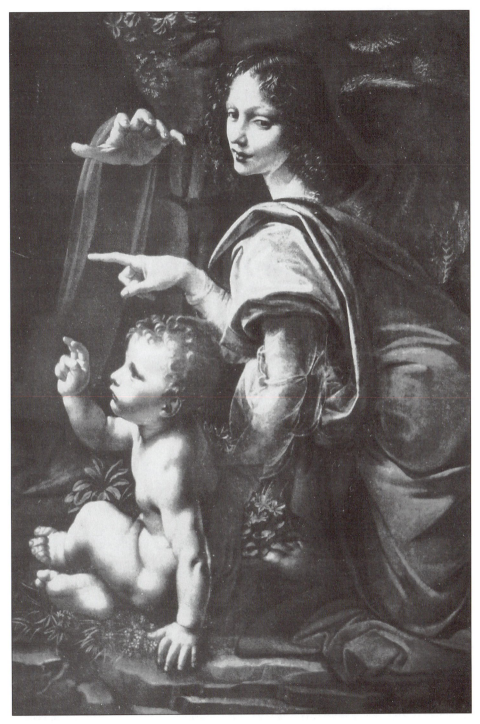

Plate 67

The moments in which cryptomorphs first appear would be particularly promising subjects for a psychoanalytic inquiry. The "method," as Freud said of Salvador Dalí, is "pure fanaticism": the writer is no longer in control, since the images simply appear. In the essay "Lenin in *Las Meniñas*" Geoffrey Waite says that the back of the painter's canvas was decorated with a skull—that is, until the painting was cleaned in the 1980s. Then the skull miraculously moved up a little, to another place higher on the canvas! First it was on the middle section, and now it is on the top section.[65] I can almost imagine Freud reading that and nodding his head—after all, it is a textbook case of hallucination, linked with a repetition compulsion. Waite does not say anything about the moment when he discovered either images: they were simply there to be seen.

There are remarkably few stories about the moment when the hidden forms first appear, almost as if it were private, or inaccessible to introspection. It could be said that the very act of searching for cryptomorphs is suspect, and, in fact, few art historians actively look for hidden images. Since they are born without historical method or critical control, it is best to be told about them by someone else, and in my experience there are many more art historians who assent to some hidden images than there are historians who have discovered their own. From a psychoanalytic standpoint it is also significant that no one who finds hidden images finds hidden images within the hidden images. Once the cryptomorph is found, the interpretation is finished. It would be very strange, I think, to read about an image hidden in another hidden image, almost as if it were an illness within an illness, or a symptom within a symptom.

But psychoanalysis is too closely bound to the history of cryptomorphs to be a reliable hermeneutic model, and I find myself happier with the more general thought that most cryptomorphs are hallucinations that are minimally provoked by the paintings, and therefore best understood as symptoms of a certain kind of seeing, and of a special desire in regard to pictures. Even when forms have demonstrably been hidden, they *also* speak about the "stato dell'animo" of the viewers—in this case, the historians—who choose to write about them. A case in point is Kandinsky, and his practice of hiding images that only he could identify. After about 1910, Kandinsky created abstract compositions by concealing some of the kinds of images that he had been using more overtly in his earlier painting. He called such pictures "hidden constructions" (*verstreckte Konstruktionen*), and said the objects in them were "veiled" (*verschleierten*) or "stripped" (*blossgelegten*). It is significant that his practice had to wait for the latter part of the century until an art

historian, Rose–Carol Long, found the case interesting enough to investigate. Her studies reveal what is hidden, changing our experience of the major early abstractions so that they become—in express defiance of Kandinsky's wishes—compositions made by hiding naturalistic images within (or as) abstract images.[66] She locates a tipped mountain, rider on horseback, bridges, boats, oars, angel trumpeters, and figures of Adam and Eve in *Composition VII* (1913), turning its "pure" abstraction into a hide-and-seek of images (plate 68). (The mountain, for example, is at the upper right, tilting toward the corner, and there is a boat with three oars at the lower left. An angel's trumpet can be seen in the middle of the top margin, pointing down and to the right.) The evidence is entirely convincing—Kandinsky supplies some of it himself—but the motive is suspicious. What exactly is happening to Kandinsky's paintings when his methods are so traduced in order to explain the very paintings they were intended to create? Why is it not significant that Kandinsky himself apparently thought that the paintings worked better when the *verstreckte Konstruktionen* remained *verstreckt?* Are Kandinsky's meanings so sturdy that they can be recovered even after the essential acts of camouflage have been revealed?

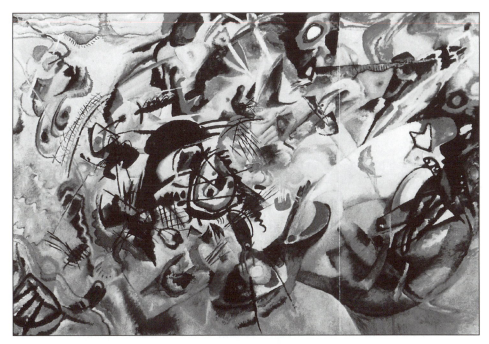

Plate 68

Such questions converge on the art historian's interest in the archaeology of hidden forms. Why do cryptomorphs continue to be such a temptation for late twentieth-century scholarship? The question would have to be asked even if most of the examples I have mentioned turned out to be planted by the artists, since it would still need to be explained why the twentieth century has shown such a sudden interest in the idea of concealment. Each of these case studies can be re-read as a description of a kind of painting, or a kind of painter, that the authors found plausible; and seen in that way the various hypotheses gain a certain coherence. The raft of misfits that supposedly lurk in Leonardo's paintings speak for a Leonardo who did not challenge his viewers with superlative renderings or difficult meanings as much as he startled them with simple allegories. The presence of "gloomy" Apes, vultures, and fetuses in paintings of the life of Christ would give us another, less subtle and stupider Leonardo than the one we already have. Leonardo's allegories of immaculate conception, presentiment, and salvation would be boiled down to low biological commentaries on mortality, freezing his interest in ambiguation and multiple meanings into static formulae.[67] Dürer's anthropomorphic pillows and mountains speak for an intellectually engaged artist who is not as interested in the intricacies of rendering rabbits, rocks, birds, pillows, or turf as in the hallucinatory side effects produced by the confluence of the emerging naturalism and late Gothic drawing techniques. The Van Gogh who showers his wheatfield with Christian symbols is not a person who might stand dazzled and bemused in front of a nature he did not understand, but rather an artist who would seek to explain nature by labeling it. Michelangelo would become an artist who sought to hide his presentation of creation in a single symbol, making one of his most celebrated paintings into an empty scaffold for esoteric meaning. The common ground is reductive cryptography: in place of the open-ended encounter with natural forms and pictorial meanings, a picture becomes a simple mechanism, deceptively encoding a single answer within an armature of distractions.

Those who search for cryptomorphs avoid the discomforts of unresolved meditation and the uncertainty that pictures continue to provoke: and at the same time they make of pictures a new kind of object, with a new form of intricacy. Michael Fried's assertion that the poses of the two figures in Courbet's *Stonebreakers* form a calligraphic monogram for the artist's initials seems unbelievable on the face of it (plate 69). Still, I am one of the readers who prefers to see the claim as a superlative rhetorical move, a

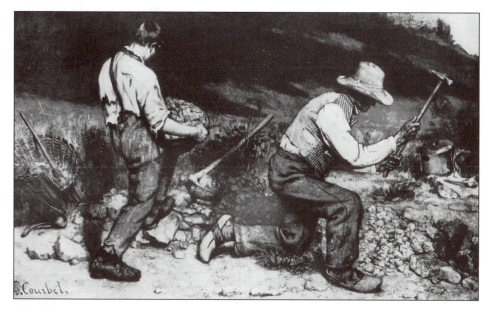

Plate 69

moment of obvious excess that serves to throw the surrounding argument into relief and make it seem more plausible — to let it take on what Stephen Melville has called a "haunting conviction."[68] Like the other "anthropomorphisms" that occupy *Courbet's Realism*, this one makes the familiar outlandish, and then — slowly, by a process that depends on a mixture of compelling argument and fastidious readings — *simply more interesting than it had been*, so that the painting remains in mind where it might have slipped away.

Even the impoverished logic of Geist's book, and his unpolished assertions, have something of the same effect: the change from *Small House at Auvers* to *Small Houses at Auvers with Pillow-Shaped Labia* is itself compelling, even if in this case I refuse to believe that the issue goes beyond projection on Geist's part. And what exactly has been created in place of the "old" Leonardo — the one that corresponds, as I still think, to the person who painted *The Virgin of the Rocks*, or the *Virgin and Child with St. Anne* — when he is revealed as a cranky biologist, secreting sexual and racist thoughts in the crannies of his paintings? What is *sfumato* if it is not merely a consummate solution to Leonardo's thoughts about pictorial coherence, naturalism, and grace, but also a veil for lurking malapropisms? It is, in the end, incrementally more interesting, more absorbing, more compelling.

SIXTH EXPLANATION: ART HISTORY FOLLOWS
PSYCHOANALYSIS AND SURREALISM

Yet even if cryptomorphs are projected, and even if they reduce pictures to simple cartoons of viewers' desires, they may not be entirely abnormal. In the Introduction, I argued for a deep affinity (and an equally deep disaffection) between some methods of mainstream art history and Birger Carlström's wilder imaginings. In assessing cryptomorphs it seems best that we begin by admitting they are mainly our invention: the overwhelming majority were sighted in our century, by art historians. Given that fact, they can take their place in a wider symptomatics of twentieth-century response to pictures. Can it be luck, for example, that the century of the cryptomorphs is also the century of the Rorschach test, the century that produced over 6,000 books and articles on "meaningless" blots? In the course of an historiographic review of the Rorschach method, Zygmunt Piotrowski suggests that the "broadest principle" of visual experience, in Rorschach tests and elsewhere, is that "there is no perception without selection": no seeing of blots without hidden figures.[69] The Rorschach test could then be understood as a strongly reductive model for seeing in general, rather than a test whose artificiality serves to bring out uncognized aspects of personality. Unfortunately, Rorschach methods are burdened by fundamental disagreements over theoretical bases, criteria for scoring, and the classification of projected forms.[70] Their potential significance is also narrowed because they have been principally aimed at pathological seeing, and at the differences between schizophrenia and normalcy.[71] But perhaps the greatest obstacle to considering the Rorschach method as a model for cryptomorphic (or modern) vision is the analysts' dogma that only certain forms can be seen, and that non-naturalistic apparitions are not indices of personality.[72] It is significant that it never occurred to Rorschach to ask his patients what they thought of the abstract blots themselves. Instead, they were encouraged to see something *else*, to "solve" the "meaningless" images by creative hallucinations.

Still, the method has strong similarities to cryptomorphic art history. Although it would be precipitous to equate Rorschach's interest in hidden images with psychoanalytic interpretation in general, it can never be irrelevant that psychoanalysis and art history are both disciplines devoted to finding meaningful symbols in inchoate, nonverbal material. As disciplines, the two are strongly and probably hopelessly entangled: Freud's book on Leonardo is the first important psychoanalytic treatment of a work of visual art, as well as the earliest attempt to fuse art history with psychoanalysis.[73] Can it be luck that it also contains the first twentieth-century cryptomorph? One of the

reasons the book is such a battered classic is the very confusion forced on Freud by the attempt to draw the parallel—which now seems so inevitable that it is all but invisible—between the unfigured ideas of the unconscious, the nonvisual images of dreams, and the nonverbal forms of paintings.[74]

Nor is it luck, I think, that the art historical literature on cryptomorphs belongs to the same century as the cryptomorphic practices of surrealism. Half-hidden images are a hallmark of modernism, from Braque and Picasso's puzzling still lifes (images so confounding that—as Christian Zervos reports—Picasso later lost the ability to read them with confidence) to Max Ernst's visionary landscapes swarming with half-painted monsters. Ernst's "decalomania" is the direct descendent of Pliny's aleamorphs, made hysterical by the concerted effort not to see anything plausible or coherent. Though the examples are distributed among several decades and different schools, they are unified by the demands they make on viewers, and the unease they promulgate (viewers have to keep asking themselves if they have found each relevant detail). The endpoint of induced hallucination is Dalí's theory of "paranoiac-critical interpretation," and its most intense painterly product is *The Endless Enigma* (1938), a painting so thoroughly laden with cryptomorphs that Dalí had to draw six keys showing how it is to be read (plate 70). In *The Endless Enigma* nothing is manifest and every visible object hides in another, which is itself hiding, and so on, in a *mise en abyme* of ambiguity. When one cryptomorph reveals itself, the remainder blurs, just as in Holbein's painting: but since each hidden image in Dalí's painting *is* the image, there is no stable ground, no frame against which the hallucinatory images can measure themselves. *The Endless Enigma* is a dispiriting image: I tend to get exhausted looking at it, and give up looking for Dalí's solutions. At that point the *entire* image recedes into a morass of "hidden" shapes.

The confluence of analytic cubism, decalomania, "paranoiac-critical" paintings, the Rorschach method, and cryptomorphic art history suggests a sixth response to the symptoms I have been cataloguing in this book. Up to this point in the chapter I have been suggesting that cryptomorphs have more to tell us about how art history imagines pictures than about any premodern historical practices, and that they present an exceptionally lucid example of what happens when the desire for interpretation is not kept in rein. That argument is intended to contribute to the picture I have been painting of twentieth-century responses to pictures: it is part of the answer to the question, *how* are our pictures puzzles. As I mentioned in the Introduction, the bulk of this book, which is now drawing to its close, is more a descriptive enterprise than a head-on assault on the question of the title. The

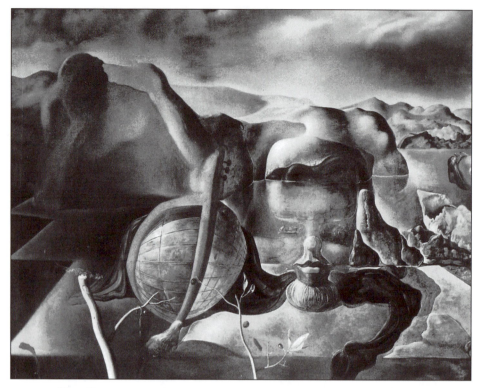

Plate 70

last "explanation" I entertained was in Chapter 2, where I considered the possibility that art historians write in order to memorialize and promote a certain version of the past. Since then, I've been caught up in my descriptive project, concentrating on how writers have captured the meaning of pictures in specific instances. This coincidence of psychoanalysis, surrealism, and art history suggests a different tack. What if the cryptomorphic turn, and the complexity of contemporary art history in general, are echo-effects of earlier movements in art and in psychoanalysis?

The possibility is appealing for several reasons. It would strengthen the idea that cryptomorphs, anamorphs, and aleamorphs are a sequence of related responses to pictures. It would help anchor traits such as the love of complexity, ambiguity, and puzzles to a specific historical moment in modernism. And most intriguing, it would mean that part of contemporary art history is replaying (at a vastly enlarged discursive scale) senses of pictorial meaning that were first developed in early modernism. If this book could have had a normative form, it would probably have been an explanation of a current academic practice by reference to an earlier artistic practice.

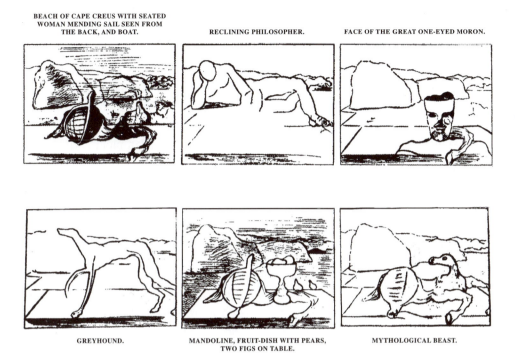

BEACH OF CAPE CREUS WITH SEATED WOMAN MENDING SAIL SEEN FROM THE BACK, AND BOAT.

RECLINING PHILOSOPHER.

FACE OF THE GREAT ONE-EYED MORON.

GREYHOUND.

MANDOLINE, FRUIT-DISH WITH PEARS, TWO FIGS ON TABLE.

MYTHOLOGICAL BEAST.

Yet I'm unsure about this explanation, for two reasons. The claim that psychoanalysis (along with some analytic cubism and surrealism) spurred art historians' propensities for hidden images is a very general one, and so it is most persuasive when it involves exact parallels between pictorial practices. Freud's book on Leonardo is the best match, even though it is decidedly odd both as psychoanalysis and as art history. Elsewhere the parallels become less convincing. Art historians tend not to find the half-illegible monsters Max Ernst hid in his paintings: instead they find eminently clear and interpretable figures. Nor do art historians find images that turn *entirely* into other images, the way that Dalí's "atmospheric apparitions" shift back and forth: instead, art historians find *smaller* images in larger ones. The half-visible forms in analytic cubist paintings might be compared to the half-visible forms found by Ladendorf, Castelli, or Carlström: but cubist still lifes are typically made of obvious *parts* of things (the neck of a carafe, a fragment of a newspaper), and the cryptomorphic critics find uniformly disfigured images.

Still, what we are searching for here is a general frame for explanation, and not an exact match, and so it might be more reasonable to let the details

go and say that contemporary art historical practice owes its general shape to the many kinds of obscurities practiced in early modern painting and psychology. The parallel with psychoanalysis is especially attractive in these general terms. I can imagine, for example, constructing the argument that Poe's *Purloined Letter* is the *locus classicus* for all cryptomorphic revelations. The apartment would be the disorderly "picture," and the letter the hidden image. The psychoanalytic interest in finding hidden symptoms could be imagined as a model for cryptomorphic discoveries, just as I argued that the detective-story genre captures one of the senses in which pictures are taken to be like picture puzzles. In terms like these, I would be ready to accept the parallel, but I would hesitate to call it an *explanation*. If current art historical practice is an echo or elaboration of ideas developed in the first half of the twentieth century, I would still want to know *why*. It can be convincing to say that art historians base much of their interpretive strategies on psychoanalysis, and in particular on the fundamental idea that key aspects of a work are unknown, invisible, or unconscious. It might also be illuminating to search for surrealist moves in art historical writing. Both surrealism and psychoanalysis are so deeply entangled in art historical thinking that they routinely serve both as subjects for debate and hermeneutic models. But where does such an explanation land us? If the art historical practices I have been exploring are to be adequately explained by noting that art historians adopt modernist interests, what do we then conclude about art history? Would it be *easier* to understand a disciplinary practice that has unwittingly adopted ideas from the art that it studies, or the theories it employs? And why, in the terms of the explanation, would art historians have taken up those particular practices? Given the intensive investigation of both surrealism and psychoanalysis (two of the most closely contested arenas in visual theory and the historiography of art), why would this particular affinity have gone unnoticed? And could it ever happen that an art historian, seeing such a connection, would suddenly renounce an interest in ambiguity or complexity?

The difficulty I have with this sixth explanation is unrelated to its potential veracity. (I think it is quite likely that art historians borrow unwittingly from surrealism and psychoanalysis, in addition to their more deliberated studies of those movements.) But I remain unconvinced by its explanatory power. Under what conditions could it be sufficient to say that the earlier senses of pictures explain our own, when those earlier senses are still so poorly understood? Lacking a good explanation (and sometimes, even an adequate description) of what happens to pictures in the hands of Picasso or

the surrealists, how can we use their reactions to explain our own? In many ways, we follow psychoanalysis, and in many ways, we are still surrealists: but does that explain us? Historiographically, it does: but I think it leaves the harder questions unasked.

I would prefer to see *both* psychoanalysis and art history as examples of a characteristically modern response to pictures. There's something historically odd about what we do, and it encompasses aspects of modernist painting as well as psychoanalysis (and other fields). As I will argue in the next chapter, Dalí is both a cryptophile and an art historian, and the one does not explain the other.

ART HISTORY AS AN EMBLEM OF HELPLESS BEWILDERMENT

Like puzzles and searches for ambiguity, cryptomorphs are a pathological extrapolation of ordinary patterns of seeing. They offer the advantage of being utterly unforgettable — and at the same time appearing irrefutable and final, so that the images themselves would have been adequately, and even sufficiently, explained. No "supplement," as Derrida says, would remain from the interpretive act. The pictures would be "solved," explained in their innermost recesses and therefore essentially put into words. The odd dynamics that mark the best readings (such as Fried's) as well as the worst (Geist's) are a powerful alchemy, transmuting the tentative and conjectural meanings of more patient historians into wild, dramatic, and potentially full solutions.

In a sense, much of contemporary art historical scholarship does the same. Contemporary writing is often engaged in finding the single answer, the previously unnoticed key, the reading that compels all others to step down. Cryptomorphs are the purest, least sophisticated forms of the common desire to solve pictures once and for all, and they have an insuperable advantage over their more sober cousins: their solutions are themselves signs of the strangeness of images. The more powerful the feeling that images need solving, the more it can be expressed only by a ridiculous and astonishing resolution. The *gaucherie* of Dalí's "psycho-atmospheric anamorphic objects" — his looming head of Mae West, the inappropriate mirage of Voltaire in the desert, the startling and pompous rows of little Lenins on the keys of a piano — express the force of his experience of strangeness in front of stages, landscapes, and pianos. (That force, I think, only became stronger when he saw the same images painted.) If *Crows in the Wheatfields* is taken as an image captured moments before the artist's death (as popular accounts continue to present it), then it may become disturbing in a special way: one might say the painting continues to insist it is only a

field of wheat, even though it must mean something more. That kind of tension might also engender cryptomorphs.

This sense of strangeness, I propose, is the real logic of art history's hidden images. In response to pictures that seem so familiar that they have become not only a little boring but even faintly nauseating (such as Renoir's *Woman at the Piano*), our minds begin to wander. In response to images that should signify (such as Van Gogh's *Crows in the Wheatfields*), we begin to feel restless or helpless at our inability to locate what seems to be appropriate meaning. In the presence of everyday objects that continue—obstinately, unaccountably—to mean nothing, we might take refuge (and even a fanatical delight) in hallucinations.

In the end, the oddest thing about cryptomorphs is that they are not explanations at all. Since they substitute one image for another, the new image merely replaces the original one as the enigmatic object. It's a sign of a lack of reflectivity among cryptomorphic historians that this obvious paradox never presents itself as a problem. Why shouldn't the angel trumpeter be just as enigmatic as the cloud he replaces? Aren't the misshapen bear, the strangled woman, and the map of Panama in Renoir's *Woman at the Piano* as much in need of explanation as the scene they infest? I offer a last example as an emblem—literally—for this *mise en abyme* that seems to be repressed even by artists and historians least prone to repression. Bernhard Koerner's *Handbuch der Heroldskunst* is a massive study of German heraldry, founded on the idiosyncratic claim that heraldry can be traced back to Germanic runes. According to Koerner the "kan," "kun," or "gan" rune (roughly a Y-shape) denotes either "dog" or "child."[75] The "ar" rune, an upside-down Y, denotes "eagle," and the "sig-rune" or "zig-zag," a backwards Z, denotes lightning. Koerner uses all three to explain Rembrandt's *Rape of Ganymede* (plate 71). At the top he illustrates the "knot-rune" "Ar-kun-sig," comprised of all three runes. The "kun" rune (the Y–shape) is given by Ganymede's body, which here represents both "child" and "fertility"; the "ar" rune (the inverted Y) is the eagle, with its spread wings; and the "zig-zag" or "sig" rune is the serpentine stream of urine. In a caption Koerner glosses his interpretation by claiming the entire painting (or the whole "knot-rune," depending on how it's seen) stands for fertility, as Rembrandt hints by the fruit in Ganymede's hand. In addition, the "y" in "Ganymede" is the same as the "i" in "nightingale" and "bridegroom" (*Bräutigam*), and the whole can also be taken to mean "the piss of a little boy."[76] So the well-known painting is transformed into an arcane composite runic sign.

What does Koerner manage to explain? Certainly the painting is

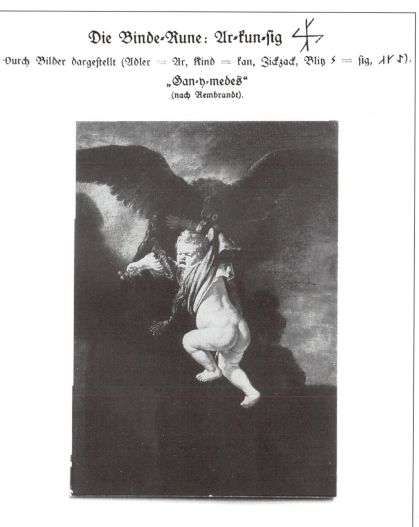

Die Binde-Rune: Ar-kun-sig

Durch Bilder dargestellt (Adler = Ar, Kind = kan, Zickzack, Blitz ⚡ = sig, ᛅᚱᛋ).

„Gan-y-medes"
(nach Rembrandt).

Die Gan- oder kan-Rune ist das Zeichen der Fruchtbarkeit (vgl. hier die Früchte in der Hand). Der „Mann" (mendes - medes) des „Könnens" (potestas virilis ᛉ) oder Ganymendes (y wie das i in Nacht-i-gall, Bräut-i-gam usw.) ist auch im Brüsseler „Mannekenpiß" erhalten.

Plate 71

puzzling: it has been discussed as evidence of Rembrandt's humorous attitude toward classical mythology, and as his inversion of the often-inverted theme of Ganymede's homosexuality. But does a runic fantasy help matters? At first Koerner's problems seem even more severe than Carlström's, as if we have finally crossed the pale into relatively pure psychosis. We may have; but I would not want to frame an answer without also considering that *any* hidden image, once revealed, must necessarily contribute *another* moment

of darkness, another mystery that refuses to yield, and ultimately yet another breeding ground for hidden forms. Who is to say what might lurk inside Ganymede's runic stream of urine?

Paintings like Rembrandt's still have their hold on us—otherwise there would be no point in returning to them again and again—but it does not seem possible that the usual interpretations could capture that mixture of utter sameness and unquenched curiosity. The solution has to be simultaneously a way of throwing out the older readings and getting *even closer* to the images. Eventually, it has to be either an insight so well supported that it can hold its own against the weight of previous readings (in which case it would take its place in the ongoing projects of art history), or else it must be a hallucination. Hidden images, therefore, are the most dramatic, drastic, and compelling way of expressing our helplessness in the face of the bewildering complexity of pictures.

THE BEST WORK
OF TWENTIETH-CENTURY
ART HISTORY

<div align="right">

8

</div>

In Chapter 2, I mentioned Louis Marin's *To Destroy Painting*, one of the most deeply exploratory of recent art historical texts. Marin is fascinated with Poussin's *Arcadian Shepherds*, since it appears to be on the verge of speaking: it employs the resources of seventeenth-century physiognomics and visual narrative to tell a story, centered on an inscription—*et in arcadia ego*, "I too [was] in Arcadia." The words are slightly elliptical, and they set in motion an indeterminate meditation on reading, and how pictures make us think of reading even when it is not possible. Marin studies the arrangement of figures: they stare, and gesture, and think, and they seem to signify meaning itself; as he says, they comprise a kind of "elementary structure of representation." He looks, and thinks of reading: he sees gestures, silences, and nameless figures, and he thinks of writing. *To Destroy Painting* is a wonderful text, in some ways a model for art historical ruminations on legibility.

That's the serious side. But in art history, nothing is as it seems, and Marin's book has a *Doppelgänger*, a wild shadow-text that mocks it even without knowing of its existence: Henry Lincoln's *Holy Blood, Holy Grail*.[1] Lincoln purports to tell the story of the secret descendants of Jesus, never recorded in the Gospels. According to a hermetic tradition, they lived on into Merovingian times, when they mingled with the protagonists of the Holy Grail romances. Even today, Lincoln says, they are among us, and

their presence is about to be revealed. One of the showpieces of *Holy Blood, Holy Grail* is the very painting that entrances Marin. Instead of circling around the idea of reading, Lincoln decodes with a fervor: "Et in arcadia ego" becomes "I tego arcana dei," "Begone! I conceal the mysteries of God!" Lincoln draws a criss-cross of lines on top of the painting, including a pentagram, forming a cryptic geographical schema of the blood lines of Jesus's hidden descendants.[2]

The one book reads, and the other contemplates reading; the one is overflowing with answers, the other offers almost none. In everything from politics to hermeneutics they are opposites; but the painting compels them both. In both books, the narrators leave the painting half-satisfied, and then return to it again and again. In both there is an insistent—at times, overwhelming—sense that the painting must be legible, and in both the kind of legibility turns out to be extremely dense, infolded with half-revealed meanings, and partly, in the end, unspoken. The desire to understand, and the magnetic pull of complexity, are identical in both works. That is the kind of uncanny parallel that tempted me to begin this book with Birger Carlström, and tempts me again to end it with an even more spectacular unwanted twin to art history.

DALÍ'S ART HISTORY

Salvador Dalí's book *The Tragic Myth of Millet's Angelus*, recently translated and published by that outlet of diluted surrealism, the Dalí Museum, is a brilliant text: a sustained series of utterly improbable fantasies about Millet's painting, presented with complete sobriety as a serious scholarly inquiry. For Dalí, "serious" means psychoanalytic, and so readers need not be too shocked when, opening the cover of the original French edition (which is intentionally designed as an old-fashioned child's school notebook, with a metal clasp) they encounter a double-page spread of an obscene postcard (plate 72).[3] The American edition tries to be a bit more chaste (it offers a reproduction smaller than a postcard), but some things can't be concealed. Dalí launches immediately into an absurd psychoanalytic theory of the image:

> Let us look at it. The mother, who could well be a variation of the phallic mother with a vulture's head of the ancient Egyptians, uses her husband, whimsically "depersonalized" into a wheelbarrow, to bury her son while at the same time causing her own impregnation, being herself the foster-mother-earth par excellence. "The double-image" of the phallus-cactus seems to us an unequivocal allusion to the desire to castrate the spouse, who, thus deprived of

his virility and reduced to the state of a simple vehicle of social productivity, can no longer form a screen, or a hindrance in the direct relations of mother-son, or the rising sun of an absolute matriarchy. In the matriarchy, the mother wishes to substitute herself for the husband by replacing him in all "situations"; in the present case, that of a wheelbarrow. Thus she would like to play, be coaxed, *a wheelbarrow rhythmically balanced by her son*, himself at the zenith of his "heroic" athletic university student strength during which, in a matri-archy, he goes through a very short period of maternal idolatry just before undergoing in turn the fate of his father the moment he becomes a *husband*.[4]

That, in essence, is Dalí's theory of Millet's famous and inoffensive painting: it supposedly depicts a mother who has just killed her son and is anticipating being sodomized by her husband before she cannibalizes him (plate 73).

There are many reasons to dismiss Dalí's book—almost too many. He was famously undependable, excessive, theatrical, egomaniacal, and frivolous: as Freud said, he was a true fanatic. The book obviously revels in what it does to the *Angelus,* which was once a ubiquitous icon of middle-class values and pallid romantic yearnings. *The Tragic Myth of Millet's Angelus* is an extravagant self-promotion, made even worse in the American edition by the addition of *The Myth of William Tell (The Whole Truth About my Expulsion from the Surrealist Group).* In terms of art history, Dalí is marginal even to those historians who have sought to privilege surrealism in place of high modernism as the central moment in twentieth-century art. And even his defenders acknowledge that his more than faintly ridiculous lust for gold got the better of him in later life.

Why, then, take the book seriously, or even bother to read it? Because, in short, it is exemplary art history. I mean that in a very particular way: Dalí's book exhibits each of the symptoms I have been examining throughout this book, and it does so without apology and without naiveté. For that reason alone it would deserve a place in this book; but it also rehearses (and for once, that overused expression is the right word) all the *normal* strategies of art history, the non-excessive and ordinary methods and theories that art historians deploy to understand pictures. In fact, it is encyclopedic and irre-proachably well-informed even about conventions that only became wide-spread long after the book was written around 1935.[5]

Where most art historians learn their theory as best they can from books, Dalí "learned" his psychoanalysis from the source itself—from Lacan. I put "learned" in quotation marks since it is far from clear that Lacan did the teaching. Their relationship in the years 1933–1936 was formative for both of

Plate 72

them, and the give-and-take is still insufficiently studied. Dalí had read
Lacan's thesis, which was finished in 1932, but his own essay "Paranoiac-Crit-
ical Interpretations of the Obsessive Image of Millet's 'Angelus'" appeared in
Minotaure in the pages just before Lacan's seminal paper "Problem of Style
and the Psychiatric Conception of the Paranoiac Forms of Experience."[6] The

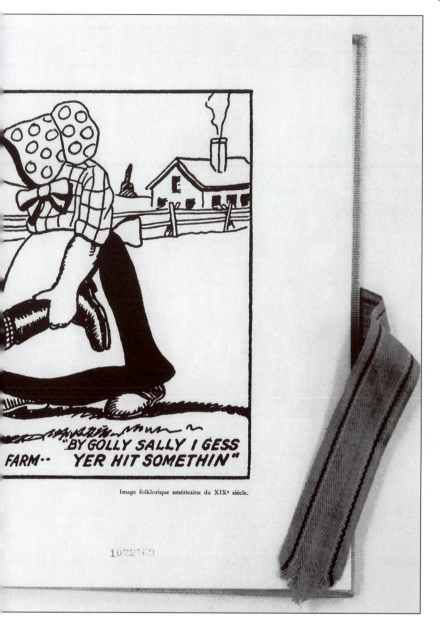

Image folklorique américaine du XIX⁰ siècle.

relation between the two is not easy to disentangle, though as Dawn Ades has pointed out, Dalí derived some support from Lacan's notion of the "objective and 'communicable'" nature of paranoid phenomena.[7] Certainly not all Lacanians are interested in pursuing his thought in Dalí's direction, and Dalí did not help matters by telling a ridiculous and embarrassing anecdote about

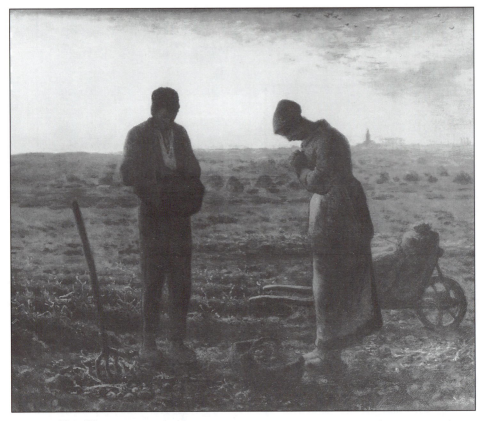

Plate 73

a meeting with Lacan in *My Secret Life*.[8] (Dalí wonders why Lacan is staring at him so strangely, and then when Lacan leaves, Dalí discovers he has a scrap of paper glued to his nose.)

In the absence of a good account of Dalí's relation to Lacan, it is enough to point to the confluence of ideas, and the fact that Dalí's book may have been written virtually simultaneously with Lacan's dissertation. What art historian could claim anything similar? Art historians who use Lacanian theories learn at first from translations of partly unreliable and mysteriously edited transcripts of seminars that took place decades ago. To some degree Dalí and his theorist *du jour* were collaborators, or at least equals.

Psychoanalysis is not the only theory mobilized in the book, though it is the only one that is named as such. The entire book is set as an exploration of the painting's power, and it is deeply confessional about the effect the painting had on his life (given, of course, that Dalí's confessions are rarely what they seem). The painting troubled him, and he lost sleep over it; it

changed the way he looked at the world, and what he looked for in the world. The encounter had effects that lasted over thirty years, from the first appearance of a Millet-motif in 1929 to *Gala Looking at Dalí in a State of Anti-Gravitation* in 1965; it was a central preoccupation, a guiding obsession, for most of his working life.[9] The autobiographical mode Dalí deploys so insouciantly is only now stumbling into art historical writing in the form of measured deconstructions of the objective authorial voice. What could be more openly autobiographical than the half-insane photograph of "The beginning of an erection on Dalí while being photographed disguised as The Angelus" (plate 74)?[10] Dalí takes for granted what we now call the "power of images," and he does so in an outlandishly personal manner. He even records an instance in which a man knifed the *Angelus* and was put in an insane asylum, and uses the anecdote to make a point about the painting's unpredictable power: exactly what David Freedberg and Leo Steinberg were to chronicle over forty years later.[11] And Dalí does them one better by providing an appendix describing the outcome of Lacan's interview with the man, in which the patient rants about Watteau's *Embarkation to Cythera* (see plate 37), which in turn leads Dalí to promise an entire book on the "marvelous trilogy" of the *Angelus*, the *Embarkation to Cythera*, and the *Mona Lisa*.[12] (Although that book never appeared, Dalí did write an essay explaining "Why They Attack the *Mona Lisa*"; it divides assailants into "ultra-intellectuals" such as Duchamp, and "more-or-less Bolivians" who throw "pebbles," or just steal the image.[13]) For Dalí, as for the surrealists, there is no question that images are disruptive, disorienting, or sexually coercive, and though he treats the issue carelessly he is more at ease with the confessional mode, and with the thought that images can have deep and unexpected effects, than even the most adventurous art historians. (Especially including those who write on surrealist subjects.)

The same could be said of several other modes of interpretation that historians have begun exploring. Semiotics, in its most recent revival, owes a great deal to Charles Peirce, and tends to emphasize the mobility of the sign: but what more mobile signs could there be than the whirling kaleidoscope of interpretations Dalí offers beginning with his very first illustration? When it comes to the current experiments in mingling "literary" and historical writing, Dalí is again enacting the same drama, but in a more thoroughgoing fashion. Contemporary philosophers such as Derrida, and writers such as Michael Fried, who experiment with expressive, philosophic, and historical prose, are outstripped (and, in a sense, caricatured) by Dalí's literally incredible reminiscences, his purple prose, and his giddy mixture of criticism,

Plate 74

philosophy, history, and confession. It is a sign of the text's overwhelming inventiveness that it has an echo of Derrida's discourse on Van Gogh's shoes almost fifty years before its time: speaking of the man who had slashed the *Angelus*, Dalí says "one cannot fail to compare this man's case with that of Van Gogh, whose obsession with Millet at the crucial point in his madness, forced him to copy in his own style several paintings by Millet from postcards. On the other hand, there is every reason for stressing the automatic repetition of drawings of wooden shoes in the pictures of Millet."[14] It's a funny passage, clearly not quite on Derrida's subject, but uncannily near it anyway: it plays with Van Gogh, shoes, obsession, interpretation, and violence.

I don't want to imply Dalí actually practices what contemporary art historians are practicing. His autobiographical writing, his confessional approach to artworks, his semiotics, and his combinations of criticism and history are too different to be in a linear genealogy leading to contemporary art history. But that is exactly the point: his writing is so free, and it embraces those ideas so fully, that it can be understood as a more radical version of the more suppressed writing we all do. In that respect *The Tragic Myth* is a perfect embodiment of many of the more interesting experiments in how art history might be written.

Dalí's formal analyses are breathtaking—they have the same hypertrophied precision that went into his paintings—and his writing style is fluent beyond what most historians could accomplish. There are a number of points in the book where his rhetorical power is used to create a force of argument that is lacking in much art history:

> How then explain and reconcile this obsessive unanimity, this undeniable violence brought to bear on the imagination, this power, this absorbing and exclusivist efficacy in the reign of images? How reconcile, as I said before, this force, this fury even in the reproductions with the miserable, tranquil, insipid, imbecilic, insignificant, stereotyped, and conventional to the most mournful degree, of the *Angelus* of Millet? How can such antagonism not seem upsetting? No explanation can henceforward appear valid to us if it continues to count on the belief that such a picture has nothing to say or "almost nothing to say." We are convinced that causes of a certain importance cannot fail to correspond to such effects, and that, in reality, under the grandiose hypocrisy of a content manifestly the sweetest and the most worthless, *something is happening.*[15]

So the theory and the writing are impeccable, judged on their own terms. The same is true of Dalí's sources; he marshals an array of evidence that puts even our most adventurous texts to shame. The pornographic postcard is

only his first popular image; as E.H. Gombrich was to do thirty years later, Dalí collected *Angelus* cartoons and postcards from all around the world. He also reports on storefront displays, sets of china, and a book he had as a child. And have any art historians cited sketches they first published in *Playboy?*[16]

When it comes to questions of technique, most art historians make use of existing conservation reports; Dalí convinced the technical laboratory at the Louvre to make an X-ray of the *Angelus,* to see if they could uncover hidden images. (The X-ray, which he reproduces, reveals a small curvilinear form on the lower margin which he claims is coffin-shaped, confirming his conviction that the painting is about the burial of a son.) His research is at times nothing short of miraculous. Having found the vaguely "trapezoidal" outline of the "coffin," he produces a photograph of a gravestone in Quinéville which is not only black and trapezoidal, but has a relief of the *Angelus* sculpted in it![17] (Needless to say, the discovery proves exactly nothing, but it is the kind of astonishing visual material that art historians always want to find.)

Dalí is also more adventurous than most art historians in his use of scientific images, though of course he puts them to irrational uses. Aside from the images of the praying mantis (they only later became clichés), there is also a reproduction of a Surinam toad, "which even today causes me to shiver," and he discusses genetics, aviation, and other scientific and technical subjects.[18]

And finally, it's worth mentioning that the book itself—its physical appearance—is more interesting than most books in art history. I noted earlier that the original French edition is bound in imitation of a schoolbook, with a sharp little metal clasp. The American editor, A. Reynolds Morse, has added information he thought Dalí would have liked, and interpolated additions throughout the book. On one page there is a reproduction of the cover of *Science,* with a photograph of a praying mantis; the issue announces the discovery that mantises have a single "cyclopean" ear in the middle of the face. "Were Dalí not so ill," the editor remarks, "there is no way of telling what interpretation his paranoiac-critical method would make of this recent discovery."[19] The most important additions are two reproductions of pornographic drawings by Millet, one showing two peasants making love "missionary style," exactly as Dalí had imagined (and painted) in reference to the *Angelus.* The editor says he got the images from Bradley Smith's *Erotic Art of the Great Masters,* which was printed just as the translation was going to press.[20] Dalí's interest in postcards and what is now called popular culture also receives comical confirmation in the form of snapshots taken by

the translator and editor on a visit to Port de la Selva and Cape Creus, where Dalí saw rock formations that reminded him of the *Angelus*. It's especially apt and unexpected to see the famous surrealist rocks oddly juxtaposed with tourist photos of the editor and his wife and friends waving at the camera.

MORE ON HALLUCINATIONS

The book gets a great deal right about art history, and goes farther than we do in directions we would like to go: in the pitch of its theory, in the range of its references, in its embracing of the first-person voice. Like Carlström's *Hide-and-Seek*, it almost *is* art history, but there is a crucial difference, much easier to spot than in Carlström's case. The project of *The Tragic Myth* is like a perfect reflection of art history, with everything reversed right to left. No matter how wild, an art historical account will always present itself as if it were setting out to describe an artwork. Even deliberate exercises in mystification such as Philippe Duboy's *Lequeu* tell us about artists and artworks. Dalí is the opposite: he pretends to uncover truths about the innocent *Angelus*, but actually the entire book is about his own hallucinations. Instead of setting out from a hunch about a picture and shoring it with evidence until it becomes a reliable explanation, Dalí begins with a hunch—actually, a hallucination—and then sets out to explain his hallucination, using the painting as evidence. The book *uses* a painting to explain its author's delusions. Dalí is fully aware of the distance between the actual image and his fantasies: "it was precisely a question of the contrast," he remarks at one point, "between the delirious image and the unalterable aspect of the known image . . . [i]n the case of the *Angelus*, the delirious productivity is not of a visual order but is very simply psychic."[21]

The book's first three chapters chronicle his successive hallucinations: an "initial delirious phenomenon" in June 1932 when the painting suddenly appeared to him, leading to the "first secondary delirious phenomenon" and the "second secondary delirious phenomenon," itself comprised of six further "phenomena." The rest of the book purports to explain those phenomena, but it does so by circling back to them, reimagining them, and introducing new hallucinations. The structure is completely labyrinthine. An excursus describes a series of subsidiary hallucinations, including a kind of Ur-image, an "instantaneous image associated with the *Angelus*" (plate 75), which gave rise to a series of further images including the line of Lenin heads on a piano, a set of fried eggs, a line of inkwells on a loaf of bread, and several sculptures, including the sculpture that Dalí had himself photographed while wearing. Even now, he says, the image "still continues

Plate 75

to cause me anguish": it seems that if any image is primordial in his imagi-
nation, this one is. But the excursus closes by saying that the analogy to the
Angelus was clarified after yet another delirious phenomenon, the unex-
pected apparition of a set of china decorated in *Angelus* motifs—and *that*
apparition is listed as number five out of six aspects of the "second secondary
delirious phenomenon": in other words, the structure closes on itself, bites
its own tail.[22]

Logically, if not chronologically or narratively, the opening moment of
the book is Dalí's sense of the *"inexplicable* uneasiness of the two solitary
figures" in the *Angelus.*[23] The "phenomena" are consistently illogical, and
Dalí toys with the signs of psychosis in the way that so irritated André Breton.
After the initial delirious phenomenon, "the admiration and sudden attrac-
tiveness" he feels for the painting "was to occur again, and in what followed
was corroborated by the 'fervent' skepticism with which my friends opposed
my abrupt admiration for the *Angelus.*"[24] The feeling must be true because
everyone around me doesn't believe it: a classic sign of paranoid schizophre-
nia, as Dalí knew perfectly well. His description, therefore, is utterly unreli-
able: it is a hallucination, first of all, and it is reported in a bombastic style
with deliberately suspicious details. At the same time, he observes his hallu-
cinations very carefully (that is, before he records them) and he is well aware
of their "delirious" quality. In the first secondary delirious phenomenon,
Dalí is lying on a beach, playing a game in which he arranges tiny pebbles
and imagines them as colossal stones (menhirs and mountains). It's also a

sexual game, and he tries out "various locations, pairings and 'situations,'" including "the evocative poses of lovemaking." Suddenly two stones remind him of the *Angelus* and provoke "the strongest emotion." Later, reflecting on the moment, he recalls how the stones formed not only a normal *Angelus*, but an exaggerated one, and "the sentiment of this exaggeration nevertheless helped make me conscious of the clearly delirious character of the association of ideas which were in question."[25]

AND ON FANTASIA

Is the text then irrecoverably different from art history? Is it art criticism in the most explicitly subjective mode, where the writer repeatedly declares— as Baudelaire did, and Diderot before him—that everything he says comes from himself? Or, to put the question the other way around: are we to recognize art history by its *exclusive* dedication to explaining pictures, at the expense (say) of generative hallucinations? The reason I chose Dalí's book for the closing chapter, and the reason I call it the best work of twentieth-century art history, is that I find that despite the most egregious acts of deliberate irrationality and deception, and despite the inverted progress of the argument away from the painting and back toward the author's favorite paranoid delusions, the book is fundamentally a superlative exercise in what the Renaissance called *fantasia*—that is, a genuine act of imagination. These days the word *fantasia* is not used, and "fantasy" is an unhelpful false cognate. In premodern thought, *fantasia* meant "vision," "presentation," or "imagination" in the most generous sense: the full engagement with an object, the power of creative imagination.[26] It is what Leonardo said to his patron by way of explaining why he stood so long in the refectory without working on the *Last Supper*: he was forming the picture in his mind, painting and repainting in thought. A fair equivalent in contemporary art historical writing would be the word "engagement," or the slightly more charged term, favored by Stanley Cavell, "conviction." *Fantasia* is the opposite, in other words, of the disengaged and emotionally neutral writing that continues to be the discipline's normal mental state.

The Tragic Myth of Millet's Angelus is in full possession of the apparatus of art history (the scientific "evidence," the theories) and is also a superlative instance of imaginative engagement. Dalí knows this very well, just as he knows his dubious moments and his excesses. At one point he meditates on the fact that even the weirdest hallucination contains the germs of something systematic: "The delirious idea would seem to carry within itself the germ and structure of the systematization: whence comes the productive value of

this form of mental activity which is found not only at the base itself of the phenomenon of personality, but which still constitutes its most advanced form of development."[27] In its own terms, it is a definition of *fantasia* as apt as any classicist's.

The moral I want to draw from this reading, and from each of the other uncontrolled and unbelievable interpretations I have described in the course of the book, is that an engaged imagination is finally what compels conviction. Indisputable facts and irrefutable discoveries are only the skeleton of art history: what counts both initially and ultimately is the ability to put a full emotional and intellectual commitment on the page, and bring the apparatus of interpretation to bear the most forceful possible manner. Dalí's book has all the traits of the modern sense of pictures, and it could nearly serve as a table of contents for this book: it is a tangled detective story, whose protagonist is bent on solving the puzzle of the *"inexplicable* uneasiness" he feels whenever the *Angelus* is near; it unfurls a monstrously ambiguous, astoundingly complex set of entangled meanings; and its argument is actually

Plate 76

founded on hallucination, instead of merely flirting with it. (And so it should come as no surprise that Dalí once designed a jigsaw puzzle, a typical pastiche of his own work with painted jigsaw-puzzle pieces.[28]) *The Tragic Myth of Millet's Angelus* is an inventory of the qualities I have been documenting, and at the same time, it is exuberant about the impossibility of avoiding the most uncontrollable "delirium" in the act of interpretation.

Of course I am not advocating willed irrationality. What Dalí does is consider the sources of his imagination as fully as he can, in order to put them to the most reflective use. Some of the best art historians fit that description: I think, despite their differences, of Michael Fried, Leo Steinberg, or Roberto Longhi. Most of the characters in this book are misfits, because they are the ones that exhibit symptoms most clearly. But the symptoms themselves are not pathologies: they become pathological when they are passively paraded instead of being folded back into the act of interpretation. Full understanding, in the sense developed by Wilhelm Dilthey and taken up by writers such as Hans-Georg Gadamer, obliges writers not to sequester imagination in the name of some distant ideal of scholarship.[29] I may not believe everything Dalí says, but I am utterly convinced by the force of his engagement.

HITLER MASTURBATING

The Tragic Myth is a brilliant text, but it is far from an ideal example. As Lacan knew, paranoid delusions are tenuous even when they seem most rigid, and that is doubly true of paranoid delusions that are partly whipped up out of thin air. Dalí often let himself forget to turn a ironic eye on what he wrote and painted, and after the 1930s he declined in the most appalling way. The American edition of *The Tragic Myth* includes an unbelievable reminder of the dangers of letting imagination loose, and then failing to recapture it: a watercolor of *Hitler Masturbating*, done in 1973 (plate 76). It is the painter's equivalent of the art historians' claims about hidden penises, apes, brains, vulvas, and other members flung from the writers' imaginations onto the pictures. All the wild cryptophiles, the devotees of unleashed ambiguity, the retentive followers of picture puzzles, are walking along the path that ends in Dalí's picture: they are letting their least controlled thoughts say what the entirety of a picture means.

ENVOI:

ON MEANINGLESSNESS

How could a puzzle possibly be like a picture? Speaking literally, it takes some violence to turn a picture into a jigsaw-puzzle: once the picture has been photographed and the photograph glued on a wooden support, the puzzle has to be cut using a jig saw, and then the pieces are broken up and put in the box. These days most commercial picture puzzles are made with die-cut stamps, so that the picture—which is mounted on cardboard, instead of wood—is cut all at once and each copy is the same as every other.[1] Either way, a picture has to be ruined to make it into a puzzle, especially when the cuts don't respect the forms in the picture itself. In a contemporary puzzle, a head may be fortuitously framed in a single piece, but most pieces are random excerpts with no more resemblance to the shapes in the picture than there is between the shard of a broken window and its original rectangle. This should be enough to remind us that pictures are not like puzzles. A picture is a single thing, a meshed whole, not a certain number of more-or-less equal parts. Any cut (imagined or real) wrecks a picture's unity, and tells more about how the picture is perceived than what it actually is.

The same can be said of cryptomorphic images. It was once a popular pastime to find images in other images; the practice began (significantly enough) in the mid-nineteenth century, roughly when the modern discipline of art history got underway. Such pictures appeared in popular maga-

zines, and later also in children's magazines. *Highlights for Children* still publishes hidden images, and older collections are often reprinted as books. Most examples are very simple. The problem with making more complex hidden-image pictures is the same as the problem with making picture puzzles where the pieces match the shapes in the picture: it is difficult to draw an ordinary picture and hide a large, realistic image inside it.[2] Cryptomorphic drawings in *Highlights for Children* tend to be either strangely abstract or oddly curvilinear. The most sophisticated hidden images for children are those in the *Waldo* and *Wally* series, where minuscule images are "hidden" by being surrounded with hundreds, sometimes thousands, of similar images.[3] Other examples, especially nineteenth-century cryptomorphs, are so ornately serpentine that they begin to look more like stained glass patterns than ordinary pictures. Both strategies help camouflage hidden images, but they also force the pictures into artificial configurations. (Magic eye puzzles are another example, since they turn images into weird repetitious patterns of hallucinatory colors.) The moral is the same as with picture puzzles: a picture is not a blind for other images, any more than it is an uncut jigsaw puzzle.

All this is obvious: so obvious that it would seem entirely unnecessary to spell it out—unless, of course, there were an opposing desire that drives us to willfully hallucinate the trappings of puzzles where there are none. Virtually all contemporary art history (and certainly not merely the lunatic sightings that I have been reporting in the last two chapters) treats images as if they were puzzles of some sort. In the end, I think the question has to be a matter of psychology as much as historiography: What makes us behave this way? Since a picture is an object that is manifestly whole and complete, why would we want to experience it as if it were hiding something? Why do we prefer ambiguities, complexities, puzzles, and even hallucinations to other kinds of calmer, less probing, less verbal, less systematic, less stringently conceptualized responses?

I have no full answer to these questions, but I would like to conclude by describing three more explanations that are at least partly plausible. I'll set them out in the order in which I think they belong, from the more limited to the most convincing and general. Still, the last explanation is far from a satisfying answer to the question in the title of the book, and I am not entirely sure that the question even makes sense as I have posed it. (It might, for instance, only be a way of asking *which* pictures we like, or demonstrating that whatever appears to us as a picture is in some degree already a puzzle.) But the three explanations are possibilities I've come back to repeat-

edly as I have worked through the material for this book, and talked it over with people who have spent time thinking about the apparently trivial, but persistently suggestive, link between Erwin Panofsky and Arthur Conan Doyle. Each explanation illuminates part of the contemporary sense of pictures, and together they suggest that we might step back even a little more from what we habitually do, in order to gain a sense of why we do it, why it seems meaningful, and why it gives us pleasure.

SEVENTH EXPLANATION: THE FEAR OF NOT UNDERSTANDING

Perhaps, to begin with the most obvious symptoms, we write so much because we fear not writing, where "not writing" is understood in absolute terms as not speaking, not teaching, not knowing what to say, and ultimately, not understanding. Art history and criticism would then be driven by an inverse perversity, speaking continuously in order not to spend time thinking about the fact that visual objects have nothing obviously or simply to do with speaking. The incessant claims to knowledge would be the symptoms of a low-level ineradicable anxiety about understanding artworks. After all, pictures are very different kinds of objects from those that art historians have mastered: historians know languages, libraries and archives, essays, reviews and monographs, but pictures are deeply alien to all those things, and fundamentally they are nothing but masses of paint or chalk.

An interesting model for the simmering anxiety I am imagining can be borrowed from the early Freud, and especially the essay "The Unconscious," written in 1911. There Freud elaborates the concept of the Censor, and works out how ideas move between the Conscious, Preconscious, and Unconscious—the three domains of the psyche according to his "first topography." Freud pictures the Unconscious as a separate realm, with a closed border. Beyond the border is the Preconscious, and beyond that the Conscious: the entire schema is like a bull's eye target, though he does not provide a drawing as Jung later did. The Censors are stationed like guards between the realms, and free energy courses through the system, waiting to be attached to the storehouses of ideas. If a certain Unconscious idea is too terrible to contemplate directly, the Censor will not allow it to pass into the Conscious. The energy associated with that forbidden thought might then jump to an apparently unrelated idea—say, the idea of a snake—which could gain entrance to the conscious mind. But according to Freud, even *that* idea might provoke too much fear, or bring with it too much anxiety (that is, free-floating energy), and so it might be displaced in turn onto related ideas—say, frogs, lizards, and worms. As the process continues they

too may provoke fear, and the energy associated with the original idea may end up transferred to quite distant and apparently innocuous ideas.

Freud uses two similes to describe the troubled border between the Unconscious and the Preconscious. In one sense it is like a patch of skin that is infected, or has a rash: it is hypersensitive and irritated, so that the least little annoyance will make it flare up. The place where the Unconscious idea threatens is the site of the infection, and secondary ideas are the reddened skin around it. After a while, any idea even remotely connected with the original one will provoke an allergic reaction. In the second simile, the border is like a castle and each new Unconscious idea is a new rampart or turret, building outward, extending the fortifications. Eventually the Unconscious castle might be constructed a fair way out into the Preconscious, so that the realm of the Unconscious grows successively larger.

In either metaphor a single unthinkable thought initiates the phobic reaction, enlisting innocent words and ideas into its pathological economy. The kind of idea Freud has in mind for the original forbidden thought is something on the order of, "I want to marry my mother." But let's say that in place of that we put something like "I do not understand pictures"—a reasonable guess if the economy of puzzle-solving is to be imagined as a phobic reaction. That horrifying thought might then be transferred to an apparently unrelated idea: not to the concept of a snake (though that might make for an interesting art historian), but to something like ekphrasis; and when ekphrasis becomes too fraught, the acceptable substitute for the generative fear might extend to connoisseurship, formalism, iconology, semiotics, and to the host of specific methods and strategies of current art history—including, inevitably, psychoanalysis itself.

Art history's interpretive strategies would then be ways of not thinking about the possibility of not understanding pictures. As a defense mechanism against the fear (the "iconophobia," in W.J.T. Mitchell's term[4]), the methods of art history would share the properties of the secondary phobias in Freud's example: their presence would excite a peculiarly intense interest, an irritation or an anxiety. That's a fairly good description of art historians' fascination with theories, games, puzzles, and the pictures that seem to embody them. We think so hard about theories and puzzles, in other words, because we can't bear to think directly about pictures.

Is it sensible to imagine art history this way? Could it be that something akin to the Freudian phobic reaction generates any significant part of what we do? Despite appearances, I think it does. At the end of the Introduction I said that art history is like a bruise that has grown up around an initial

injury, and in many ways that is so. We are hypersensitive to pictures, and to each other's theories about pictures. Our libraries and reading-lists are swollen, and we are constantly attending to the state of the discipline, its health, its complaints and problems—we even dispute whether the metaphor of ill-health is ill-suited. There's a great deal of pathology in the ways we write and behave. Rashes, bruises, injuries of various sorts—all the figures fit the speech. If I were to give a name to art history's characteristic illness, I might call it cryptomania: like monomania, catatonia, and hysteria, it may very well be a disease that is historically determined, and it may vanish as quietly as it first appeared. Naming the disease helps remind us that we are a single community: even if we're not all cryptomaniacs, each of us has a slight case—we are all slightly ill in the presence of pictures.

The Freudian model goes some way toward accounting for art history's propensity to see puzzles where there are only pictures, and it has the intriguing consequence of helping us understand our interpretive methods as substitute formations instead of independent ideas. Methods such as social art history, feminisms, and even psychoanalysis would be "of interest" largely because they *can be*: they are subjects we can study with impunity, shelters from the more troubling images they partly mask. The unnaturally intense curiosity that historians characteristically have for certain methods would be explained, in Freud's model, as a substitute formation: we think hard about methods, theories, languages, and all other kinds of interpretive tools because we would rather not think about something else that is closer to the images.

To me these are intriguing thoughts, but the Freudian model also has its drawbacks. I am not sure that it makes sense to think of our various interpretive methods as substitutes for any single generative anxiety, because many methods and skills are, in the Freudian term, relatively uncathected. Nor do I think that it would be sensible to chain an explanation to the well-known problems of Freud's first topography—though there is the curious fact that psychoanalysis and art history grew up together in the first half of this century.[5] And in the end, the Freudian model itself suffers from an unfortunate neurosis: it is unable to specify the exact nature of the fear that causes so many secondary phobias.

Without the model, it can still make sense on occasion to recall that art historians tend to have a certain anxiety about pictures built in to their education. Pictures are made in studios, far away from the loquacious environment of academic art history. Most art historians cannot draw or paint, and a substantial number have limited contact with the world outside acad-

emia. As a result, art historians may feel more uncomfortable in studios, or in direct encounters with pictures (that is, without the usual apparatus of slides, labels, monographs, and prepared notes) than they admit. The situation, I might note, is very different in other disciplines: literary historians and critics may not be skilled poets, but they trade in words just as their subjects do. Musicologists and music critics are often (and often notoriously) unskilled, but virtually all can play music as well as read and analyze it. Art history may have a more ingrained discomfort with its subject than literary studies or musicology, simply as a consequence of the separation between places where pictures are made and where they are studied. In that sense, rather than in the evocative but somewhat vague Freudian sense, our pictures are puzzles because we need to be able to solve *something*, even if we cannot master or even understand a great deal about how pictures are made.

EIGHTH EXPLANATION: PICTURES AS LOST PARTS
OF THE WORLD

One of the problems with the seventh explanation is that most working art historians have long ago put away their anxieties about being unskilled, and although many may regret it in a generalized sense, it would not be easy to show that the gap between scholarship and production is perceived as a problem. My eighth try at an explanation begins from the more abstract observation that a picture can be understood as an object that seems somehow *incomplete*, that poses questions and requires solutions. It is fundamentally strange that we think pictures—conglomerations of oil and rock, or photographic chemicals—should need to be *solved*. It is also strange that our favored ways of "solving" the object should bring it into proximity with the conventions, the obsessions, and the repetitions of murder mysteries. And in linguistic terms, it is strange to think that words can "solve" images at all.

The idea that a picture seems to ask for a solution is, I think, one of the deepest currents in Derrida's *The Truth in Painting*, and several of his ideas can be brought together with the notions of fear or anxiety in the previous explanation. Derrida begins by asking some conventional philosophic questions about the relation of painting and truth: Can painting be the truth itself, "restored, in person, without mediation, makeup, or mask"? Can painting be a direct representation of the truth, "faithfully represented, trait for trait"? Is it a representation of truth in paint, as opposed to in words, in architecture, or in sculpture? Or does it perhaps contain a truth within itself, as a knowledge of oil or tempera or canvases?[6] As I read the text, Derrida

wants to displace the whole discourse of painting and truth—to stop weigh-
ing theories and begin to see the shape of the desires that are set in motion
by pictures. As Jay Bernstein puts it, for Derrida "'painting' is the (excessive)
gift that produces the desire for restitution, but for which no restitution is
possible."[7] Or, as I quoted Derrida in the Introduction, "what is a desire of
restitution if it pertains to the truth in painting?"[8] In the final chapter of *The
Truth in Painting*, the problem becomes how *not* to continue writing as if
pictures were really or merely puzzles, how to stop ourselves from thinking
that pictures pose questions about the relation to truth, and how to begin
seeing them as something other than problems to be solved.[9]

Derrida offers a number of solutions, and they take their sense from
remembering or recognizing a "structure of detachment" that prevents
pictures from connecting easily to words or to the world. Van Gogh's shoes
are not a painting of Van Gogh's shoes. Both the painting and the objects
themselves are unknowable, in different ways; and both propose connections
to the other, in different ways. The "structure of detachment" has two
elements: first the objects in the picture, whether they are realistic forms or
painterly gestures, are detached from their referents in the world; and
second, the picture itself is detached from the world, at the least because it
represents the world rather than being an example of something in the
world. Derrida implies that the machinery of interpretation cannot get
started unless it takes those two detachments as a pair—the picture must be
to its parts as the world, or part of it, is to its parts. Without a bridge between
artworks and words, there is no immediate sense to any solution, and with-
out a determinate connection to the world, talk about truth "in" or "of"
painting becomes unclear and ultimately symptomatic instead of truthful.

It is also possible to come around to the same point by thinking of the
semiotic and non-semiotic marks that comprise pictures. If a painting is a
mark, then the object it represents can be said to "re-mark" it—that is, to
identify it as a picture, "the repeatable sign of some signified." In *Dissemi-
nation*, Derrida calls the result a "double mark" or "mark-supplement" (*le
supplément de marque*). As Jay Bernstein notes, Derrida emphasizes the
looseness of the defining relation between mark and re-mark:

> Although the re-marking is what first gives to the mark its possibility of sense,
> hence the analogy to transcendental grounding [as in theories that claim
> painting has a certain relation to the truth], what does the re-marking is
> detachable from and independent of what it doubles and re-marks. And that
> detachment, the possibility of detachment that attaches to all re-marking,

infects, deflates, withdraws the grounding security, the reliability, insinuated by the quasi-transcendental movement of constitution provided by the re-marking.[10]

Derrida's *Dissemination* draws an equation between this double mark and the anxious search for some solution. The "mark-supplement," he says, "is inseparable from desire."[11]

The account in *The Truth in Painting* has more to do with the behavior of actual historians and philosophers when they are presented with opportuni-ties to enact their desire for appropriation, identification, and ownership in front of paintings; the passages in *Dissemination* can be read as the transcen-dental conditions of their plight. Pictures would be objects that *necessarily* present us with obligations that cannot be fulfilled: by the nature of the graphic mark, they would impel viewers to try to restore them to their origi-nal referents, to their proper parts of the world. Art history would be an espe-cially vexed arena for the enactment of that "obligation." The rush and force of art historical interpretations that Derrida describes so well in the final chapter of *The Truth in Painting* would be the typical symptoms of the disci-pline, or, in his words, the shape of the "desire of *restitution* if it pertains to the truth in painting." It is an unhappy scene, because the structure of detachment intrinsic to pictures must always upset the precipitous "rush" to interpretation, and there is no way to escape the desire as long as we attend to how pictures exist in the world. (As opposed, that is, to taking them as examples *of* the world or as perfect representations of it.) Derrida's own strat-egy is to slow the desire as much as possible, writing as he says "around" painting; but toward the end of *The Truth in Painting* he speeds up, acqui-esces to the desire, and makes a number of strong claims about Meyer Schapiro, Heidegger, truth, and painting.

Derrida's approach is a good way to see how pictures are objects that exert a peculiar fascination, and how they seem—unaccountably, automati-cally—to stand in need of a particular kind of intellectual work. Wisely, I think, he separates the theory of the trace, and in particular the "mark-supplement," from its institutional consequences; but ultimately, that sepa-ration becomes counter-intuitive. The reason Schapiro writes so tersely and impatiently about Van Gogh's shoes is not because he is interested in wrest-ing them from Heidegger and from the politics Heidegger represents: though he does not mention it, Schapiro is undoubtedly well aware of that motivation. He "rushes" because he is *unaware* of what impels him—rush-ing is a sign of anxiety, of something not quite thought out, or thought

through — and in Derrida's account, the impelling force has to be intrinsic to pictures *in general,* and therefore it has to be located in the trace and the graphic mark. I put it this way to suggest why Derrida's approach to pictures, and this eighth explanation, have moments of weakness between the rhetorical account of actual writing in art history, and the transcendental critique of the trace that alone can inform it. The fragile point is not an overlooked flaw in Derrida's account: it is an intentional dissociation, and I would only say, as I did for Freud's topography of Censors, that in art history it is often interesting to inhabit precisely that gap.

NINTH EXPLANATION:

PICTURES AS MEANINGLESSNESS ITSELF

There is one last possibility, the most easily stated and I think the one that lies most deeply under our various odd behaviors. Pictures — this can be put quickly because it is a fact that is in front of our eyes every time we look at pictures — have no words, and therefore they do not "say" anything. If we rarely remember this simple truth in the course of writing art history, it is because we are so engrossed in creating words. The outlandish descriptive armaments we have constructed for some pictures both clarify and alter their meanings, but they also — in the last analysis, at the furthest remove from the writers' intentions — serve to help us come to terms with the fact that in so far as they are pictures, they mean nothing. Art history as a whole may be a collection of ways of coping with a feeling of helpless bewilderment — a feeling that grows whenever we take time to attend to the persistent, senseless silence of images.

One of the obstacles in thinking about what pictures are is the absence of analogies outside of human picture-making. There are some pictures in nature: a caterpillar with large eyespots mimics a snake, which is to say the caterpillar makes part of itself into a picture of a snake. Beyond the biological, there are also "pictures" made by impressions and mineral traces — fossils, natural casts and molds, stains that preserve the shapes of objects. Seventeenth-century collectors were entranced by "picture agates" and *grapholithoi,* stones whose cut surfaces seem to reveal landscape paintings. Cast shadows also trace "pictures," and they have been enlisted as the origin of image-making in general. Plato's cave is the first instance in Western writing, and the myth that painting began by tracing cast shadows has been well studied in art history. Many of these possibilities were of interest to natural philosophers before and during the Enlightenment, and other parallels to pictures have been made in the pre-scientific literature. But there is another

kind of natural picture, one that leads the analogy to painting in a different direction. I am thinking of fallen leaves, especially ones with bright colors.

If it is early in the fall and there aren't too many other leaves around, a leaf that's especially colorful may attract my attention: but even if I pick it up and look at it carefully, I put it down again in a moment because I see it means nothing. It says nothing (nothing's written on it), and I know it is not communicating to me in any way I might hope to describe. Even in biological terms, its colors are meaningless: they don't signal to any animal, they're not warnings, protective coloration, or camouflage. And leaves don't represent anything—they don't resemble, mimic, or depict any object or color. In semiotic terms they are signs without referents—literally so, since they have forever lost their original connections to the tree. Fallen leaves are entrancing, partly because they are detached from any meaning I might put into words: for me, a perfect—if partial—definition of a picture.

I take leaves as an example instead of something more traditional (and more fanciful) like shadows projected on a wall, or some mysterious fossil "painted" in a rock, because leaves are so ordinary. It may seem that the paintings studied in art history are very unlike leaves, because they represent things in the world, and they are made with meanings in mind. But given the interpretive frenzies we have witnessed in this book, I am tempted to think that art history purposively searches out pictures that are most amenable to meaning, precisely in order to avoid the meaninglessness that is inescapable in "simpler" pictures and in natural objects like leaves. We prefer our pictures to be so dense with signs that they are already half inside language. But a picture is also something whose signs don't spell anything. This is a truth that art history finds very hard: even the most fascinating and absorbing pictures, the ones that call for the full expertise of the discipline, are fundamentally meaningless: if they were not, they would not be pictures—they would be texts.

There are many ways of acknowledging the meaninglessness and trying to bring it into the texts. The *je ne sais quoi* is one, and so are the notions of "genre," the *fête galante*, and the Not-Subject and Anti-Subject. Though I have avoided casting this book in the language of classical aesthetics, the word "beauty" as it is used by Kant is also a name for whatever is nonpropositional. "Beauty" still lingers in some art criticism and aesthetics as an ill-defined word for whatever eludes words. Closer to art history, Walter Pater's "decadent" aestheticism is replete with gestures in the direction of meaninglessness. (At one point he reminds his readers that "a great picture has no more definite message for us than an accidental play of sunlight and shadow

for a few moments on the wall or floor.") I am not saying that we need to choose between the *je ne sais quoi* and the Anti-Subject, or between Pater's tenebrous poetics and Kant's brilliant analytic. The inennarable portion of pictures is whatever appears under the sign of meaninglessness. For modern writers, that sign has increasingly become the invisible residue of a torrential onslaught of words. That is why it helps to remember that some pictures — like fallen leaves — are irrefutably, permanently, and wholly meaningless. I know that whatever I write about the meaning of a fallen leaf is poetry, but somehow I always manage to forget that when I am writing about paintings.

DO WE KNOW WHAT WE'RE DOING?

Each of the nine explanations I have proposed in the course of this book has some truth in it, even if they don't add up to a good answer for the question of the title. The first, second, third, and fourth (in order: that knowledge has increased radically; that the discipline has grown exponentially; that we have new insight into pictures; and that the culture has changed the meaning of pictures) are mostly unsatisfying. They are too obvious, and they don't take us very far toward understanding what we are doing. The fifth (that we write more in order to construct and preserve the past) makes historical sense, and so does the sixth (that art historians are practicing a belated psychoanalysis and a belated surrealism). I wonder, though, about their conceptual stability: do I really know more about my writing because I know it may be an after-effect of a movement such as psychoanalysis? We are inside psycho-analysis, just as we are inside our sense of history, and so I am not much enlightened by having contemporary writing explained as a consequence of such a labile and unencompassable conceptual field.[12] The seventh explanation (that art historians feel some anxiety about their lack of knowledge of picture-making) speaks to the education of art historians, and it helps in specific instances. The eighth (that pictures seem incomplete, as if they stood in need of reconnection to the world) and ninth (that pictures are our best examples of meaninglessness) are the most general, and so I like them the best. But I don't want to try to herd the nine explanations into a single, overarching explanation, because I am not sure how they fit together. Their differences might serve as a warning that my question is ill-formed, or that all of this is still too close and too little tested. In that spirit, instead of drawing a moral I will end the book with another question.

There are many signs that our sense of pictures is troubled. Our unease, our sometimes intense anxiety, our compulsion to puzzle about pictures, our neurotic symptoms, our phobias, our habit of rushing to "frame," iden-

tify, attribute, and "appropriate" pictures, are all a bit wild. One of the few tones that is absent from contemporary art history is Erwin Panofsky's calm and measured prose. His generation of art historians could write with a grace, evenness, and decorum that is unavailable today. Wittkower's clarity, Wind's gentle descriptions, Blunt's urbane decorum are not only signs of a different social sense of art history (one that most of us would not want to recall), but of a version of pictures significantly less turbulent than ours. Examples farther in the past appear even calmer, more at ease, more conversational. I have offered no explanation in this book for *how* we became so feverish, and so dedicated to writing. Instead, I have been preoccupied with showing that our pictures *are* puzzles, and in saying what kinds of puzzles they are. I have said next to nothing, because I have almost nothing to say, about how our pictures became puzzles to begin with. Even the last few explanations only succeed in saying why pictures might be puzzles *to anyone*, rather than why they have become puzzles only in the last hundred years of writing on art. There are a number of possibilities. Following writers such as Derrida or Rosalind Krauss, I might have chosen to stress the foundational effects of psychoanalysis on our sense of pictures. Or, following historians like Barbara Stafford, I could have said that Enlightenment education paved the way for a different visual culture, one that requires more exegetical fervor. Or I could have taken a cue from Hans Belting, and assigned the disparity to the inception of the concept of art at the end of the middle ages. In earlier drafts of this book, I tried to work out what might be said from these and other perspectives. But in the end, they all shrank back into the text (they are mostly implied in the fourth and sixth explanations) because I was not sure I wanted *any* contextual explanation to have the last word. Why are our pictures puzzles? is a question not just for historiography, but for reflection. It's not that historiographic analyses are unrewarding or superficial: it's that I would not want to be lulled into thinking I understand myself because I understand something about history.

At the moment I can only say that for some reason pictures failed to strike previous generations with anything near the force with which they have afflicted us. The majority of contemporary art history is puzzle solving, and when the puzzle is easy or uninteresting, or the problem does not seem pressing, or the interpretive theory is simple, indifferent, or absent, then the writing becomes detached from what is most vigilant and reflective in the discipline. We are inescapably attracted to pictures that appear as puzzles, and unaccountably uninterested in clear meanings and manifest solutions. The discipline thrives on the pleasure of problems well solved, and it

languishes in the face of the good, the common, the merely true, the skill-
ful, and above all, the image that refuses to present itself as a puzzle.
Certainly we need to take seriously the historical isolation of our strangely
vexed relation to art works, and to resist seeing our responses as universal,
conventional, or unproblematic. But part of that historical awareness would
have to include a notion about how little of our situation we have so far been
able to understand. For some reason, pictures make us anxious; and one of
the things that people do when they are anxious about something is talk a
great deal—as we all do in art history, and as I have just done again here.

NOTES

NOTES TO THE INTRODUCTION

1. *Paintings by Renoir*, edited by Leigh Bock (Chicago: Art Institute of Chicago, 1976), n. p., text to pl. 20. The following quotation is from the same source.

2. Birger Carlström, *Hide-and-Seek, Text and Picture in the Pictures, Impressionists from Turner from [sic] Gainsborough* (Urshult, Sweden: Konstförlaget [privately printed], 1989), 40. Further references will be in the text.

3. *Ibid.*, plates 37, 35, 32, 27, 3, 7, and 15 respectively.

4. These questions of disciplinary coherence are explored in my *Our Beautiful, Dry, and Distant Texts: Art History as Writing* (University Park, PA: Pennsylania State University Press, 1997).

5. See my essay, "On the Impossibility of Close Reading: The Case of Alexander Marshack," *Current Anthropology* 37 no. 2 (1996): 185–226, with critical exchange and response. An expanded version of the essay (but without the ensuing critical exchange) is in *Our Beautiful, Dry, and Distant Texts, op. cit.*

6. LaCapra, "History, Language, and Reading: Waiting for Crillon," *American Historical Review* 100 no. 3 (1995): 799–828. The idea of speaking "within" or "in" is developed in *Our Beautiful, Dry, and Distant Texts: op. cit.*, chapter 1.

7. Derrida, *The Truth in Painting*, translated by Geoff Bennington and Ian McLeod (Chicago: University of Chicago Press, 1987), 10.

8. This is the subject of my "The Snap of Rhetoric: A Catechism for Art History," *Sub-Stance* 68 (1992): 3–16, revised in *Our Beautiful, Dry, and Distant Texts, op. cit.*

NOTES TO CHAPTER I

1. Carrier, *Principles of Art History Writing* (University Park, PA: Pennsylvania State University Press, 1991), 29.

2. Steiner, *Real Presences* (Chicago: University of Chicago Press, 1989), 25.

3. The only published source for the number of American dissertations is the annual list published by *The Art Bulletin*. *Art Bulletin* 69 no. 2 (1987): 316–20 lists about 200 dissertations for 1986. *Art Bulletin* 77 no. 2 (1995): 347–53 lists about 330 dissertations for 1994. Since dissertations do not have to be reported to the *Art Bulletin*, it stands to reason many are not; so I have extrapolated and added about 25 percent. The 400 or so dissertations compare ominously with the approximately 12,000 members in the College Art Association, and the 50 or so teaching jobs advertised each year in the discipline. I thank Ann Jones, serials librarian at the Art Institute of Chicago, for assistance compiling these statistics.

4. These numbers are based on the 1994 BHA. For the *Art Index*, the exact numbers

are 34,704 essays and articles in the 1995 *Art Index,* as opposed to 33,599 in 1985 and 30,442 in 1988. I thank Alison Dickey for information on the *Art Index.* For related information in architectural history, see John Maas, "Where Architectural Historians Fear to Tread," *Journal of the Society of Architectural Historians* 28 no. 1 (1969): 3–8. I thank Udo Kultermann for this reference.

5. This is estimated from two figures—34,704 articles and essays, and 4,773 subject headings—with allowance made for historians who wrote more than one essay or article.

6. From this point on, the numbers are very rough estimates, done by sampling pages and multiplying the results. No statistics of this kind are kept by the relevant publications, or are available from their databases.

7. Here description is a relative term; I have estimated the number of artists who are given more than two or three lines of text in the Third Edition.

8. *Philostratus,* Imagines; *Callistratus,* Descriptiones, edited by Arthur Fairbanks (Cambridge, MA: Harvard University Press, 1960).

9. Pausanius X.xxv.3–xxvii.4 describes the *Iliupersis;* X.xxviii.1–xxxi.12 describes the *Nekyia.* See for example *Description of Greece,* translated by W.H.S. Jones (Cambridge, MA: Harvard University Press, 1935), vol. 4, 513–55. For additional examples see Mary Louise Hart, "Athens and Troy, The Narrative Treatment of the *Iliupersis* in Archaic Attic Vase-Painting" (Ph.D. dissertation, UCLA, 1992).

10. Stansbury–O'Donnell, "Polygnotus's *Iliupersis:* A New Reconstruction," *American Journal of Archaeology* 93 no. 2 (1989): 205–15; and see Stansbury–O'Donnell, "Polygnotus's *Nekyia:* A Reconstruction and Analysis," *American Journal of Archaeology* 94 (1990): 213–35. The next-most lengthy example is Pausanius V.xvii.5–xix.10, translated in *Description of Greece, op. cit.,* vol. 2, 479–95, and see also *ibid.,* vol. 5, 188.

11. Carl Robert, *Die Iliupersis des Polygnot* (Halle: M. Niemeyer, 1893); and L. Faedo, "Breve racconto di una caccia infruttuosa, Polignoto a Delfi," *Ricerche di Storia dell'Arte* 30 (1986): 5–15; and compare Mary Louise Hart, "Athens and Troy," *op. cit.*

12. *Iliad* XVIII.478–607. In the *Theogony* there is a 79–line description of Pandora; see George Kurman, "Ekphrasis in Epic Poetry," *Comparative Literature* 25 (1974): 1–11.

13. For Aratus see, for example, *Aratos Phainomena: Sternbilder und Wetterseichen,* edited by Manfred Erren, with 23 maps by Peter Schimmel (Munich: Heimeran Verlag, 1971). For images in Virgil see Edward Nolan, *Now Through a Glass Darkly: Specular Images of Being and Knowing from Virgil to Chaucer* (Ann Arbor: University of Michigan Press, 1990).

14. For discussion of documents pertaining to the iconoclasm see Hans Belting, *Likeness and Presence, A History of the Image before the Era of Art,* translated by Edmund Jephcott (Chicago: University of Chicago Press, 1994), especially 146–55; Henry Maguire, *Art and Eloquence in Byzantium* (Princeton: Princeton University Press, 1981); Fernanda De'Maffei, *Icona, pittore e arte al Concilio Niceno II e la questione della scialbatura delle immagini, con particolare riferimento agli angeli della chiesa della Dormizione di Nicea* (Rome: Bulzoni, 1974); and for a more popular introduction, Jaroslav Pelikan, *Imago Dei: The Byzantine Apologia for Icons* (Washington, DC: National Gallery of Art, 1990). Among longer texts concerned with art there is *The Pilgrim's Guide to Santiago de Compostela,* edited by William Melczer (New York: Italica Press, 1993), and see *The Pilgrim's Guide to Santiago de Compostela: A Gazetteer,* edited by Annie Shaver-Crandell and Paula Gerson (London: Harvey Miller, 1995). I thank Rachel Dressler for these references.

15. Belting, *Likeness and Presence, op. cit.*, 472.

16. Gombrich, "The Leaven of Criticism in Renaissance Art: Texts and Episodes," in *The Heritage of Apelles* (Ithaca, NY: Cornell University Press, 1976), 111–31.

17. Paul Otto Kristeller, "The Modern System of the Arts: A Study in the History of Aesthetics,' *Journal of the History of Ideas* 12 (1951): 496 ff., and 13 (1952): 17 ff., vol. 12, 505; Julius von Schlosser, *Die Kunstliteratur: Ein Handbuch zur Quellenkunde der neueren Kunstgeschichte* (Vienna: A. Schroll & Co., 1985).

18. Panofsky, *Renaissance and Renascences in Western Art* (New York: Harper and Row, 1972), and Panofsky, "The First Page of Giorgio Vasari's "Libro": A Study on the Gothic Style in the Judgment of the Italian Renaissance," *Meaning in the Visual Arts* (Chicago: University of Chicago Press, 1972), 169–235.

19. For several of these terms see David Summers, *Michelangelo and the Language of Art* (Princeton: Princeton University Press, 1981).

20. Schlosser, *Die Kunstliteratur, op. cit.*; see also Michael Podro, *The Critical Historians of Art* (New Haven: Yale University Press, 1982).

21. For Bassi see my *Poetics of Perspective* (Ithaca, NY: Cornell University Press, 1994), 72–77; for Comanini see *Il figino*, in Paola Barocchi, *Trattati d'arte del Cinquecento*, vol. 3 (Bari: G. Laterza, 1962), and Anna Ferrari–Bravo, *Il Figino del Comanini, theoria della pittura di fine '500* (Rome: Bulzoni, 1975).

22. Thomas Da Costa Kaufmann, paper delivered at the College Art Association conference, Boston, February 1996. For Winckelmann see *Winckelmann: la naissance de l'histoire de l'art à l'epoque des Lumieres* (Paris: Documentation française, 1991); and the valuable work by Karl Justi, *Winckelmann, Sein Leben, seine Werke und sein Zeitgenossen* (Leipzig: F.C.W. Vogel, 1866–72).

23. The two-page count is based on Vasari, *Le Vite*, edited by Rosanna Bettarini (Florence: Studio per Edizioni Scelte, 1976), vol. 4, 25–27. Bettarini's edition has Vasari's first edition (1550) at the bottom of each page, and the second (1568) at the top; the 1550 edition occupies 22 lines of text, and the 1568 edition 58 lines. Vasari's account also occupies two pages in *Lives of the Most Eminent Painters, Sculptors and Architects*, translated by Gaston de Vere (London: Philip Lee Warner, 1912–14), vol. 4, 96–97. See also Leo Steinberg, "Leonardo's *Last Supper*," *Art Quarterly* 36 no. 4 (1973): 297–410. Steinberg's account is *over* sixty times longer because each page is longer.

24. Modified from the translations given in Paul Holberton, "Giorgione's *Tempest* or 'Little Landscape with the Storm with the Gypsy': More on the Gypsy, and a Reassessment," *Art History* 18 no. 3 (1995): 383–404, especially 383. The original of the first may be found in Marcantonio Michiel, *Notizia d'opere di disegno nella prima meta del secolo XVI. esistenti in Padova, Cremona, Milano, Pavia, Bergamo, Cremona e Venezia*, edited by G. Frizzoni (Bologna: Zanichelli, 1884), 218. The second is quoted in A. Ravà, "Il camerino delle anticaglie di Gabriele Vendramin," *Nuovo Archivo Veneto* 39 (1920): 177.

25. Henrik Lindberg's book, the least known, is *To the Problem of Masolino and Masaccio* (Stockholm: P.A. Norstedt, 1931), 2 vols.

26. For the literature on the Brancacci Chapel see my *Our Beautiful, Dry, and Distant Texts: Art History as Writing* (University Park, PA: Pennyslvania State University Press, 1997).

27. I argue this in a work in progress, "Chinese Landscape Painting as Western Art History." For this question see *The Traffic in Culture, Refiguring Art and Anthropology*, edited by George Marcus and Fred Myers (Berkeley: University of California Press, 1995).

28. Histories of art written outside Western Europe and America are surveyed in my "Is It Still Possible to Write a Survey of Art History?," *Umění* 43 (1995): 309–16.

Chinese, Indian, and Persian examples are discussed in my *On Pictures and the Words that Fail Them* (New York: Cambridge University Press, 1988), 188–209.

29. In reference to Chinese art, see my "Art History Without Theory," *Critical Inquiry* 14 (1988): 354–78; and "Remarks on the Western Art Historical Study of Chinese Bronzes, 1935–1980," *Oriental Art* 33 (autumn 1987): 250–60. The nature of Chinese art history is addressed in Stanley Abe, "Inside the Wonder House, Buddhist Art and the West," in *Curators of the Buddha*, edited by Donald Lopez (Chicago: University of Chicago Press, 1995), 63–106.

30. In reference to Mesoamerican work, see my "Question of the Body in Mesoamerican Art," *Res* 26 (1994): 113–24.

31. For Ojibwa signs and Native American picture-writing in general, see first Garrick Mallery, "Picture–Writing of the American Indians," *United States Bureau of Ethnology Annual Report* 10 (1893): 1–822.

32. W.J. Hoffman, "Pictography and Shamanistic Rites of the Ojibwa," *American Anthropologist* 1 (1888): 209–29.

33. Armin W. Geertz, *Hopi Indian Altar Iconography* (Leiden: E.J. Brill, 1987).

34. For discussion of an example from Arnhem Land see my *The Domain of Images: The Historical Study of Visual Artifacts* (Ithaca, NY: Cornell University Press, forthcoming); for complex interpretations (by a Western anthropologist) see Howard Morphy, *Ancestral Connections* (Chicago: University of Chicago Press, 1991).

35. Quoted in Michael Anderson, "Art and its Description: Ekphrasis in the Ancient World," *Comparative Literature* 26 (1995): 19–39, especially 25. I thank Caitlin Rae for this reference. For ekphrasis see also Murray Krieger, *Ekphrasis* (Baltimore: Johns Hopkins University Press, 1992).

36. *Description of Greece, op. cit.*, vol. 4, p. 513, X.xxxv.3.

37. For these terms see Gerhard Ebeling, "Hermeneutik," in *Die Religion in Geschichte und Gegenwart*, edited by Kurt Galling (Tübingen: J.C.B. Mohr, 1957), vol. 3, 242 ff., and Peter Szondi, *Einführung in die literarische Hermeneutik*, edited by Jean Bollack and Helen Stierlin (Frankfurt: Suhrkamp, 1975), sections 9–26; both cited in Oskar Bätschmann, *Einführung in die kunstgeschichtliche Hermeneutik* (Darmstadt: Wissenschaftliche Buchgesellschaft, 1988), 4, 57.

38. See Bätschmann, *Einführung, op. cit.*, 33, and for a discussion of nonliteral interpretations, see Michael Podro, review of Mieke Bal, *Reading "Rembrandt,"* in *The Burlington Magazine* 135 (October 1993): 699–700.

39. Bellori, *Le vite de' pittori, scultori e architetti moderni* (1672), edited by Evelina Borea (Turin: G. Einaudi, 1976), 8 ff., cited in Bätschmann, *Einführung, op. cit.*, 50–51. It is Bätschmann's claim that "Bellori dürfte der erste sein, der die Distanz der Sprache um Bild reflektiert hat" (*Ibid.*, 50). *Je ne sais quoi* is discussed below, pp. 165–67.

40. My first two "explanations" are parallel to the two hypotheses Carrier suggests in *Principles of Art History Writing, op. cit.*, 29–30. But his conjectures are neither elaborated nor strongly defended, so I am not addressing them directly here.

41. Svetlana Alpers, "*Ekphrasis* and Aesthetic Attitudes in Vasari's *Lives*," *Journal of the Warburg and Courtauld Institutes* 23 (1960): 190–215; W.J.T. Mitchell, *Picture Theory, Essays on Verbal and Visual Representation* (Chicago: University of Chicago Press, 1994), 151–82.

42. See Whitney Davis's treatment of Winckelmann, in *Replications, Archaeology, Art History, Psychoanalysis* (University Park, PA: Pennsylvania State University Press, 1996).

43. Richard Fichtner, *Die verborgene Geometrie in Raffaels »Schule von Athen«* (Munich: R. Oldenbourg, 1984), and Philipp Fehl, "Rocks in the Parthenon Frieze," *Journal of the Warburg and Courtauld Institutes* 24 (1961): 1–44.

44. Lillian Schwartz, "The Art Historian's Computer," *Scientific American* 272 (April 1995): 106–11. See Harvey Hix, review of my *Poetics of Perspective, op. cit.,* in *Philosophy and Literature* 19 no. 2 (1995): 368–70.

45. For the smile, see Ludwig Goldscheider, *Leonardo da Vinci, Life and Work, Paintings and Drawings* (New York: Phaidon, 1959), 157, citing Robert de Serianne's 1896 mention of Agnolo Firenzuola's *Della perfetta bellezza d'una donna* (1541), enjoining one-side smiling. On anatomy see Ritchie Calder, *Leonardo and the Age of the Eye* (London: Heinemann, 1970), 161; on preganacy see Dr. Keele's opinion, quoted in Raymond Stites, *The Sublimations of Leonardo da Vinci* (Washington, DC: Smithsonian Institution Press, 1970), 336; on the chair, Pedretti, *Leonardo, A Study in Chronology and Style* (Berkeley: University of California Press, 1973), 134.

46. See especially Sylvie Beguin, "La Joconde et le demon," *Connaissance des Arts* 475 (1991): 62–69, and Frank Zöllner, "Leonardo's Portrait of Mona Lisa del Giocondo," *Gazette des Beaux–Arts* 121 (1993): 115–38. I thank Suzanne Miller for bringing this to my attention.

47. Baxandall is quoted (from a personal correspondence) as saying Vasari does "all the modern art critic does, and a bit more, but differently and sometimes elliptically," in David Carrier, *Principles of Art History Writing, op. cit.,* 30.

NOTES TO CHAPTER 2

1. Marin, *To Destroy Painting* (Chicago: University of Chicago Press, 1995), 7.

2. For the *velo* see my *Poetics of Perspective* (Ithaca, NY: Cornell University Press, 1994); Damisch, *La fenêtre jaune cadmium, ou, Les dessous de la peinture* (Paris: Seuil, 1984).

3. Sandström, *Levels of Unreality: Studies in Structure and Construction in Italian Mural Painting During the Renaissance* (Uppsala: Almqvist & Wiksell, 1963); Julian Schnabel, *CVJ: Nicknames of Maître D's and Other Excerpts from Life* (New York: Random House, 1987).

4. For the Caravaggio see Michael Fried, *Courbet's Realism* (Chicago: University of Chicago Press, 1990); for Vermeer's and Cézanne's tables, see my essay "The Failed and the Inadvertent: The Theory of the Unconscious in the History of Art," *International Journal of Psycho-Analysis* 75 part 1 (1994): 119–32.

5. For Dutch naturalism see first Svetlana Alpers, *The Art of Describing: Dutch Art in the Seventeenth Century* (Chicago: University of Chicago Press, 1983); for nineteenth-century realism see the views of Michael Fried and T.J. Clark, for example in Fried, *Courbet's Realism, op. cit.*

6. There are exceptions; see his *Shadows, The Depiction of Cast Shadows in Western Art* (London: National Gallery Publications, 1995).

7. Foucault, *The Order of Things, An Archaeology of the Human Sciences* (New York: Vintage, 1973 [1968]), 4–5. Before Foucault there was, most prominently, Charles de Tolnay's claim that the mirror is a unique variant on the tradition of showing deceased members of a family by depicting their portraits. See Tolnay, "Velázquez's *Las Hilanderas* and *Las Meniñas:* An Interpretation," *Gazette des Beaux-Arts* 35 (1949): 21–38. Most of the mid-twentieth century scholarship centers on Velázquez's position in the court, and the status of painting in relation to the liberal arts, and the image depicted on Velázquez's canvas. See also Carl Justi, *Diego Velázquez and his Times,* translated by A.H. Keane (London:

H. Grevel and Company, 1889), 416; Kenneth Clark, *Looking at Pictures* (London: John Murray, 1960), 31; George Kubler, "Three Remarks on *Las Meniñas*," *The Art Bulletin* 38 (1966): 212–14; Elizabeth Du Gue Trapier, *Velázquez* (New York: Hispanic Society of America, 1948); Gustave Kunstler, "Über *Las Meniñas* und Velázquez," *Festschrift Karl M. Swoboda* zum 28. Januar 1959 (Vienna: R.M. Rohrer, 1959), 141–58. I thank Deborah Juengst, Ari Wiseman, and Clarissa Conger for several *Las Meniñas* references.

8. Snyder, "*Las Meniñas* and the Mirror of the Prince," *Critical Inquiry* 11 (1985): 539–72. In this respect I would link my own diagrams with those of an author whose intentions, and sense of explanation, is otherwise distant from either my own interest or Snyder's: John Moffitt, as in "Velázquez in the Alcazar in 1656: The Meaning of the *Mise-en-Scène* of *Las Meniñas*," *Art History* 5 (1983): 271–30; and see Angel del Campo, *La Magia de Las Meniñas* (Madrid: A–Z Ediciones, 1989).

9. There's also the anachronism of analyzing the pictorial space in a finished painting; see my *Poetics of Perspective*, op. cit., 239–47.

10. For Holbein's painting see Udo Kutlermann, *History of Art History* (New York: Abaris, 1993), 141–48; and for the Laocöon, *ibid.*, 37–46.

11. The literature would now have to include interdisciplinary essays such as Ann Hurley, "The Elided Self: Witty Dis–Locations in Velázquez and Donne," *Journal of Aesthetics and Art Criticism* 45 (1986): 357–69.

12. Bal, *Reading "Rembrandt," Beyond the Word–Image Opposition* (Cambridge: Cambridge University Press, 1991), 247–85.

13. Geoffrey Waite, "Lenin in *Las Meniñas*: An Essay in Historical–Materialist Vision," *History and Theory* 25 no. 3 (1986): 248–285, especially p. 281 fig. 3.

14. Enriqueta Harris, "*Las Meniñas* at Kingston Lacy," *The Burlington Magazine* 132 (1990): 125–30 (about a copy of the painting); Hugh and Robert Kenner, "The First Photo (Reinventing Photography: Fifteen Distinguished Artists' Versions of How the World's First Photograph Ought to Have Looked)," *Art and Antiques* 6 (1989): 69–79 (includes a reproduction of Joel–Peter Witkin's *Las Meniñas*); Robin Stemp, "Reflections on the Past: Drawing on Historical Subjects (Reflections after *Las Meniñas*, Mead Gallery, Warwick University, England; Traveling Exhibit)," *The Artist* [Tenterden, England] 103 (1988): 28–31; Hilton Kramer, "Trashing *Las Meniñas*: The Vulgar Spectacle of Picasso's Artistic Revenge," *Art and Antiques* 6 (1989): 87–88; Susan Galassi, "The Arnheim Connection: *Guernica* and *Las Meniñas*," *Journal of Aesthetic Education* 27 (1993): 45–56; and for an example of recent work see Amy Schmitter, "Picturing Power: Representation and *Las Meniñas*," *Journal of Aesthetics and Art Criticism* 54 no. 3 (1996): 256–68.

15. Leo Steinberg, "Velázquez's *Las Meniñas*," *October* 19 (1981): 45–54, especially 48; Mitchell, *Picture Theory, Essays on Verbal and Visual Representation* (Chicago: University of Chicago Press, 1994), 58.

16. Pierre–Gilles Guéguen, "Foucault and Lacan on Velázquez: The Status of the Subject of Representation," *Newsletter of the Freudian Field* 3 (1989): 51–57. See further my *Poetics of Perspective, op. cit.*, 119. Among the recent literature see especially Frederic Chorda, "Computer Graphics for the Analysis of Perspective in Visual Art: *Las Meniñas*, by Velázquez," *Leonardo* 24 no. 5 (1991): 563–67; John Moffitt, "The Theoretical Basis of Velázquez's Court Portraiture," *Zeitschrift für Kunstgeschichte* 54–53 no. 2 (1990): 216–25; George Kubler, "The Mirror in *Las Meniñas*," *The Art Bulletin* 67 (1985): 316.

17. This is one of the points made, for a very different purpose, by Jonathan Brown, for example in *Velázquez, Painter and Courtier* (New Haven: Yale University Press, 1986), 303.

18. For the historiographic argument, setting out reasons why Velázquez would have

wanted his picture to be complex, see for instance Snyder, "Mirror of the Prince," *op. cit.*; Brown, "On the Meaning of *Las Meniñas*," in *Images and Ideas in Seventeenth–Century Spanish Painting* (Princeton: Princeton University Press, 1978), especially 96–97; and Jan Baptiste Bedaux, "Velázquez's *Fable of Arachne (Las Hilandres)*, A Continuing Story," *Simiolus* 21 (1992): 296–304.

19. Svetlana Alpers, "Interpretation without Representation, or The Viewing of *Las Meniñas*," *Representations* 1 (1983): 31–42, especially 31.

20. For "paradox" see Joel Snyder and Ted Cohen, "Reflexions on *Las Meniñas*: Paradox Lost," *Critical Inquiry* 7 (1980): 429–77.

21. All the entries under "door" in the *Art Index* for 1929 (vol. 1) through 1941 (vol. 4), approximately 200 entries, are for actual architecture rather than representations.

22. Gandelman, *Reading Pictures, Viewing Texts* (Bloomington: Indiana University Press, 1991), 36–55.

23. Hasenmüller, "A Machine for the Suppression of Space, Illusionism as Ritual in a Fifteenth Century Painting," *Semiotica* 29 nos. 1–2 (1980): 53–94.

24. She cites among others Leach, *Culture and Communication, The Logic by which Symbols are Connected* (Cambridge: Cambridge University Press, 1976).

25. Elkins, *Poetics of Perspective, op. cit.*, 34–35.

26. See Damisch, *The Origin of Perspective*, translated by John Goodman (Cambridge, MA: MIT Press, 1993); and the account of Damisch in Yve–Alain Bois, *Painting as Model* (Cambridge, MA: MIT Press, 1990).

27. Derrida, *The Truth in Painting*, translated by Geoff Bennington and Ian McLeod (Chicago: University of Chicago Press, 1987), 255–382.

28. Derrida, *The Truth in Painting, op. cit.*, 10: "What is a desire of *restitution* if it pertains to . . . the truth in painting?" For this reading and further bibliography see my book *Our Beautiful, Dry, and Distant Texts: Art History as Writing* (University Park, PA: Pennyslvania State University Press, 1997), which contains a revised version of the essay "The Snap of Rhetoric: A Catechism for Art History," *SubStance* 68 (1992): 3–16.

29. See Jonathan Culler, Umberto Eco, Richard Rorty, Jonathan Culler, and Christine Brooke-Rose, *Interpretation and Overinterpretation* (Cambridge: Cambridge University Press, 1992).

30. I take this as one of the consequences of Hans Blumenberg's *The Legitimacy of the Modern Age*, translated by Robert Wallace (Cambridge, MA: MIT Press, 1983).

31. Steinberg, "Velázquez's *Las Meniñas*," *op. cit.*, 48. I thank Ari Wiseman for suggesting this fifth explanation.

32. There have been few discussions of the relevant qualities of those texts, which are among the richest in the recent literature. Willibald Sauerländer notes Koerner's open-endedness and the difficulty of arguing with his very carefully plotted suspensions in "German Art: The Return of the Repressed," *The New York Review of Books* (March 21 1996), 33–35. Koerner, *The Moment of Self-Portraiture in German Renaissance Art* (Chicago: University of Chicago Press, 1993); Clark, *The Painting of Modern Life: Paris in the Art of Manet and His Followers* (New York: Knopf, 1985).

33. This is discussed in my review of Stafford, *Body Criticism* (Cambridge, MA: MIT Press, 1991), in *The Art Bulletin* 74 no. 3 (1992): 517–20.

34. The first quotation is from the abstract of Stephen Campbell's session at the 1997 College Art Association conference, titled "Decadence and Dystopia, 1300–1600: Historical Typologies and the Imaging of Experience." For a critique of the homogeneous "golden age" of the Renaissance, see my *Poetics of Perspective, op. cit.* The second quotation is from Sauerländer, "German Art: The Return of the Repressed," *op. cit.*, 33.

35. For example "Remnant painting" between the Ming and Ch'ing Dynasties is the subject of Jonathan Hay, "The Suspension of Dynastic Time," *Boundaries in China*, edited by John Hay (London: Reaktion, 1994), 171–97.

36. Davis, *Replications, Archaeology, Art History, Psychoanalysis* (University Park, PA: Pennyslvania State University Press, 1996).

37. For the blood scrolls see Linda Schele and Mary Ellen Miller, *The Blood of Kings: Dynasty and Ritual in Maya Art* (New York: George Braziller, 1986), and my "Question of the Body in Mesoamerican Art," *Res* 26 (1994): 113–24.

38. See my "On the Impossibility of Stories: The Anti-Narrative and Non-Narrative Impulse in Modern Painting," *Word & Image* 7 no. 4 (1991): 348–64.

39. The best collection of such terms is in Donald Preziosi, *Rethinking Art History: Meditations on a Coy Science* (New Haven: Yale University Press, 1989), especially xii-xv. "Parallactic" is from Hal Foster, *Compulsive Beauty* (Cambridge, MA: MIT Press, 1993).

40. Marin, *To Destroy Painting, op. cit.*, 38.

41. Fried, "Representing Representation: On the Central Group in Courbet's *Studio*," in *Allegory and Representation*, edited by Stephen Greenblatt (Baltimore: Johns Hopkins University Press, 1981), 100; Crimp, "Positive/Negative: A Note on Degas's Photographs," *October* 5 (1978): 89–100.

42. Schmarsow, *Masaccio, der Begründer des klassischen Stils der italienischen Malerei*, vol. 4, *Masaccio oder Masolino?* (Kassel: T.G. Fisher & Co., 1895–1900).

43. Fried, *Courbet's Realism, op. cit.* For a ten-page gloss, see my *Our Beautiful, Dry, and Distant Texts, op. cit.*

44. Steinberg, "Leonardo's *Last Supper*," *Art Quarterly* 36 no. 4 (1973): 298.

45. *Illustrated Catalogue of . . . Oil Paintings . . . From the Collection of William S. Kimball . . . James A. Garland [et al.]* (New York: American Art Association, 1924), no. 72.

46. *Illustrated Catalogue of . . . Oil Paintings . . . From the Collection of Mrs. Leo Wormser* (New York: American Art Association, 1937), no. 18 (auction, May 6 1937).

NOTES TO CHAPTER 3

1. Keith Moxey, *The Practice of Theory* (Ithaca, NY: Cornell University Press, 1994), 111.

2. Clark, "In Defense of Abstract Expressionism," *October* 69 (1994): 22–48.

3. There are almost no histories of jigsaw puzzles. See Linda Hannas, *The English Jigsaw Puzzle, 1760–1890* (London: Wayland, 1972), especially plate 16 and p. 117; and Betsy and Geert Bekkering, *Stukje voor stukje* (Amsterdam: Van Soeren, 1988). I thank Anne Williams for the latter reference.

4. Settis, *Giorgione's Tempest, Interpreting the Hidden Subject*, translated by Ellen Bianchini (Chicago: University of Chicago Press, 1990), 76.

5. Bertrand Jestaz, review of Settis, *L'invention d'un tableau, «la tempête» de Giorgione* (Paris: Minuit, 1987), in *Bulletin monumental* 146 no. 2 (1988): 166–68, especially 167: "Revenu à la table rase, l'auteur rappelle les règles du jeu, ces règles sans lesquelles le recherche iconologique risque de n'être qu'une divagation arbitraire, mais qui, à ma connaissance, n'ont jamais été clairement formulées. Ce sont, pour reprendre son image pleine d'humour, celles du *puzzle*: utiliser *toutes* les pièces, sans en laisser une seule de côte; ne laisser aucun trou; parvenir à une image entirièrement cohérente."

6. W. McAllister Johnson, *Art History, Its Use and Abuse* (Toronto: University of Toronto Press, 1989), 181: "There are inescapable historical facts behind this sad

turn of events. Were one to have lived around the turn of the present century, large pieces...."

7. Lavin, *Piero della Francesca, The Flagellation* (London: Viking, 1972), 15, also quoted in Carrier, *Principles of Art History Writing* (University Park, PA: Pennsylvania State University Press, 1991), 39.

8. Anne Williams, *Jigsaw Puzzles, An Illustrated History and Price Guide* (Radnor, PA: Wallaca–Homestead, 1990), 12.

9. Arasse, *Le Détail, pour une histoire rapprochée de la peinture* (Paris: Flammarion, 1992), 265–67.

10. Linda Nochlin, *Gustave Courbet: A Study of Style and Society* (New York: Garland, 1976).

11. Carlo Ginzburg, "Morelli, Freud, and Sherlock Holmes: Clues and Scientific Method," *History Workshop* 9 (1980): 5–36. The essay has been reprinted at least four times; see also the condensed version, "Clues, roots of an Evidential Paradigm," in *Clues, Myths, and the Historical Method,* translated by John and Anne C. Tedeschi (Baltimore: Johns Hopkins University Press, 1989), 96–125. Ginzburg's essay is also discussed in my *Our Beautiful, Dry, and Distant Texts: Art History as Writing* (University Park, PA: Pennsylvania State University Press, 1997), chapter 3.

12. Ginzburg documents this, and there is independent evidence in William Heckscher, *Art and Literature,* edited by Egon Verheyen (Durham, NC: Duke University Press, 1985), 17: "Next to the film as an art form, Panofsky was fascinated by what he called the Aristotelian quality of the mystery or detective story."

13. An example, with further references, is discussed in my *Pictures of the Body: Pain and Metamorphosis* (Stanford: Stanford University Press, 1999).

14. I thank Gabriella Müller for bringing this to my attention. See Traeger, "La Mort de Marat et la religion civile," *David contre David* (Paris: Louvre, 1993), 401–19, and Traeger, *Der Tod des Marat: Revolution des Menschenbildes* (Munich: Prestel, 1986), especially 149–50; and see the review by Matthias Bleyl, *Zeitschrift für Kunstgeschichte* 51 no. 2 (1988): 292–96.

15. Ginzburg, *The Enigma of Piero,* translated by M. Ryle and K. Soper (London: Verso, 1985), 21.

16. For an analysis see my "On Modern Impatience," *Kritische Berichte* 3 (1991): 19–34.

17. Jean Suyeux, *Jeux Joconde* (Paris: R. Laffont, 1969). I thank Erin McLeod for this reference.

18. Other interesting analogies are suggested by the four jigsaw puzzles that comprise *Adami, Del Pezzo, Schifano, Tadini* (Milan: Studio Marconi, n.d. [c. 1970]), and see also the puzzle in Kazimir Severinovich Malevich, *K. Malevich* (Amsterdam: Thoth, 1989).

19. Lyotard, *Duchamp's Trans/formers: A Book* (Venice, CA: Lapis Press, 1990); Thierry de Duve, *Pictorial Nominalism: On Marcel Duchamp's Passage from Painting to the Readymade,* translated by Dana Polan and the author (Minneapolis: University of Minnesota Press, 1991).

20. See my comments on *Pictorial Nominalism* in a review of Hal Foster, *Compulsive Beauty,* in *The Art Bulletin* 76 no. 3 (1994): 546–48, and further in a reply to Ellen Spitz, *The Art Bulletin* 77 no. 2 (1995): 342–43.

21. This happens, for instance, in de Duve's recent book, *Kant After Duchamp* (Cambridge, MA: MIT Press, 1996).

22. For Caravaggio as a proto–abstract painter, see Frank Stella, *Working Space* (Cambridge, MA: Harvard University Press, 1986), and my "Abstraction's Sense of

History: Frank Stella's *Working Space* Revisited," *American Art* 7 no. 1 (winter 1993): 28–39.

23. The artist known as Jess has experimented with a number of picture–puzzle formats. See *Jess: Paste–Ups (And Assemblies), 1951–1983*, edited by Michael Auping (Sarasota, FL: John and Mable Ringling Museum of Art, 1983), especially 97.

24. Derrida, "Signature Event Context," in *Margins of Philosophy*, translated by Alan Bass (Chicago: University of Chicago Press, 1982), 307–30, especially 326.

25. See the discussion in my *Our Beautiful, Dry, and Distant Texts, op. cit.*

26. Duboy, *Lequeu, An Architectural Enigma* (Cambridge, MA: MIT Press, 1987), especially 89–104. Among the reviews see Joseph Rykwert, in *Casabella* 51 (1987): 37; Philip Larson, *Print Collector's Newsletter* 20 (1989): 145–47; Benedetto Grav-agnolo, in *Domus* no. 704 (1989): 12–13; and Bruno Porter, in *L'Architecture d'Aujourd'hui* no. 252 (1987): 46–47.

27. *Marcel Duchamp, Work and Life*, edited by Pontus Hulten, texts by Jennifer Gough–Cooper and Jacques Caumont (Cambridge, MA: MIT Press, 1993).

28. "Mischievous" is a term E.H. Gombrich applied to my "On Monstrously Ambigu-ous Paintings," *History and Theory* 32 no. 3 (1993): 227–47, in "Inventing Leonardo," *New York Review of Books* 41 no. 12 (June 23, 1994): 39–40.

NOTES TO CHAPTER 4

1. Clark, "Mona Lisa," *The Burlington Magazine* 115 (1973): 144–51, quotations pp. 144 and 147. I thank Erin McLeod for bringing this to my attention.

2. Their mechanical nature is nicely demonstrated by the attempts to build robots that can assemble jigsaw puzzles. See Girgore Cristian Burdea, "Robot Assembly of Jig–Saw Puzzle Pieces," Ph.D. dissertation, New York University, 1987 (Disser-tation Abstracts International 48–11B).

3. Bal, *Reading "Rembrandt," Beyond the Word-Image Opposition* (Cambridge: Cambridge University Press, 1991), and see also her *Narratologie: essais sur la signification narrative dans quatre romans modernes* (Utrecht: HES Publishers, 1984).

4. See Gombrich's argument about Dürer's *Large Apocalypse* in "The Evidence of Images," in *Interpretation*, edited by Charles Singleton (Baltimore: Johns Hopkins University Press, 1969), 35–104, well discussed in Oskar Bätschmann, *Einführung in die kunstgeschichtliche Hermeneutik* (Darmstadt: Wissenschaftliche Buchge-sellschaft, 1988), 49–50, 66–68.

5. Priscilla Muller, *Goya's "Black" Paintings, Truth and Reason in Light and Liberty* (New York: Hispenic Society of America, 1984).

6. In a journal entry of August 5, 1946, Beckmann refers to the painting as *Puss in Boots* (the cat appears in the central panel). For Beckmann, see first Hans Belting, *Max Beckmann, Die Tradition als Problem in der Kunst der Moderne* (Munich: Kunstverlag, 1984); and also *Max Beckmann, Retrospective*, edited by Carla Schulz-Hoffmann, Judith Weiss *et al.* (St. Louis: St. Louis Art Museum, 1984); and Erhard Göpel and Barbara Göpel, *Max Beckmann, Katalog der Gemälde* (Bern: Kornfeld & Cie., 1976), 2 vols.

7. Kessler, *Max Backmann's Triptychs* (Cambridge, MA: Harvard University Press, 1970), 81.

8. This movement may be related to the expressionist "simultaneous stage"; see Schulz-Hoffmann, Weiss *et al., Max Beckmann, op. cit.*, 43.

9. Kessler, *Max Beckmann's Triptychs, op. cit.*, 84.

10. Schulz-Hoffmann, Weiss *et al., Max Beckmann, op. cit.*, 311; for the connection to Goethe, see Kessler, *Max Backmann's Triptychs, op. cit.*, 82–83.

11. An even stronger block to the idea that this picture is a puzzle comes from the right-hand scene. It is known that the boy is a spiritual self-portrait, since Beckmann has said that he made himself into a "picture factory" in school to entertain his friends; but without or aside from that information, there are three or four boys in the picture who are close enough to the red-haired protagonists of the other scenes. If there is more than one subject in a scene which is clearly not a continuous narrative, then *The Beginning* may not be about one boy at all: and if it is not, then there is less chance that there is any diachronic order.

12. Clifford Amyx, *Max Beckmann, The Iconography of the Triptychs* (s.n.: s.l., 1951), translated into German in *Max Beckmann, Die Triptychen im Städel* (Frankfurt am Main, 1981), 99: "Sie mögen gekennzeichnet sein durch eine Mehrdeutigkeit."

13. Dieter Gleisberg, "Gestaltung ist Erlösung? Bemerkungen zu Beckmanns Triptychen," in *Max Beckmann Gemälde 1905–1950* (Frankfurt am Main: Städtelsches Kunstinstitut, 1990), 27–35, discussing among others Heinrich Petzet's analysis of the "Altäre der Verzweifulung" in the *Frankfurter Allgemeine Zeitung* (December 9, 1955), and Wilhelm Fischer's sense of Beckmann's "hermeticism" (Fischer, *Max Beckmann, Symbol und Weltbild* [Munich: W. Funk, 1972)]).

14. Elkins, "On the Impossibility of Stories: The Anti-Narrative and Non-Narrative Impulse in Modern Painting," *Word & Image* 7 no. 4 (1991): 348–64.

15. Camille, *Image on the Edge: The Margins of Medieval Art* (Cambridge, MA: Harvard University Press, 1992); for the question of "modernist" interpretation versus "postmodern" playfulness, see Camille, "'How New York Stole the Idea of Romanesque Art': Medieval, Modern, and Postmodern in Meyer Shapiro," *Oxford Art Journal* (special issue on Meyer Schapiro) 17 (1994): 65–75.

16. In addition to the works I discuss here, see Hermann Ulrich Asemissen, *Ästhetische Ambivalenz, Spielarten der Doppeldeutigkeit in der Malerei*, edited by Peter Gerche (Kassel: Kurhessische Gesellschaft für Kunst und Wissenschaft, 1989), which looks at *trompe l'oeil* illusions from this point of view; and Albert Jacquard, *Abecedaire de l'ambiguïté, de z à a, des mots, des choses, des concepts* (Paris: Seiul, 1989), a short dictionary of leading ambiguous concepts.

17. See Derrida, "Signature Event Context," in *Margins of Philosophy*, translated by Alan Bass (Chicago: University of Chicago Press, 1982), 317, 320, 326 respectively. The essay is also translated by S. Weber and J. Mehlman, *Glyph: Johns Hopkins Textual Studies* 7 (1977). The entire debate cannot be followed in Derrida's book, *Limited Inc.* (Evanston: Northwestern University Press, 1988), since it omits essential antecedent texts: Condillac, *Essai sur l'origine des connaissances humaines* (Paris: Galilee, 1973), with an introduction by Derrida, and J.L. Austin, *How to do Things with Words*, 2nd ed., edited by O. Urmson and Marina Sbisa (Cambridge, MA: Harvard University Press, 1975), as well as an element of the debate itself, J.R. Searle, "Reiterating the Differences: A Reply to Derrida," *Glyph: Johns Hopkins Textual Studies* 1 (1977): 198 ff. The book does, however, include an added "Afterword."

18. See Derrida, "White Mythology: Metaphor in the Text of Philosophy," in *Margins of Philosophy, op. cit.*, 207 ff.; Paul Ricoeur, *Freud and Philosophy, An Essay on Interpretation*, translated by Denis Savage (New Haven: Yale University Press, 1970).

19. Roland Jacques, "Logique de l'ambiguïté," in *Autrement que savoir, Emmanuel Levinas*, edited by Guy Petitdemande [*sic*: Petitdemange] and Jacques Rolland (Paris: Osiris, 1988).

20. *L'Ambiguïté, cinq études historiques*, edited by Jacqueline Cerquiglini *et al.* (Lille: Presses Universitaires de Lille, 1988).

21. Derrida, "Signature Event Context," *op. cit.*, 320.

22. Important early criticisms (which in general attack Empson for being overly strict about separating meanings that should be fluid) include J.C. Ransom, "Mr. Empson's Muddles," *The Southern Review* 4 (1938): 334 ff., and P. Wheelwright, "On the Semantics of Poetry," *The Kenyon Review* 2 (1940): 264–87. Appreciations include M.C. Bradbrook, "Sir William Empson (1906–1984): A Memoir," *The Kenyon Review* (1985): 106–115 and J. Lucas, "William Empson: An Appreciation," *Poetry Review* 74 no. 2 (June 1984): 21–22.

23. See Paul de Man, "The Dead-End of Formalist Criticism," in *Blindness and Insight* (Minneapolis: University of Minnesota Press, 1971), 229–45 (originally published in 1956), and C. Norris, "Some Versions of Rhetoric: Empson and de Man," in *Rhetoric and Form: Deconstruction at Yale*, edited by Robert Con Davis and Ronald Schleifer (Norman: University of Oklahoma Press, 1985), 191–214; and further, J.D. McCoy, "The Middle Way: *Seven Types of Ambiguity* and the Critics," Dissertation Abstracts International 42 no. 7 (January 1982): 3156A.

24. For Marshack see my *Our Beautiful, Dry, and Distant Texts: Art History as Writing* (University Park, PA: Pennsylvania State University Press, 1997), and "On the Impossibility of Close Reading: The Case of Alexander Marshack," *Current Anthropology* 37 no. 2 (1996): 185–226.

25. This example is pursued in more detail my *The Domain of Images: On the Historical Study of Visual Artifacts* (Ithaca, NY: Cornell University Press, forthcoming).

26. For an analysis of the earlier "pictographic" paintings, see *ibid.*

27. Hubert Crehan, "Adolph Gottlieb," *Art News* 59 (1960): 12; Arnason, *American Abstract Expressionists and Imagists* (New York: Guggenheim Museum, 1961), 27; Ashton, *The Unknown Shore, A View of Contemporary Art* (Boston: Little, Brown, and Company, 1962), 25–26, all quoted in Mary MacNaughton, "The Painting of Adolph Gottlieb, 1923–1974," Ph.D. dissertation, Columbia University, 1981 (Ann Arbor: University Microfilms International, 1980), 201.

28. Gottlieb, statement in *The New Decade, 35 American Painters and Sculptors* (New York: Whitney Museum of American Art, 1955), 36, and a taped interview, both cited in MacNaughton, "Painting of Adolph Gottlieb," *op. cit.*, 195.

29. Quoted in MacNaughton, "Painting of Adolph Gottlieb," *op. cit.*, 196.

30. There is good evidence that duality of polarity is a master trope, and the individual interpretations are secondary. Part comes from Gottlieb's statements, such as the ones I have quoted; and there is also a consensus of contemporary critics. See the passages quoted in MacNaughton, "Painting of Adolph Gottlieb," *op. cit.*, 202; MacNaughton also proposes duality as the paintings' principal meaning.

31. Empson, *Seven Types, op. cit.*, 133.

32. *Ibid.*, 153.

33. This example is the locus of debate for those who feel Empson has gone too far. He does battle in a footnote, declaring against M.C. Bradbrook that "if clauses are in apposition, they must be supposed to be somehow distinguishable, or why do they have to be said one after another?" But it is also here that Empson is at his least convincing when he claims "I must protest again that I enjoy the lines very much," despite the fact that they are logically "shuffling" (*Ibid.*, 154).

34. I thank Levi Smith for bringing Matisse to mind as an example of this phenomenon.

35. The painting is an echo chamber, with allusions to painters from Piero della Francesca to Balthus himself. It reflects most clearly his own paintings, including the 1929 version of the same title, and works such as *Brother and Sister*; and it conjures the apparitions of Masaccio and Filippino Lippi's *Miracle of Theophilus's Son* (the model for the round-faced child), Piero della Francesca's scene of the *Queen of Sheba Worshipping the Cross* in Arezzo (the model for the woman facing

right), his *Carrying of the Wood of the Cross* (for the man carrying the cross), and, as a looming presence, Seurat's *La Grande Jatte*.

36. Clair, "Balthus et les métempsychoses," and Starobinski, both quoted in *Balthus*, edited by Dominique Bozo (Paris: Centre Georges Pompidou, 1983), 104–107 and 69 respectively. See also Yves Bonnefoy's observations on this figure, in "L'Invention de Balthus," in *Ibid.*, 91–92.

37. Empson, *Seven Types, op. cit.*, 176, 182.

38. *Ibid.*, 184 n. 2.

39. Clark, *The Painting of Modern Life, Paris in the Art of Manet and His Followers* (New York: Knopf, 1984), 249–51, as excerpted in Klaus Herding's review, *October* 37 (1986): 113–24, quotation on p. 119. For more on the *Bar at the Folies-Bergère* see my "Precision, Misprecision, Misprision," a reply to Thierry de Duve, *Critical Inquiry*, forthcoming.

40. *Ibid.*, 48.

41. Fried, *Courbet's Realism* (Chicago: University of Chicago Press, 1990), 139.

42. This is discussed in my *Our Beautiful, Dry, and Distant Texts, op. cit.* See also my discussion of Brian Rotman's extension of Alpers's schema in *Signifying Nothing: The Semiotics of Zero* (New York: St. Martin's Press, 1987), in my *Poetics of Perspective* (Ithaca, NY: Cornell University Press, 1994), 253–54.

43. This list as adapted from Derrida's enumeration of the problems facing intentionalist criticism, in *Limited Inc., op.cit.*

44. "Paraintentionality" is from the title of a College Art Association panel chaired by Whitney Davis, Boston, 1995.

45. George Steiner, *After Babel, Aspects of Language and Translation*, 2nd ed. (New York: Oxford University Press, 1992).

46. See my "From Copy to Forgery and Back Again," *The British Journal of Aesthetics* 33 no. 2 (1993): 113–20, and the references to copies of *Las Meninas* in Chapter 2 of this book.

47. Among the many possibilities for expanding this list, the most interesting may be category (h), since it includes pictures "held" as a financial investments (for example, paintings kept as monetary equivalents in a private vault), as financial vouchers or chits (paintings valued as trading pieces, as in museum exchanges), and as financial statements (painting kept as non-negotiable signs of money that is itself kept elsewhere, as in a painting in a bank lobby or corporate headquarters).

48. Evidence for its complexity is principally the utter lack of a concerted response in the 25 years since its publication. More recent essays tend to concentrate on the restoration, on psychoanalytic readings, and on computer reconstructions. For basic material see Ludwig Heydenreich, *Leonardo, The Last Supper* (London: Allen Lane, 1974), 12–71.

49. Steinberg, "Leonardo's *Last Supper*," *Art Quarterly* 36 no. 4 (1973): 300; for the first quotation see Matthew 26:23.

NOTES TO CHAPTER 5

1. Heckscher, *Art and Literature, Studies in Relationship*, edited by Egon Verheyen (Durham, NC: Duke University Press, 1985), 17.

2. Some of these may seem less unencompassable, depending on the languages each historian prefers. For Vermeer's painting, for instance, see Lida ven Mengden, *Vermeers De Schilderconst in den Interpretationen von Kurt Badt und Hans Sedelmayr* (Frankfurt am Main, Bern, and New York: Peter Lang, 1984).

3. For English literature on Chao Meng–fu see Li Chu–Tsing, *The Autumn Colors in the Ch'iao and Hua Mountains, A Landscape by Chao Meng–fu* (Ascona, Switzerland: Artibus Asiae, 1965); and for Huang Kung–wang, see A. John Hay, "Huang

Kung-wang's *Dwelling in the Fu-chun Mountains*, The Dimensions of a Landscape," Ph.D. dissertation, Princeton University, 1978 (Ann Arbor: University Microfilms International, 1982).

4. For Giotto see Roberto Salvini, *Giotto bibliografia* (Rome: Fratelli Palombi, 1938), which lists 845 entries with extensive summaries of their contents (making the literature "readable" in a limited sense). For Leonardo see Mauro Guerrini, *Bibliotheca Leonardiana, 1493–1989* (Milan: Editrice Bibliografica, 1990), and Alberto Lorenzi, *Bibliografia Vinciana, 1964–1979* (Florence: Giunti Barbera, 1982). For Velázquez see Juan Antonio Gaya Nuño, *Bibliografía crítica* (Madrid: Fundacíon Lazaro Galdiano, 1963), which lists 1,814 entries. For Goya see Genaro Estrada, *Bibliografía de Goya* (Mexico City: La Casa de España en México, 1940), and Augustin Ruiz Cabriada, *Aportacíon a una bibliografía de Goya* (Madrid: Junta Tecnica de Archivos, Bibliotecas y Museos, 1946).

5. The two principal Michelangelo bibliographies are Luitpold Düssler, *Michelangelo–Bibliographie, 1927–1970* (Wiesbaden: Harrassowitz, 1974), which continues Ernst Steinmann, *Michelangelo–Bibliographie, 1510–1926* (Leipzig: Klinckhardt and Biermann, 1927). Steinmann lists 2,107 entries. The engravings are listed in Luigi Passerini, *La bibliografia di Michelangelo Buonarroti* (Florence: M. Cellini, 1875), 157–256.

6. Fried, *Manet's Modernism, or the Face of Painting in the 1860's* (Chicago: University of Chicago Press, 1996). For Matisse, see Catherine Bock, *Henri Matisse, A Guide to Research* (New York: Garland, 1996), which contains 1,400 books and articles and 1,200 exhibition catalogues. For Pollock see Inga Forslund, [Jackson Pollock bibliography] (S.I. [New York]: s.n. [the Museum], 1967), a photocopy of a typescript held in the Museum of Modern Art, New York. The exhibition catalog, Franci V. O'Connor, *Jackson Pollock* (New York: Museum of Modern Art, 1967), is modified from this original.

7. For "pathognomonics" see Robert Scully *et al.*, "CASE 35–1995," *New England Journal of Medicine* 333 no. 20 (November 16, 1995), 1343.

8. *The Sistine Chapel, A Glorious Restoration*, with contributions by Carlo Pietrangeli *et al.* (New York: Abrams, 1992) That volume has for its excuse the new meanings that became apparent when the Sistine was cleaned—but the veneer of dirt that covered the ceiling did not mislead every previous scholar: many theories about the ceiling are just as valid in full color.

9. Lecture, University of Chicago, fall 1995.

10. Hourticq, *Le problème de Giorgione* (Paris: Hachette, 1930), 52–58, especially 57; and see Lionello Venturi, "Le problème de Giorgione, à propos d'un livre de L. Hourticq," *Revue de l'Art Ancien et Moderne* 60 (1931): 169–84, with a reply by Hourticq; an essay of the same title by C. Mauclair, *Revue de l'Art Ancien et Moderne* 59 (1931): 131–38; a review by M. Malkiel Jirmounsky, *Gazette des Beaux–Arts* ser. 6, vol. 5 (1931): 130, with a reply by Hourticq, *Gazette des Beaux–Arts* ser. 6, vol. 6 (1931): 190–91; and four other reviews. The "hysterical" report of the purchase is "Tempest Taken at Confiscatory Price," *Art Digest* 6 (1932): 5.

11. Christopher Wood, *Albrecht Altdorfer and the Origins of Landscape* (Chicago: University of Chicago Press, 1993).

12. Creighton Gilbert, "On Subject and Not-Subject in Italian Renaissance Pictures," *The Art Bulletin* 34 (1952): 202–16.

13. Paul Holberton, review of Salvatore Settis, *Giorgione's* Tempest, in *Art History* 14 (1991): 126–29, especially 128.

14. Salvatore Settis, *La «Tempesta» interpretata, Giorgione, i committenti, il soggetto* (Torino: Giulio Einaudi, 1979), 11. Hereafter *TI*. "Oddments" is the translation in

Settis, *Giorgione's* Tempest, *Interpreting the Hidden Subject,* translated by Ellen Bianchini (Chicago: University of Chicago Press, 1990), 8. Hereafter *GT.*

15. *Parergon* is used by Pliny in the sense of "embellishment," and in Renaissance and post-Renaissance painting it comes to mean more specifically "embellishment in landscape painting." A different genealogy (beginning with Kant) leads to the current use found in Derrida's *The Truth in Painting,* translated by Geoff Bennington and Ian McLeod (Chicago: University of Chicago Press, 1987). In Baroque criticism *parerga* were also called *staffage.* Further references are cited in *TI,* 18, n. 8.

16. The literature on the painting is reviewed in my *Our Beautiful, Dry, and Distant Texts: Art History as Writing* (University Park, PA: Pennsylvania State University Press, 1997).

17. Gombrich, "The Renaissance Theory of Art and the Rise of Landscape," *Norm and Form* (Oxford: Phaidon, 1966), 107–21.

18. For the Lorenzetti examples, see A. Ronen, "A Detail or a Whole?," *Mitteilungen des kunsthistorischen Instituts in Florenz* 10 (1961–63): 286–94, cited in Settis, *TI,* 18 n. 11.

19. *GT,* 9; *TI,* 12.

20. Creighton Gilbert, "On Subject and Not-Subject," *op. cit.,* 205.

21. *GT,* 9; *TI,* 12.

22. For the detachment from tradition, see my "Abstraction's Sense of History: Frank Stella's *Working Space* Revisited," *American Art* 7 no. 1 (winter 1993): 28–39.

23. *GT,* 37 ff.

24. Morassi, "Esame radiografico della 'Tempesta' di Giorgione," *Le Arti* 1 no. 6 (1939): 567–70.

25. Franz Wickhoff, "Giorgiones Bilder," in *De Schriften Franz Wickhoffs,* edited by Max Dvorak, vol. 2 (vol. 1 was never published), *Abhandlungen, Vorträge und Anzeigen* (Berlin: Meyer und Jenssen, 1913). The opinion was seconded by L. Justi, *Giorgione* (Berlin, 1908). See Statius, *Thebiad* IV. x. 730 ff.

26. Rudolf Schrey, "Tizians Gemälde 'Jupiter und Kallisto' bekannt als 'Die Himmlische und Irdische Liebe,'" *Kunstchronik* 26 (1915): 568–73, especially 573: "Schüchtern möchte ich die 'Familie des Giorgione'… auch als eine freie Illustration zu Ovids Metamorphosen in Anspruch nehmen; das Gemälde zeigt wohl Deukalion und Pyrrha nach der Flut, die alle dahingerafft, bis auf diese selbst; die Wasser verziehen sich, sinnend steht Deukalion, sorglos dagegen sehen wir Pyrrha, Trost findend in ihrer Mutterschaft."

27. Federico Hermanin, *Il mito di Giorgione* (Spoleto: C. Argentieri, 1933), 70; Antonio Morassi, *Giorgione* (Milan: U. Hoepli, 1942), 87; Gustav Hartlaub, "Arcana Artis," *Zeitschrift für Kunstgeschichte* 6 (1937): 289–324; Hartlaub, "Der Paris–Mythos bei Giorgione," *Zeitschrift für Aesthetik und allgemeine Kunstwissenschaft* 32 (1938): 252–63, especially 257 ff.; and Hartlaub, "Zu den Bildnismotiven des Giorgione," *Zeitschrift für Kunstwissenschaft* 7 (1953): 57–84, especially 78–80. Robert Eisler, *New Titles for Old Pictures,* is cited by George Martin Richter, *Giorgione del Castlefranco, Called Giorgione* (Chicago: University of Chicago Press, 1937), 241, as being published in London in 1935. As Settis notes, the book was never published. See *TI,* 79 n. 40.

28. Piero De Minerbi, *La Tempesta di Giorgione e l'amore sacro e l'amore profano di Tiziano* (Milan: L. Alfieri, 1939). *GT,* 61.

29. Angelo Conti, *Giorgione* (Florence: Fratelli Alinari, 1894).

30. Conti, *Giorgione, op. cit.,* 12, quoted in *TI,* 48. Translation mine.

31. Arnaldo Ferriguto, "Del nuovo su «La Tempesta» di Giorgione (Raggi e personaggi), *Misura* (Bergamo) November 1946, 297–300. See *TI,* 81 n. 68.

32. Günther Tschmelitsch, *Harmonia est discordia concors. Ein Deutungsversuch zur "Tempesta" des Giorgione* (Vienna: Verlag "Kunst ins Volk," 1966); Maurizio Calvesi, "La Tempesta di Giorgione come ritrovamento di Mosè," *Commentari* 13 (1962): 226–55, esp. 229; and Tschmelitsch, *Zorzo, Genannt Giorgione: Der Genius und sein Bannkreis* (Vienna: W. Braumuller, 1975).

33. Calvesi, "La *Tempesta* di Giorgione," *op. cit.*, 238.

34. Nancy DeGrummond, "Giorgione's *Tempesta*: The Legend of St. Theodore," *L'Arte* 75 (1972): 5–53.

35. Luigi Stefanini, *Il motivo della "Tempesta" di Giorgione* (Padua: Liviana, 1955).

36. Edgar Wind, *Giorgione's* Tempesta, *With Comments on Giorgione's Poetic Allegories* (Oxford: Clarendon Press, 1969), 2, 3; reviewed by J. Maxon, *Renaissance Quarterly* 24 no. 1 (1971): 73–75 and by Jan Bialostocki, *Zeitschrift für Kunstgeschichte* 34 no. 3 (1971): 248–50.

37. Wind, *Giorgione's* Tempesta, *op. cit.*, 1, 4.

38. Walter Pater, "The School of Giorgione" (1877), in *The Renaissance, Studies in Art and Poetry* (Oxford: Oxford University Press, 1986), 87.

39. "Diaphanetè (1864)," in *The Renaissance, op. cit.*, 154–58, especially 157.

40. Phillips, "Introduction" to Pater, *The Renaissance, op. cit.*, ix.

41. Lionello Venturi, *Giorgione e il giorgionismo* (Milan: Ulrico Hoepli, 1913), 82–87, especially 87. Venturi uses "man, woman, and child" as universals: "uomo, donna, e bambino, sono soltanto elementi—non i principali—della natura." See also Venturi, *Come si comprende la pittura, da Giotta a Chagall* (Torino: G. Einaudi, 1975), 61 ff.

42. Venturi, *Giorgione e il giorgionismo, op. cit.*, 82: "Giorgione aveva chiaro nello spirito un effetto naturale estivo in Venezia assume carattere particolarissimo. Quando il sole è sceso da poco, e lascia il cielo di ponente affatto limpido, mentre verso oriente le nubi si sovraccaricano, allora le nubi assumono una colorazione di un intensissimo verdazzurro minaccioso, e se più sotto vi sono case colorano di luce argentine con riflessi di lievissimo azzurro e di rosa: il tutto ha una delicatezza, una finezza quasi timida di fronte all'ampia a greve massa azzurra."

43. Roy McMullen, *Mona Lisa, The Picture and the Myth* (Boston: Houghton Mifflin, 1975).

44. Bertrand Jestaz, in *Bulletin monumental* 146 no. 2 (1988): 168.

45. *GT*, 76.

46. *GT*, 53.

47. Roy McMullen, *op. cit.*

48. *GT*, 113 and 118. Settis sees a small blade on Adam's staff.

49. For the history of the story in Hebrew, Latin, and Irish, see *The Irish Adam and Eve Story From the* Saltair na rann (Dublin: Dublin Institute for Advanced Studies, 1976).

50. See Arasse, *Le dé tail pour une histoire rapprochée de la peinture* (Paris: Flammarion, 1992), 265–66.

51. See Paul Barolsky and Norman Land, "The 'Meaning' of Giorgione's *Tempest*," *Studies in Iconography* 9 (1983): 57–65; Frank Büttner, "Die Geburt des Reichtums und der Neid der Götter, Neue Überlegungen zu Giorgiones *Tempesta*," *Münchner Jahrbuch der bildenden Kunst* 37 (1986): 113–30; and Alessandro Parronchi, *Giorgione e Raffaello* (Bologna: M. Boni, 1989); all cited in Holberton, "Giorgione's *Tempest*," *op. cit.*, 400–1, n. 8; and the references in the following note.

52. Bertrand Jestaz, in *Bulletin monumental, op. cit.*, proposes the painting should be called *L'indifférance à l'orage*, arguing that "son trait le plus frappent et le plus orig-

inal me paraît la parfaite indifférance des personnages à l'égard des menaces du ciel." "J'ai scrupule à presenter de telles idées," he adds, "qui semblent relever de cet hédonisme primaire auquel S. Settis a voulu justement s'opposer." See also Charles Hope's review, in *The New York Review of Books* (February 14, 1991); and Francesco Cioci, *La Tempesta interpretata dieci anni dopo* (Florence: Centro Di, 1991).

53. Motzkin, "Giorgione's *Tempesta*," *Gazette des Beaux–Arts* ser. 6 vol. 122 (1993): 163–74.

54. Kaplan, "The Storm of War: The Paduan Key to Giorgione's *Tempesta*," *Art History* 9 no. 4 (1986): 405–27; Kaplan acknowledges a similar interpretation by Deborah Howard, "Giorgione's *Tempesta* and Titian's *Assunta* in the Context of the Cambrai Wars," *Art History* 8 no. 3 (1985): 271–89.

55. Pater, "Leonardo da Vinci" (1869), in *The Renaissance, op. cit.*, 63–82, especially 80.

56. This is the reason why I am not doubting the universal assumption that the artist's or patron's intentions are what matters in the *Tempesta*. Although it is reasonable to ask what meanings the picture has apart from reconstructed intentions, such inquiries tend to leave the literature behind. For a meditation on the *Tempesta* without intentionality, see David Carrier, "Artist's Intentions and Art Historian's Interpretation of the Artwork," *Leonardo* 19 no. 4 (1986): 337–42, especially 338. For an example of how detached non–intentional meanings are from the existing scholarship, see the last three sentences of Paul Kaplan's "The Storm of War," *op. cit.*, 416: "We may finally ask ourselves why the *Tempesta* is still a gripping image. Its commentary on the struggle for Padua is no longer intelligible without considerable effort, but the viewer is attracted to something more than the artist's virtuoso handling. The *Tempesta* moves us even now because the historical crisis which prompted the painting moved Giorgione."

57. Modified from the translation given in Paul Holberton, "Giorgione's *Tempest*, or 'Little Landscape with the Storm with the Gypsy': More on the Gypsy, and a Reassessment," *Art History* 18 no. 3 (1995): 383.

58. Hourticq had said as much: "Sans doute, on y peut reconnaître seulement une fantasie dont l'ulilité et de donner du poids à l'aile gauche de la composition." *Le problème de Giorgione, op. cit.*, 57.

59. Holberton, "Giorgione's *Tempest*," *op. cit.*, 398.

60. Holberton, review of Settis, in *Art History, op. cit.*, especially 129.

61. For Botticelli's *Primavera* see especially E.H. Gombrich, "Botticelli's Mythologies: A Study in the Neo-Platonic Symbolism of his Circle [1945]," in *Symbolic Images* (Ithaca, NY: Cornell University Press, 1972).

62. G. Pochat, "Giorgione's *Tempesta*, Fortuna and Neoplatonism," *Konsthistorisk Tidskrift* 39 nos. 1–2 (1970): 14–32.

63. Charles Dempsey, *The Portrayal of Love: Botticelli's Primavera and Humanist Culture at the Time of Lorenzo the Magnificent* (Princeton: Princeton University Press, 1992), especially p. 4; and see the review by Laura Lepschy, *The Burlington Magazine* 136 (March 1994): 176–77. The first influential biographical interpretation is Wilhelm von Bode, *Sandro Botticelli* (London: Methuen: 1925); for astrological and alchemical meanings see Mirella Levi d'Ancona, *Boticelli's Primavera—A Botanical Interpretation Including Astrology, Alchemy, and the Medici* (Florence: Olschki, 1983). The "hermetic–Christian" reading is Joanne Snow–Smith, *The Primavera of Sandro Botticelli, A Neoplatonic Interpretation* (New York: Peter Lang, 1980). More recent literature includes: Nicole Levis, "La *Primavera* et la *Naissance de Venus* de Botticelli, ou le cheminement de l'ame selon Platon," *Gazette des Beaux-Arts* ser. 6 vol. 121 (1993): 167–80, and Richard

Cocke, "Botticelli's *Primavera:* The Myth of Medici Patronage," *Apollo* 136 (1992): 233–38.

64. Dempsey, *Portrayal of Love, op. cit.,* 19.

65. Gombrich, "Botticelli's Mythologies," *op. cit.,* 7.

66. *Ibid.* on wit in Renaissance art, see my "Uccello, Duchamp: The Ends of Wit," *Zeitschrift für Ästhetik und allgemeine Kunstwissenschaft* 36 (1991): 199–224 and 10 plates.

67. Gombrich, "Botticelli's Mythologies," *op. cit.,* 34–36.

68. Lightbown, *Sandro Botticelli, Life and Work,* vol. 1 (Los Angeles: University of California Press, 1978), as described in Dempsey, *Portrayal of Love, op. cit.,* 3.

69. Giulio Carlo Argan, *Botticelli: A Biographical and Critical Study* (New York: Skira, 1957), 23, 74. I thank Sylvia Schweri for bringing this and the following source to my attention.

70. This is one of the tendencies in H.D. Ettlinger and Helen Ettlinger, *Botticelli* (New York: Oxford University Press, 1977), especially 119–22.

71. This observation leads in a different direction in Lightbown, *Sandro Botticelli, op. cit.,* 80.

72. For an introduction to the literature on the cleaning (itself a monstrous topic) see K. Weil–Garris Brandt, "Twenty–five Questions about Michelangelo's Sistine Ceiling," *Apollo* 126 (1987): 392–400, and D. Ekserdjian, "The Sistine Ceiling and its Critics," *Apollo* (1987): 401–4. I thank Charles Cohen for these references, and for several in *Source, Genders,* and the *Women's Art Journal,* cited below.

73. Among the primary sources for this subject are the following: Esther Dotson, "An Augustinian Interpretation of Michelangelo's Sistine Ceiling," *The Art Bulletin* 41 (1979): 223–56, 405–9; Frederick Hartt, "*Lignum vitæ in medio paradisi,* The Stanze d'Eliodoro and the Sistine Ceiling," *The Art Bulletin* 22 (1950): 115–45, 181–23; Staale Sinding-Larsen, "A Re-reading of the Sistine Ceiling," *Acta ad Archæologiam et Artium Historiam Pertinentia (Institutum Romanum Norvegiæ)* 4 (1969): 143–57; Johannes Wilde, "The Decoration of the Sistine Chapel," *Proceedings of the British Academy* 44 (1958); Edgar Wind, "Maccabean Histories in the Sistine Ceiling," in *Italian Renaissance Studies,* edited by Ernest Fraser Jacob (London: Faber and Faber, 1960), 312 ff.; H.B. Gutman, "Jonah and Zachariah on the Sistine Ceiling," *Franciscan Studies* 13 (1953): 159–77; Gutman, "Religiöser Symbolismus in Michelangelos Sintflutfresco," *Zeitschrift für Kunstgeschichte* 18 (1955): 74–76; Gutman, "Michelangelos Botschaft in der sixtinischen Kapelle," *Archivium Franciscanum Historicum* 56 (1963): 258–83; Edgar Wind, "Typology in the Sistine Ceiling: a Critical Statement," *The Art Bulletin* 33 (1951): 41–47.

74. It is not irrelevant that the abbreviated selections in *Michelangelo, The Sistine Chapel Ceiling, Illustrations, Introductory Essay, Backgrounds and Sources, Critical Essays,* edited by Charles Seymour (New York: W.W. Norton, 1972), continue to be the most frequently read in undergraduate classes. Hereafter SC.

75. See Charles de Tolnay, *Michelangelo,* vol. 2, *The Sistine Ceiling* (Princeton: Princeton University Press, 1945), condensed in *SC,* 221–26. The same ideas recur in Sydney J. Freedberg; see especially *SC,* 192, 197, 203.

76. Freedberg, in *SC,* 192. The description is revised from Freedberg's *Painting of the High Renaissance in Rome and Florence,* revised edition (New York: Hacker, 1985).

77. Hartt, review of Tolnay, *Michelangelo,* in *The Art Bulletin* 32 (1950), 245.

78. A number of recent accounts have modified Tolnay's Neoplatonism without abandoning it. See for instance Patricia Emison, "Michelangelo's Adam: Before and

After Creation," *Gazette des Beaux–Arts* 112 (1979): 115–18, which is sympathetic of the Neoplatonic interpretation but also wary of "programmatic" readings.

79. Wind, "Typology in the Sistine Ceiling."

80. Hartt, "*Lignum vitæ*," *op. cit.*, 197, also cited in Sinding Larsen, "A Re-reading of the Sistine Ceiling," *op. cit.*, 147.

81. Dotson, "An Augustinian Interpretation," *op. cit.*, 408.

82. Hartt, "*Lignum vitæ*," *op. cit.*, 135.

83. *SC*, 190–91.

84. Bull, "The Iconography of the Sistine Chapel Ceiling," *The Burlington Magazine* 130 (1988): 597–605; the quotation is on p. 597.

85. *SC*, 117.

86. Freedberg, *Painting of the High Renaissance* , *op. cit.*, in *SC*, 188.

87. Sinding-Larsen, "A Re-reading of the Sistine Ceiling,"*op. cit.*, 144 n. 1 and 143.

88. Wölfflin, *Die Klassische Kunst* (Munich: F. Bruckmann, 1924 [1899]), quoted in *SC*, 178. "Torturing" is on p. 175.

89. Sandström, in *SC*, 217, 220. The *fondo*, or deepest level, is shown in Sandström's diagram, *ibid.*, 213, even though there is no way to relate the spandrels to the back walls of the seers' thrones, or the fronts of their thrones to the backs, because Michelangelo has covered the crucial passages with draperies.

90. Seymour, in *SC*, 84, 85.

91. Although James Beck has doubted that the scene represents the Sacrifice. (He identifies it as the Sacrifice of Cain and Abel.) See Beck, "Michelangelo's *Sacrifice* on the Sistine Ceiling," in *Renaissance Society and Culture, Essays in Honor of Eugene F. Rice, Jr.*, edited by John Monfasani and Ronald G. Musto (New York: Italica Press, 1990), 9–17.

92. The third alternative is proposed in Hartt, "*Lignum vitæ*," *op. cit.*, 135; the fourth in Dotson, "An Augustinian Interpretation," *op. cit.*, 233 and 238; she defends the absence of signs of "life" by positing that Michelangelo wanted to emphasize God's dealings with mankind. The austerity would when be in line with Michelangelo's lack of interest in landscape.

93. Vasari, *La Vita di Michelangelo*, edited by Paola Barocchi (Milan: R. Ricciardi, 1962), vol. 1, 42; Ascanio Condivi, as in *SC*, 118. For the modern literature see Wind, "Maccabean Histories," *op. cit.*, 312 ff.; Rudolf Kuhn, *Michelangelo, Die sixtinische Decke* (Berlin: de Gruyter, 1975); and Dotson, "An Augustinian Inter-pretation," *op. cit.*, 421–24.

94. Charles Hope, "The Medallions on the Sistine Ceiling," *Journal of the Warburg and Courtauld Institute* 50 (1987): 200–4. The subjects are taken from woodcut illustrations in a 1493 edition of Niccolò Malermi's *Biblia vulgare istoriata*, and represent scenes from Genesis, II Samuel, I and II Maccabees, and II Kings.

95. Hope, "The Medallions on the Sistine Ceiling," *op. cit.*, 203.

96. Dotson, "An Augustinian Interpretation," *op. cit.*, 236.

97. In addition to sources mentioned above, see Edgar Wind, "Sante Pagnini and Michelangelo: A Study of the Succession of Savonarola," *Gazette des Beaux–Arts* 26 (1944): 211–32, and J. Schulyer, "Michelangelo's Serpent with Two Tails," *Source* 9 (1990) 23–28.

98. Some examples: Leo Steinberg, "Who's Who in Michelangelo's *Creation of Adam*: A Chronology of the Picture's Reluctant Self–Revelation," *The Art Bulletin* 72 (1992): 552–66, and the exchange in *The Art Bulletin* 73 (1993): 340–44; Paul Barolsky, "Metaphorical Meaning in the Sistine Ceiling," *Source* 9 (1990): 19–22.

99. Hope, "The Medallions on the Sistine Ceiling," *op. cit.*, 201.

100. Roberto Salvini, "Painting," in *The Complete Work of Michelangelo*, edited by

Mario Salmi *et al.* (New York: Reymal in Association with W. Morrow, 1965) vol. 1, 201; and Mary Pittaluga, *La Sappella Sistina* (Florence: Del Turco, 1949), 35; both also cited in Dotson, "An Augustinian Interpretation," *op. cit.*, 232 n. 59.

101. Tolnay, *Michelangelo*, vol. 2, *The Sistine Ceiling, op. cit.*, 21.

102. For example J.D. Oremland, *Michelangelo's Sistine Ceiling, A Psychoanalytic Study of Creativity* (Madison, CT: International Universities Press, 1988); J. Saslow, "'A Veil of Ice Between My Heart and the Fire': Michelangelo's Sexual Identity and Early Modern Constructs of Homosexuality," *Genders* 2 (1988): 77–90; and Y. Evan, "The Heroine as Hero in Michelangelo's Art," *Woman's Art Journal* 11 (1990): 29–33.

103. Tolnay, *Michelangelo*, vol. 2, *The Sistine Ceiling, op cit.*, 159.

104. Hartt, review of Tolnay, *Michelangelo, op. cit.*, 255.

105. I make this argument in analytic terms in "The Case Against Surface Geometry," *Art History* 14 no. 2 (1991): 143–74.

106. *Il Libro delle figure dell'abate Gioachino da Fiore*, edited by Leone Tondelli *et al.*, 2 vols. (Torino: Società Editrice Internazionale, 1953), especially vol. 2, plates IX–X and XVIII. See Bull, "Iconography of the Sistine Chapel Ceiling," *op cit.*

107. See Sinding-Larsen, "A Re-reading of the Sistine Ceiling," *op. cit.*, 155 ff. The basis for this was set out by Henry Thode, *Michelangelo, Kritische Untersuchungen über seine Werke* (Berlin: G. Grote, 1908–13).

108. Freedberg in *SC*, 187–206.

109. Holberton, review of Settis, in *Art History, op. cit.*, 128. I have truncated the sentence; it continues: "…and to suppose, by way of a starting–point, that the unusualness of the *Tempest* might just have something to do with the unusualness of its subject?"

110. Leo Steinberg, "Leonardo's *Last Supper*," *Art Quarterly* 36 no. 4 (1973): 298.

111. *Ibid.*, 298 and 310, closely paraphrased on 356.

112. Freud, "The Moses of Michelangelo" (1914), for example in *Collected Papers*, edited by Joan Riviere, 5 vols. (New York: Basic Books, 1959), vol. 4, 286.

113. Motzkin, "Giorgione's *Tempesta*," *op cit.*, 169.

114. This is explored in William Hauptman, "Some New Nineteenth–Century References to Giorgione's 'Tempesta,'" *The Burlington Magazine* 136 (1994): 78–82, especially 81 and 82. Byron's poem *Beppo* may have been inspired by the *Tempesta*, or by another painting then atributed to him.

115. André Chastel, "La redécouverte de Giorgione," in *Giorgione e l'umanesimo veeziano*, edited by Rodolfo Pallucchini (Florence: L.S. Olschki, 1981), 565–82; A. Fabris Grube, "La fortuna di Giorgione nella letteratura inglese e anglo–americano," in *Giorgione, Atti del convegno internazionale di studio per il 5° centenario della nascità* (Venice: Comitato per la Celebrazione Giorgionesche, 1979), 321–28; and E. Hüttinger, "Il culto di Giorgione della fin–de–siècle, premesse e conseguenze," in *Ibid.*, 329–38; all cited in Hauptman, "Some New Nineteenth–Century References," *op. cit.*

NOTES TO CHAPTER 6

1. Abbé Dominique Bouhours, *La Maniere de bien penser dans les ouvrages d'esprit*, second edition (Paris: Veuve de S. Mabre-Cramoisy, 1688), 216–17. Hereafter *LM*.

2. Moxey, *The Practice of Theory* (Ithaca, NY: Cornell University Press, 1994), 138, 136, 113 respectively.

3. du Certeau, *The Mystic Fable*, translated by Michael Smith (Chicago: University of Chicago Press, 1992), 49–72. I thank Kevin Chua for this and several of the following references to Bosch.

4. Cook, "Change of Signification in Bosch's *Garden of Earthly Delights*," *Oud Holland* 98 no. 2 (1984): 85.

5. Ernst Gombrich, *Symbolic Images* (London: Phaidon, 1972), 124.

6. Erwin Panofsky, *Early Netherlandish Painting* (Cambridge, MA: Harvard University Press, 1966), 358.

7. Roger Marijnissen, *Hieronymus Bosch, The Complete Works* (Antwerp: Mercator-fonds, 1987), 43, dates the expansion of the literature to Fränger's *Das Tausendjahre Reich* (Coburg, 1947), translated by Eithne Williams and Ernst Kaiser as *The Millenium of Hieronymus Bosch* (Chicago: University of Chicago Press, 1951).

8. Dixon, *Alchemical Imagery in Bosch's* Garden of Earthly Delights (Ann Arbor, MI: UMI Research Press, 1981); and see Dixon, "Bosch's Garden of Delights Triptych: Remnants of a 'Fossil' Science," *The Art Bulletin* 63 (1981): 96–113; and Dixon, "Water, Wine, and Blood: Science and Liturgy in the *Marriage at Cana* by Hieronymus Bosch," *Oud Holland* 96 (1982): 73–96. Other alchemical readings include Jacques van Lennep, *Art et alchimie: Étude de l'iconographie hermétique et de ses influences* (Brussels: Meddens, 1966), and Madeleine Bergman, *Hieronymus Bosch and Alchemy*, translated by Donald Bergman (Stockholm: Almqvist & Wiksell, 1979).

9. Elkins, "On the Unimportance of Alchemy in Western Painting," *Konsthistorisk tidskrift* 61 (1992): 21–26, and a reply to Didier Kahn on the same subject, "What is Alchemical History?," *Ibid.* 64 no. 1 (1995): 51–53.

10. Madeleine Bergman, *Hieronymus Bosch and Alchemy*, translated by Donald Bergman (Stockholm: P.A. Norstedt, 1970), especially 102–3. Bergman's book also contains summaries of the scholarship on Bosch and hermeticism from 1560 to 1978. Recent unpublished work by Michael Crumbock attempts to fold alchemical meanings into more general humanist readings of the paintings.

11. Moxey, *Practice of Theory, op. cit.*, 112.

12. For example Moxey, *Practice of Theory, op. cit.*, 138.

13. See Posner, *Antoine Watteau* (Ithaca, NY: Cornell University Press, 1984), 240.

14. C. Opperman, "Watteau in Retrospect," review of Posner, *Watteau, op. cit.*, and M.R. Michel, "Watteau, un artiste au XVIIIe siècle," *The Burlington Magazine* 118 (1985): 915–17. Discussions of meaning in Watteau go back to the Comte de Caylus's *Vie d'Antoine Watteau*. For recent texts see Margaret Morgan Grasselli and Pierre Rosenberg, *Antoine Watteau, 1684–1721* (Washington: National Gallery of Art, 1984) 12.

15. Michel, "Watteau, un artiste au XVIIIe siècle," *op. cit.*

16. Levey, "The Real theme of Watteau's Embarkation for Cythera," *The Burlington Magazine* 103 (1961): 180–85.

17. Gérard Le Coat has come to a similar conclusion regarding *Le pélegrinage à l'isle de Cythère*. See his "Le pélegrinage à l'isle de Cythère: un sujet 'aussi galant qu'allegorique,'" *Revue d'art Canadienne* 2 no. 2 (1975): 9–23. Le Coat comes closest to my position when he says Watteau "leaves it up to the reader to choose among several readings"; but his ideas of a guiding topos are inconsistent with an intentional ambiguity such as I posit here.

18. Reported in Grasselli and Rosenberg, *Antoine Watteau, op. cit.*, 433a. For Watteau see further Linda Nochlin, "Watteau: Some Questions of Interpretation," *Art in America* 73 (1985): 73–80.

19. This, I assume, is close to Grasselli and Rosenberg's position—as implied on 13, 242, *et passim* (*Antoine Watteau, op. cit.*).

20. *Ibid.*, 13 and 264.

21. For Caylus's statement see *ibid.*, 12 and 243; for the modern phrase, *ibid.*, 13.

22. Michael Levey, cited in Grasselli and Rosenberg, *Antoine Watteau, op. cit.*, 401.

23. For facsimile see Grasselli and Rosenberg, *Antoine Watteau, op. cit.*, 396.

24. *Ibid.*, 12.

25. Erwin Panofsky, *Gothic Architecture and Scholasticism* (New York: Meridian, 1958), 87.

26. V.M. Hamm, "Father Dominique Bouhours and Neo-Classical Criticism," in *Jesuit Thinkers of the Renaissance*, edited by Gerard Smith (Milwaukee: Marquette University Press, 1939), 73. The principal source for Bouhours is still George Doncieux, *Le Père Bouhours, un Jésuite homme de lettres au dix-septième siècle* (Paris: Hachette, 1886).

27. Racine is recorded as having said to Bouhours, "Vous êtes un des plus excellentes maîtres de la langue." Cited in F.B. Clark, *Boileau and the French Classical Critics in England (1660–1830)* (Paris: E. Champion, 1925), 264. See also Doncieux, *Père Bouhours, op. cit.*, 100–16; and for Boileau's opinion, V.M. Hamm, "Father Dominique Bouhours," *op. cit.*

28. For Bouhours's influence in England, see Bouhours, *The Art of Criticism*, edited by Philip Smallwood (Delmar, NY: Scholars' Facsimiles, 1981 [1705]), v–xvii (*The Art of Criticism* is an English translation of *LM.*). The Italian reaction is principally due to the Marchese Giovan Giosetto Orsi; see Doncieux, *Père Bouhours, op. cit.*, 125, and Orsi, *Considerazioni del marchese Giovan-Gioosetto Orsi: bolognese, sopra La maniera di ben pensare* (Modena: Bartolomeo Soliani, 1735). Other examples include Girolamo Baruffaldi, *Osservazioni critiche, nelle quali asaminandosi la lettera toccante le Considerazioni del marchese Gian-Giuseppe Orsi sopra la Maniera di ben pensare* (Venice, 1710), and *Vagliatura tra Bajone e Ciancone mugnaj della Lettera toccante le Considerazioni* [de G. Orsi] *sopra la Maniera* (Padua, 1731). For a German reaction see E. Haase, "Zur Frage, ob ein Deutscher ein 'bel esprit' sein kann," *Germanisch-romanische Monatsschrift* 50 (1959): 360–75, and G.W. Leibniz, *Unvergreiffliche Gedanken betreffend die Auseubung und Verbesserung der deutschen Sprache* (1897). Additional sources are cited in the *Enciclopedia Filosofica* (Florence: Sansoni, 1968–69), *v.* Bouhours, v. 1, 1033a. And see Pierre Bayle, *Dictionnaire historique et critique*, second edition (Rotterdam: Chez Reinier Leers, 1702), *v.* Bouhours, where Bayle quotes with approbation the following opinion: "The good Father Bouhours never understood his own language, not to mention German or any other European language."

29. The play, entitled "Le Je ne sais quoi; comédie en un acte avec un divertissement," was written by Louis de Boissy and performed by the Théâtre du Italiens in 1731. The character Je ne sais quoi rebukes "Géomètrie," a "Petit Maître," a drunken "Officier Suisse," and a "Public Féminin" to retain his identity as an independent personage. See W. Thorman, "Again the *Je ne sais quoi*," *Modern Language Notes* 73 (1958): 351–55.

30. For a summary of the facts of Watteau's life see John Sunderland and Ettore Camesasca, *The Complete Paintings of Watteau* (New York: H.N. Abrams 1968), 83–86. Watteau may have heard of Bouhours (and of contemporary criticism in general) before his arrival in Paris, but it seems more likely that he became acquainted with Parisian criticism during his visits to the print shops in the Rue St. Jacques, which began in ca. 1703. Pierre Mariette II and Jan Wleughels both appear to have had extensive connections with the Parisian art world (*Ibid*, 83, 85). After his entrance into more fashionable society (beginning with his stay with the "concierge" of the Luxembourg Palace, Claude Audran III, in ca. 1707–1708) his opportunities to learn Bouhours's ideas would have increased. Barring any new evidence, his contacts with Caylus and De Piles, and his entry into the "plus beaux cabinets" constitute the strongest evidence that he knew of Bouhours. The most extensive contemporaneous document, Caylus's address to the Académie, does not mention Bouhours. (Comte de Caylus, *Vie d'Antoine Watteau lué à l'Académie en 1748*, in

Pierre Champion, *Notes Critiques sur les vies anciennes d'Antoine Watteau* [Paris: E. Champion, 1921].) For Bouhours's fame at this time, see Doncieux, *Père Bouhours, op. cit.*

31. The *Entretiens d'Artiste et d'Eugène* first appeared in 1671. Subsequent editions appeared in 1672, 1682, 1683, 1703, 1708, 1711, 1748, and 1768. There are several reprints, for example (Hildesheim: Georg Olms, 1987).

32. Erich Köhler, "*Je ne sais quoi*, Ein Kapitel ausder Begriffsgeschichte des Unbegreiflichen," *Romanistisches Jahrbuch* 6 (1953–54): 21–59.

33. They go on to find it in even more unexpected places: in "toutes les qualitez occultes des Philosophes" and in the World to Come, which God has promised: indeed, the *je ne sais quoi* may be "divine grace" itself. Bouhours, *Entretiens, op. cit.*, first edition, 251, 254–55, and compare 239, 241–44. Doncieux distinguishes three kinds of *je ne sais quoi:* "amoreux," "pictural," and "théologique, qui est la Grace" (*Père Bouhours, op. cit.*, 264, n. 1). But it does not appear that Bouhours meant to distinguish three kinds: his exposition simply makes use of three images.

34. Bouhours, *Entretiens, op. cit.*, 239–40.

35. *LM* went through an even greater number of editions: 1687, 1688 (*ed. cit.*), 1689, 1691 (Amsterdam), 1692, 1701, 1705, 1709, 1715, 1756, and 1791. *LM* was translated into English in 1705 (see *The Art of Criticism, op. cit.*), and paraphrased by John Oldmixon, *The Arts of Logick and Rhetorick* (London: the Author, 1728), reprinted (Hildesheim: G. Olms, 1976). Oldmixon includes these observations: "Father Bouhours was sometime of [the] opinion that he shou'd call his Book the History of Thoughts, and not the Manner of Thinking. For he often represents the Origin of them, the Progress, the change & the Decadence" (p. 4, quoted form the first edition). Oldmixon adds English examples and deletes imflammatory quotations: "I have done it paraphrastically, and thrown out the Dialogue, which has, indeed, some French impertinencies in it" (xix from Ibid.). An Italian translation appears in v. 1 of Orsi, *Considerazioni, op. cit.*

36. It is telling that Voiture, the most eminent figure at the *préciosité* salon at the Hotel de Rambouillet, receives more praise than Virgil or Cicero. Yet English writers in particular have often read something of Locke or Kant into Bouhours. Joseph Addison writes: "Bouhours, whom I look upon to be the most penetrating of all *French* Criticks, has taken Pains to show that 'tis impossible for any thought to be beautiful which is not just, and has not its Foundation in the Nature of Things: That the Basis of all Wit is Truth; and that no thought is valuable, of which good Sense is not the Ground-work." From the *Spectator*, quoted in Oldmixon, *Arts of Logick, op. cit.*, xxxii. For a study of Voiture's *préciosité* see M. Droke, *Préciosité in Voiture's Letters*, Ph.D. dissertation, University of Chicago, 1917.

37. *LM*, 21, 104.

38. *LM*, 212–13. *Sublime* comes from Boileau's translation of Longinus, and *agréable* has echoes of Pascal. (And see *Pensées*, II, 162 for the *je ne sais quoi*.) For the *sublime* see Doncieux, *Père Bouhours, op. cit.*, 236, n. 1. For the connection between *agréable* and Pascal, see Jean Ehrard, *L'Idée de nature en France dans la première moitié du XVIII^e siècle* (Paris: S.E.V.P.E.N., 1963), v. 1, 259 n. 1.

39. *LM*, 214.

40. In the *équivoqué*, as Ernst Cassirer has said, "Falsches und Wahres gemischt und zu einer Einheit verbunden ist." Cassirer, *Die Philosophie der Aufklärung* (Tubingen: Mohr, 1932), 403. Cassirer's analysis is not the first to stress the subjective elements in Bouhours's writings. See also Heinrich von Stein, *Die Entstehung der neueren Ästhetik* (Stuttgart: J.G. Cotta, 1886), 87 ff. A line from Martial, "Vox diversa sonat, populorum est vox tamen una," is the occasion for a discussion of the depths of subtlety which ambiguities can produce; see *LM*, 29–30. Bouhours

does not count the associations of evocative passages—that would trespass on the *je ne sais quoi*—but Cassirer is right to emphasize the large number of meanings which are usually involved: "Ein ästhetischer Gedanke empfängt seinen Wert und seinen Reiz nicht durch seine Genauigkeit und Deutlichkeit, sondern durch die Fülle der Beziehungen, die er in sich fasst" (*Die Philosophie, op. cit.,* 401). This sense of truth is peculiar to Bouhours; the Abbé Jean-Baptiste Du Bos, who is Bouhours's successor in other ways, disposes of the *vray* foundation which is essential to Bouhours and turns to the passions and the subjective origins of beauty. The "feu poëtique" is far from Bouhours's calm and somewhat removed *vérité*.

41. See Emile Dacier and Albert Vuaflart, *Jean de Julienne et les graveurs de Watteau en XVIIIe siècle* (Paris: M. Rousseau, 1921–1929); L. de Fourcauld, "Watteau, scénes et figures théâtrales," *Revue de l'Art Ancien et Moderne* 10 (1901): 105 ff. and 15 (904): 135 ff; and most recently, François Moureau, "Theater costumes in the work of Watteau," in Grasselli and Rosenberg, *Antoine Watteau, op. cit.,* 507–26.

42. Sunderland and Camesasca, *Complete Paintings of Watteau, op. cit.,* 119a, and A. Brookner, *Watteau* (New York, 1971), 33.

43. For the identification with Danchet and Campra's ballet of the same name, see E. Boury, "Fêtes vénitiennes," *Études italiennes* 3 (1921), and the response in Dacier and Vuaflart, *Jean de Julienne, op. cit.*

44. It is easy to deduce the emotions and roles of characters in pictures like Lancret's *Le Colin-maillard* in Stockholm or the Potsdam *Montreur de lanterne-magique:* each figure is either player or spectator, and each spectator has a function or physiognomically encoded expression. See the discussions in Robert Rey, *Quelques satellites de Watteau* (Paris: Librairie de France, 1931).

45. For the statue, see A. de Mirimonde, "Statues et emblèmes dans l'oeuvre de Watteau," *La Revue du Louvre et des Musées de France* 1 (1962): 11–20.

46. For the identification with Pierrot, see Grasselli and Rsenberg, *Antoine Watteau,* 430–34.

47. Watteau's unfortunate is only *compared* to an animal, but the animal seems to suffer doubly by the comparison: it looks at us with "the saddest eye ever painted." Dora Panofsky, "Gilles or Pierrot?," *Gazette des Beaux-Arts* 162 (1952): 319–40.

48. "Les auteurs de ces Epigrammes, ajoûta Eudoxe, avoient un peu du génie des Peintres qui excellent en certaines naïvetez graceieuses, & entre autres du Corrége, dont les peintures d'enfans ont des graces particuliéres, & quelque chose de si enfantin, que l'art semble la nature mesme" (*LM,* 203–4).

49. *LM,* 415.

50. See Posner, *Antoine Watteau, op. cit.*

51. *LM,* 213.

52. *LM,* 215, and see 111.

53. Dora Panofsky, "Gilles or Pierrot?," *op. cit.*

54. See Grasselli and Rosenberg, *Antoine Watteau, op. cit.,* 33–34.

55. *LM,* 215.

56. *LM,* 237.

57. Le Coat, "Le pélegrinage," *op. cit.*

58. Bouhours, *Entretiens, op. cit.,* 242.

59. *Ibid.,* 251. See also 248: "Mais outre ce je ne sçay quoy qui repare, comme nous avons dit, tous les defauts naturels, & qui tient lieu quelquefois de beauté, de bonne mine, de belle humeur, & mesme d'esprit. . . ." The reference is to 241, in which they had agreed that "le je ne sçay quoy raccommode tout." And further

250, in which it is claimed that the *je ne sais quoi* distinguishes individual faces and arouses antipathy or sympathy immediately.

60. Preëminent is the Mezetin's Family in the Wallace Collection; but portraits of Wleughels and others are scattered through the work on a smaller scale. See also Posner, *Antoine Watteau, op. cit.*, 243.

61. Bouhours, *Entretiens, op. cit.*, 241, 252–53.

62. "Il y en cela [a letter of Munster to the Comte d'Avaux] bien de l'anjoûment, dît Philanthe, & un anjoûment spirituel qui a esté ce me semble inconnu aux Anciens an matiére de loûanges. Cicéron aime fort à rire, mais il ne rit pas quand il loûë. Martial qui badine, & qui plaisante d'ordinaire, est sérieux & grave en loûant" (*LM*, 281–82).

63. Watteau's sense of play or reverie extends even to his military scenes, which are unserious and pleasant even in comparison to compositionally similar paintings like Van der Meulen's *Die Belagerung von Charleroy* or the *Siège de Dôle* in Versailles.

64. See n. 29, and Donald Posner, "Watteau mélancolique: la formation d'un mythe," *Bulletin de la societé de l'Histoire de l'art français* (1973): 345–61.

65. In the sixteenth century Mme. de Gournay said "l'amour, qui est je ne sçay quoy, doit sourdre aussi de je ne sçay quoy." See Doncieux, *Pére Bouhours, op. cit.*, 265 n. He names Marivaux and Montesquieu as echoes (264 n.). The *je ne sais quoi* is mentioned in connection with Boileau in Alfred Lombard, *l'Abbé Du Bos, un initiateur de la pensée moderne (1670–1742)* (Geneva: Slatkine, 1969), 185.

66. Doncieux, *Pére Bouhours, op. cit.*, 238 n. 1. Further, modern studies of the *je ne sais quoi* include: José Navarro de Adriaensens, "Je ne sais quoi: Bouhours-Feijoo-Montesquieu," *Romanistisches Jahrbuch* 21 (1970): 107–15; Fritz Schalk, "Nochmals zum *je ne sais quoi*," *Romanische Forschungen* 86 (1974): 131–38; S. Guellouz, "Le Père Bouhours et le je ne sais quoi," *Les Annales Econ. Société, Civilisation* 7 no. 2 (1971): 3–14; and Vladimir Jankelevitch, *Le je-ne-sais-quoi et le presque-rien* (Paris: Presses Universitaires de France, 1957).

NOTES TO CHAPTER 7

1. Oskar Pfister, "Kryptographie, Kryptolalie, und unbewusstes Vexierbild bei Normalen," *Jahrbuch für psychoanalytische und psychopathologische Forschungen* 5 (1913): 117–56, as translated in Sigmund Freud, *Leonardo da Vinci and a Memory of his Childhood* (1910), in *The Standard Edition of the Complete Psychological Works of Sigmund Freud*, edited by James Strachey (London: Hogarth Press, 1953–), vol. 11, 59–137.

2. For geometric figures see Elkins, "The Case Against Surface Geometry," *Art History* 14 no. 2 (1991): 143–74, and Leo Steinberg, "The Line of Fate in Michelangelo's Painting," *Critical Inquiry* 6 (1979–80): 411–54.

3. For cryptomorphs in Courbet see the discussion in Michael Fried, *Courbet's Realism* (Chicago: University of Chicago Press, 1990), 238 ff., commenting on Hélène Toussaint *et al.*, *Gustave Courbet (1819–1877)*, exhibition catalogue (Paris: Grand Palais, 1977). For Goya see Barbara Stafford, "From 'Brilliant Ideas' to 'Fitful Thoughts': Conjecturing the Unseen in Late Eighteenth-Century Art," *Zeitschrift für Kunstgeschichte* 48 (1985): 329–63, especially 352; and Priscilla Muller, *Goya's "Black" Paintings, Truth and Reason in Light and Liberty* (New York: Hispanic Society of America, 1984). In addition to the sources I cite below, see W. Kroy, "Ambiguous Figures by Bosch," *Perception and Psychophysics* 35 no. 4 (1984): 402–4.

4. Fried, *Courbet's Realism, op. cit.*, 238–54, discussing a tradition of such sightings that began with Toussaint *et al.*, *Gustave Courbet, op. cit.*, 150, 152.

5. Lorenz, personal communication, c. 1986. For another scientific example of hidden images see my *On Pictures and the Words that Fail Them*, (New York: Cambridge University Press, 1998), 276.

6. See for example Lucretius, *De rerum natura* iv. 132 ff.; Pliny, *Historia naturalis* xxxv.10.

7. For examples see David Murray, *Museums: Their History and their Use, With a Bibliography and List of Museums in the United Kingdom* (Glasgow: J. MacLehose and Sons, 1904), vol. 1.

8. See *Dictionnaire des antiquités Grecques et Romaines*, edited by Ch. Darmberg and E. Saglio (Paris: Hachette, 1877), *v.* "argoi lithoi," 413–14, and "baetylia," 612–47.

9. Paolo Graziosi, *L'arte dell'antica età della pietra* (Florence: Sansoni, 1956), 274 ff.

10. For the scandal of faked fossils see Melvin E. Jahn and Daniel J. Woolf, *The Lying Stones of Dr. Johann Bartholomew Adam Beringer* (Berkeley: University of California Press, 1963), J.M. Edmonds and H.P. Powell, "Beringer 'Lügensteine' at Oxford," *Proceedings of the Geologists' Association* 85 (1984): 549–54, and Mark Jones *et al.*, editors, *Fake? The Art of Deception* (London: British Museum, 1990), 91.

11. H.W. Janson, "The 'Image Made by Chance' in Renaissance Thought," *De Artibus Opuscula XL, Essays in Honor of Erwin Panofsky* (Zurich: Bueher, 1961), 262. A simpler but more wide-ranging version of Janson's essay appeared as "Chance Images," in *Dictionary of the History of Ideas*, edited by Philip Wiener (New York: Scribner's, 1973), vol. 1, 340b ff. See Pliny, *Hist. nat.* xxxv.10.

12. For Ugo da Carpi, see Georges Didi–Huberman, *Devant l'image, question posee aux fins d'une histoire de l'art* (Paris: Minuit, 1990).

13. See my critique of Giancarlo Maiorino, *The Portrait of Eccentricity: Arcimboldo and the Mannerist Grotesque* (University Park, PA: Pennsylvania State University Press, 1991) and Jacques Lacan's reading of the *French Ambassadors*, both in my *The Poetics of Perspective* (Ithaca, NY: Cornell University Press, 1994), 35, 167.

14. I am counting Piero's *trompe l'oeil* as an anamorph, because its viewpoint is so close the shape is difficult to discern. The identification is legitimate because anamorphs are only linear perspective representations with the center of projection displaced an arbitrary distance from a line orthogonal to the center of the picture. See my *Poetics of Perspective, op. cit.*

15. Karel Van Mander, *The Lives of the Illustrious Netherlandish and German Painters, From the First Edition of the* Schilder-boeck *(1603–1604)*, translated by Hessel Miedema (Doornspijk: Davaco, 1994), vol. 1, 134 and 137, punctuation modified.

16. I have usually kept clear of the term "subliminal" because of its associations with coercive advertising and its limited (recent) history. Wilson Bryan Key, *Subliminal Seduction: Ad Media's Manipulation of a Not So Innocent America* (New York: New American Library, 1974) is the principal source.

17. Another example, historically anomalous as far as I am aware, is Alexander Golovin's *Two Visions of Skriabin* (c. 1908), in which the second "vision" can only be seen if the painting is viewed through a blue filter (or a blue glass dinner plate, when I was shown the painting). It is possible, in that case, that the effect would be seen when the painting was illuminated in blue light—for example during a seance. In 1995, the painting was on loan to the Duke University Art Museum.

18. Ronald Lightbown, *Mantegna, With a Complete Catalogue of the Paintings, Drawings and Prints* (Berkeley: University of California Press, 1986), 80, 408.

19. Stuart Welch, *Persian Painting, Five Royal Safavid Manuscripts of the Sixteenth Century* (New York: Braziller, 1976), 38.

20. See Douglas Barrett and Basil Gray, *Painting of India* (Lausanne and Paris: Skira, 1963), 87–89.

21. This according to Janson, "The 'Image Made by Chance,'" *op. cit.*; see Erwin Panofsky, "The Early History of Man in Two Cycles of Paintings by Piero di Cosimo," in *Studies in Iconology* (New York: Harper, 1972), 33–68, especially 63.

22. Castelli, "Umanesimo e simbolismo involuntario," *Umanesimo e simbolismo, etti del iv convegno internazionale di studi umanistici*, published in *Archivio di Filosofia* 2–3 (1958): 17–21.

23. "Per vederlo (meglio: per riconoscerlo) bisogna 'cercarlo,' altrimenti rimane un tronco qualunque di un albero spezzato." *Ibid.*, 19.

24. *Ibid.*, 20: "intravedere, cioé *scoprire*," italics original

25. Panofsky, quoted in Janson, "The 'Image Made by Chance,'" *op. cit.*, n. 39.

26. For *Highlights* images see *Super Colossal Book of Hidden Pictures*, compiled by the editors of *Highlights for Children* (Honesdale, PA: Boyds Mills Press, 1994). For related examples see the *Waldo* or *Wally* books by Martin Hanford, and Margret Rey, *Curious George Goes to the Hospital* (Boston: Houghton Mifflin, 1966).

27. Castelli, "Umanesimo e simbolismo involuntario," *op. cit.*, 20 n. 6.

28. In the normal interpretation, the drawing is an incomplete rendering of a moralizing theme (owls representing sin, envy, and hatred).

29. Naturally there's no end. The article concludes with Langerholc's supposition that the drawing might be an allegory of the Book of Job, and there is a single footnote recording opinions of friends who they consulted: "One young lady pointed out that, when turned upside down, the 'thigh' in the main branch of the tree can also be seen as a *tête de biche*, a deer's head" and so forth. Kroy and Langerholc, "Ambiguous Figures by Bosch," *Perception and Psychophysics* 35 (1984): 402–4; the quotations are on pp. 402 and 404.

30. Ladendorf, "Zur Frage der künstlerischen Phantasie," *Mouseion, Studien aus Kunst und Geschichte für Otto Förster* (Cologne: M. DuMont Schanberg, 1960), 21: "viele, ungriefbar sich ineinander verschränkende Gesichter und Masken in den verformten Kissen scheinen zu lebendigen, chimärischen Wesen geworden zu sein.... Der linke Rand des Kissens oben links kann als ein großes Profil mit eingesunkenem Auge und groß herausgezeichneter Nase mit hervorgehobenem Nasenflügel aufgefaßt werden, man kann aber auch ein kleines Gesicht aus dem Kissenzipfel herauslesen. Das Kissen rechts oben gibt eine seltsam deformierte Kopfform, der des Kissens darunter in Richtung und Bewegung ähnlich. Ob aus dem Kissen unten rechts ein nach links blickender Männerkopf mit großer, bis zu den Augen über die Stirn gezogener Kappe abgelesen werden kann, scheint der Phantasie des Betrachters überlassen zu bleiben."

31. Schefold, "Zur Frage der künstlerischen Phantasie," *Antike Kunst* 4 no. 2 (1961): 79, calls it "[e]in besonders schönes Beispiel," and it is also mentioned in Janson, "The 'Image Made by Chance,'" *op. cit.*, 345a.

32. See P. Reuterswärd, "Sinn und Nebensinn bei Dürer, Rendbemerkungen zur 'Melencola I'," *Gestalt und Wirklichkeit, Festgabe für Ferdinand Weinhandl* (Berlin: Duncker und Homblot, 1967), 411–36. For another example in Dürer see Walter Strauss, *The Complete Drawings of Albrecht Dürer* (New York: Abaris, 1974), vol. 1, nos. 1493/7 and 1495/31.

33. Janson, "The 'Image Made by Chance,'" *op. cit.*

34. Ladendorf, "Zur Frage," *op. cit.*: "Hier wird man sicher sein, nicht nur ein Gesicht in das Kissen hineinzusehen, sondern es aus ihm herauszulesen."

35. The same kind of invitation to mutual invention has been seen in the Book of Hours of Anne of Cleves. See John Plummer, *The Hours of Catherine of Cleves* (London: Barrie and Rockliff, 1966), 16. I am not denying that such playfulness

with the viewer ever takes place; I am only underscoring our contemporary interest in it.

36. For the painting see James Cahill, *An Index of Early Chinese Painters and Paintings, T'ang, Sung, and Yüan* (Berkeley: University of California Press, 1980), 165. Cahill calls it "an early and important work in the style, possibly by [Mi Youren]."

37. Peter Sturman, "Mi Youren and the Inherited Literati Tradition," PhD dissertation, Yale University, 1989, 240 ff. Sturman proposes that Mi Youren's "extraordinary wit" and political sentiments made him place an image of scholarly freedom in the clouds. He also argues that clouds in other paintings are reminiscent of "the immortal islands carried on the heads of the great *Ao* tortoises" (*Ibid.*, 202). Hence the face, in his view, is not entirely without contemporaneous parallels.

38. William Willetts, *Chinese Calligraphy: Its History and Aesthetic Motivation* (Hong Kong: Oxford University Press, 1981), 220–21.

39. Steinberg, *The Sexuality of Christ in Renaissance Art and in Modern Oblivion* (New York, 1983), 91; see now the revised edition (Chicago: University of Chicago Press, 1996).

40. See further my "Abstraction's Sense of History: Frank Stella's *Working Space* Revisited," *American Art* 7 no. 1 (winter 1993): 28–39.

41. Rosenblum, *Modern Painting and the Northern Romantic Tradition* (New York: Harper and Row, 1975).

42. Chave, *Mark Rothko, Subjects in Abstraction* (New Haven: Yale University Press, 1989).

43. Beckett, *Ill Seen Ill Said*, translated from the French by the author (New York: Grove Press, 1981).

44. Janson, "The 'Image Made by Chance,'" *op. cit.*, 262 n. 39. The "unconscious symbol" refers to E. Castelli's idea that hidden images are examples of what Suzanne Langer calls "unconsummated symbols," which he translates as "simbolo non fruito." (Castelli, "Umanesimo e simbolismo involuntario," *op. cit.*, 20 n. 6.)

45. Freud, *Leonardo da Vinci and a Memory of his Childhood*, *op. cit.*, 59–137.

46. Fagiolo dell'Arco, *Il Parmigianino, Un saggio sell-ermetismo nel Cinquecento* (Rome: Bulzoni, 1970), 58–59, 197.

47. Arasse, *Le détail, pour une histoire rapprochée de la peinture* (Paris: Flammarion, 1992), 264.

48. Arasse, *Le détail, op. cit.*, 266.

49. David Morgan, "Printed Pictures: Protestant Visual Culture in the Age of Mass Production," unpublished MS (1997); see *Icons of American Protestantism*, edited by David Morgan (New Haven: Yale University Press, 1996).

50. The Seventh Day Adventist Church, which owns copyright to the image, prohibits all reproduction. See the illustration in Raymond Woolsey and Ruth Anderson, *Harry Anderson: The Man Behind the Paintings* (Washington, DC: Review and Herald Publishing Association, 1976), 112. I thank David Morgan for this reference.

51. I have also argued this example in "Histoire de l'art et pratiques d'atelier," *Histoire de l'art* 29–30 (1995): 103–12

52. Korshak, "Realism and Transcendent Imagery: Van Gogh's 'Crows over the Wheatfield,'" *Pantheon* XLII (1985): 115—23.

53. Meshberger, "An Interpretation of Michelangelo's *Creation of Adam* Based on Neuroanatomy," *Journal of the American Medical Association* 264 (1990): 1837–41 and cover.

54. *Ibid.*, 1841.

55. See my "Michelangelo and the Human Form: His Knowledge and Use of Anatomy," *Art History* 7 (1984): 176–86.

56. For the coincidence of anatomy and architecture see Elkins, "Two Conceptions of the Human Form: Bernard Siegfried Albinus and Andreas Vesalius," *Artibus et historiæ* 14 (1986): 91–106.

57. Birger Carlström, *Hide-and-Seek, Text and Picture in the Pictures, Impressionists From Turner From [sic] Gainsborough* (Urhult, Sweden: Konstförlagt [privately printed], 1989), 69. "Consert" is in the original.

58. Geist, *Interpreting Cézanne* (Cambridge, MA: Harvard University Press, 1988). For Cézanne see further Diane Lesko, "Cézanne's 'Bather' and a Found Self–Portrait," *Artforum* 14 (1976): 53.

59. For an analysis of uncognized motifs in early Cézanne, see Elkins, "The Failed and the Inadvertent: The Theory of the Unconscious in the History of Art," *International Journal of Psycho-Analysis* 75 part 1 (1994): 119–32.

60. For further arguments regarding cryptomorphs in Cézanne see Geist, "Cézanne: Metamorphosis of the Self," *Artscribe* 26 (December 1980): 10 ff.; Diane Lesko, "Cézanne's 'Bather' and a Found Self-Portrait," *Artforum* 15 (1976): 52 ff.; and Theodore Reff, "Painting and Theory in the Final Decade," in William Rubin, editor, *Cézanne, The Late Work* (New York: New York Graphic Society, 1977), 26.

61. Drawing by Christian Broutin, illustrated in Jean Seyeux, *Jeux Joconde* (Paris: R. Laffont, 1969). I thank Erin MacLeod for this reference.

62. Eissler, *Leonardo da Vinci, Psycho-Analytic Notes on the Enigma* (New York: International Universities Press, 1961), 51, commenting on P. Stites, "More on Freud's Leonardo," *College Art Journal* 8 (1948): 40 ff.

63. Crookshank, *The Mongol in our Midst, A Study of Man and His Three Faces* (London: K. Paul, Trench, Trubner and Co., 1925), 118. Crookshank is discussed at length in my *Pictures of The Body: Pain and Metamorphosis* (Stanford: Stanford University Press, forthcoming).

64. Pfister, "Kryptographie, Kryptolalie," *op. cit.* Pfister says only that he will consider cases where "chance" appears to be excluded, so that the images are not "seen in" the paintings (*Ibid.*, 145). He also works from an undeveloped theory of cryptomorphic imagery, since he compares the overlapping forms in the Leonardo to paintings by Lucas Cranach in which Jesus is represented several times "as a person, as a lamb, or as a serpent on the cross" (*Ibid.*, 149). See also Oskar Pfister, *The Psychoanalytic Method* (New York: Moffat, Yard, and Co., 1917); Sigmund Freud, *Correspondance avec le pasteur Pfister, 1909–1939* (Paris: Gallimard, 1966); and Pfister, "The Illusion of a Future: A Friendly Disagreement with Prof. Freud," *International Journal of Psycho–Analysis* 74 no. 3 (1993): 557–79.

65. Waite, "Lenin in *Las Meniñas*: An Essay in Historical–Materialist Vision," *History and Theory* 25 no. 3 (1986): 277.

66. See Rose-Carol Washton Long, *Kandinsky, The Development of an Abstract Style* (Oxford: Clarendon Press, 1980). Hans Roethel calls *Composition VII* a "secret communicated by secrets" (H. Roethel, *Kandinsky*, [Oxford: Phaidon, 1979], 107). See further Félix Thürlemann, "Kandinskys Analyse-Zeichnungen," *Zeitschrift für Kunstgeschichte* 48 (1985): 364–78, and further Margaret Olin, "Validation by Touch in Kandinsky's Early Abstract Art," *Critical Inquiry* 16 (1989): 144–72, esp. 148 n. 13.

67. Leo Steinberg, "Leonardo's *Last Supper*," *Art Quarterly* 36 no. 4 (1973): 298 ff.

68. Melville, "Compelling Acts," review of Fried, *Courbet's Realism, op. cit.*, in *Art History* 14 (1991): 116–22.

69. Piotrowski, *Perceptanalysis, A Fundamentally Reworked, Expanded, and Systematized Rorschach Method* (New York: MacMillan, 1957); the quote is from Richard

Howes, "The Rorschach: Does it Have a Future?," *Journal of Personality Assessment* 45 no. 4 (1981): 339–51, esp. p. 340.

70. For the question of theoretical bases, see H. Eysenck, "Personality Tests: 1950–1955," in *Recent Progress in Psychiatry*, edited by Gerald Fleming (New York: Grove, 1959); for rival scoring systems see Hermann Rorschach, *Psychodiagnostics: A Diagnostic Test Based on Perception* (Bern: Hans Huber, 1942); Piotrowski, *Perceptoanalysis, op. cit.*; B. Klopfer, "The Present Status of the Theoretical Development of the Rorschach Method," *Rorschach Research Exchange* 1 (1937): 142–47; John Exner, *The Rorschach, A Comprehensive System* (New York: John Wiley, 1974); and Roy Schafer, *Projective Testing and Psychoanalysis* (New York: International Universities Press, 1967). No assessment of the Rorschach method should omit Florence Miale, *The Nuremberg Mind, The Psychology of the Nazi Leaders*, with an introduction and Rorschach records by Gustave Gilbert (New York: Quadrangle, 1975).

71. For a table of psychoses and "normal" responses, see Samuel Beck, *Introduction to the Rorschach Method* (New York: American Orthopsychiatric Association, 1937), 266–69.

72. W. Weiss and M. Katz, "Rorschach Form Level and the Process–Reactive Dimension of Schizophrenia," *Journal of Clinical Psychology* 33 (1977): 875–78.

73. The case for entanglement is made in my review of Hal Foster, *Compulsive Beauty* (Cambridge, MA: MIT Press, 1993), in *The Art Bulletin* 76 no. 3 (1994): 546–48, and the ensuing exchange, "Construction and Deconstruction in Art History," *The Art Bulletin* 77 no. 2 (1995): 342–43.

74. This reading of Freud's text is adumbrated in my "The Failed and the Inadvertent," *op. cit.*, and (though I now think the body of the essay is ruined by wrongheaded comparisons) my "Psychoanalysis and Art History," *Psychoanalysis and Contemporary Thought* 9 (1986): 261–98.

75. Koerner, *Handbuch der Heroldskunst, wissenschaftliche Beiträge zur Deutung der Hausmarken, Steinmetz–Zeichen und Wappen*, 2 vols. (Görlitz: C.A. Starke, 1923), vol. 2, 294.

76. Koerner, *Handbuch der Heroldskunst, op. cit.*, vol. 2, text to plate 17: "Der 'Mann' (mendes•medes) des 'könnens' (potestas virilis Y) oder Ganymedes (y wie das i in Nacht•i•gall, Bräut•i•gam usw.) ist auch im Brüsseler 'Mannekenpis' erhalten."

NOTES TO CHAPTER 8

1. I thank David Carrier for introducing me to this text, and Sharon Lanza for a skeptical reading. See Henry Lincoln, Michael Baigent, and Richard Leigh, *Holy Blood, Holy Grail* (New York: Delacorte Press, 1982); Henry Lincoln, *The Holy Place, The Mystery of Rennes-le-Château—Discovering the Eighth Wonder of the Ancient World* (New York: Arcade, 1991 [1986]). For further reading along these lines see James Stanley, *The Treasure Maps of Rennes-le-Château* (Heathfield: Seven Lights, 1984); P.A. Fanthorpe, *The Holy Grail Revealed: The Real Secret of Rennes-le-Château* (North Hollywood, CA: Newcastle, 1982); R. Lionel Fanthorpe, *Rennes-le-Château: Its Mysteries and Secrets* (Middlesex, England: Bellevue Books, 1991); DeAnna Emerson, *Mars/Earth Enigma: A Sacred Message to Mankind* (St. Paul, MN: Galde Press, 1996); Jean Blum, *Rennes-le-Château: Wisigoths, Cathares, Templiers, le secret des heretiques* (Monaco: Éditions du Rocher, 1994); Gerard de Sede, *Rennes-le-Château: Le dossier, les impostures, les phantasmes, les hypotheses* (Paris: R. Laffront, 1988); Jean-Jacques Bedu, *Rennes-le-Château: Autopsie d'un mythe* (Portet-sur-Garonne: Éditions Laubatieres, 1990); Jean Markale, *Rennes-le-Château et l'enigme de l'or maudit* (Paris: Pygmalion / G. Watelet, 1989); Pierre Jarnac, *Les Archives de Rennes-le-Château* (Nice: Belisane,

1987); Frederic Pineau, *Le tombeau de Virgile, roman ou presque* (Paris: M. Isabelle, 1990), etc., etc.

2. Lincoln, *The Holy Place, op. cit.*, 64.

3. Dalí, *Le mythe tragique de l'Angélus de Millet, interprétation «paranoïaque-critique»* (Paris: Jacques Pauvert, 1963). Hereafter *MT*.

4. Dalí, *The Tragic Myth of Millet's Angelus, Paranoiac–Critical Interpretation*, edited by A. Reynolds Morse, translated by Eleanor Morse (St. Petersburg, FL: privately printed and published by the Salvador Dalí Museum, 1986), v. Hereafter *TM*.

5. The date is my own supposition, by comparison with the evolution of Lacan's doctrines. The American editor says "before 1938" and then, in a footnote, "possibly even as early as 1932–1933." *TM*, xi.

6. Dalí's essay is in *Minotaure* 1 (1933): 65–67, translated in *TM*, 209–18.

7. Ades, *Dalí and Surrealism* (New York: Harper and Row, 1982), quoted in *TM*, 173–76, especially 175. See also David Macey, *Lacan in Contexts* (New York: Verso, 1988).

8. Dalí, *The Secret Life of Salvador Dalí*, translated by Haakon M. Chevalier (New York: Dial Press, 1961).

9. *TM*, xvi.

10. *TM*, x, and see also 155, 158, 222. The editor notes the similarity between the photographs and those in Dalí's "Apparitions aérodynamiques des êtres-objets," *Minotaure* 6 (1934): 33–34.

11. *TM*, 39. See Steinberg, "Art and Science: Do They Need to be Yoked?" *Daedalus* 115 no. 1 (1986): 1–16.

12. *TM*, 171–72.

13. Dalí, "Why They Attack the *Mona Lisa*," *Art News* 62 (March 1963), 36.

14. *TM*, 39, 176.

15. *TM*, 40.

16. *TM*, 166.

17. *TM*, 8.

18. *TM*, iii, 84, and see 163.

19. *TM*, 33; *Science* 231 (February 14, 1986).

20. *TM*, 140–41.

21. *TM*, 29.

22. *TM*, 169, 17. The image I am calling the *Ur*-image is hardly introduced in the body of the text: Dalí says only "The images in question (1)," and the reference leads the reader to the long excursus. *MT*, 24.

23. *TM*, vii.

24. *TM*, 7.

25. *TM*, 9.

26. Michael Anderson, "Art and its Description: Ekphrasis in the Ancient World," *Comparative Literature* 26 (1995): 26.

27. *TM*, 25.

28. See Anne Williams, *Jigsaw Puzzles, An illustrated History and Price Guide* (Radnor, PA: Wallaca-Homestead, 1990), fig. 10–10.

29. At this point, the argument of this book converges with my *Our Beautiful, Dry, and Distant Texts: Art History as Writing* (University Park, PA: Pennsylvania State University Press, 1997), whose argument concerns the possibility of allowing writing, in a fuller sense of that word, to find a place in art history. For Dilthey and art history see Oskar Bätschmann, *Einführung in die kunstgeschichtliche Hermeneutik* (Darmstadt: Wissenschaftliche Buchgesellschaft, 1988).

NOTES TO CHAPTER 9

1. Evan Kern, *Making Wooden Jigsaw Puzzles* (Mechanicsburg, PA: Stackpole Books, 1996).

2. A recent example of ornate pictures hiding simple images is the imitation marquetry paintings in an intitled book by Kit Williams (New York: Knopf, 1984). (The title is to be guessed by deciphering the images.)

3. For example Martin Hanford, *Find Waldo Now* (Boston: Little, Brown, 1994); Hanford, *Where's Wally: The Ultimate Fun Book* (London: Walker, 1990).

4. Mitchell, *Iconology: Image, Text, Ideology* (Chicago: University of Chicago Press, 1986).

5. Some ramifications of this are explored in my essay "The Failed and the Inadvertent: The Theory of the Unconscious in the History of Art," *International Journal of Psycho-Analysis* 75 part 1 (1994): 119–32. See, too, Sigmund Freud, "The Unconscious" (1915), in *The Standard Edition of the Complete Works of Sigmund Freud*, edited by James Strachey (London: Hogarth Press, 1957), vol. 14, pp. 166–204.

6. Jacques Derrida, *The Truth in Painting*, translated by Geoff Bennington and Ian McLeod (Chicago: University of Chicago Press, 1987), 5–8.

7. Bernstein, *The Fate of Art: Aesthetic Alienation from Kant and Derrida to Adorno* (University Park, PA: Pennsylvania State University Press, 1992), 144.

8. Derrida, *The Truth in Painting, op. cit.,* 10.

9. I argue a related point in "The Snap of Rhetoric: A Catechism for Art History," *SubStance* 68 (1992): 3–16, expanded in my *Our Beautiful, Dry, and Distant Texts: Art History as Writing* (University Park, PA: Pennsylvania State University Press, 1997). Schapiro's essay, the subject of Derrida's final chapter, is "Still Life as a Personal Object: A Note on Heidegger and Van Gogh," in *The Reach of Mind, Essays in Honor of Kurt Goldstein* (New York: Springer, 1968).

10. Bernstein, *Fate of Art, op. cit.,* 153–54.

11. Derrida, *Dissemination*, translated by Barbara Johnson (Chicago: University of Chicago Press, 1981), 258, quoted in Bernstein, *Fate of Art, op. cit.,* 154. Marking and semiotics are also discussed in my *On Pictures and the Words that Fail Them* (New York: Cambridge University Press, 1998), 3–46; and see Hubert Damisch, *Traité du trait, Tractatus tractus* (Paris: Seiul, 1995).

12. The argument of the first part of this sentence, and an adumbration of the second, are in Jacques Derrida, "'To Do Justice to Freud': The History of Madness in the Age of Psychoanalysis," *Critical Inquiry* 20 (1994): 227–66.

INDEX